2002 BIENNALE OF SYDNEY

(THE WORLD
MAY BE)
FANTASTIC

ART GALLERY OF NEW SOUTH WALES

MUSEUM OF CONTEMPORARY ART

ARTSPACE

OBJECT GALLERIES

CITY EXHIBITION SPACE

CUSTOMS HOUSE

GOVERNMENT HOUSE

SYDNEY OPERA HOUSE

24A ORWELL STREET, POTTS POINT

15 MAY–14 JULY

2002 BIENNALE OF SYDNEY

Catalogue
Editor: Ewen McDonald
Assistant Editor: Rosalind Horne
Research assistant: Caroline Walker
Copy editor: Jo Wodak
Design: Gretta Kool
Catalogue cover: Biennale of Sydney
Production: NetPrint Pty Ltd, Sydney
Scanning, Pre-press & Printing:
D&D Global Group Pty Ltd, Melbourne
Using Agfa Galileo CTP technology
Printing plates supplied by Agfa Australia

ISBN: 0 9580403 0 3

Printed and Bound in Melbourne, Australia

Available through D.A.P./Distributed Art
Publishers
155 Sixth Avenue, 2nd Floor, New York,
NY 10013, USA
Tel: + (212) 627 1999
Fax: + (212) 627 9484

Published by the Biennale of Sydney Ltd

Cataloguing-in-Publication

Biennale of Sydney (13th : 2002).
2002 Biennale of Sydney : (the world may
be) fantastic.

Bibliography.
ISBN 0 9580403 0 3.

1. Biennale of Sydney - Catalogs.
2. Art - New South Wales - Sydney -
Exhibitions. 3. Art, Modern - 21st century
- New South Wales - Sydney - Exhibitions.
I. McDonald, Ewen. II. Grayson, Richard,
1958- . III. Biennale of Sydney.
IV. Title : Biennale of Sydney 2002.

700.7499441

CONTENTS

THE BIENNALE OF SYDNEY 2002

When my father, Franco Belgiorno-Nettis, established the Biennale of Sydney in 1973 it was modelled on the noble aspirations of its 100-year old progenitor, La Biennale di Venezia. In many ways the Biennale of Sydney's achievements have exceeded his expectations. It is now Australia's largest single art exhibition, distinguished by its promotion of international dialogue and cultural exchange. Over one thousand artists from more than sixty countries have participated, and more than half have been able to travel to Australia under our auspices. We are most thankful to the many countries who continue to support their artists at our invitation.

I think one of the Biennale's greatest strengths is as a catalyst. The art exchange that occurs when the local arts community comes together with their international contemporaries is a powerful mix. The scale and reach of the exhibition itself, its publications and educational and visitor programs, have combined to forge lasting benefits to both individuals and organisations around the world.

We thank all the artists who are the core of the exhibition and our public programs. Richard Grayson, the first practising artist to be engaged as Artistic Director, has succeeded in realising his fantasy, through the work of fifty-six artists and collectives from twenty-three countries.

The leadership and financial commitment of our principal public supporters in Australia provide the backbone of our funding: the New South Wales Government through the Ministry for the Arts which commits triennial monies and critical insurance cover, the City of Sydney with multi-year funding, and the Australia Council who have backed us at a number of levels for nearly three decades.

Each exhibition is also reliant upon a small but growing number of businesses: our two Principal Sponsors, Transfield, the Founding Sponsor, and Tempo make generous cash contributions which provide the foundation of our private sector support. Other major sponsors are Beyond Online, JCDecaux ,ResMed, Singapore Airlines, SBS Television and Sydney Airport.

A number of foundations have generously helped present particular elements of the show, allowing us to realise projects which would normally be outside our reach: the Myer Foundation, the Toshiba International Foundation, the Shiseido Foundation and an Australian foundation wishing to remain anonymous.

CHAIRMANS FOREWORD

We are grateful to our many corporate sponsors, including Allco Finance, the Board of Architects NSW, CSR, Macquarie Bank Foundation, the College of Fine Arts/ University of NSW, Smorgon Steel, Sheraton Hotels, Price Waterhouse Coopers, Asahi Breweries, Marrickville City Council, ArtHouse Hotel, Thrifty Car Rental, Transfield Services and Yarra Trams. All of our associate partners and contributors are credited elsewhere in this publication.

This year we inaugurated a program for individual Benefactors whose contribution is directed towards artists and their work. These Benefactors are separately acknowledged with sincere thanks.

We are indebted to all our venues for their cooperation, in particular the Art Gallery of New South Wales and the Museum of Contemporary Art, and especially their staff, who have worked in close collaboration with our own to make real the imaginary!

The gifted team at the Biennale of Sydney have worked creatively to deliver the event in the face of considerable financial constraints. They deserve special mention for their professionalism, commitment and sheer hard work. I would particularly like to thank our General Manager, Paula Latos-Valier, who has delivered seven Biennales with unflagging dedication. As Chairman I would also like to pay tribute to the loyalty of my fellow Directors who have faced up to a challenging fundraising campaign.

I am proud to continue the tradition laid down by my father and brother Guido before me. In 2003 we reach an important milestone - our thirtieth anniversary: still young yet mature, confident but still ambitious!

(THE WORLD MAY BE) FANTASTIC

CURATOR
Richard Grayson

ADVISORY PANEL
Susan Hiller (London)

Ralph Rugoff (San Francisco)

Janos Sugar (Budapest)

(THE WORLD MAY BE) FANTASTIC was curated by myself in association with an Advisory Panel of three people whose input to the project I invited because of the significant contributions they have individually made to many of the areas that I hoped this exhibition would explore.

The Panel received a project rationale in December 2000 and initially our communications were electronic and then, in March 2001, we all met in London. Over three days of intensive discussion, different ways of developing the concerns of this exhibi-

PREFACE

THE ADVISORY PANEL

tion were proposed and analysed, and various artists and practices nominated and considered. This exhilarating exchange profoundly shaped the project and its aims and bought into play ideas and artists that I was either ignorant of or simply hadn't thought of in this context. (THE WORLD MAY BE) FANTASTIC would be a very different and poorer show without their input and I wish to acknowledge the fundamental importance and depth of the Advisory Panel's contribution to the exhibition

It is also important, however, to reiterate that they are working in an advisory not a curatorial role: they suggested but did not select. Final decisions about the artists represented in (THE WORLD MAY BE) FANTASTIC are my responsibility and mine alone. The exhibition includes some artists that the Panel never discussed and excludes some that were much discussed: so, whilst the Advisory Panel may rightfully claim the successes of the project, the errors are mine.

THE ADVISORY PANEL

SUSAN HILLER

Susan Hiller, a UK-based American artist known for her innovative and influential art practice in a wide range of media from drawing to installation. The common denominator in all her works is their starting point as a cultural artefact from our own society. Her varied projects have been described as 'investigations into the unconsciousness' of culture. Recent representation of her work includes: *The Muse in the Museum*, MoMA, New York (1999) and *Live in your head: Conceptual Art in Britain 1965-75*, Whitechapel Gallery, London (2000). Recent solo exhibitions include *Witness* (Artangel 2000) and the *PS I Girls*, Gagosian Gallery, New York 2001. She has four works in the Tate Collection and *From the Freud Museum* is currently installed at the Tate Modern. She is also the curator of the recent Hayward Gallery travelling exhibition *Dream Machines*.

RALPH RUGOFF

Ralph Rugoff is a San Francisco-based writer and art curator. He is a frequent contributor to such journals as *frieze*, *Artforum*, and *Parkett*, and newspapers such as *The Financial Times* and the *LA Times*. He has also written books and catalogue essays on a range of contemporary artists from the micro-miniaturist Hagop Sandaldjian to his 1995 publication, *Circus Americanus* – a collection of essays on popular visual culture in the USA.

Rugoff is the curator of such notable exhibitions as *Scene of the Crime* (1997) at the Armand Hammer Museum, Los Angeles, and *Just Pathetic* (1991). Rugoff is at present the director of the CCAC Institute in San Fransisco, an organisation devoted to the exhibition of contemporary art, design and architecture.

JANOS SUGAR

Janos Sugar is an artist based in Budapest and is a significant figure in the development of contemporary art in Eastern Europe. Sugar's practice is primarily concerned with the processes of ordering and the narratives that effect communication. He works across a range of media including painting, sculpture, film, video, performance and electronic and computer networks. Between 1980 and 1986 he was involved with Indigo, an interdisciplinary art group led by Miklos Erdely. Since 1990, Sugar has been the Professor of New Media at the Hungarian Academy of Fine Arts. Sugar has participated in a number of international exhibitions since 1984, such as *documenta IX* (1992), *Manifesta 1* (1996), and *L'autre Moitié de l'Europe* (Jeu de Paume, Paris, 2000).

I would also like to thank all the people in various countries from Portugal to Iceland, Japan to Norway and elsewhere, who took the time to talk to me during the development of this project… suggesting artists, discussing ideas and organising meetings and journeys. This list is too long and too fraught with the possibility of leaving someone out to even attempt, but I am deeply grateful for their help and assistance.
RICHARD GRAYSON 2002

After "Lights out for the Territory", a man sent me an X Ray of his brain tumour. He'd super-imposed it over a map of London and was try-ing to heal himself by walking out its routes through the city.
Iain Sinclair, interviewed by *Fortean Times*, issue 147

In late 2000 I had a studio residency at Artspace, Sydney, making new work for some forthcoming shows. At the same time the Biennale of Sydney was undertaking a number of public consultations about possible directions and models in which I became peripherally involved. So when I got a letter from the Biennale asking for an outline of my ideas or approach for a projected exhibition I knew that the same request was being sent to other people around the country and therefore didn't think this was the moment to sit down and write something 'that would get the job', as that outcome seemed unlikely. Rather I used it as an opportunity to put down in writing the description of a hypo-thetical exhibition I had long wanted to see. Called (THE WORLD MAY BE) FANTASTIC, this would focus 'on practices that use fic-tions, narratives, invented methodologies, hypotheses, subjective belief systems, modellings, fakes and experiments as a means to generate work. The exhibition concentrates on projects and approaches that are fantastic, partial, various, sugges-tive, ambitious, subjective, wobbly and eccentric to normal orbit... I suggested that:

These practices reflect in turn on quotidian cul-tures and dominant belief systems, suggesting that they too are not inevitable, but are muta-ble, contingent, developing, hallucinatory, slip-pery, and various.

My long-held fascination with these concerns had been significantly expanded through the seven years I had spent fol-lowing the evolution of the work *No Other Symptoms - Time Travelling with Rosalind Brodsky* by my partner Suzanne Treister. This complex CD-Rom and publication project operates as an archive from an imaginary institution of the future – The Institute of Miltronics and Advanced Time Interventionality – dedicated to the life and works of the dead Rosalind Brodsky, born 6 June 1970, who joined the Institute when she was thirty five. Brodsky operates as an imagined (semi) alter ego to the artist. She may or may not be delusional and has left records indicating that she believes that she can time-travel and she goes back to the Russian Revolution; has analysis with Freud and Jung, Lacan, Klein and Kristeva when they are at the height of their practices; and tries to save her grandparents from the Death Camps of

Nazi Germany. Sometimes Brodsky gets his-tory and fiction confused, for instance when she accidentally manifests herself on the set of *Schindler's List*, the time machine confusing it with the real thing. Other-times what we think of as fictions turn out to be true in her world – The Brigadier from *Doctor Who* is the guide and facto-tum for the Institute. Brodsky also travels into the future to the Martian settlements. I had written about the project a few times and the work's use of narrativity and fic-tion, interwoven with detailed fakes and facsimiles of the 'real' world I found fasci-nating.

Witness by Susan Hiller was also in my thoughts. I encountered this work on the dimly-lit upper floor of a derelict chapel in London. The work consists of a circular cloud of small transparent speakers suspended from wires through which the visitor walks, listening to the sounds of hundreds of voices speaking different languages. When you focus on an individual voice you realise they are relating stories of contacts and experiences with Unidentified Flying Objects. It is a work that speaks not only of a specific cultural event (UFO contacts) but, through this, seems to address the human nervous system's need to believe in something outside of itself. For me, there is always a question of 'unknowability' in Hiller's work. She refuses to allow some-thing to be easily assimilated or digested, instead she collides readings and method-ologies to open up areas of new possibility between previously accepted attitudes or systems. Her work often focuses on differ-ent approaches and readings of culture which she works with almost as if they are concrete, raw material, rather than ineffa-ble constructions and systems. In a 1985 text (reproduced in her 1996 Tate Gallery catalogue), she writes:

These incoherent insights at the margins of society and at the edge of consciousness stand as signs of what cannot be repressed or alienated, signs of that which is always and already destroying the kingdom of law.

My own work as an artist has increasingly addressed the ways that we construct and understand the 'objective' world. A few years ago I finished a series called 'Alternative History Paintings'. These were text-based works that put together different state-ments of historical 'fact', but reversed them: 'The Incas beat the Spanish', or 'The Corn Laws weren't repealed'. The state-ments were to do with personal history as well as the grand narratives of history. These, I hoped, would suggest an alterna-

tive world that floated behind the one we occupy: a world that is engendered when the child starts questioning what would have happened had its parents never met (a proposal in one of the paintings). This, as every child knows, is tremendously scary and tremendously exciting.

These were the triangulation points from which the ideas and structures of (THE WORLD MAY BE) FANTASTIC developed.

In 1962 Philip K Dick published *The Man in the High Castle*, a novel describing a world where the Axis powers won World War Two. In constructing the story, Dick often consulted the I-Ching, the ancient Chinese Book of divination, to determine outcomes at crucial moments of the plot and to generate alternative scenarios. In the novel, there is a character called Aben-dsen who is writing a novel called 'The Grasshopper lies Heavy', a text that has the premise that the Axis powers didn't win the war. Abendsen is using the I-Ching to help construct this projected alternative world. The one he comes up with is pretty close to the world that we, the readers, inhabit but not in all respects – for in-stance in the Grasshopper world President

RICHARD GRAYSON

GRASSHOPPER WORLDS

Roosevelt is followed by President Tugwell, who didn't quite make it in our history.

Over the last couple of decades model-ling the 'counter-factional' has become a recognised academic tool for historical investigation, albeit without the use of the I-Ching, where methodologies and logics are tested through attempts to model the effects and outcomes had, for instance, the American Revolution failed, or Germany won World War One.

At some early point in life we become aware of the weird, shaky fragility of the stories that we move through, for instance at school, when history teachers went to considerable lengths to describe how his-tories of the Eighteenth Century divided into 'Whig' and 'Tory'. However most of the time we do not pursue the idea that 'the objective' exists as a description – an imposed pattern, shared fiction or consen-sual hallucination – as it does as the 'real'. It is only when we return to previous attempts at arriving at objective descrip-tions of the world – such as Bishop James Ussher's dating of the moment of creation

to 22 October 4004 BC through an analysis of the generations in the Old Testament (a date later refined in the Nineteenth Century by Dr John Lightfoot of Cambridge University as being 23 October at 9 in the morning 4004 BC) – that we are made freshly aware that our idea of the objective world is an agreed hypothesis. Most of us now regard the Bishop's date as profoundly and utterly wrong-headed and counter-intuitive: a fiction. On the other hand fundamentalist Christians still use it as the date the world started. In this reading the fossil record is either put there by the devil with the intention of misleading (a trap that Western liberal rationalists seem to have walked right into) or it is made up of the remains of animals that drowned in Noah's Flood. Fictions can also trigger our awareness of the fragility and contingency of the events that have (seemingly) bought us to where we are now. Stories by science fiction writers, and more recently an episode of the Simpsons, move the counter-factional departure point back into deep time. In the Simpson episode Homer is accidentally and repeatedly transported back in time, and his clumsy crushing of passing insects and flowers, or his sneezing at dinosaurs in the Jurassic age, means that the Springfield he keeps returning to is fundamentally altered. And with Homer's repeated visits and repeated stumblings and accidents we see thousands of different outcomes... D' Oh!

At the moment contemporary physics in the form of second wave string theory (or M theory... don't ask) is proposing a matrix for Homer's many worlds – a universe that has eleven dimensions which generate an awful lot of alternative space/time possibilities.

In choosing to look at art practices that use and explore 'fictions, narratives, invented methodologies, hypotheses' and so forth, there was (and is) no intention of claiming that these are central in 'contemporary art', either for the work happening around us in the here and now, or in a period rather more widely defined. In fact one could construct a history in which such approaches have been notable for their marginality or at least non-centrality for a considerable time. One of the drives of Modernism can be seen as the gradual abandonment of issues and narratives outside those of the art work itself. For instance Cézanne starts interrogating the way that the painter constructs a picture, registering the hesitancies of sight and the construction of the image, rather than producing a work that refers to the complex cultural narratives of history or religion. High Modernism continues this interiorised interrogation as to the matter of the art object, Greenberg positing 'flatness' as the concern above all of a painting. When I was at art school in the seventies, to describe a work as ' literary' was a damning criticism, locating the work's intentions as reactionary and old fashioned. In this context the aesthetic discourses generated by Duchamp's readymades are easier to assimilate than the mischievous hermetic obscurities of his *The Bride Stripped Bare by her Bachelors. Even (The Large Glass)*. However, the forces that drive the desires of reference and reckless invention seem to have their own need to be, and much of the work linked to 'Post Modernism' can be read as a way to try and embed the seemingly mute art object within a matrix of reference and illusion no less complex and baroque than the narratives that lie behind *The Large Glass* or Renaissance Christian iconography. Even then, this intention is buried and obscured, and contemporary discourses are still not entirely comfortable with such agendas.

Despite this, such arcane approaches have embedded themselves in the narratives that have constituted Modernism and Post Modernism without becoming a fully historicised component. Indeed the way that they maintain their disruptive shifting values is particularly charismatic and attractive. Such practices, by their very nature, problematise totalising forces and theories and refuse to be recuperated into seamless trajectories (which makes writing about them an interesting pastime). There are discernible (if occluded) trajectories through the histories of Twentieth Century and Contemporary Art, sometimes articulated in reference to the relationship between the visual arts and literary models and movements. We can easily trace direct links between the Surrealists' interest in Raymond Roussel, the inventor of the man machine, to Alfred Jarry's *The Passion Considered As An Uphill Bicycle Race*, to *Pere Ubu* and the writer's invention of Pataphysics, through to Duchamp's fascination with, and use of, the pataphysical in many of his major works based on invented rules and codified chance operations – the physics of the love gas, the roles of the Bachelors and the 'mallic moulds', the measuring unit of the three standard stoppages – his invention of his alter ego Rrose Selavy, and his later, fictional, withdrawal from practice. From here we can progress, if we wish, to the OuLiPo Group or to the detailed and influential literary constructions and fictions of Borges. Panamarenko – an artist in this exhibition – is an honorary member of the 'College de Pataphysique', along with Duchamp and Ionesco.

Alternatively we can trace the spiritual or religious eschatologies underpinning the blunt abstractions of Kandinsky, Mondrian and Barnett Newman or plot the patterns and linkages between the utopias/dystopias and generative modellings of the Futurists to the dissonant pirate science-fiction gay utopias of William Burroughs alluded to in the works of Mike Nelson, and the biomachine exoskeleton galactic futures of Stelarc. The very first Utopia – the book by Thomas Moore – was presented as the 'real' record of a real land, complete with a map of the layout of the island and with examples of the alphabet that the inhabitants utilised. Or we can take from the Dadaists and even the Bauhaus, the idea of systems and generative strategies which, differently inflected, can suggest an almost Talmudic fascination in the substrata of the visible world, or become the building blocks of immense new futures.

There is a short story by Borges ('The Aleph') in which he talks of a writer called Daneri, who..."had in mind to set to verse the entire face of the planet, and by 1941 has already dispatched a number of acres of the State of Queensland, nearly a mile of the river Ob... and a gasworks to the North of Veruca."

The traffic between 'the real' and the 'not real' is of course osmotic. Sir John Manderville published *Manderville's Travels* at the end of the Fourteenth Century. To us, it is a work of fiction and fable, with its reports of one-eyed people in the Andaman Islands and dog-headed people in the Nicobar islands – Manderville also locates paradise, but rather charmingly says he cannot say any more about it as he has not yet been there. Certainly by the Sixteenth Century 'to Manderville' had become a colloquialism for lying and exaggerating. However Columbus planned his 1492 expedition after reading the book, Ralegh pronounced every word true, and Frobisher was reading it as he trail blazed the northwest passage. So the 'false' maps gradually segue into the maps that we now accept, but these too are open to constant revision.

The relationship between the description of an event and the way that the event is understood seems to be both self-explanatory and at the same time hugely mysterious and problematical. To describe a world is to pull one into being, and it is this protean force of description and of mapping that links the approaches of art with those of science, the occult and paranoia. Discerning patterns in turn implies larger patterns, and we are bought into the 'everlasting emphasis on macrocosm and microcosm' that lies at the heart of occult systems (Frances Yates, *The Rosicrucian Enlightenment*) as well as those of art and of science. Rewinding the tape even further, some evolutionary psychologists suggest that the way we map one set of events through overlaying our understandings and expectations of another separate set of experiences may be a crucial element in human development. For instance many modern hunter gatherers reason about the natural world as a social being and see the landscape as socially constructed. E Gellner (in *The Plough, Sword and Book: The structure of Human History*, Collins Harvill 1988) argues that the seemingly strange associations and analogies made in the thought and language of non-Western traditional societies reflect a complex and sophisticated cognition which serves to accomplish many ends at once. It is the "singlestrandedness, the neat and logical divisions of labour, the separation of functions" characteristic of modern Western society which are anomalous and which need to be explained. (This precis is taken from *The Prehistory of the Mind*, Steven Mithen Phoenix London 1998.)

Although the approaches that concern (THE WORLD MAY BE) FANTASTIC may not be 'mainstream' I do think that there are developments that give them a particular force and interest right at this moment.

The first development is in the field of thinking which has articulated and reflected art and its approaches back to itself for the last thirty or forty years, loosely described as 'post modern'. Although difficult to crystallise, there was a feeling by the eighties that ideas of the simulacrum and the determined contextualisation of a work as an expression of ideological and political networks had problematised the transformative and ontological agendas of art to such an extent that it seemed nearly impossible to do anything much. The only room left was for a constant repositioning and re-examination of art's inability to do other than reflect on the histories and conditions of its own production and consumption. 'Content' became increasingly impossible, and the arguments for the validity of this position are/were compelling.

One way of coping with this impasse was a reactionary dismissal of what was usually witheringly described as 'French' theory – thus indicating its essential foreignness, untrustworthiness, fancipanciness and lack of Anglo-Saxon commonsense – as some academic plot hatched only to keep academics in tenured positions and keep honest down-to-earth artists unemployed and marginalised. The intellectual paucity of such a position was manifest just looking at the people who expressed it.

Another reaction was to concede the power of the argument and to engage in a constant endgame of abstruse cerebral delicacy. This increasingly produced practices that had currency solely within their own terms of reference, closed system choreographies that symbolically celebrated their own disenfranchisement. Although possessing an intellectual purity that appealed to many, and though the role of radical martyr to the inevitable erosions of capital and history was attractive, such positions became increasingly pointless and not a little smug. This approach later transmogrified into making works that seem to function almost entirely on a symbolic level, where a sign occupies the space that was once that of 'art' but proclaims its abjectness and inability to fulfil what once may have been expected of it. Another strategy is a sort of 'haute modernism lite', which seems to hope that through mimesis of avant garde forms the intentions can also be regained

A third possible reaction was for artists to say yes, we accept the premises and the outcomes of these positions: we agree that the grand narratives are no longer reclaimable, that the position of author may be nearly impossible, that the transformative agendas are compromised and that the real no longer exists: we agree that we are in fact in the midst of a maelstrom of simulacra... but let's pretend for a moment that this is not so. Let us knowingly and wilfully operate along the fiction that it may be possible to write the grand narrative Victorian novel or generate worlds and bodies of work. Such a move would allow 'content' to operate as a game or construct rather than as an inalienable teleological truth. This sort of approach is prefigured in Borges' love of the 'old fashioned' narratives of Stevenson and the Father Brown stories of J B Priestly, or his proposition that to rewrite *Don Quixote* identically hundreds of years later is to generate two totally different texts. It fits Borges' delight in looped logics and systems that the writer who should have identified so many of the conditions identified as 'post modern' – think of Baudrillard's use of Borges' story of the map of China that was so detailed and accurate that it covered and replaced China – should also suggest useful stratagems to operate within these conditions.

The increasing centrality of the dialogues of the 'post modern' in the intellectual life of the West coincided uncannily with the collapse of the command economies of the Soviet Union and the Eastern Bloc. This demise has had, and will have, effects that we can, as yet, only start to guess at. The psychic geographies through which we move have been irrevocably shifted. An immediate outcome has been to unanchor ideas of the 'alternative' from the real. No matter what you felt about the reality of Marxism, the existence of states based on its philosophies gave a concrete charge to propositions of an alternative or radical change to the everyday structures of the West. With the failure of the validating engines of 'historical inevitability' and dialectical materialism, a central forum for the alternative has disappeared, leaving all such propositions seemingly equivalent, shimmering and fantastical in the air, be they based on the workers' ownership of the means of production or the hidden hand of the illuminati and messages from Sirius in the processes of history.

This withering has been mirrored by the dull grey triumphalism of the current rhetorics of Western capitalism and economic rationalism. Increasingly things and activities are viewed in terms of function and 'use value' and a constant enervating reference is made to 'commonsense'. However the current universality of such criteria makes it hard to imagine other ways of doing things or to articulate other functions, and it seems impossible to see an edge or end to its hegemony. Lack of possibility and dull pragmatism have increasingly shaped artists' (and arts institutions') intentions and expectations of their practice. Such pervasiveness encourages an interiority, as it seems impossible to be 'outside' it, to imagine territories beyond the border, instead it is as if you have to disappear below the surface, enclosed in a sphere of your own making.

Such a seemingly hermetic act does have an electric political charge, even if not a linear directed one. Bulgakov wrote *The Master and Margarita*, a tale of the devil coming to Moscow, talking cats and other shenanigans, at the height of Stalin's power, and just this act of fantastic invention suggested territories beyond the reach of state or political power. Such 'bringing into being' helps position the subject as the opposite of a (passive) consumer and instead makes the subject a generative force. In many such productions there is a sort of crazy power to the process which we find disturbing, as if the sources of energy are barely contained. These productions often seem recalcitrant to 'use value', and they are not necessarily overtly political, analytical or able to be articulated in terms of received code or discourse, be those discourses social or aesthetic. But I would suggest that *because* they do not fit comfortably within these received, attenuated discourses, ironically, this is where their 'usefulness' lies.

The tessellation of subjective world views, the confusion and layering of codes, generative taxonomies, and the potential slipperinesses of identities, newly demand our attention through developments in science and new technology, where previously secure definitions of the real and the non-real, and the fantastic have become increasingly porous and osmotic. Only a very few people can even begin to understand the basics of contemporary physics, (and I am not one of them), but even the dimly perceived existence of these concepts makes for a background buzz of information that destabilises our understanding and suggests that the working of the universe may be, to all intents and purposes, counter-intuitive and irrational: much as a crazy fiction. On a more local scale the fact that our lives have shifted into the electronic has destabilised previous certainties. Money now exists as a series of magnetic pulses, on the Net my identity is unverifiable and therefore elective, contingent on my ability – or desire – to maintain a continuous fiction, and war for most of us has blurred into Hollywood and video games. Even our rhetorics for this arena are fantastic and removed from what may constitute an objective understanding. We proclaim a 'World Wide Web', but were the map of that world printed it would bear no resemblance to Mercator's projection, as it would exclude much of the globe: there are still fewer phone lines in Sub-Saharan Africa than

there are on Manhattan Island. Even those who do not use computers have had their modellings of the world shaped by these technologies. When the footage of Osama Bin Laden seeming to claim responsibility for the World Trade Centre strikes first came into the public domain, an immediate issue was whether the tape was 'real', or some electronic *Lord of the Rings* manifestation of the reality desired by shadowy American intelligence agencies. Back to Baudrillard world: Photoshop™ has done more to deconstruct our faith in the 'real' than decades of monographs and lectures.

Digital space also seems a nourishing environment for the construction of particular subjective worlds. It does this in two ways: firstly, by individualising each person's experience. Digital TV means that each person has their own communion with the program they are watching; the social dimension that broadcast TV provided – where you could talk of last night's programs in the playground or the pub – has evaporated. Electronic games and computer spaces continue this atomisation with an intense individualised experience specific to each interaction. Secondly, the Web provides the possibility for new, specific groupings made up of individuals linked by interest, be that in E-bay, fascism, weird sex or hydroponic gardening, allowing communities of difference to grow and link. This encourages promiscuous dialogues questioning that which may be considered authorised and 'real' and the unauthorised and 'not real'. Certainty fades fast in electronic worlds.

These developments provide a context in which to consider the works that make up (THE WORLD MAY BE) FANTASTIC. However I hope that the works do not contain or illustrate themes, as the exhibition is intended to work as a proposition rather than as a diagnosis.

This holds true both for each work's relationship to the ideas I have outlined here and to the show as a whole. It is a hypothesis. It does not claim that these are the artists and practices who are 'setting the pace' right now. Or that this is the best art from around the world of the last two years. Or that the work represents movements that are defining the future (or the present) as Biennales often tend to do. Nor is the exhibition 'global' – although artists from different countries are represented. I did not think the global approach useful, desirable or, in this case, achievable right now: intellectually, logistically or financially. Large global art exhibitions tend to

have a flattening effect, to homogenise, in bizzare contradiction to their intended aims and certainly an anathema to a project that desires to look at "approaches that are fantastic, partial, various suggestive, ambitious, subjective, wobbly and eccentric to normal orbits...".

This Biennale intends to provide a platform for certain works by certain artists at a certain time. The thesis of the exhibition is intended to function more as a table that allows these things to be shown, explored, and considered, than as an envelope which contains and covers them. Keeping true to the aims and intentions of the exhibition, this list of works and artists is one of many versions of the exhibition that could have taken place, of shows with different artists and different work exploring similar concerns.

Each artist participating in this version of the show (as would the artists in other versions of the show) brings with them a cosmology, a system of thought or action that serves to lever open other possibilities and worlds in the fabric of the one which surrounds us. The drive to make models and generate alternative narratives is buried deep in the configurations of the nervous system which makes us 'human' even if these acts seem to have no immediate 'utility'. Many of the productions and works in this exhibition, although de facto existing in the 'art' world – and therefore largely codified and self aware – have that strange autonomy and gravity that we find in 'primary' productions, those acts of imagination and creation that people do for themselves in their bedrooms or in their sheds, which seem to be individual and pathological as much as cultural. Chis Burden's bridges remain lumpy and problematic in this context as do Henry Darger's strange imaginings of the adventures of the Vivian Girls, even though one exists easily in the exchanges of the modern Western art world and the other lived in a basement withdrawn from general society. His world view could have provided subject matter for Veli Granö's biographies or Hiller's mapping's of UFO contact. The cosmology's are often obdurate, perverse; the works polymorphous, expansive and energising, and all serve to problematise and make fantastic the worlds that we build around us.

ACCONCI/ACCONCI STUDIOS ADAMS

AHTILA ANGUS ANTIN ARAÚJO

ATELIER VAN LIESHOUT BARBIER

BLAST THEORY BROWN BURDEN CARDIFF & BURES MILLER CORILLON DALWOOD DARGER

FISCHER & EL SANI GILL GRAHAM GRANÖ HAINES HILL HILLER HINTERDING JÓZEFOWICZ

KAY LINCOLN MACPHERSON MIR NELSON NGUYEN-HATSUSHIBA NICOLAI NOBLE

PANAMARENKO PAREKOWHAI PARRENO PATTERSON PENALVA PICCININI POPE ALICE

PRENDERGAST RIOS RITCHIE SALON DE FLEURUS SHAW SIDÉN SIWES SONE STEVENSON

SUH TANDBERG TREISTER TSE VALLANCE WEDGE XIN YANAGI

15

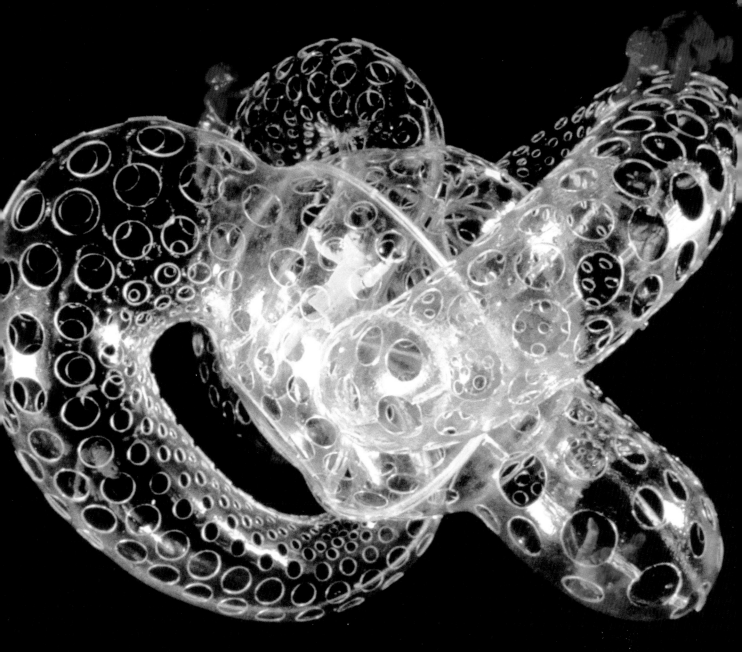

VITO ACCONCI/ACCONCI STUDIO

IF WE CAN'T CHANGE THE WORLD, WE CAN POSSIBLY CHANGE THE PLACES AND THINGS IN THE WORLD; WE TRY TO INTERFERE WITH – TO RE-DESIGN, TO RE-ORIENT, TO THICKEN THE PLOT OF – THE MATERIAL OF THE WORLD, RANGING FROM A CUP, OR A WRISTWATCH, TO A CITY. WE DESIGN PROJECTS BOTH BUILDABLE (THOUGH POSSIBLY, LIKELY, UNBUILT) AND THEORETICAL. WE LOVE A PROPOSAL AS CLARITY, AS THEORY, AS AN ESSAY; WE WANT THAT PROPOSAL TO BE BUILT, TO BECOME AN EXPERIMENTAL SPACE, SO THAT it (AND OTHER PEOPLE, AND OTHER TIMES) SCREWS UP THE THEORY. The impetus for a project almost the project's designer – is the site and the situation; our projects should have no connecting stylistic quirks, as in a family. Our projects have a dialogue, maybe an argument, with the site; the project subverts and/or re-invents and/or re-vivifies a site; our projects perform a site, as if we are trying to coax the project out of the site, as if it's been there all the time. Our projects go under a site, like an earthquake; they attach to a site, like a leech; they replicate the site, like a disease. Our attempt is to put a space into the hands of people: to liberate the site, and the people who use the site. Our projects melt into, and out of, the site – not as an art form but as an event, and as a trajectory for events. Our public spaces are flows from private to public and back again; our public places break down into and fly away in – private capsules. We build one world within another: landscape within architecture, the urban within the rural, the virtual within the actual, and vice versa. Our projects install scaffolding that supports another site, either around or within the old one: a future city, a city in the air, a city *of* air, precisely because it *wasn't* there all the time. The old site is left to fend for itself, while a new one is attached as (literal) *para*-site. In the back of our minds is the dream of escaping from the site: the dream of the house that you can carry with you, like a turtle: the dream of the city you carry inside you, in your mind and through your bones. VITO ACCONCI/ ACCONCI STUDIO/JULY 2000

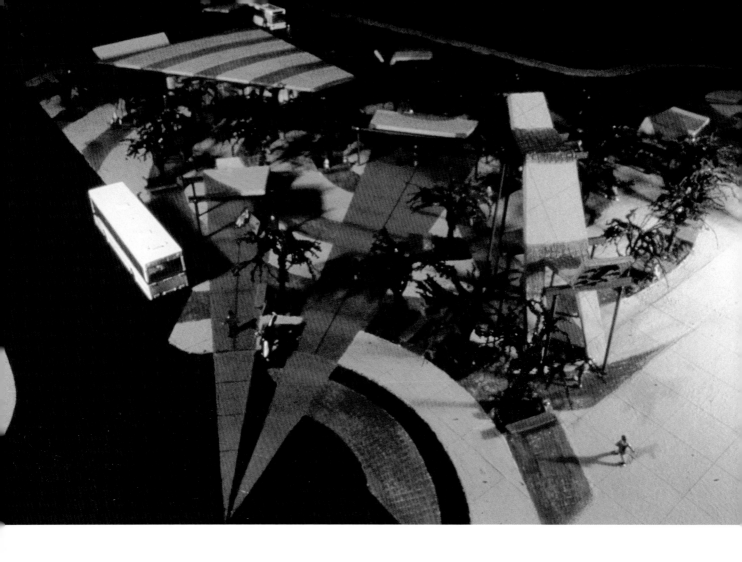

VITO ACCONCI'S

ARCHITECTURAL PROJECTS

GREGORY VOLK

In 1988, Vito Acconci, one of the major conceptual artists who came to prominence in the early 1970s, signaled what for him had already become a shift into public, architecturally-related projects by altering how he presents himself: not Vito Acconci but Acconci Studio. If you go to the head-quarters of Acconci Studio, which fills a giant 8th floor space in an industrial building in Brooklyn's Dumbo neighborhood, what you find are six or seven assistants from different countries and Acconci himself, all working together on several simultaneous projects. There is an overwhelming evidence of projects: architectural models and draw-ings for proposals or for works which are currently being realized, files and boxes everywhere, a table where Acconci and his assistants share lunches and exchange ideas, an atmosphere of controlled chaos, and Acconci in the middle of it all like some especially sympathetic ringleader.

You immediately sense the energy going on here, which is improvisational, collabo-rative, obsessive, intelligent, and risky, and Acconci (the artist, among many other proj-

ects, of *Seed Bed*, a legendary installation/ event from 1972 which consisted of Acconci hidden from view beneath a slightly sloped floor in the gallery while masturbating and intoning his fantasies of the audience above him) is known for his risky aesthetic. With Acconci, what you're dealing with now is a highly idiosyncratic artist whose work crosses over into architecture, bringing with it a transforming, at times hilarious, and richly poetic sensibility which can be at once antic and precise, rigorously conceptual and soaringly nutty. What Acconci is angling for in his public architectural works are environments that directly affect, scram-ble, confront, and ultimately liberate con-sciousness right now.

Depending on the site in question, and on questions of use and intention, Acconci's projects can differ markedly, but they often have similar attributes, notably a thorough conflation of public and private, the pres-ence of nature but as slices of greenery fit into containers or mechanized contraptions, a general scrambling of basic directions like up and down, and a pronounced (if ex-tremely quirky) sculptural elegance. For Munich, in a project called *Circles in the Square*, 1998 (not included in this show), Acconci has proposed a series of interlock-ing spheres which one can walk into, up, around, and through via pedestrian walk-

ways made of grating. Each sphere has a separate function: a park, a swimming pool, a cinema, a parking lot. It all makes perfect sense, but then again its perfectly out-landish, a public architecture project that seems like a science fiction environment or some sort of weird utopian community. When discussing a combinatory work like this one, Acconci speaks of a 'New York space', a situation in which things are heaped up and playing off one another in a way which is at once fractious and gorg-eous, conflicted and invigorating. Born in the Bronx in 1940, Acconci has long been linked to the life of New York, imbued with its energies and tensions, and suffused with its raucous vitality. Certainly what he's connected to is a context in which mundane activities take on an element of spectacle and wonderment.

There are, in fact, many carnivalesque aspects in Vito Acconci's projects, which function as a sort of mutant architecture on the loose, replete with basic structures (like walls, floors, and parks) that just don't behave as they normally do, while every-thing remains grounded in an everyday usefulness. Perhaps one inspiration for his architectural work is the memory of amuse-ment parks altogether, like Brooklyn's Coney Island: their whimsy, excitement and semi-nightmare charm; the sense along their

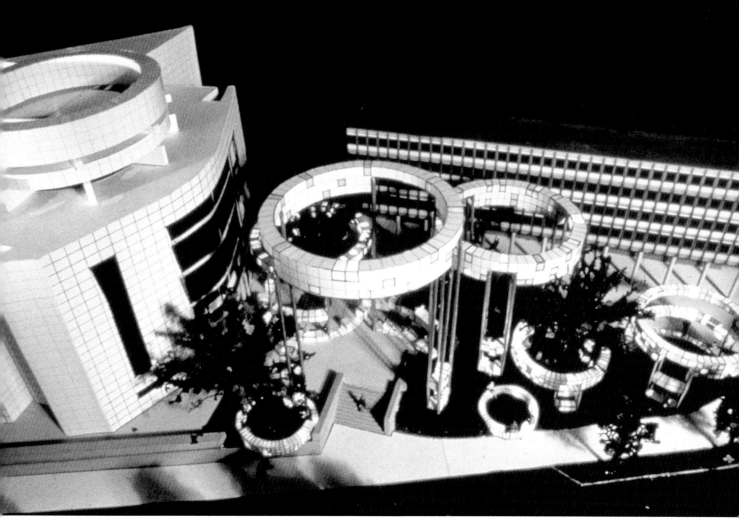

borders that this is where the known world ends and where a new, weird and promising, one begins.

Here, it's worth recalling the Russian literary critic Mikhail Bakhtin, and specifically his theory of the carnival, which he applied to literature but which could equally be applied to visual art and perhaps many other genres. In Bakhtin's terms, the 'carnivalized moment', or the 'carnivalized situation' are those moments when the normal rules, hierarchies, values, and modes of apprehension are temporarily suspended in favor of a brand new freedom, one which can be simultaneously ungainly and spiritually elevated, at once confusing and substantially liberating. Importantly, for Bakhtin these carnivalized moments in no way seek to transcend normal life – they are not revolutionary in the sense of wanting to substitute a new, improved consciousness for an enervated and encumbering one. Rather, both exist together, side by side, and one's experience has everything to do with participating in both, with moving back and forth between the two, with entering the carnivalized situation in order to be tested and transformed and then returning to one's normal life with some of the wisdom that one gained.

With Vito Acconci, this can involve really familiar things which are suddenly pre-sented in strange new ways, like an urban park that leaves the ground altogether to vertically cling to a building's facade, where it doubles as a kind of public, very precarious, stairway (*Park Up a Building*, 1996). It can also involve larger projects that transform whole sections of a city. Project for Riverside, Warrington ('City in the River'), 1998, designed for a part of the River Mersey in Warrington, England, is currently moving from the planning stage to realization. In devising his proposal, Acconci noted how little the river actually enters into the life of the city. It's traversed by bridges for traffic but otherwise it's generally ignored, and in Acconci's work one can often detect a democratizing drive to discover and transform sites which usually don't receive much attention.

Via steel cables anchored to the shore, mast-like structures in the middle of the river will support walkways that take one from the shore directly over the river, seating areas next to the walkways which will allow one to sit over the river, a 'floating restaurant' made of translucent fabric and adjoining discs that float on the river, and triangular canopies of plants overhead – climbing plants growing from the shore into the sky. This is the kind of circus-like, gravity-defying environment that Acconci favors and indeed he describes it as "...the installation of a temporary town, or a fair-grounds, that has come down from outer space and landed on the river" – there's that carnivalesque element again. Instead of a work by the river, Acconci will install a complex one over the river, which will conflate water and shore, sky and earth, stasis and motion, and which will directly involve the river itself, for water will be pumped through tubing in the masts to form triangular pools on the shoreline, as if the river were coming to greet visitors. The river will thus be restored as a central site in the town, but also as a poetic force. Acconci's masts, illuminated at night, will suggest ships and voyages, far away places, the ocean in the distance, rhythms of travel and return. As Acconci puts it, "...in the middle of town, there's the call of the sea." For all their gleeful hi-jinx and convention-breaking verve, Vito Acconci's architectural projects, like this one, tend to be richly evocative, pulling in a host of associations and suggestions.

This text is an edited and slightly rewritten version of 'The Carnivalized Sublime: Vito Acconci's Architectural Projects', *Daidalos*, no. 73, Berlin, November 1999.

Acconci Studio/

Vito Acconci born Bronx, New York, USA, 1940. Lives and works in Brooklyn, New York.

SELECTED SOLO EXHIBITIONS

2001 *Vito Acconci/Acconci Studio: Acts of Architecture*; Milwaukee Art Museum; Contemporary Art Museum, Houston; Miami Art Museum; Aspen Art Museum, USA

2000 *Para-Cities: Models for Public Spaces*; Arnolfini Gallery, Bristol, UK

1996 *Vito Acconci: Living Off the Museum*; Centro Gelego de Arte Contemporanea, Santiago de Campostela, Spain

1993 *Vito Acconci: Making Public*; Stroom, Netherlands
 Vito Acconci: The City Inside Us; Osterreichisches Museum fur Angewandte Kunst, Vienna, Austria

1991 *Vito Acconci*; Centre d'Art Contemporain, Grenoble, France

1988 *Vito Acconci: Public Places*; The Museum of Modern Art, New York, USA

1987 *Vito Acconci: Domestic Trappings*; La Jolla Museum of Contemporary Art, USA

1980 *Vito Acconci: A Retrospective*; Museum of Contemporary Art, Chicago, USA

1978 *Vito Acconci: Headlines and Images*; Stedelijk Museum, Amsterdam, Netherlands; Studio Ala, Milan, Italy

SELECTED GROUP EXHIBITIONS

2001 *Media City Seoul*; Contemporary Art and Technology Bienniale, Seoul, Korea

1997 *Rooms with a View: Environments for Video*; Solomon R. Guggenheim Museum, Soho, New York
 documenta X, Kassel, Germany

1994 *Hors Limites*; Centre Georges Pompidou, Paris

1993 *Tyne International 1993*; Newcastle upon Tyne, UK

1991 *1991 Biennial*; Whitney Museum of American Art, New York, USA

1981 *1981 Biennial*; Whitney Museum of American Art, New York, USA

1980 *40th Venice Biennale*; Venice, Italy

1978 *38th Venice Biennale*; Venice, Italy

1977 *documenta VI*; Kassel, Germany
 1977 Biennial; Whitney Museum of American Art, New York, USA

1976 *36th Venice Biennale*; Venice, Italy
 Rooms; P.S.1 Institute for Art and Urban Resources, New York, USA
 documenta V; Kassel, Germany

SELECTED BIBLIOGRAPHY

Vito Acconci, *Avalanche*, Fall, 1972
Jan Avigkos, 'Interview with Vito Acconci', *Art Papers*, Jan. 1981, pp 1-5
Francesco Bonami, 'Vito Acconci', *Flash Art*, Feb. 1992. pp 86-88
Germano Celant, 'Dirty Acconci', *Artforum*, Nov. 1980, pp 76-83
Judith Russi Kirshner, *Vito Acconci: A Retrospective: 1969-1980*, exhibition catalogue, Museum of Contemporary Art, Chicago, 1980
Ed Levine, 'In Pursuit of Acconci', *Artforum*, Apr. 1977, pp 38-41

Kate Linker, *Vito Acconci*, Rizzoli: New York, 1994
Gloria Moure, *Vito Acconci Writings, Works, Projects*, Ediciones Poligrafa, Barcelona, 2001
Peter Noever, *Vito Acconci: The City Inside Us*, exhibition catalogue, Museum fur Angewandte Kunst, Vienna, 1993
Patricia C Phillips, 'Vito Acconci at International With Monument', *Artforum*, Summer, 1987, pp 121

CHECKLIST OF WORKS

PROJECT FOR SEE-SAW LAWN, WILLIAMS COLLEGE MUSEUM LAWN, WILLIAMSTOWN, 2000
model: mixed media
35.6 x 94 x 66 cm
project: concrete, grass, light
6.7 x 27.4 x 49.1 m

PROJECT FOR COURTYARD, NEW SIEMENS BUILDING, OSCAR-VON-MILLER-RING, MUNICH, 1998
model: mixed media
36.8 x 109.2 x 81.2 cm
project: white painted metal panels, frosted glass or translucent polycarbonate, light, steel structure, columns
21 x 28 x 49 m

PROJECT FOR SANSOM COMMONS, UNIVERSITY OF PENNSYLVANIA, PHILADELPHIA ("A PLAZA THAT FUNCTIONS AS A CITY/A CITY WHOSE BUILDINGS ARE LANDSCAPE") 1997
model: mixed media
66 x 73.7 x 168.9 cm
project: steel, mesh, climbing plants, concrete, light
14.6 x 7.3 x 60.9 m

PROJECT FOR LOLOMA TRANSPORTATION CENTER, SCOTTSDALE, ARIZONA, 1995-7 (built)
model: mixed media
17.8 x 121.9 x 121.9 cm
project: concrete, grass, trees, glass, steel
12.2 x 88.4 x 97.5 m

PROJECT FOR LIGHT-WELLS FOR BASEL BAHNHOF OST, 1997
model: mixed media
120.7 x 91.5 x 58.5 cm
project: translucent plastic fabric, cable, light
20 x 13.5 x 6.5 m

PROJECT #2 FOR LONGVIEW SCHOOL, PHOENIX, 1992
model: mixed media
19 x 90.2 x 101.6 cm
project: concrete, steel, earth, lights
6.7 x 90.2 x 34.1 m

PROJECT FOR GRIFT PARK, UTRECHT, 1996
model: mixed media
20 x 91.5 x 94 cm
project: soil, grass, concrete, steel grating, light
0.3 x 24.4 x 24.4 m

EARTH WALL, CENTER FOR ART AND HUMANITIES, ARVADA, 1991
model: mixed media
32 x 61 x 162.5 cm
project: earth, glass, galvanized steel
0.6 x 107.4 x 1.2 m

Works courtesy the artist and Barbara Gladstone Gallery, New York

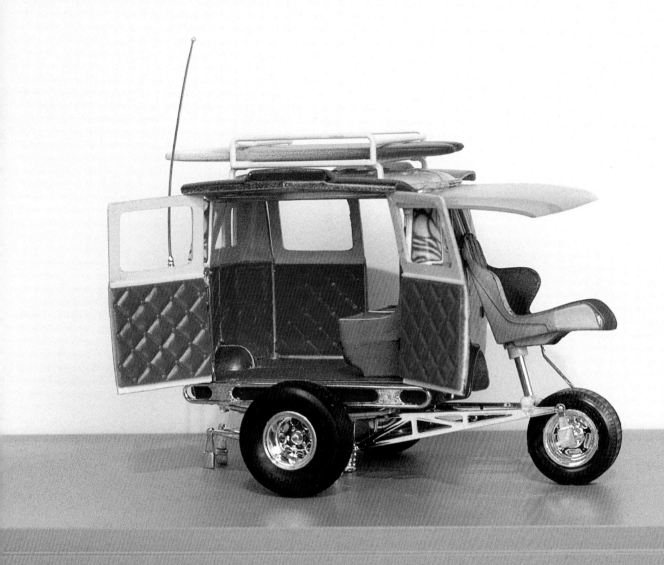

NON-PLACES ARE THE REAL MEASURE OF OUR TIME; ONE THAT COULD BE QUANTIFIED... BY TOTALLING ALL THE AIR, RAIL AND MOTORWAY ROUTES, THE MOBILE CABINS CALLED 'MEANS OF TRANSPORT' (AIRCRAFT, TRAINS AND ROAD VEHICLES), THE AIRPORTS AND RAILWAY STATIONS, HOTEL CHAINS, LEISURE PARKS, LARGE RETAIL OUTLETS, AND FINALLY THE COMPLEX SKEIN OF CABLE AND WIRELESS NETWORKS. – MARC AUGÉ / In a recent solo-exhibition at the Power Plant Contemporary Art Gallery in Toronto, Kim Adams' large, colourful sculptures were displayed on heavy-duty warehouse shelving that lined several walls of that gallery's vast central space, permitting a rotating display of his works to occupy the floor. This industrial-commercial display strategy was not only entirely consistent with Adams' practice of ad hoc appropriation – his sculptures are assembled from consumer goods – but was also very effective at transforming the cultural geography of the gallery space, temporarily converting an urban art gallery (itself, interestingly, a converted industrial building) into its very antithesis: a 'big box' warehouse store of the sort that can be found on the sprawling fringes of cities the world over. The work of Kim Adams is very much about place. In particular, it is about the non-place of contemporary 'exurbia'. Kim Adams addresses the aesthetics of the changing, dynamic zone at the edge of the contemporary city: the space of agri-business, 'new' tract-houses, shopping malls, warehouse stores, automobile dealerships, industry, trucking depots, new and improved roads, recreational parks: as well as landfill sites and garbage dumps: the space of both dreams and derision. It is this geographic transition zone between the rural and the suburban – and the human values that are invested in it – that forms the critical subject of Adams' work. I would like to discuss three exurban' themes that resonate in his work; populism, automobility and utopia. RAFAEL GÓMEZ-MORIANA/ CONTINUED....

TOASTER WORK WAGON AND EVERY-WHICH-WAY 1997 VW BUS PARTS, BICYCLES. PHOTOGRAPHY: THE ARTIST.
CRACKERBOX MUSEUM 2000 STEEL, WOOD, PLASTIC, GRAIN BINS, 1960'S VW BUS PARTS, BICYCLES. PHOTOGRAPHY: CHERYL O'BRIEN.

Many people like suburbia. – Robert Venturi

Suburbia, the condition that has given rise to the exurb,[1] is the common referent of North America; its popular voice and the base of its populism. Kim Adams understands this populism: he celebrates DIY culture, invites active participation, and employs the stratagem of the decoy as a vehicle for people to access his work.

DIY culture thrives in exurbia. On farms, doing-it-yourself is a necessity, while in suburban neighbourhoods it is a widely practised hobby. Rural and suburban houses are typically stand-alone structures constructed of 'stick-frame', lending themselves particularly well to self-modification, while driveways, farm sheds and garages offer ideal spaces for those who are mechanically-inclined to modify vehicles. DIY itself represents an independence from the aesthetic dictates of urbanity. In addition to comprising a form of bricolage itself, Adams' work is also largely inspired by his ongoing research into *popular* bricolage. He has built up an exhaustive collection of 'research slides' documenting 'ordinary' street remakes of vehicles, trailers and homes.

Adams has also experimented extensively with installations and vehicles that invite viewers to participate in his work. In early works such as *Mini Ride* 1984, and *Toaster Ride* 1985, he constructs roller-coasters outside and inside the gallery respectively, inviting the public to ride them with himself present as Carney. Other sculptures, such as *Gift Machine* 1988, which hands

KIM ADAMS

FROM WHITE CUBE TO BIG BOX:

THREE EXURBAN THEMES

RAFAEL GÓMEZ-MORIANA

out gifts to passers-by, are conceived to occupy streets and other public places, and instigate conversations. Interestingly, when the question 'is this art?' is inevitably posed, Adams does not reply in the affirmative because, as he puts it, "then the conversation just ends right then and there".[2] Adams presents himself precisely as an 'ordinary person' and *not* as an artist in order to engage, rather than alienate, an exurban sensibility that is often hostile to contemporary art.

Familiarity is present in Adams' work as well, functioning also as a vehicle for popular engagement. His sculptures are assembled from ordinary objects of the sort one finds in 'big-box' warehouse stores; anything from car and truck parts and industrial hardware to patio furniture, gardening equipment, sports gear, and children's toys. With their familiar logos, bright colours, and often-times seamless assembly, Adams' sculptures resemble, at first glance, a new line of consumer products, thereby acting as 'decoys' that lure shoppers into the

world of art.[3]

That's what a house is: it's where you keep your stuff while you run around getting more stuff. – George Carlin

The automobile is to the suburban house what the elevator is to the skyscraper: it is the mechanical invention that is necessary in order to make the building type inhabitable. Yet while both the house and the car represent the most important purchases of a typical suburban family, aesthetically, the automobile is inversely related to the house. The suburban tract house is typically conservative and conformist, while contemporary automobiles are works of cutting-edge design. A car expresses a great deal more about the aesthetic predisposition, taste, and personality of its owner than does a house, which must always display a polite facade. Indeed, for many, the house represents a solid financial investment while the car is seen as a disposable toy. The house is expected to accrue in value while the car depreciates rapidly, placing the two in a compensatory relationship.

Works such as *Chameleon Unit* 1988, and *Two Headed Lizard With a Single Shot* 1986, appear to hybridize vehicle and home. Both of these works are on wheels – as are indeed most of Adams' works – yet both also make reference to domestic architecture by means of garden sheds, recalling the suburban house's lesser cousin, the mobile home. Interestingly, trailer parks with mobile homes – communities often disparaged as 'trailer trash' – are often the first kind of residential architecture we encounter when we approach a city, representing the suburban dream of living between city and countryside par excellence.

The trailer is the leitmotif of Adams' work. *Earth Wagons* 1989-91, for example, in addition to being a trailer itself, also plays host to a number of reduced-scale models of trailers. Symbolizing automobility par excellence, usually for escaping from the city, trailers are the very embodiment of modernist-utopian values such as modularity, standardization, flexibility, freedom of movement and living in proximity to nature.

The whole of French soil should be turned into a superb English park, adorned with all that the fine arts can add to the beauties of nature. – Claude-Henri de Saint-Simon

Exurbia, has been the subject of much utopian thinking. From Ebenezer Howard's Garden City and Frank Lloyd Wright's Broadacre City through the recent 'New Urbanist' experiments of Seaside and Celebration – all sited well away from pre-existing cities – finding an ideal synthesis between town and country has long pre-occupied utopian thinkers.

It is in Adams' miniaturized scenarios that he most directly addresses utopian ex-urbanism. Adams works with reduced-scale similarly to 'real' or full-scale: he buys ready-to-assemble kits that are mass-produced and available commercially, then joins the parts in unorthodox ways.[4] What is significant here about the use of the

reduced scale-model, however, is that it provokes more than a passive gaze by inviting the viewer to actually dominate over it. For this reason reduced-scale models, from museum dioramas to architects' models and model train sets, have long been objects of popular fascination. A model is no more than a representation of something real or imagined, but, whether it is an art object, a means for visualizing a three-dimensional design, or a toy, a model is also an idealization of that which it represents; something more perfect than the 'real' thing. In fact, a scale-model is utopian, since it is placeless and free from contingency. Models are other, alternate worlds upon which real impulses, including those of mastery and domination, can be projected.

Adams' miniaturized works, like their full-scale counterparts, also act as decoys, concealing something behind the attractive appearance of a consumer product – in this case that of a model train set – in order to lure the viewer. The expectation of models is that they are perfect, harmonious places, and it is this very expectation that makes the scenarios played out in Adams' models effective. In *Earth Wagons* 1989, for example, leisurists and tourists – modern nomads – can be seen happily playing in a landscape that has been devastated by the very infrastructure of tourism and consumerism: by an excess of roads carrying excessive traffic, factories spilling chemicals, and garbage dumps full of discarded products. The landscape, though exaggeratedly dense, is nevertheless ex-urban. As with every utopia, we realize that a promising appearance conceals, in fact, a nightmare; that it contains its very opposite.

By way of its ex-urban nature, then, Kim Adams' work can be seen within the art world as iconoclastic. The art world is highly urbanized: its capital is New York City, the densest, most urban environment in the world. Its biennials, such as this one, happen in major urban centres. Contemporary art is, moreover, highly differentiated from the more traditional, folkloric and craft-based art-forms that are more typically based in rural regions. In this regard, Adams is clearly an urbanite, but one who brings ex-urban culture into the city and secularizes its most sacred spaces. The work of Kim Adams bridges not only high and low, but also centre and periphery.

1. "Increased out-migration from urban and suburban areas, more land consumption per capita, and edge city formation around the periphery of central cities have led to more complicated patterns of settlement in which the distinction between suburban and rural has become increasingly blurred. A new type of development that is neither fully suburban nor fully rural has emerged, sometimes referred to as the 'exurbs.'" The Exurban Change Project (http://aede.ag.ohio state.edu/programs/exurbs/def.htm)
2. Conversation with the author, 'Kitbashing, Street Remakes and Bisexual Architecture' *C Magazine*, #70, Summer 2001, p 14
3. Andy Patton refers to *Decoy Homes* as a lure into the institution of 'art', 'Trousers on Head' in Madill & Lux (eds), *Kim Adams*, (Winnipeg Art Gallery, 1990), p 18
4. Several of Adams' sculptures, eg *Decoy Homes* and *Chameleon Unit* exist in both a full-scale and reduced-scale version.

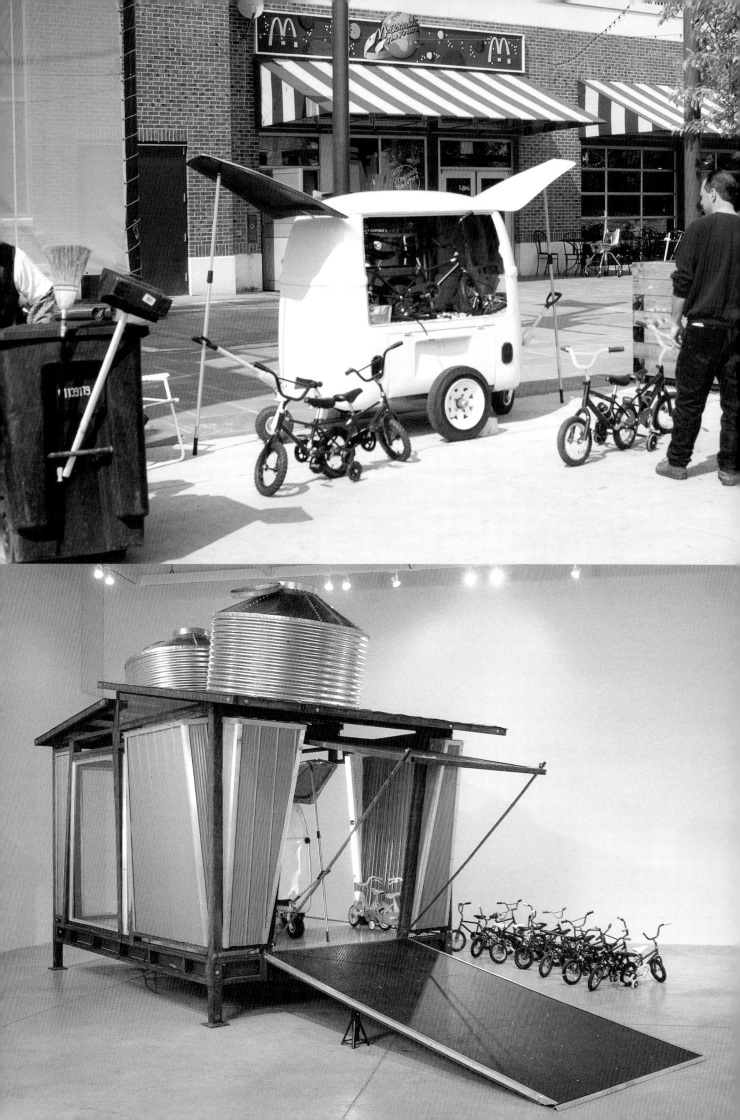

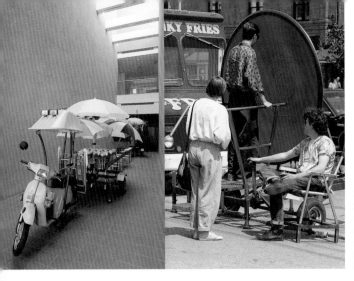

LEFT: **GIFT MACHINE** 1988 SCOOTERS, WHEELBARROWS, LADDERS, TENNIS BALLS, UMBRELLAS, BAGS, INSTALLATION VIEW; THE POWER PLANT, TORONTO. PHOTOGRAPHY: CHERYL O'BRIEN **CURBING MACHINE** 1986 SATELITTE DISH, GAS MOTOR, LAWNCHAIR AND UTILITY TRAILER. PHOTOGRAPHY: KIMMY CHAN. FRONT PAGE IMAGE: **SURFER RICK (MODEL)** 2001 PLASTIC MODEL PARTS. PHOTOGRAPHY CHERYL O'BRIEN

Kim Adams born Edmonton, Canada, 1951. Lives and works in Grand Valley, Canada.

SELECTED SOLO EXHIBITIONS

2002 *Street Remakes*, Art Gallery of Calgary and Dunlop Art Gallery, Calgary/ Regina, Canada
2001 *Survey Exhibition*, The Power Plant, Toronto, Canada
Bruegel Bosch Bus, Oakville Galleries, Oakville, Canada
1999 *Street Works*, Charles H Scott Gallery, Vancouver, Canada
1998 *Earth Wagons*, Winnipeg Art Gallery, Winnipeg, Canada
1996 *Kim Adams*, Museé d'art contemporain, Montreal, Canada
1995 *Kim Adams*, Centraal Museum, Utrecht, Netherlands
1992 *Earth Wagons*, The Power Plant, Toronto, Canada
1991 Kim Adams: Selected Works, Winnipeg Art Gallery, Winnipeg, Canada
1990 *Gift Machine, Pepper Grinder, and Working Models*, Shedhalle, Zurich, Switzerland

SELECTED GROUP EXHIBITIONS

2002 *Model World*, Aldrich Museum of Contemporary Art, Ridgefield, CT, USA
Officina America, Bologna, Italy
2000 *Art Grandeur Nature* (Biennial), Paris, France
On Location: Public Art for the New Millennium, Vancouver Art Gallery, Vancouver, Canada
1999 *Centrifugal*, Art Gallery of Hamilton, Hamilton, Canada
Culbutes dans le millenaire, Musee d'art contemporain, Montreal, Canada
1998 *La Biennale de Montreal*, Montreal, Canada
1997 *Skulptur Projekte 97*, Münster, Germany
InSite 1997, San Diego, USA, and Tijuana, Mexico
Picturing: Art According to the World, Center for Curatorial Studies, Bard College, New York

SELECTED BIBLIOGRAPHY

Carol Brown & Bruce Ferguson, *Un-Natural Traces*. Barbican Art Gallery, London, England, 1991
Klaus Bussmann, Kasper König, Florian Matzner (eds). with an essay by Walter Grasskamp. *Sculpture Projects in Münster 1997*, Verlag Gerd Hatje, Westfälisches Landesmuseum, Münster, 1997.
Sjarel Ex & Yolande Racine, *Kim Adams*. Centraal Museum, Utrecht, 1995
Bruce Ferguson, *Northern Noises*. 19th São Paulo International Biennial, Winnipeg Art Gallery, Winnipeg, 1987
Gary Garrels & Jock Reynolds, *Sculpture at the Point*, Three Rivers Arts Festival, Pittsburgh, Pennsylvania, 1988
Sandra Grant-Marchand, *Kim Adams*. Musee d1art Contemporain, Montreal, Canada, 1996
Shirley Madill & Andy Patton, *Kim Adams*. Winnipeg Art Gallery, Winnipeg, 1992
Richard Martin (ed), *The New Urban Landscape*, Olympia & York, World Financial Center, 1990
Marc Mayer, Marnie Fleming & Tomas Pospiszyl, *Kim Adams* The Power Plant and Oakville Galleries, 2001

CHECKLIST OF WORKS

CURBING MACHINE 1986
utility trailer, engine, metal, satellite dish, chair, lights
167.64 x 320.04 x 274.3 cm

GIFT MACHINE 1988
Honda motor scooters, ladders, sports bags variable length
1524 x 182.9 x 228.64 cm (max)

TOASTER WORK WAGON 1997
VW body parts, trailer, lawn chair
350.54 x 152.4 x 172.72 cm

EVERY-WHICH-WAY 1997-2001
children's bicycles, metal, rubber
121.9 x 60.96 x 60.96 cm

CHEESE TRUCK II 1996
HO model plastic parts (model)
25.4 x 10.8 x 11.43 cm

TWIN MAKER 1998
HO model plastic parts (model)
25.4 x 10.8 x 11.43 cm

SPOTTED DICK 1998
HO model plastic parts (model)
25.4 x 10.8 x 11.43 cm

SLEEP HOUSE 1998
HO model plastic parts (model)
25.4 x 10.8 x 11.43 cm

VIEW TANK 1997
HO model plastic parts (model)
25.4 x 10.8 x 11.43 cm

LONG DISTANCE 1992
HO model plastic parts (model)
25.4 x 10.8 x 11.43 cm

WORK MUSEUM 2000
ink and pen brush
48.26 x 39.37 cm

STREET WORK 2000
ink and watercolour
48.26 x 39.37 cm

SQUID HEADS 2001
pen and watercolour
48.26 x 39.37 cm

TYPHOON 1988
ink and pen on paper
58.42 x 48.26 cm

STREET TATTOOS 1989
pen and ink on paper
58.42 x 48.26 cm

G-WEEV PRODUCTION MACHINE 1988
pen and ink on paper
58.42 x 48.26 cm

Works courtesy the artist.
Kim Adams is represented by Galerie Christiane Chassay, Montreal and Wynick/Tuck, Toronto

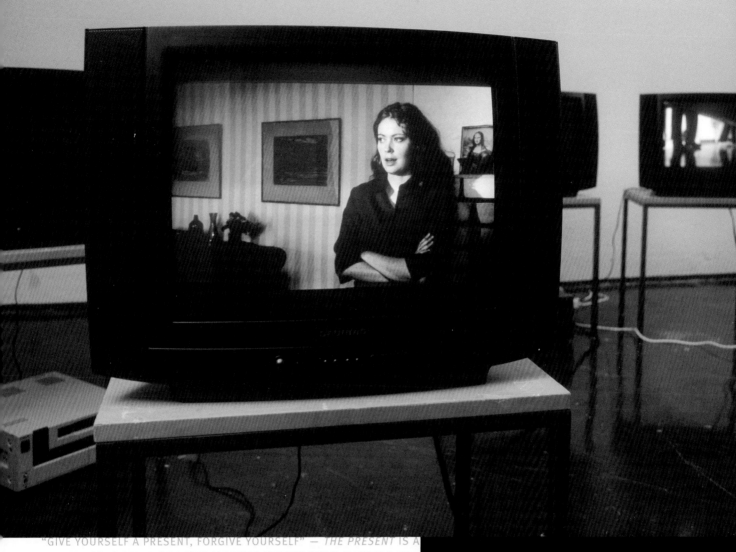

"GIVE YOURSELF A PRESENT, FORGIVE YOURSELF" — *THE PRESENT* IS A
PROJECT CONSISTING OF A FIVE-MONITOR INSTALLATION SHOWING FIVE
SHORT, INDEPENDENT STORIES TO BE EXHIBITED IN MUSEUMS AND
GALLERIES. THERE ARE ALSO FIVE 30-SECOND SPOTS MADE UP OF THE
SAME ORIGINAL MATERIAL TO BE SHOWN REPEATEDLY AMONG THE ADVERTS ON TV. The installation consists of five
short stories each shown in its own monitor. The material runs as a loop, and two of the stories play simultaneously. The
length of the stories varies from 1 min 12 secs to 2 minutes. The different lengths cause the pieces to start at varying intervals.
The series of five 30 second TV-spots was made at the same time as the installation material. The spots are like adverts
and are intended to be shown repeatedly in advertising slots. The aim is to broadcast the work on television and in a museum/
gallery space over the same period, so as to involve two different contexts and audiences. The theme of the works is
forgiveness. At the end of each story there is a text: "Give yourself a present, forgive yourself". Forgiveness is also some-
thing that is advertised. The project's subject matter is the stories and personal worlds of women who have developed
psychoses. Each episode tells a story of one woman. All episodes are fictional even though the material is based on inter-
views. The stories depict a particular event in the life of each of the women. As part of the project, blankets bearing the
slogan "Give yourself a present, forgive yourself" are sold through the gallery or museum.

EIJA-LIISA AHTILA

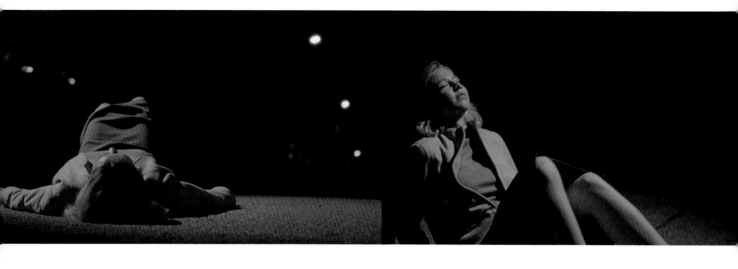

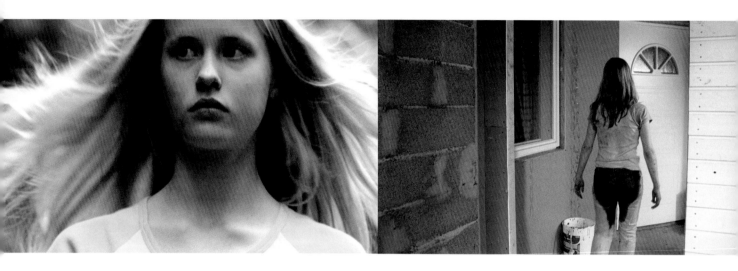

HUMAN DRAMAS

TIINA ERKINTALO

Eija-Liisa Ahtila's works exist as 35 mm films and multi-channel video installations. Her projects, in both expression and context, are located in an uncharted terrain: between big screen and television monitor, cinema, living room and art gallery.

Through investigating the structure of her material and bending genres, Ahtila creates a new grammar of the moving image. By transforming a language that has been tamed to the point of banality into a highly individual expression, Ahtila resists defini-tion. The works, firmly rooted in rhythm, montage and effective use of sound, grow into controlled studies of audio-visuality. The focus of her investigations is the inter-woven construction of the image, language, narrative, space, and the viewer's position.

According to Eija-Liisa Ahtila, what interests her in film above all is the story. She calls her films 'human dramas'. They deal, as do many of her other works, with human relationships, sexuality, the difficulty of communication, individual identity, its formation and disintegration. The stories in the films are based on real and fictive events, on the experiences and memories of the artist herself, of those she knows, or of complete strangers. From these multi-layered accounts, a fictive tale is constructed which, with its many of voices, speaks both on an individual and collective level.

In the trilogy of 90-second, mini-films from 1993 – *Me/We*, *Okay* and *Gray* – Ahtila deconstructs audio-visual narrative for the first time, consciously transgressing the narrative conventions of visual art/film and the short fiction/advert. The trilogy also calls into question ways of looking and presenting. These 'fiction bulletins' that use the condensed, fragmented language of adverts and music clips have also been

shown outside the art gallery context, in cinemas between trailers and on television intermingled with the commercials. The works acquire new meanings from each situation or presentation, and in relation to the surrounding material – and no doubt also reach a totally different kind of audience.

Me/We is about a nuclear family onto which the father projects his own self. *Okay* depicts the problem of superimposed identities in a violent love affair. *Gray* deals with nationality, borders and communal identity, as well as the threat to the self from a catastrophe, a foreign language or culture. The works are marked by the ambivalence of identity: the question of the viewer's position is tuned to one of 'who is speaking?' Ahtila's subjects are multi-vocal, the parties to the human relationship speak from the same lips – through the father's mouth, a woman with a man's voice.

In her films, the artist offers numerous different viewpoints and narratives pre-

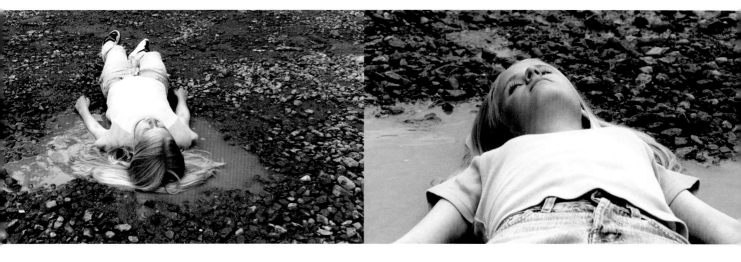

sented by different characters, and viewers can choose from among them or combine them into their own versions of the story. In place of an unambiguous plot, the open and at times contradictory unfolding narrative is commented on by several subjects within the story who, at times, recite flowing, poetic monologues directly to the viewer. These speeches, echoing poetic metre or hit-song lyrics, often verge on cacophony. At other times, the characters literally use someone else as a mouthpiece, but without communicating to each other – the dialogue is mostly directed at the viewer.

The events in Ahtila's films do not always comply with causality: they can be presented in an illogical order, using different audio-visual elements, which gain prominence only occasionally or cyclically. For example, in Ahtila's 1995 film If 6 was 9 (Jos 6 olis 9), the characters' and/or narrators' presence in and withdrawal from the narrative space is successfully managed using a split-screen technique. This facilitates the narrative flow by deliberately giving prominence to images, movement, speech, sounds, a certain space or mood. Specifically because of the tripartite projection built into the work, If 6 Was 9 works most effectively as a video installation in an exhibition space, where the individual image fields and their shared sound setting alternate and overlap, reacting to each other as the story progresses.

If 6 Was 9 is about teenage girls and sexuality, and has a strong documentary feel to it, even though it is a cleverly constructed fiction. Part of its trick lies in the fact that adolescent girls are shown in their everyday surroundings – at school, hanging out together, speaking frankly about their dreams and most intimate fantasies.

The same kind of 'straightforwardness' can also be found in Today (Tänään) 1997, which is one of Eija-Liisa Ahtila's works that formally is closest to the traditional short film. It is a story about a family, about fatherhood and especially, about the relationship between father and daughter. At the same time, it is a puzzling, strangely plotted thriller about the accidental death of the grandfather. By dividing the story into three parts, Ahtila manipulates the elements of time and memory in the process of narration. Each member of the family in turn bursts into laconic, prose/poem-like monologues, which are like the statements given in evidence, speeches for the defence or the prosecution, which challenge the viewer to be the jury. But there are no guilty parties here... perhaps not even a crime. The viewer feels like a detective trying to unravel the mystery of non-linear drama. A prying voyeur, he/she listens to the father and daughter, and their simultaneous need for and fear of closeness. The loss of someone close is just as hard to deal with as the demanding presence of those still around us.

First published in Cinéma, Cinéma – Contemporary Art and the Cinematic Experience, Stedelijk Van Abbemuseum, Eindhoven, Netherlands, 1999

Eija-Liisa Ahtila

born Hämeenlinna,
Finland, 1959. Lives
and works in
Helsinki, Finland.

SELECTED SOLO EXHIBITIONS

2002 *Fantasized Persons and Taped Conversations*,
Kiasma, Museum of Contemporary Art, Helsinki,
Finland
Fantasized Persons and Taped Conversations, Tate
Modern, London, UK
2001 Charles H. Scott Gallery, Vancouver, Canada
Sala Montcada of Fundació "La Caixa", Barcelona,
Spain
2000 Neue Nationalgalerie, Berlin, Germany
1999 Anthony Reynolds Gallery, London, UK
Museum of Contemporary Art, Chicago, USA
1998 Museum Fridericianum, Kassel, Germany
Kunsthaus Glarus, Glarus, Switzerland

SELECTED GROUP EXHIBITIONS

2002 *Never ending stories*, Haus der Kunst, Munich,
Germany
2001 *Le repubbliche dell'arte: Interferenze*, Contemporary
Art Centre Palazzo Delle Papesse, Siena, Italy
2000 *The Vincent, the exhibition of the short listed artists*,
Maastricht, Netherlands
Kwangju Biennale, South Korea
1999 *Signs of Life/ Melbourne International Biennal*,
Melbourne, Australia
Kramlich Collection, San Francisco Museum of
Modern Art, USA
Venice Biennial, Nordic Pavillon, Venice, Italy (with
Annika von Hausswolff and Knut Asdam)
1998 *Manifesta 2*, Luxembourg, Luxembourg
Nuit Blanche, Musee d'Art Moderne de la Ville,
Paris, France
1997 *5th Istanbul Biennial*, Istanbul, Turkey

SELECTED BIBLIOGRAPHY

*Fantasized Persons and Taped
Conversations*, exhibition catalogue,
Kiasma/Museum of Contemporary Art,
Helsinki, Finland, 2002
Eija-Liisa Ahtila: Anne, Aki i Déu,
exhibition catalogue, Fundació "La
Caixa", Barcelona, Spain, 2001
*Coutts Contemporary Art Foundation
Awards 2000*, exhibition catalogue,
Coutts Bank Switzerland Ltd,
Switzerland, 2000
Festival Catalogue, Filmpalast Lichtburg,
Oberhausen, Germany, 2000
*End of the Story, The Nordic Pavilion la
Biennale di Venezia 1999*, Nordic
Pavilion, Venice Biennial, Italy, 1999
Daniel Birnbaum, *Eija-Liisa Ahtila*,
Museum Fridericianum Kassel,
Germany, 1998
Nuit Blanche, Musee d'Art Moderne de
la Ville de Paris, France, 1999
Jean-Charles Masséra, 'Intimite, verdure
et blancheur éclatante. Représentations
du vivre en famille dans les travaux
vidéo d'Eija-Liisa Ahtila', *Parachute*,
Spring 1999
Beatrix Ruf, 'Hybride Wirklichkeiten - Die
'Menschlichen Dramen' der Eija-Liisa
Ahtila/Hybrid Realities - Eija-Liisa Ahtila's
'Human Dramas', *Parkett*, No. 55

CHECKLIST OF WORKS

LAHJA/THE PRESENT 2002
Written and directed by Eija-Liisa Ahtila;
production Crystal Eye Ltd
Five TV spots and five short films as a
DVD monitor installation
dimensions variable
courtesy the artist, Crystal Eye Ltd,
Helsinki, Klemens Gasser and Tanja
Grunert Inc, New York
© 2001 Crystal Eye Ltd, Helsinki

"According to Charles Baudelaire, 'The Beautiful is always strange,'[1] and it is this touch of strangeness that gives art its particular beauty. To Baudelaire strangeness is art's 'endorsement' – its 'mathematical characteristic.' A strange mathematics that cannot be controlled by 'Utopian rules conceived in some scientific temple, without mortal danger to art itself."[2]

The Sydney Opera House (where James Angus' work is installed) is the perfect example of a Quixotic equation – as architect Jørn Utzon based the shape of the building on a segmented orange (not the 'sails' of popular imagination). So the Opera House reads like the world's largest Cubist still life. Yet Utzon's design for the interior of the Opera House belies the idealism of the superstructure, as it was so functional as to border on Brutalism – Utzon's was an organicism *sans* ornament. His abiding vision was the construction of an ideal working theatre. Even so, in a meeting between Mies van der Rohe and Utzon,

JAMES ANGUS

SIMON REES

the Bauhaus master expressed an overall disdain for the project – as Utzon was reinjecting expressionism into architectural form long after it had been killed by International Style's reason and aggressive recto-linear logic.

Meanwhile, James Angus' upside-down balloon (titled *Shangri-La*) is a theatrical accomplice that takes the dialectical tension between function and form, mathematics and strangeness, a step further. In this setting *Shangri-La* is a resolutely ornamental spectacle that would look brilliant floating under the *trompe l'oeil* skies painted on the ceiling domes of a host of 'classical' Opera theatres (though it probably wouldn't fit under the gilded coronets and cornices of an *Opéra*). Rather, *Shangri-La* makes its niche in the clear atrium space of the modernist building. By drawing our attention to the clean aesthetics, and the emptying of space, Angus reminds us that an effect of modernist architectural minimalism was the elevation of architects and buildings over artists and art. In fact a new category of Western art was bred as a result of this triumphalism: foyer art; as architects and developers tended to commission art work with the aim of planning concessions rather

than as a commensurate element of the building. *Shangri-La* is turning this blandised category, and relationship, on its head reintroducing a spectacular accompaniment reminiscent of the work of Bernini or Oskar Schlemmer.

Angus has been injecting strangeness into the mathematics of architecture for some time. Working with computer-aided design (CAD), Angus has been building altered-state models of iconic modernist buildings. In a recent work, *Lakeshore Drive Möbius Loop* 2001, he rendered a scale model of Mies van der Rohe's landmark Chicago apartments as a Möbius loop. (In relation to *Shangri-La* we might consider that like a balloon, the Lakeshore Drive apartments are famous for 'floating' – as the glass-curtain foyers appear to be free of internal structural supports). Lying on their side, the foyer and roof cemented together in a schizoid marriage, the normally erect buildings look more like ∞ (the symbol for infinity) which seems to hint at the infinite possibilities open to architecture in the age of CAD (or the multiplication of visuality in the era of computer generated images, CGI, and Silicone Graphics™). At the same time Angus is warning of the inescapability of a discourse with modernism – you cannot exit these particular dream buildings after entering their circuit – unless we radicalise our artistic expectations.

The recent work of Frank Gehry is a proto-typical example of this reconsideration. Gehry has almost done away with sketching, the straight-line, and scale models (the *raison d'etre* of architecture) altogether.[3] His work enacts a strange mathematics indeed, in its morphogenesis from concept to built form via the uterine facility of CAD and laser technology, in combination with new hi-tech building materials. Gehry's organic buildings appear to have dispensed with the concrete reality of gravity – they seem to float, the forms wind and unwind, like nothing so much as Robert Smithson's *Spiral Jetty*.

James Angus has also done away with scale models, and gravity, in the production of *Shangri-La*. Architectural models in the guise of sculpture have been a major element of Angus' practice for some time. Angus has previously re-worked Van der Rohe's *Lakeshore Drive* 2001 and *Seagram Building* 1999 & 2000, as well as King Ludwig II of Bavaria's fairy tale castles in *Neuschwansteins* 1998 and *Falkensteins* 1999. This latest work, however, *is* a balloon.

Yet the form winds and unwinds, as our perception oscillates between the reality of its balloon-ness and its sculptural depiction. It is sculptural – and strange – in as much as the balloon is floating upside-down: the basket and skirt are suspended above the volume of the envelope.

Inversion is crucial to Angus' practice; it is the divisor of his mathematics. His *Seagram Building* lies on the floor, the horizontality of the model decreasing the mythic quotient of Mies' vertical monument. Angus made his sculpture of *Robert Wadlow* 1997 – the world's tallest ever man – proportionately smaller than the average person as Wadlow was tall. By standing next to the lilliputian rendering the audience gained a vicarious experience of Wadlow's stature. His *Bodhisattva* 1999 is an appropriation of a fifteenth-century bronze in the collection of the Metropolitan Museum in New York. Angus bent the statue through ninety degrees, to reveal its hollow base – exposing the negative space at its centre to the viewer. In doing so Angus, like Gehry, turns our expectation of the solidity of sculpture inside out, adding another dialectical tension, and excavating the conceptual core of his practice.

Suspended in the Opera House foyer *Shangri La* is a *Deus ex Machina* – a theatrical 'god machine'. We cannot be sure whether it is descending or rising, or whether in fact, like a sculpture, it is frozen. Its presence alerts us, however, that things are afoot – and focuses our attention on the unfolding drama. If *Shangri-La* is plummeting, like Orpheus or Icarus, it is warning of the totalitarian tendencies of aggressive architectonics. In ascension it reminds us that technology and architecture are still possessed with a romantic and humanist potential, if paired with the strangeness of art.

1. Baudelaire is quoting Edgar Allen Poe, who is quoting Roger Bacon.
2. Baudelaire, Charles, *Art In Paris 1845-1862 Salons and Other Exhibitions Reviewed by Charles Baudelaire,* ed. & trans., Jonathan Mayne, Phaidon Press, 1965, p 124
3. Gehry has one model made which is scanned into a computer using a program developed by French aerospace firm Dassault Systems, though he considers everything up to the finished building itself with a healthy scepticism, as something much less than the building itself. In Martin Filler, 'Ghosts In The House', *New York Review of Books*, Vol. XLVI, No. 16, 21 October 1999

James Angus born
Perth, Australia,
1970. Lives and
works in Sydney,
Australia.

SELECTED SOLO EXHIBITIONS

2001 Roslyn Oxley9 Gallery, Sydney, Australia
 Govett-Brewster Art Gallery, New Plymouth, New
 Zealand
 Experimental Art Foundation, Adelaide, Australia
 Australian Centre for Contemporary Art,
 Melbourne, Australia
1999 Gavin Brown's enterprise, New York, USA
1997 Gavin Brown's enterprise, New York, USA
1995 Roslyn Oxley9 Gallery, Sydney, Australia
 Perth Institute of Contemporary Arts, Perth,
 Australia
1994 200 Gertrude Street, Melbourne, Australia

SELECTED GROUP EXHIBITIONS

2000 *The Age of Influence*, Museum of Contemporary
 Art, Chicago, USA
 Never Never Land, Florida Atlantic University, Boca
 Raton, USA
1999 *New Urban Sculpture*, Public Art Fund, New York,
 USA
1998 *Unfinished History*, Walker Art Center, Minneapolis,
 USA
1997 *Penambrae*, Perth Institute of Contemporary Arts,
 Perth, Australia
1996 *Adelaide Biennial of Australian Art*, Art Gallery of
 South Australia, Adelaide, Australia
 Transformers, Auckland Art Gallery, New Zealand
 Hans Accola, James Angus, Fischli & Weiss, Gavin
 Brown's enterprise, New York, USA
1992 *ARX 3 (Artists' Regional Exchange)*, Lawrence
 Wilson Art Gallery, University of Western Australia,
 Perth, Australia
 PRIMAVERA, Museum of Contemporary Art, Sydney

SELECTED BIBLIOGRAPHY

Francesco Bonami, *Unfinished History*,
exhibition catalogue, Walker Art
Center, Minneapolis, USA, 1998, p 29
Christopher Chapman, 'Haptic Geo-
metry', *Eyeline*, Oct. 2000, pp 14-17
David Hunt, 'Gulliver's Troubles', *Art/text*,
Feb 2000, pp 46-7
Ken Johnson, 'Art in Review', *The New
York Times*, Sept. 1997, p 37
Stuart Koop, 'Look Again', *Monument*,
Feb. 2001, pp 92-5
David McNeill, 'James Angus and the
Industrial Sublime', *Adelaide Biennial of
Australian Art*, exhibition catalogue, Art
Gallery of South Australia, 1996, pp
44-5
Linda Michael, *PRIMAVERA*, exhibition
catalogue, Museum of Contemporary
Art, Sydney, 1992
Jerry Saltz, *Time Out New York*, 7 Oct.
1997, p 51
John Stringer, *Art+Text*, May 1993, p 80
Margaret Sundell, *Artforum*, Nov. 1999,
p 142

CHECKLIST OF WORKS

SHANGRI-LA 2002
hot-air balloon
installation, dimensions variable
courtesy the artist, Roslyn Oxley9
Gallery, Sydney and Gavin Brown's
enterprise, New York

SOME THOUGHTS ON AUTOBIOGRAPHY — REMEMBER JUNIOR HIGH SCHOOL IN SEPTEMBER, AFTER SUMMER, AND THE TEACHER ASKED YOU TO WRITE A COMPOSITION, "MY SUMMER VACATION"? YOU CAN'T REMEMBER NOW WHAT IT WAS YOU WROTE, BUT YOU KNOW IT WASN'T ABOUT PETTING UNDER THE BOARDWALK. YOU HAD A VERY CLEAR SENSE OF THE BOUNDARIES. NOW, SUPPOSING YOU WERE A TROUBLE-MAKER AND YOU WROTE ABOUT YOUR SUMMER ABORTION, AND YOU FOUND YOURSELF ON THE OTHER SIDE OF THE RULES. YOU DIDN'T GET THERE BY ACCIDENT. THE RULES WERE SO WELL KNOWN TO YOU THAT VIOLATING THEM AT THAT MOMENT WAS MORE IMPORTANT THAN THE ABORTION. THE RESPECTORS OF PROPRIETY AND ITS VIOLATORS SHARE A CONCERN WITH THE RULES. Take another autobiographical form, the Diary. You are twelve years old, and you bought a diary. The diary has one page for each day because that's the way the publisher printed it. There was no way the publisher could know you were going to have a big experience on January 4th, March 15th, and September 11th. It turned out that December 5th didn't even exist as far as your consciousness was concerned. So you had no room to finish january 4th, and by January 5th you gave up literature and became an artist. Each day you wrote a single sentence on your allotted page. "Today was a boring day." "Today was a boring day." "Today was a boring day." You saved your financial investment and became an academic, conceptual artist. This is an art work because it makes no claim to truth. It is also not autobiographical, although it may count as an autobiographical art work. Real autobiography makes a powerful claim to truth. Autobiographical art works do not. They only make a claim to the idea of autobiography. The substance is a speech made in the first person. But speaking in whatever person, the voice of the speaker is situated in the present. The voice defines the locality of the present. Autobiography, regardless of what person is speaking, must speak in the present tense. But the material of autobiography must always be in the past. It is the present trying to produce the past to take possession of the future. Think of Jean-Jacques Rousseau calling up his moment of humiliation. When he confesses to having been a flasher, to whom does he speak? And what does he want from them? Is this the same as Dostoyevski dragging Turgenev into a corner at a party and remorselessly recounting how he molested little girls? We know what Dostoyevski wanted from Turgenev. Turgenev was an insufferably decent man and Dostoyevski was an insufferably indecent man, and he wanted to force a conspiratorial and guilty complicity with that suave, cultivated belletrist. Under the pressure of this powerful desire to have a companion in the sewer – where one may think we all belong – is it possible that one may misremember, make mistakes, lie? I can see how that could happen. In fact, it is hard not to imagine it happening. So that the claim to truth is itself infected by desire. Desire is not a record. It may be a fairy-tale, a romance, an allegory or a novel, but it is not a documentary. A documentary is only an impoverished romance, and there is no virtue in a thrifty romance. By the end of the Nineteenth Century poverty ceased being a sign of truth. It is only a sign of misery. Truth may be luxuriously expensive, and we may have to pay its price whatever it happens to be. I'm a spendthrift, and I empty my pockets every time. ELEANOR ANTIN, Sun & Moon magazine – A Journal of Literature and Art #

ELEANOR ANTIN

33

According to the dictionary, most modern usage of the word *fantastic* connotes weirdness, grotesquery, and extravagant or capricious flights of fancy, often beyond credibility. But the dictionary also discloses that its etymology derives from the ancient Greek *phantastikos*, meaning 'able to present or represent to the mind', and has kinship with other forms of the word that mean 'to make visible', 'light', and 'bright'. In these earlier senses, fantasy has less to do with bizarre and delusive mental concoctions than with imaginative conception and creative apperception, and illuminating truth.

It is in this direction that Eleanor Antin has forged her art for well over three decades, garnering a history as a pioneer in the early development of conceptual, feminist, installation, performance and video art. And her art, which can seem at first glimpse to be make-believe suggestive of child's play, reveals itself, upon further consideration, as sophisticated social commentary, satire, political protest, a feminist-inspired inquiry into the nature of personal identity, and an existential meditation on the possibilities and limitations of human life.

Antin was born and raised in New York City and received her formal training in both visual arts and acting there, and even had a nascent career as a painter there. In 1969 she and her husband David Antin moved to Southern California where, for many years, they were on the faculty of the University

FANTASTIC ANTIN

HOWARD FOX

of California, San Diego. The move away from New York, just as Antin was coming of age artistically, was precipitous. And liberating.

The New York that Antin left was just then dominated by male artists and critics who were reacting against Abstract Expressionism and what they regarded as its bravura gesturalism, the personality cults that grew up around its virtuosi, and a philistine art market. In its place they promulgated various strains of formal and minimalist art which might be very elegant or very rugged in appearance but that generally was concerned with purifying art to its essentials in a very literal, no-nonsense investigation of artistic materials and process, presented with a matter-of-fact attitude. Antin – now a continent away from the latest developments and hypercriticality of the New York art world, and virtually indifferent to its hegemony – gleefully moved off in a quite opposite direction.

She was certainly provocative in her early experiments in concept-based art, in the mid-1960s, that pre-dated much of the critical discourse that later established 'conceptual art' as a recognizable phenomenon. Among her early works, for example, were a series of 'movie boxes' that mimicked theater lobby promotions of coming attractions. The movies she featured did not exist except in the form of her would-be advertisements for them. Incorporating still photos that purported to depict moments from the feature attraction – but that she actually appropriated (long before such creative 'borrowings' were called that) from books and magazines – each display evoked a perception of the content and mood of the movie. Antin says she made these protonarrative montages because she could not afford to make real movies; her rationale clearly reflects what would become an abiding attribute of her art: its relationship to narrative, theatrical presentation, fiction, and artifice – qualities shunned by formalist and minimalist art. Her art also assigned a most active role to the beholder's imagination, a part of the psyche not much engaged by puritanical – and decidedly un-fantastical – formal and minimal art.

Following the *Movie Boxes* Antin created numerous personal 'portraits' consisting of arrangements of household objects and consumer goods (sometimes annotated with a brief narrative text) that were meant to evoke the personal histories and characters of the real or fictitious people they stood for. Again, Antin's furnishing of material evidence of her characters' lives vested considerable faith in the viewer's intuition to be completed as works of art. During the early 1970s, Antin produced many text-based works, sometimes in combination with objects or photo-documentation of actions or planned actions. In *Carving: A Traditional Sculpture* 1972 she presented a grid of 144 black-and-white photographs of her nude body documenting a ten-pound weight loss during a month of dieting, as she 'carved' her body into its 'ideal' feminine form. An accompanying text cunningly evoked Michaelangelo's notion that the sculptor's art is to liberate the ideal form that resides within the hunk of marble, and it quietly satirized prevalent notions, promulgated by women's magazines and popular culture, of what constitutes feminine beauty and what women must do to attain it. Like the soldiers hidden within the Trojan horse, a feminist critique of the objectification of women is implanted in Antin's apparently objective documentation of her weight loss.

Antin was among the very first artists anywhere to address such feminist concerns in their art. Antin had not set out to advocate or propagandize for women's issues; but feminists discerned in her art an alternative paradigm to the strict disciplines of formalist art that then governed the art world. They perceived in the intuitively driven content of her art, and especially in its assigning so much independence and latitude and empowerment to the viewer, a revolutionary new compact between artist and viewer that resonated with their own political and ethical values – values that Antin shared.

She accepted the feminist/humanist argument that the self is not a preordained identity issued as if by natural law, but is a gradually evolving, ever-changing sensibility that, while surely is in some measure innate, might be molded to a much greater degree by inclination, belief, and personal choice. Rather than a pre-determined condition, identity might be largely an act of self-determination and freedom of choice. Fantastic!

The American feminist movement exhorted women to assert the right to challenge social norms and become whatever ideal self each woman wished to be, not the one described by tradition, convention, or lack of imagination. Antin went the movement one better: if she were going to be another 'self,' she wondered who she might be if she were a man. She decided that her male self would be an ideal male, a king – a benevolent and caring leader to his people (unlike, say, the American president at the time, Richard Nixon, who was then beset by the Watergate scandal that ultimately drove him from office). To become a king, Antin had to transform herself into a man, which she did by applying a theatrical beard to her woman's face – an hour-long process that she documented as a video. She also needed the raiment of a king, and so she assembled his regal vestments. She donned high leather boots that she wore over denim tights paired with a radiant silk shirt topped by a cape, the whole ensemble crowned by a grand broad-brimmed hat – *et voilá* – Antin was transformed into the King of Solana Beach, the California coastal town where she lived.

From time to time, the King would actually walk the length and breadth of his realm, greeting his subjects at the bank, in the grocery, on the street. Antin conceived of these impromptu strolls as performances, and she had them documented as photographs, in which her humor and the townsfolks' bemusement fully come across. Antin even established the personal history of the King through a series of meditations – sepia-toned drawings and writings from the King's personal diaries penned in his patently archaic florid handwriting.

The most complex incarnation of the King was in a solo performance that Antin presented at small theaters and alternative art spaces throughout the United States between 1975 and 1978 and at the Venice Biennale in 1976. *Battle of the Bluffs* recounts the political struggles of the King against landowners and real estate developers who seize the royal forest for their

own financial gain; the King leads his subjects in a popular revolt against them, only to lose to their superior power and be deposed and exiled. The import of Antin's performance, though it has humorous passages, is not about the absurdity of dressing up and pretending to a make-believe throne. The fable is sober and troubling, and in the context of American politics of the period was understood as an indictment of American political, economic, and ecological policies. Antin's King is fantasy, it is true; what is genuinely fantastic was Antin's envisioning herself – as an intellectual proposal, as a presentation to the mind – as the King, or as anyone other than who she knew herself to be in the here-and-now.

While she was still engaged with the King, Antin introduced another fictitious persona, this time of her idealized female self, the Ballerina, whose history, like the King's, was told through a variety of media ranging from photographs, video tapes, performances, drawings, writings, films, and installations. The Ballerina made her first appearance in Antin's *oeuvre* in 1973 as a nameless would-be who could momentarily hold a perfect balletic pose for the camera but who was comically inept as a dancer. She could only longingly dream about *une vie en la danse*. Antin retired the anonymous Ballerina after several photographic series and two video movies and in 1975, she invented another persona, the Nurse, who appeared in two guises – first as a subservient somewhat ditzy soap opera heroine, and ever an adjunct to male physicians: and later as a more heroic and philosophical figure, Eleanor Nightingale, whose character was loosely based on Florence Nightingale, the founder of modern nursing. By 1979 however she brought the ballerina back as a far more developed character, Eleanora Antinova (her invented character), the famous black ballerina – the *only* black ballerina – of Diaghilev's *Ballets Russes*.

Antinova had a complex personality and a confounding artistic history. She was born in the United States and went to Paris to 'break into' the field of classical ballet, even though she was self-trained and learned only to pose – not to dance – by looking at picture books. As the *only* black ballerina in the *Ballets Russes*, Antinova wished to dance the canonical classical roles, but her patron Diaghilev saw her as a passionate, if noble, primitive and assigned her to such roles as the Queen of Sheba, Cleopatra, and the American Indian princess, Pocahantas. Of course, these roles are all as fictitious as the King of Solana Beach, but Antin made them visible to the eye and the mind's eye in a series of photographs depicting Antinova in her Great Roles. Part of a larger body of work collectively titled *Recollections of My Life with Diaghilev*, these sepia-tone

photographs exactly mimicked the compositions, the poses, the lighting, and the vintage costumes and backdrops of ballet theater photographs of the early twentieth century. These formal portraits were accompanied by printed pages from Antinova's (non-extant) autobiography in which she describes the roles and her experience in dancing them. *Recollections* also includes such fictitious memorabilia as a group of exquisite pen-and-ink drawings and watercolors of costumes and sets for Antinova's ballets and impromptu portraits of her café-society friends – Picasso, Stravinsky, Derain, and so on.

In 1980, all of these materials were brought together as a salon-style exhibition at Ronald Feldman Fine Arts in New York, where several nights each week during the run of the show Antin appeared in an hour-long performance as Antinova – now retired and in rather dire financial straits – reminiscing about her once celebrated, now unsung, life on and off the stage. Antinova ended her reminiscence distracted and morose, selling her autograph and offering her services for hire to speak at cocktail parties and teas. Most audience members understood the multiple layers of fiction in Antin's project; some did not and in fact discretely approached Feldman about offering financial support to the aging, pathetic Antinova.

Antinova's decline had begun in 1929, following the death of her patron and protector Diaghilev, when the black prima ballerina was snubbed and soon forgotten by the ballet establishment's dancers, choreographers, critics, and historians. Antinova returned to her native country, the United States, where she lived a degraded life having been reduced to performing novelty dances on shabby vaudeville stages – and even lesser theaters – and acting in silent movies.

In 1986 Antin created an exhibition of 'filmic installations' featuring this period of Antinova's life. Viewers encountered what is essentially a stage set of an old fashioned theater marquée; looking through round windows of the elaborate entry doors into the theater, they could see cardboard silhouettes of the sparse audience watching Antinova in her silent movie roles. Projected on the screen is a pastiche of short films, each just a few minutes long, shot in a variety of styles ranging from light Chaplinesque comedy to gloomy cinematic expressionism. (In 1987 Antin anthologized the six short films into a eighteen minute videotape titled *From the Archives of Modern Art*. According to the film's credits, the original 16-mm reels had recently been discovered in an abandoned warehouse minutes before it was to be demolished; like the King and Antinova, the films themselves had a *faux* history of which they were survivors.) In another part of the

1986 installation, viewers came upon Antinova's dressing table. It is strewn with the accoutrements of a ballerina, and the mirror is eerily haunted (through the illusionism of rear-screen projection) by the visage of a glum Antinova contemplating her fallen state.

In 1989 Antin introduced another persona into her repertoire, Yevgeny Antinov, a fabled director of silent movies and the reputed lover of Eleanora Antinova. Antinov was never fleshed out as a 'real' character, as were the King and Antinova, but he is known through his achievements in film. *The Last Night of Rasputin* portrays the corruption and cultural decadence of the Romanov dynasty in the last days before Tsarist Russia fell to the Soviet revolution. Antinova appears in the movie, but not really as its subject; she serves as an icon, the visible representation to the imagination, of purity and artistic idealism in this cinematic morality play.

Most of the action takes place at a party in the home of Rasputin, the charismatic and deranged spiritual advisor to the Romanovs. Rasputin's guests, debauchees all, are indulging themselves in shameless excesses and licentiousness when the erratic Rasputin suddenly tires of the depravities and longs for real beauty. He orders his servant to bring him a ballerina – 'a real dancer' – and he obliges by abducting Antinova as she leaves the ballet theater following a performance. Rasputin commands the fearful Antinova to dance for his guests; she obeys but defiantly dedicates her dance to all the oppressed proletariats of the world. Following the dance, she collapses in mental and physical exhaustion, and the lascivious guests attempt to prey upon Antinova while she sleeps. Rasputin demands their repentance, chaos erupts, Antinova is rescued by revolutionary friends, and in short order an empire falls.

The film was widely shown after its debut at the Whitney Museum of American Art in 1989, and on numerous occasions in 1989, 1990, and 1991. Antin, appearing in character as Antinova, introduced the film in a half-hour performance that she revives for the Biennale of Sydney.

As characters, the King and Eleanora Antinova were bitterly disappointed in life but never exactly disillusioned. That is, the ideals – ideological, artistic, and emotional – they aspired to were always shining, visible, and represented to their imaginations, even when conditions of life defeated them. Eleanor Antin's genius is inventing fictions about fictitious characters, trying to imagine life as it *might* be – even better, imagining life as it might *not* be, which is fantastic indeed.

Eleanor Antin born
New York, USA, 1935.
Lives and works in San
Diego, California, USA.

SELECTED SOLO EXHIBITIONS

2000 *Eleanor Antin: Real Time Streaming*, Arnolfini, Bristol, UK
1999 *Eleanor Antin (Retrospective)*, L A County Museum of Art, Los Angeles, USA
1997 *New Acquisitions, 'Angel of Mercy'*, Whitney Museum, New York, USA
1986 *Loves of a Ballerina*, Ronald Feldman Fine Arts Gallery, New York, USA
1980 *Recollections of my Life with Diaghilev*, Ronald Feldman, New York, USA
1978 *The Ballerina*, Whitney Museum of American Art, New York, USA
1977 *The Nurse and the Hijackers*, Ronald Feldman, New York, USA
 The Angel of Mercy, M L D'Arc Gallery, New York, USA
1976 *Adventures of a Nurse*, Ronald Feldman, New York, USA
1973 *100 BOOTS*, Museum of Modern Art, New York, USA

SELECTED GROUP EXHIBITIONS

2000 *MOMA 2000*, Museum of Modern Art, New York, USA
 Made in California, L A County Museum of Art, Los Angeles, USA
1999 *The American Century*, Whitney Museum, New York, USA
1998 *Out of Actions*, Museum of Contemporary Art, Los Angeles, USA
1995 *1965-1975: Reconsidering the Object of Art*, Museum of Contemporary Arts, Los Angeles, USA
1989 *Whitney Biennial*, Whitney Museum of American Art, New York, USA
1976 *Venice Bienale*, Venice, Italy
1977 *American Narrative/Story Art*, Museum of Contemporary Art, Houston, USA
1975 *Video Art U.S.*, São Paolo Biennale, São Paolo, Brazil
1969 *Language 3*, Dwan Gallery, New York, USA

SELECTED BIBLIOGRAPHY

Eleanor Antin, *Being Antinova*, Astro Artz, Los Angeles, 1983
Eleanor Antin, *Eleanor Antinova Plays*, Introduction by Henry Sayre, Frantisek Deak essay, Sun & Moon Press, Los Angeles, 1994
Eleanor Antin, *100 Boots*, Introduction by Henry Sayre, Running Press, Philadelphia, 1999
Jonathon Crary & Kim Levin, *The Angel of Mercy*, exhibition catalogue, La Jolla Museum of Contemporary Art, La Jolla, California, 1977
Howard Fox, Lisa Bloom, *Eleanor Antin*, exhibition catalogue, Los Angeles County Museum of Art & Fellows of Contemporary Art,1999

Vickie Goldberg, *As A Feminist, A King... As A Ballerina, A Klutz*, New York Times, 8 Aug, 1999
Lucy Lippard, *Six Years: The Dematerialization of the Art Object*, Praeger Press, New York, 1973
Eleanor Munroe, *Originals: American Women Artists*, Simon & Schuster, New York, 1979
Leah Ollman, *Art in America*, Feb. 2000
Jeffrey Skoller, 'The Shadows of Catastrophe, Towards an Ethics of Representation in Films by Antin, Eisenberg And Spielberg', *Discourse: Theoretical Studies in Media and Culture*, 19, Fall, 1996, pp 131-59

CHECKLIST OF WORKS

THE KING (video) 1972
videotape
(black and white, silent, 52 minutes)
courtesy Electronic Arts Intermix, New York

From THE KING'S MEDITATIONS 1974-75
#2 (THE HORSES' ASSES)
#6 (THE CASTLE)
#11 (THE ROYAL COACH)
wash, ink, and chalk on photosensitive paper, 44.5 x 52 cm; 44.5 x 78.7 cm; 44.5 x 47 cm
collection: Gary and Tracy Mezzatesta, Los Angeles
courtesy Ronald Feldman Fine Arts, New York

PORTRAIT OF THE KING n/d
black and white photograph, 28. x 35.6 cm
collection: Gary and Tracy Mezzatesta, Los Angeles
courtesy Ronald Feldman Fine Arts, New York

THE KING OF SOLANA BEACH 1974-75
black and white photographs, mounted on board, with text panels.
8 photographs, each 15.2 x 22.9 cm
collection: Washington University, St Louis, Charles H Yalem Art Fund, 2000
courtesy Ronald Feldman Fine Arts, New York

KING MANNEQUIN 1974-75
mannequin with beard and hair, original costume, consisting of wool cape, silk blouse, bush hat, blue jeans, boots, walking stick and stand
171.5 x 58.4 x 65.4 cm

collection: Washington University, St Louis, Charles H Yalem Art Fund, 2000
courtesy Ronald Feldman Fine Arts, New York

5 COSTUME STUDIES FROM "BEFORE THE REVOLUTION" 1979
tempera on paper: unframed, 35.6 x 28 cm each
courtesy the artist and Ronald Feldman Fine Arts, New York

BALLERINA (INSTALLATION) n/d
installation consisting of dressing table, artifacts, costumes, video, ballerina mannequin, suitcases, dimensions variable
courtesy the artist and Ronald Feldman Gallery, New York

RECOLLECTIONS OF MY LIFE WITH DIAGHILEV 1981
11 drawings, watercolour on paper, unframed 28 x 35.6 cm each
courtesy the artist and Ronald Feldman Fine Arts, New York

RECOLLECTIONS OF MY LIFE WITH DIAGHILEV 1981
11 pages of text, 28 x 35.6 cm
courtesy the artist and Ronald Feldman Fine Arts, New York

RECOLLECTIONS OF MY LIFE WITH DIAGHILEV 1981
18 sepia photographs 35.6 x 28 cm each
courtesy the artist and Ronald Feldman Fine Arts, New York

MADAME ANTINOVA (PERFORMANCE)
19 May 2002
performance – Sydney Opera House

he regnar tu fai nel cel

VASCO ARAÚJO

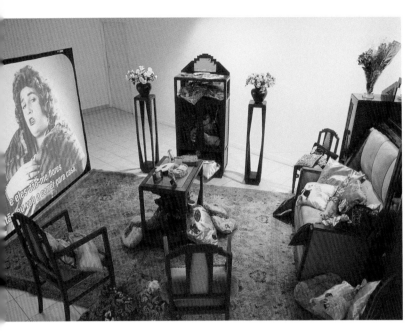

VASCO ARAÚJO

SOFTLY WEIRD

ISABEL CARLOS

The title, *La Stupenda*, refers to the opera singer, Joan Sutherland, but this installation from Vasco Araújo, which was shown for the first time in Lisbon in 2001, means much more than a putative tribute or fascination for this Australian singer; it is a work about stardom and the human condition. And the fact that the work is based on the world of opera does not derive from a mere external enchantment for an un-real and baroque universe, it is because Araújo is not only a person who has a profound knowledge of the matter, he himself is also a practitioner: he sings opera.

"Cosa naturale", that's the way Italian masters designated singing. But in opera nothing is natural: you sing instead of talk-ing, you dance instead of walking, the sce-narios are artificial and cumbersome, the wardrobe is excessive and fantastic. In opera, the quest for naturalness is accompanied by the highest technique, by a degree of sophis-tication, which is almost artificial, anti-natural we should say, as most radically illustrated by the existence of *castràti*. Rather than a substitute for women in opera, the *castràto* was the third sex in opera, the third voice, somewhere between a woman's voice and a child's voice. A voice created by man by means of physical amputation.

The imaginary comparison created bet-ween *castràto* and *prima donna* was based on an erotic notion of the body and on a strictly naturalist notion of sex: thus, it is not surprising that Jean-Jacques Rousseau hated both the voice and the figure of the *castràto* and that he favoured the *prima donna*. Equally it is not surprising that Sade was a defender of the *castràto*. The *prima donna*, with a woman's voice, exacerbates

the sentimental and the natural, like an epiphany of sensibility; whereas with the *castràto* we have the cry, the excess, the immolation of the body, rather than of the character, the epiphany of fury.

Once the pair *castràto/prima donna* ceased to exist, speculation started on the question of the perfect voice, and on the notion of diva. The diva is supposed to have the per-fect voice, the complete feminine voice; this is the ideal which Maria Callas incar-nated like nobody else: a vocal plenitude allowing her to sing – that is, to incarnate Isolda as well as Delilah, or Medea or Rosina, covering several feminine *tessitura*. Of course, we must not forget that Callas' case has also much to do with the fact that opera and Greek tragedy have much in common – the existence of a choir, the artificiality, the mythical, almost absurd, plots. A dark-eyed Greek opera singer tends to reinforce this tragic and dark feature.

Tragedy and drama are also characteristic

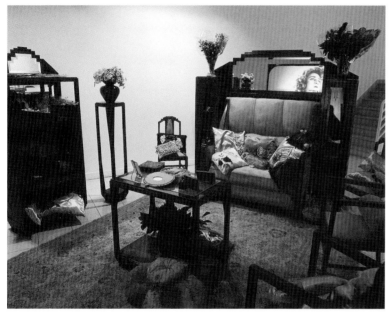

of the most popular Portuguese musical form of expression, the *fado*. Its lyrics talk about desperate and impossible love, and mismatching and sadness, about the notorious and untranslatable *saudade* and the difficulties of daily life. And *fado* also has its own diva: Amália Rodrigues. Vasco Araújo picked some lines from one of Amália's songs for his video's text: referring to 'women washing clothes in the river', Araújo evokes an image connoted with one of Amália's famous *fados* ("Povo que lavas no rio"), but also with an ideological feature of the Estado Novo period[1].

Facing the installation, the viewer might start smiling: the homely environment, almost kitsch, a man dressed as a woman, reciting burlesque sentences like...

Singing to me is this: the whole universe flows into my chest and then I let it flow out for as long as the music lasts. I offer the universe to my public, and then the public... in other words, the populace, in other words, the common people, in

other words, the rabble, stands up applauding and crying, in other words, the crowd... that is, the ordinary people, the washerwomen singing by the river, give me flowers and more flowers, which I accept and bring here to dry.

As this narrative advances however, the initial smile disappears, replaced by an uncomfortable sensation.

Vasco Araújo, in an installation with elements that are simultaneously burlesque and tragic, merges the universes of opera and *fado*. He depicts a retired opera singer – or, at least, a singer momentarily at home – who uses dried flower petals from bouquets offered by her fans to fill pillows on which she sews the dates and places of her performances; a singer who talks about her family as a burden she has to bear, a singer who defines her public as an uninformed mass and who, in a self-centred almost autistic speech, refuses to answer any questions she is being asked.

Visually, the image isn't really one of a

travesty, but one where the border between masculine and feminine is clearly unstable. The apparently bourgeois comfort of delicate velvets and satins on art-deco furniture becomes a canvas for a weird narrative – the solitude of this human imprisoned by both memories of glory and the insignificance of her daily life is confronting. *La Stupenda* is a body that has no reason for existence off stage or away from opera's artificiality where everything is possible. In the homely and intimate atmosphere, this body disintegrates, becomes a ruin that cannot exist beyond the show world. It is a 'soft weirdness': the artist himself (who in turn brings this work into the area of self-representation) incarnates this body – it becomes an artistic act that is both coherent and deeply human.

1. Portugal existed for 48 years, until 1974, under a dictatorship, which was called Estado Novo.

Translated by Miguel Magalhães

che regnar tu fai nel cel

Vasco Araújo born Lisbon, Portugal, 1975. Lives and works in Lisbon

SELECTED SOLO EXHIBITIONS

2002 Gallery Senda, Barcelona, Spain
2001 *La Stupenda*, Galeria Cesar/ Filomena Soares, Lisbon, Portugal
 FADO, Home Project, XXX Las Lavras, Lisbon, Portugal

SELECTED GROUP EXHIBITIONS

2002 *Melodrama*, Artium, Centro-Museo Basco de Arte Contemporaneo, Vitoria-Gasteiz, Spain
 Trans Sexual Express: A Classic for the Third Millennium, City Council Hall, La Coruna, Spain; Kunsthalle Mucsarnok, Budapest, Hungary
2001 *Trans Sexual Express: A Classic for the Third Millennium*, Centre d'Art Santa Mònica, Barcelona
 NADA (Lisboa Capital do Nada), Lisbon, Portugal
2000 *Nonstopopening-Lisboa*, Gallery ZDB, Lisbon, Portugal
 Try to be more accommodating (we love our audience), W C Container, Edificio Artes em Partes, Oporto, Portugal
 THE POSTMAN ONLY RINGS TWICE, 11 projects by students of the School of Arts Maumaus, Museu das Comunicações, Lisbon, Portugal
 Festival Video/ SISTER SPACES, Southern Exposure & www.gotofrisco.net, San Francisco, USA
1999 *Biennial Young Creators of Europe and The Mediterranean*, Rome, Italy

SELECTED BIBLIOGRAPHY

Maria Lluïsa Borrás, 'Transgresiones y acomodos', *La Vanguardia*, Spain, 13 July 2001
Maria Lluïsa Borrás, 'Art Report no convence Calidada desigual en la selección de exposiciones', *La Vanguardia*, Spain, 20 July 2001
Catarina Campino, 'O carteiro toca sempre duas vezes', *Video Plus*, Portugal, October 2000
Catarina Campino, 'Reality Check', *Arte Ibérica*, Portugal, June 2000
Óscar Faria, 'Vidas Contemporâneas', *Público*, Portugal, 2 June 2000
Óscar Faria, 'O carteiro toca apenas duas vezes', *160 caracteres: uma paixão política*, Portugal, 2000
José Sousa Machado, 'Vasco Araújo, Galeria Cesar/ Filomena Soares, Lisboa La Stupenda', *Arte Ibérica*, Portugal, March 2001
Celso Martins, 'Vasco Araújo, Galeria Cesar/ Filomena Soares, Lisboa', *Expresso*, Portugal, 10 March 2001
João Pinharanda, O problema das comunicações, *Público*, Portugal, 1 September 2000
Jaume Vidal, 'El arte travestido', *El Pais*, Babelia, Spain, 2001

CHECKLIST OF WORKS

LA STUPENDA 2001
video installation, dimensions variable
courtesy the artist and Galeria Filomena Soares, Lisbon

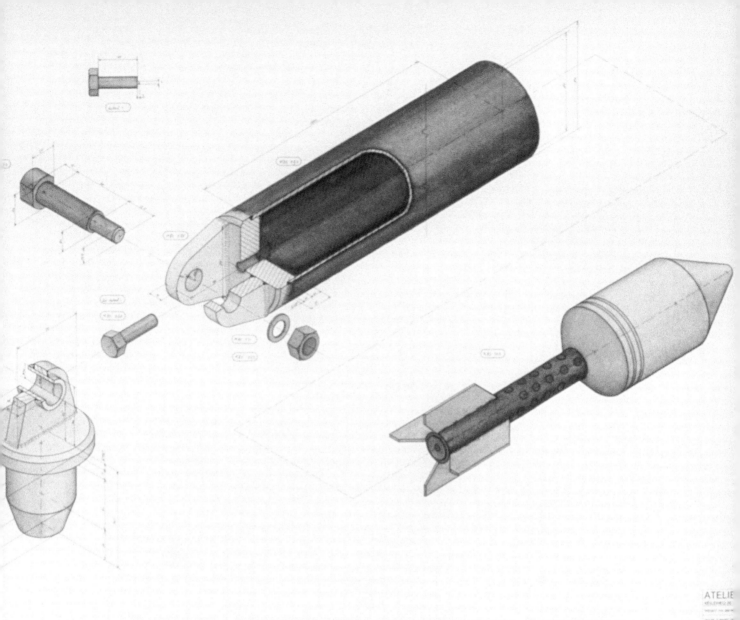

ATELIER VAN LIESHOUT

LAST YEAR, WHEN ROTTERDAM WAS CULTURAL CAPITAL OF EUROPE, ATELIER VAN LIESHOUT REALISED THEIR BIGGEST ARTWORK TO DATE: *AVL-VILLE*. THIS FREE STATE WAS AN AGREEABLE MIX OF ART ENVIRONMENT AND SANCTUARY, FULL OF WELL-KNOWN WORKS BY AVL. THE GOAL OF THIS FREE STATE WAS TO CREATE AN AUTONOMOUS SPACE WHERE EVERYTHING IS POSSIBLE WITHIN A COUNTRY THAT IS OVER-REGULATED TO AN INCREASINGLY OPPRESSIVE DEGREE. *AVL-VILLE* HAD ITS OWN FLAG, ITS OWN CONSTITUTION AND ITS OWN MONEY. BESIDES THIS IT HAD A FULLY OPERATIONAL FARM, AN ENERGY PLANT, SEPTIC TANKS, AN ALCOHOL DISTILLERY AND EVEN A WORKSHOP TO MAKE WEAPONS AND BOMBS. AVL-VILLE WAS LOCATED IN THE ROTTERDAM HARBOUR AREA AND MAY IN THE NEAR FUTURE BE REBUILT ON A CONTAMINATED SOIL DUMP NEAR ROTTERDAM AIRPORT. For several years AVL worked on the realisation of this large scale project. Drawings were made, and all the artworks that AVL produced since 1998 were designed to ultimately function inside AVL-Ville. The Still that AVL made in 1999 is one of them. The distilling of alcohol is something that AVL has been experimenting with for several years. *The Workshop for Alcohol and Medicines* is an artwork built inside a 20 ft shipping container. It consists of a fully operational distillery that can be used to produce all kinds of liquor as well as medicines. The materials needed for this process are very simple: you can even produce alcohol from pig-food. This process is demonstrated in one of the AVL drawings: *the Bio-Pig*. AVL's installation for the Biennale of Sydney demonstrates the process of distilling alcohol. Included as well are drawings that illustrate life at *AVL-Ville* and several mortars that AVL produced to defend its free state from possible hostile intruders.

Atelier van Lieshout

established 1995.

Joep van Lieshout

born Ravenstein,

Netherlands, 1963.

Lives and works in

Rotterdam, Netherlands.

SELECTED SOLO EXHIBITIONS

2002 *Biennale of São Paulo*, São Paulo, Brazil
2001 La Biennale, Venice, Italy
 Sonsbeek 9, Arnhem, Netherlands
 Milano Europa 2000, PAC, Milan, Italy
2000 *Wonderland*, St. Louis, USA
 Over the Edges, SMAK, Gent, Belgium
 Hangover 2000, performance and installation, Expo
 Hannover, Hannover, Germany
1999 *In the Midst of Things*, Birmingham/ Bourneville, UK
 Arte all'Arte, San Gimignano, Italy
1998 'NL', Van Abbe Museum, Eindhoven, Netherlands
 Constructen ontwerpen voor stad en land, in
 collaboration with Birgitte Louise Hansen, De
 Paviljoens, Almere
1997 *Sculpture Projects 97*, Münster, Germany

SELECTED GROUP EXHIBITIONS

2002 *Biennale of São Paulo*, São Paulo, Brazil
2001 La Biennale, Venice, Italy
 Sonsbeek 9, Arnhem, Netherlands
 Milano Europa 2000, PAC, Milan, Italy
2000 *Wonderland*, St. Louis, USA
 Over the Edges, SMAK, Gent, Belgium
 Expo Hannover, "Hangover 2000", performance
 and installation
1999 *In the Midst of Things*, Birmingham/
 Bourneville, UK
 Arte all'Arte, San Gimignano, Italy
1998 'NL', Van Abbe Museum, Eindhoven, Netherlands
 Constructen ontwerpen voor stad en land, in
 collaboration with Birgitte Louise Hansen, De
 Paviljoens, Almere
1997 *Sculpture Projects 97*, Münster, Germany

SELECTED COMMISSIONS

2001 A-Portable, Women On Waves, Amsterdam,
 Netherlands
 STAR-wagon, STAR Museum Veendam
2000 Visitor's Space Prison Hoogvliet, Rotterdam,
 Netherlands
 Sound reflectors, Luxor theatre, Rotterdam,
 Netherlands
 AVL-Men, public space, Knokke, Belgium
1999 Toilet-Units, Museum Boijmans Van Beuningen,
 Rotterdam, Netherlands
1998 *The Good, the Bad + the Ugly*, Walker Art Center,
 Minneapolis, USA

SELECTED BIBLIOGRAPHY

J Allen, 'Up the organization', *Art-forum*,
April 2001, pp 104-111
R Fuchs, J Allen, *Schwarzes und Graues
Wasser*, Bawag Foundation, 2001
D Hickey, 'Joep van Lieshout's Rebel
Housing. Architecture as Rock and
Roll', *Issues*, Dec. 1999
P J Hoefnagels, M J Noordervliet, B O
Lootsma, *Atelier van Lieshout – The
Good, The Bad + The Ugly (English
edition)*; *Le Bon, La Brute + Le Truand
(French edition)*; *The Good, The Bad &
The Ugly (German edition)*, exhibition
catalogue, Les Abattoirs/Toulouse;
Migros Museum für Gegenwartskunst/
Zürich, Atelier van Lieshout/ NAi
Publishers/Rotterdam, 1998
S Maurer, 'Das Modulaire Multi-Frauen-
Bett im Museum', *Tagesanzeiger*, 5
April 1999
M A Miller, D Hickey, J Dellinger, *A
Supplement*, Contemporary Arts
Museum, Tampa, April 1999
M Milgrom, 'Target: AVL', *Metropolis*,
May 2000
J van Lieshout, B O Lootsma, P de
Jonge, *Atelier van Lieshout – A Manual
/Ein Handbuch*, exhibition catalogue,
Kölnischer Kunstverein/Cologne;
Museum Boijmans Van Beuningen/
Rotterdam, Cantz Verlag/Ostfildern, 1997
P. van Ulzen, 'Atelier van Lieshout',
Parachute, No. 102, pp 44-57
I Schwarz, 'AVL-Ville. De grenzen van
kunst in de openbare ruimte', *Items*
No. 4 Sep/Oct 2001, pp 72-79

CHECKLIST OF WORKS

STILL 1999
steel approx 200 x 100 x 100 cm

AVL M80 MORTAR 1999
3 works, steel each 110 x 90 x 110 cm

10 DRAWINGS 1998-2000
watercolour on paper, various sizes

ALCOHOL MAKING INSTALLATION 1999
steel, approx 400 x 200 x 100 cm

Works courtesy Atelier van Lieshout,
Rotterdam

GILLES BARBIER

MANY ARTISTS TRY TO SAVE THEIR ART WITH SOLIPSISM, WITH AN AUTHORITARIAN GESTURE (THE CULT OF GENIUS). THIS IMPOTENT GESTURE BELONGS TO A TRADITION THAT EXISTS IN THE VARIOUS FORMS OF TWENTIETH-CENTURY ART. A 'BUNKER IDEOLOGY' IS BROUGHT IN AS AN ATTEMPT TO SAVE THE 'AUTONOMY' OF ART (OR WHAT ONE THINKS IT IS), THEREBY MERELY DEMONSTRATING ITS LACK OF FUNCTION. HOWEVER, THE TWENTY-FIRST CENTURY IS SEEING AN AWARENESS OF THIS LACK OF FUNCTION, AND ART IS BEING OFFERED A ROLE IN OUR SOCIETY OF LEISURE: 'YOU HAVE TO HAVE FUN'; AND THE ONLY WAY TO HAVE FUN IS 'TAKING PART'. THE ARTIST IN THE ROLE OF ENTERTAINER OR MC IS JUST AS RIDICULOUS AS THE ARTIST AS AUTIST. ART SHOULD MEASURE ITSELF AGAINST PROGRESS IN HERMENEUTICS AND MAKE ITS OWN CONTRIBUTION, AS HAS ALREADY OCCURRED IN OTHER AREAS OF THE CONSTRUCTION OF KNOWLEDGE. THE CRAFTY ASSUMPTIONS NECESSARY TO THE PRODUCTION OF ART HAVE ALREADY BEEN ANALYSED AT SUFFICIENT LENGTH. WE LACK CONCEPTS FOR APPLYING ART TO THE FUNCTION OF KNOWLEDGE, IN THE WAY THAT OTHER FIELDS OF KNOWLEDGE HAVE LONG BEEN USED: BIOLOGY, PHYSICS, CHEMISTRY, RESEARCH INTO INTELLIGENCE, MEDICINE, ETC. Barbier is interested in dislocating our habitual environments whose comfort is based on a construction of reality. He puts these pieces together in a different way in order to make a new reality that is equally valid. One has the impression of a breeze blowing through our world, dispelling the ideological stuffiness and giving the brain a breath of fresh air. But this does not mean that he uses his art to create counter-realities. What he shows is much more a method. Art is a means of representing this, a vehicle enabling us to follow the process of knowledge while experimenting with different rules. In this, he is in phase with this age of theories and models, which he applies to art. These form the basis for reading many of his works. Beyond this, however, he sketches out concepts that do not ground the specificity of artistic activity in the reproduction of images and sensualism, but express the need to find equivalents of scientific activity. Development of society depends on failure at every level, including that of art.

MATTHIAS LENGNER, Mmmh! Oooohh!/ Gilles Barbier, exhibition catalogue, Museum of Contemporary Art, Marseille, Summer 2001

45

TOP RIGHT: POLYFOCUS 3 2001 COLOUR PHOTOGRAPH. RIGHT: CIAO (MIGRATION) 2001 INSTALLATION.

To discuss the possibility of reproducing the world may lead an audience astray because it implies that such a world exists. At the very least a reproduction presupposes that there is something that can be reproduced. However, such a supposition refers to a topic in Occidental culture and art which is no longer self-evident. On the one hand, we cannot really determine what 'a world' is. We cannot speak of one world in a political or cultural sense, particularly after September 11, 2001. Anyone speaking about it in these terms makes claims to power which are no longer legitimate. At best, one can put forward a range of descriptions, all of which will refer back to other discussions about hegemony [2]. In doing so, it remains completely unclear as to whether these descriptions are not also constructions. The border between description and construction is not clearly defined.

On the other hand, the possibility of reproduction is a reference mode which still demands validity in its classical form – that which is not a picture becomes a picture. Media-based culture lives off pictures which are repeatedly reproduced. Pictures

GILLES BARBIER

FORGING THE WORLD[1]

THOMAS WULFFEN

refer to pictures which refer to pictures. The search for the 'original' ends in an infinite regress or in the eventual construction of a pretentious 'original'.

The work of Gilles Barbier is an answer to a given situation which otherwise only evokes melancholic reactions. Gilles Barbier is a realist. His encyclopedic approach tries to represent the world and make sense of it. He includes all types of media: drawing, sculpture, installation and digital pictures. The artist, born in Marseille in 1965, works on two levels, a macro level and a micro level. A work such as *trou de balle dans la tête* 2001, proves a good example. It shows the exact anatomic sections affected by a shot penetrating the head. The sculpture may be considered an anatomical study, thus referring to a specific cultural-historic background. On the other hand it can also be seen in the context of films such as Tarantino's *Pulp Fiction* (1994). So, what does the work actually reflect?

This mini-sculpture should be viewed in the context of another sculpture which pretty much speaks for itself. In *Aaaaaah!* 2001, the beholder sees a human figure

which has been deserted by its inner organs. Instead of the human speaking, the intestines, the lung, the spleen and the liver all speak. Here we encounter another picture, that of the 'Alien', the extra-terrestrial life form in the 1979 movie by Ridley Scott. What was then 'alien' has here become part of a body which, once defragmented, completely falls apart. This can be interpreted as the conversion of the human body into a commodity, which has found its most recent expression in gene technology. But there is something else in these works which can be described as turning the body into fiction. The concept of 'fiction' has two different connotations, first that of de-realisation as simulation and second that of the narrative as a literary technique.

The clone is also a derivative of the 'body' in a digital universe because it minimises the difference between production and reproduction. A photographic work such as *Polyfocus 3* 2001 indirectly makes this clear. The duplication of the figures in a photographic picture is only possible through the use of digital technology. Simulation is the beginning of reproduction, just as simulations were pre-drawn for the three-dimensional clones. Within this cycle of works the artist presents himself in a variety of situations in order to develop his own 'Psycho-biography' along the lines of the 'Psycho-geography' of Deleuze/Guattari.

In Gilles Barbier's own words, "I also think that an artist, as a human being, a complex subject, is many other persons (each much less than any imagined whole) not necessarily bound to artistic preoccupations. The artist is at the same time always definitely not an artist."[3] It only becomes possible to turn things into fiction through distance from one's own body and one's own works. In this case that means that a narration must be produced, be it in the form of a reality correction or in the form of a situation. Objects and collections of objects are assigned new meaning on the scraps of paper in the reality corrector. Each object has a different meaning attached to it. "Reality is only a convention. Tell yourself that instead of what you see here, you could see something else. (Kindly go beyond your interpretative codes here)".[4] This is mainly the duty of the observer who translates the act of reading into an act of perception. The observer enters the literary space of Gilles Barbier's opus which does not depict a strict separation of the visual and the readable, for in Gilles Barbier's work the visual is readable and

the readable visual. If you find pieces of furniture talking to each other or a space ship holding a monologue then you might be looking at the work of Gilles Barbier. You may well think that you have been taken to the world of Lewis Carroll.

This is due, among other things, to a specific translation of theoretical entities from specific areas of knowledge into the context of Gilles Barbier's work. This 'translation' is put into a diagrammatical order of the *oeuvre* which leads the reproduction of the world astray on a range of different levels.

In certain works, these theoretical entities combine to become independent theories which lay no claim to being subject to verification or falsification. Yet they are still explanations, they are bound in a system which is transposable onto a reality which has been constructed within the system. This system contains modes of comparison to other systems and can therefore be interpreted. Possible connections remain open, not linear, as common systems of cognition suggest or wish to suggest. 'Forging the world' can thus be determined in two different ways: from its essence, ie. in the sense of a single, real world which is then forged, or as a construction of worlds among which a choice can be made, ie. "do anything with anything". The world has always been a forgery and Gilles Barbier adds a few more of them, another 'configuration *instabile*'. The world has always been a picture and the reproduction of the world is a picture of a picture. In other words, "With words you can start saying who you are. But all I can say is what I am not. I am not a work of art. Works of art know who they are and they say it: 'We are works of art!' How I envy them! 'One, two, three'."

1. The title of this article is the German title of the first famous novel by William Gaddis: *The recognitions*, New York 1955, which tells the story of Wyatt Gwyon, a forger of classical paintings.
2. See Ernesto Laclau and Chantal Mouffe, *Hegemony & Social Strategy. Towards a radical democratic politics*, London, 1985
3. In the interview with Thom Collins in *Gilles Barbier 'The pack of trans-schizophrenic clones/La meute des clones trans-schizophrenes'*, Musée de L'Abbaye Sainte-Croix d'Olonne, 2000
4. Reality Corrector no. 9, in *Reality Corrector* 2001

Translated by Anglo-German Communications, Sydney

46

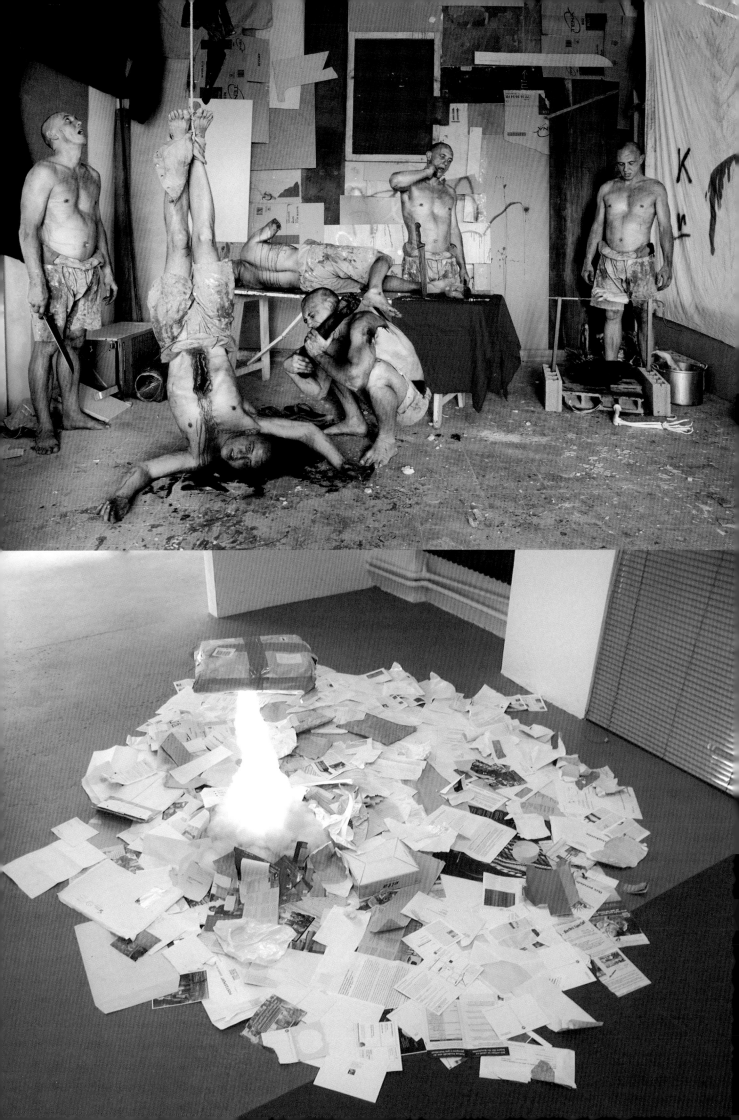

Gilles Barbier born
Vanuatu, 1965.
Lives and works in
Marseille, France.

SELECTED SOLO EXHIBITIONS

2001 *Gilles Barbier*, Galerie Georges-Philippe & Nathalie
Vallois, Paris, France
Gilles Barbier, Rena Bransten Gallery, San Francisco,
USA
Pique-nique au bord du chemain, Museum of Con-
temporary Art, Marseille, France

2000 *La meute des clones transschizophrenes*, Musee de
l'Abbaye de Sainte-Croix, Les Sables d'Olonne,
France
Gilles Barbier (with Alain Bublex), Galerie Juliane
Wellerdiek, Berlin, Germany

1999 *Copywork*, Santa Barbara Museum of Art, Santa
Barbara, USA
The pack of transschizophrenic clones, Henry Art
Gallery, University of Washington, Seattle, USA

1998 *Gilles Barbier (with Savarino Lucariello)*, FRAC,
Provence Alps Cote d'Azur, Marseille, France

1997 *Les Pages roses*, Offenes Kulturhaus, Linz, Austria
Comment mieux guider notre vie au quotidien,
Galerie Georges-Philippe. & Nathalie Vallois, Paris,
France

SELECTED GROUP EXHIBITIONS

2001 *Metamorphoses et clonage*, Museum of
Contemporary Art, Montreal, Canada
*New Presentation of the Collections (Gilles Barbier,
Jim Shaw, Ian Wallace)*, Museum of Modern and
Contemporary Art, Geneve, Switzerland

2000 *Jour de Fete*, Centre Georges Pompidou, Paris

1999 *dAPERTutto*, 48th Venice Biennale, Venice, Italy
Missing link – Menschen – bilder in der Fotographie,
Museum of Fine Arts, Bern, Switzerland

1998 *On the Edge: New Art from Private Collections in
France*, Tel Aviv Museum of Art, Israel

1997 *Transit*, Ecole Nationale des Beaux Arts de Paris,
France
L'autre, 4ieme Bienniale d'Art Contemporain de
Lyon, France

1995 *Histoire de l'imfamie*, Venice Bienniale, Venice, Italy

1994 *Ateliers 94*, ARC, Musee d'Art Moderne de la Ville
de Paris, France

SELECTED BIBLIOGRAPHY

Paolo Bianchi, 'As an artist, I'm my first
victim', *Artis Zeitschrift Fur Neue Kunst*,
August 1996, pp 42-46
Fabrice Bousteau, Remi Fenzi, Eric
Mangion, 'Gilles Barbier – Les voyages
neurologiques', *Beaux Arts Magazine*,
No.190, 2000, pp 92 - 99
Thom Collins, 'Conversational drift: an
interview with Gilles Barbier', *The Pack
Of Transschizophrenic Clones*, exhibition
catalogue, Les Sables d'Olonne, France,
2000, pp 12-45
Christoph Doswald, 'Selbstbefragungen',
Neue Bildende Kunst, Oct. 1996, p 53
Christoph Doswald, 'Das Diagramm als
Ausgangspunkt autopoetischer Simul-
ationen', *Kunstforum*, June-July 2001,
pp 183-187
Diana C. du Pont, *Copywork*, exhibition
catalogue, Santa Barbara Museum of
Art, USA., 1999
Catherine Francblin, 'The Return of the
Eternal', *Art Press*, Nov. 1997, p 82
Jean-Ernest Joos, *Metamorphoses et
Clonages*, exhibition catalogue, Museum
of Contemporary Art, Montreal, 2000
Jean-Yves Joannais, 'Gilles Barbier:
Delays, diversions and other adventures',
Art Press, Nov. 1995, pp 49-53
Catherine Perret, *Gilles Barbier*,
exhibition catalogue, Centre d'Art
Plastiques de Saint-Fons, 2000

CHECKLIST OF WORKS

MANIFESTATION DES SUPER HEROS
1999
approx. 100 plastic toy figures,
dimensions variable

INSTALLATION DOMESTIQUE 2000:
– MON SALON EST UNE BASE
MARTIENNE (MY LIVING ROOM IS A
MARTIAN BASE)
– MON SALON EST UN DRAGSTER (MY
LIVING ROOM IS A DRAGSTER)
colour photographs, edition x 3,
130 x 210 x 4 cm each

THIS IS WHAT THEY WANT 2001
colour photograph on aluminium,
edition x 3, with diasec 136 x 150 x 4 cm

I AM A DOG 2000
mixed media, 175 x 50 x 30 cm

Works courtesy the artist, Galerie
Georges-Philippe & Nathalie Vallois,
Paris and Galerie Juliane Wellerdiek,
Berlin

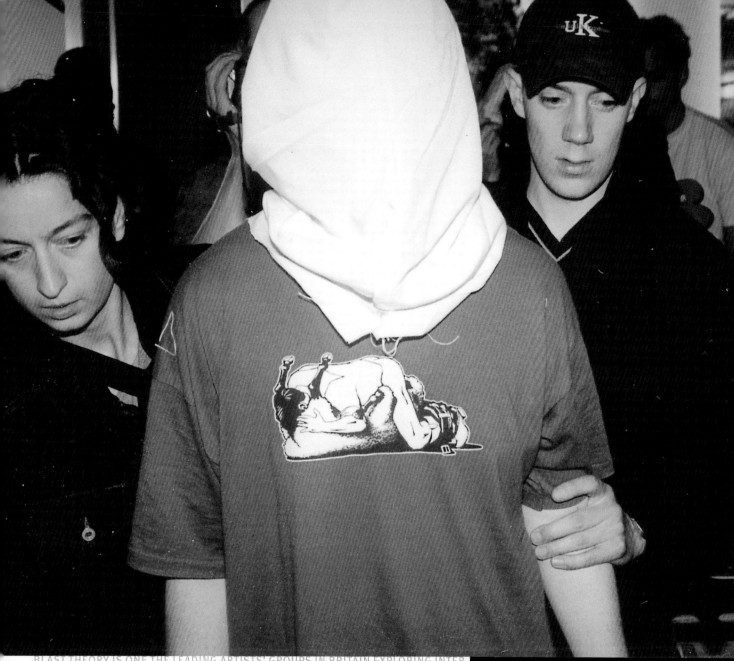

BLAST THEORY

BLAST THEORY IS ONE THE LEADING ARTISTS' GROUPS IN BRITAIN EXPLORING INTER-
ACTIVITY AND THE RELATIONSHIP BETWEEN REAL AND VIRTUAL SPACE. THE GROUP'S
WORK CONFRONTS A MEDIA SATURATED WORLD IN WHICH POPULAR CULTURE
RULES. IT USES VIDEO AND COMPUTERS TO ASK QUESTIONS ABOUT THE IDEOLOGIES
PRESENT IN THE INFORMATION THAT ENVELOPS US. THE WORK IS A FAST CUTTING COLLAGE OF IMAGES AND
ACTIONS, OFTEN APPROPRIATED FROM ELSEWHERE. BASED IN LONDON SINCE 1991, THE GROUP HAS A CREATIVE
TEAM OF FOUR. IT HAS SHOWN WORK IN GALLERIES, THEATRES, CINEMAS, UNIVERSITIES AND FOUND SPACES
THROUGHOUT EUROPE AND BEYOND. EARLY WORKS SUCH AS GUNMEN KILL THREE 1991, CHEMICAL WEDDING
1992, AND *STAMPEDE* 1994, DREW ON CLUB CULTURE TO CREATE MULTIMEDIA PERFORMANCES THAT INVITED PARTIC-
IPATION. Following a residency at Kunstlerhaus Bethanien in Berlin in 1997, the group's work has further diversified into
online, installation and new media works such as *Kidnap* 1998, *Desert Rain* 1999, and *Can You See Me Now?* 2001. These
last two works are part of a long-term collaboration with the Mixed Reality Lab at the University of Nottingham. The group
pioneered the use of new technologies within performance contexts, starting with digital video projection, leading on to
interactive pressure pad systems triggered by audience members, video and audio streaming, collaborative virtual envi-
ronments and mobile devices. The group has worked with partners such as Channel 4, BBC FictionLab, BBC Online, ZKM
(Centre for Arts and Media) in Karlsruhe, the South Bank Centre, Banff New Media Institute, Australian Network for Art and
Technology and the Institute of Contemporary Art in London. Group members have taught extensively at graduate and post
graduate level to students of design, theatre, dance, performance, architecture and new media. The group has worked as
consultants on performance and new technologies for clients such as London's National Theatre and Royal Opera House,
and Adera+ in Stockholm.

BLAST THEORY'S

TRUCOLD

DOMINIC EICHER

At present there are over 6 billion people on the planet but only a few of them – digitally registered as remote, fleeting, scurrying pixel smudges – make an appearance in Blast Theory's new video *TRUCOLD* 2002.

TRUCOLD is a series of fixed camera shots of eerie, strangely depopulated, difficult to place, urban views; all of them at night, sometimes in glowing fog and set to electronic music. While it is suggestive of time lapse techniques, the footage in fact unfolds in real time. Each location is illuminated by electric light – security spots, street lamps, and banks of unforgiving fluorescent tubes in empty offices. These light sources generate flared hot-spots and, despite their attractive palette, create strong contrasts and a charged atmosphere. This lighting is not designed to be pleasing to the eye but rather for the protection of property: the

night seems filled with undefined threats. Lighting is also a way of emphasising value, whether the illuminated object is a tourist attraction, a high security zone or a coveted watch in a display case. In *TRUCOLD* however, rows and bunches of pretty lights are shown in the service of security, safety and maintenance. In the West, a century or more of electrified modernity has made this type of spectacle ubiquitous – and it seems, as the associated dreams of Modernity have faded, the demand for brightness has multiplied. These are the kind of scenes then, which make you long for a starry sky.

Back on the ground wherever dull-lit asphalt appears, inevitably so do battery powered brake-lights and low-beams from the occasional passing car. These little 'personal-space extensions' of their owners provide brief moments of animation and partly alleviate a feeling of suspension. But as if oblivious to this, the vehicle's occupants sit in darkness – a darkness which, despite its slow shutter speed, the video camera cannot penetrate – with their motor skills in semi-automatic and their thoughts probably elsewhere. Although shot from

angles and in places that differ from the view from a car, the idea of *TRUCOLD* has something in common with the experience of 'driving through'... that place you find yourself in between where you've come from and where you think you're trying to go. It is impossible to recall every corner, road, office tower, tunnel, or concrete curve you've ever seen – and you'd be driven a bit crazy if you could. These details or memories belong to a category of similarly featureless things. Particular places or buildings, even those on well-trodden paths – like the way to work – seem only to become significant when something, good or bad, actually happens there. In *TRUCOLD,* city locations such as these are not so much sites of urban alienation as places where something *ought* to happen. In time-based media like video or film, this sense of anticipation is even more urgent – it is an element that experimental filmmakers and artists have been largely responsible for exploring and manipulating. [1] Viewers of *TRUCOLD* are like passengers on a fragmented journey: you find yourself trying to identify things, orient the space in the

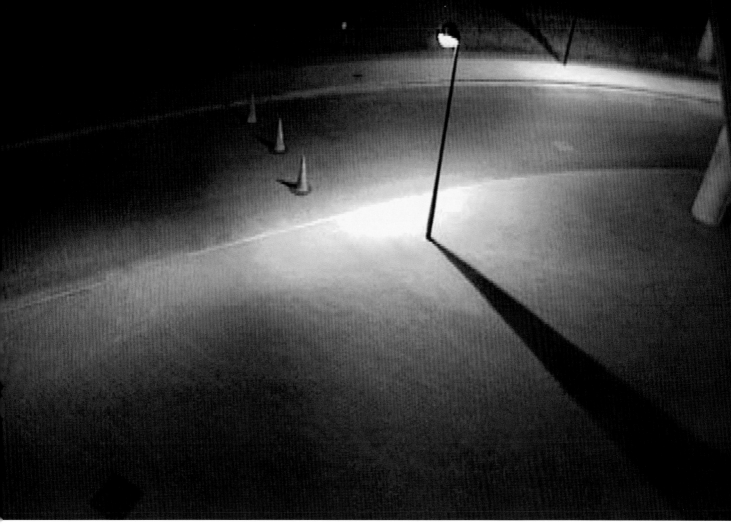

image, attaching real, imagined or ficti-tious events to it. In the absence of a screen protagonist, you become one.

For Blast Theory, *TRUCOLD* – the title for which is a made-up word taken from the side of a commercial van – is about "the power of the viewer or participant to fictionalise their surroundings and to experience things which are not really there". Interaction and the consequences of merging 'reality' and 'media reality' remain a central concern. For example, in their computer/street game combination *Can You See Me Now?* 2001, online 'play-ers' get hunted down by a Blast Theory street team. After a panel discussion on this topic at the 2001 Berlin Biennale, art critic Joerg Heiser noted: "

When art invents reality, it imitates the formats of media-constructed reality; when art attempts to recover reality, it sets a stage for the every-day by putting a frame around it... Reality can-not be taken for granted any more, since media realities are overlapping with physical reality, like semitransparent screens in different colours and textures that are perpetually blending into one another in new kaleidoscopic ways."[2]

Blast Theory once used some of the *TRUCOLD* footage in this way in an earlier work *10 Backwards* 1999, a theatre piece about physical displacement, déjà vu, amnesia and time travel. Accordingly, the views in *TRUCOLD* can also be seen as backdrops or stage settings – a space or place for viewer's private projections.

Blast Theory's members call themselves artists in order to claim "the greatest possible freedom" for their projects but haven't confined their activities to tradi-tional visual art media, contexts or venues. Past projects have included a sophisticated mixture of interactive environments and media, dance and theatre. *Kidnap* 1998, for example, was an elaborate and confronting work that involved the abduction of two volunteers (from a few hundred applicants) for 48 hours. As part of the lead-up, Blast theory ran a slick advertising campaign in British cinemas and created a detain-and-interview installation in Künst-lerhaus Bethanien, Berlin. The detainees, sometimes hooded and subjected to pranks, were under constant webcam surveillance. Visitors to the ICA, London and web users were able to zoom in and out, and change the cam-

era angles. A couple of years later, Blast Theory staged the equally logistically ambitious *Desert Rain* 2001, in collaboration with the Mixed Reality Lab at the University of Nottingham. This is an elaborate inter-active installation, performance and game, combining a trip into a hunt-and-kill virtual world that demonstrates just how easy it is to become a willing accomplice. While *TRUCOLD* is modest in comparison to these pieces, it connects with many of Blast Theory's main interests such as the role and nature of new technology and its affects on urban environments and its users. It is a part of an ongoing exploration of the potential for violence and subjective res-ponses to surveillance, power and control.

1. For example, Andy Warhol's *Empire* 1964 comes to mind. Interestingly however, Blast Theory were more influenced by Swiss film-maker Cleo Uebelmann's bondage image film *Mano Destra.*
2. Joerg Heiser, 'Real Fictions', *Formate der Lüge - Berlin Biennale 2001*, p 66

Blast Theory

artists' group

based in London

since 1991.

CURRENT + FUTURE PROJECTS

	Uncle Roy All Around You
2003	ICA, London
	Can You See Me Now?
2002	International Festival for Art & Technology, Rome
	Mousonturm, Frankfurt, Germany; i-camp, Münich, Germany
2001	b.tv festival 2001, Sheffield, UK
	An Explicit Volume
2002	Warwick Arts Centre, Warwick, UK; Tramway, Glasgow, Scotland
2001	OctoberFest, in association with Battersea Arts Centre, London, UK
	Viewfinder
2001	Liste 2001, Basel, Switzerland
	Desert Rain
2002	Typografie, Prague; Cornerhouse, Middlesborough, UK
2001	Las Palmas, Rotterdam, Netherlands
2000	ZKM, Karlsruhe, Germany; Riverside Studios, London, UK
	Industrial Museum, Bristol, UK; Tramway, Glasgow, Scotland
	KTH, Stockholm, Sweden;
	Digital Summer, Manchester, UK
1999	Premiered at Now 99, Nottingham, UK

SELECTED PREVIOUS WORK

1999	*Route 12:36*. Commissioned by South London Gallery. An interactive artwork on two London bus routes.
1998	Commission for the Architecture Foundation, London. Interactive sound piece made for local residents to explore ideas about urban regeneration.
1998	*Kidnap*. Performance event including web broadcast. Two members of the public were picked at random from a pool of entrants, kidnapped for 48 hours and held in a secret location.
1998	*Atomic*. Commissioned by CASCO, Utrecht. Two way, live questionnaires held in the anonymity of video linked booths.
1997	*Safehouse*. Installation, Kunstlerhaus Bethanien. Visitors interviewed about to what extent Kidnap infiltrates our lives - culturally, politically, fictionally.
1997	*Kidnap* Blipvert. 45-second film for cinemas. Shown in independent cinemas in England, France, Germany and Canada as an advertisement project prior to main cinema features.

RECENT PRESENTATIONS

2002	'Intimate Technologies, Dangerous Zones', Banff New Media Institute; 'Theatres of Life', Performance Studies Conference, New York; 'Edrom-Electronic Stage', Tempodrom, Berlin
2001	'Hot Docs Documentary Film Festival', Toronto; 'Virtuosity', Institute of Contemporary Art, London; Banff Television Conference; Cairo International Festival of Theatre; Mediamatic, Amsterdam
2000	'Interactive Screen', Banff New Media Institute, Canada; Alchemy Masterclass, Powerhouse, Brisbane; Performance Space, Sydney; 'Future Moves Three', DEAF (Dutch Electronic Arts Festival), Rotterdam; Station Arts Electroniques, Rennes, France Residencies
2002	Banff New Media Institute, supported by an Arts Council of England International Fellowship Award
1997	Kunstlerhaus Bethanien, Berlin
1995	Institute of Contemporary Art, London
1994	Arnolfini, Bristol

RESIDENCIES

2002	Banff New Media Institute, supported by an Arts Council of England International Fellowship Award
1997	Kunstlerhaus Bethanien, Berlin
1995	Institute of Contemporary Art, London
1994	Arnolfini, Bristol

AWARDS

2001	International Media Art Award, ZKM, Karlsruhe, shortlisted for *Kidnap*
	Transmediale Awards, Berlin, Honorary Mention for *Desert Rain*
	Breakthrough Award for Innovation, Arts Council of England, shortlisted
2000	Interactive Arts BAFTA Award, shortlisted for *Desert Rain*

CHECKLIST OF WORKS

TRUCOLD 2002
DVD duration 14 minutes
courtesy Blast Theory, London

GLENN BROWN

Originality is a problem, it always has been. For Glenn Brown originality, or its impossibility, is a fertile territory in which to work. None of Brown's images are original; they all visually demonstrate their primary source and its mutation, though his paintings, sculptures and photographs seem to speak of themselves as works in their own right. They are extraordinary things, the oil paintings with their immaculately crafted finish, the sculptures thick with the impasto of oil paint and the photographs either a blur of a presumed video still or frozen in the icy majesty of black and white. What reveals them as works with origins elsewhere is their diversity. The personal

GLENN BROWN

STEPHEN HEPWORTH

vocabulary of image and style which we recognise as that of an individual artist is displaced by the incongruous mix that Brown chooses to create.

Portraiture is prominent in the body of work that Brown has made over the last decade. Many of these are derived from the works of the British artist Frank Auerbach, whose portraits of a small number of sitters are known for their long gestation yet apparent spontaneous quality as indicated by their thick gestural appearance. Brown's relationship to his source material is complex. He chooses to work from reproductions found in catalogues, books or postcards, often collecting many images of the same painting. They are often paintings that he likes, and has developed a relationship with, and he begins to develop an aspect or a character from within them, from the armature that the drawing provides, or perhaps the skeleton on which to hang fresh pigment or grow new flesh. As Brown works he strips away the appearance and dominant identity of the work, allowing what he talks of as the ghosts that inhabit a painting to be seen, the aspects of character that have perhaps become lost

under the gloup of the paint. Focusing on these he edits: removing elements, cropping and altering scale, stretching the dimensions of the original, sampling from the palette of specific works by other artists. Brown recognises the fragility of these new identities, painted through the construction of a shifting focus. These embryonic individuals are like wisps of paper caught in the wind, often appearing like masks evaporating at their edges. The reasserted paint brushstrokes blur into a non space. Across the surface, marks which appear absolute dissolve with trompe l'oil trickery. As paintings they no longer show the trace of marks from which they are constructed. Instead there is a glossy surface more akin to that of a photograph.

Brown's sculptures similarly sit within their own spaces. Vitrined from the outside world they are placed atop wooden display bases topped by perspex boxes, asserting a geometry of framing that is reminiscent of Francis Bacon's pictorial space frames. Mutant in form, they could be could be the free-standing actualisation of Auerbach's vision. Crude multiple faces appear and disappear, gashes suggest mouths, protrusions are noses, and hollows – eyes. The palette is derived from a sickly eighteenth-century Fragonard scene or a vivid twentieth-century Kirchner portrait; they are pathetic in their self-importance. Like an obese Giacometti they sit suffocating, the heroic stifled by the weight of paint.

The bringing together of oppositional or inappropriate elements and the evocation of art historical figures are constants in the work of Brown, part of his mapping out of territory, or a specific space. Often achieved through the use of humour, his work undermines the portentous and cherishes the lowly. Brown's ongoing series of science fiction paintings elevates commercially produced illustrations for book jackets to the equivalent of grandiose Victorian visionary painting through massive enlargement. This series re-enlivens the youthful excitement that such images first elicited, while also suggesting exhaustion. Stilled with a con-

trolled palette or saturated to the point of decay, the titles signify barrenness of faith and a desire to decorate the void that remains. Titling is an important part of Brown's work, some are culled from pop songs or films, others refer to paintings or the personal history of an artist. They fuse together figures from different worlds. This is not a gratuitous act of cut and paste, but a further way of giving voice to the newly developed identity of the work, to give voice to an emotional need.

In his exhibitions Brown juxtaposes works creating imagined stories rather than exploring more formal concerns. The space between a Fragonard and an Auerbach may be a couple of centuries but their interaction is flirtatious, like a momentary encounter in a bar. He chooses how he will inhabit the given space, making it his own, sometimes by painting the walls a colour, changing the lighting, boarding windows and closing out the world of others. Within these altered spaces the characters and vistas he has developed in his imagination and within the refuge of his studio can converse and so gain a further reality.

In his most recent works Brown has started to introduce human features to inanimate objects and body parts, bowls of flowers develop eyes and blowsy roses hint at cleavages, while a re-inverted Georg Baselitz foot develops a plume of phalluses. The sexualisation evident in these works is in contrast to the paintings derived from Auerbach's oeuvre which are often goulish in appearance, haunted by introspection, embraced by innocence or betrayed by arrogance; while a series of Rembrandt self-portraits as a child appear tragic and afflicted. The humour in these later works appears more determinedly adolescent, in the spirit of the surrealist Salvador Dali who Brown much admires. Naughtiness is a theme that runs throughout Brown's work, a desire to misbehave with the facts of history, play games with value and taste, and question what is truly acceptable.

Glenn Brown born
Northumberland,
England, 1966.
Lives and works in
London, UK.

SELECTED SOLO EXHIBITIONS

2001 Patrick Painter Inc., Los Angeles, USA
2000 Domaine de Kerguennec, Bignan, France
 Galerie Max Hetzler, Berlin, Germany
1999 Patrick Painter Inc., Los Angeles, USA
 Jerwood Gallery, London, UK
1998 Patrick Painter Inc., Los Angeles, USA
1997 Galerie Ghislane Hussenot, Paris, France
1996 Queens Hall Art Centre, Hexam, UK
1995 Karsten Schubert Gallery, London, UK

SELECTED GROUP EXHIBITIONS

2001 *Azerty*, Centre Pompidou, Paris, France
2000 *Hypermental*, Kunsthaus Zurich, Switzerland
 Turner Prize, Tate Britain, London, UK
 The British Art Show, and touring, UK
1999 *Examining Pictures*, Whitechapel Art Gallery,
 London, UK
1998 *Secret Victorians*, Arnolfini Gallery, Bristol, UK
 Abstract Painting: Once Removed, Contemporary
 Arts Museum, Houston, Texas, USA
1997 *Sensation*, Royal Academy, London
 Treasure Island, Fundacao Calouste Gulbenkian,
 Minneapolis, USA
1996 *Brilliant*, Walker Art Center, Minneapolis, USA

SELECTED BIBLIOGRAPHY

Matthew Collings, 'Higher Being
Command', *Modern Painters*, Summer
1999, pp 58-64
Jennifer Higgie, 'Review', *Frieze*, no.
47, 1999, pp 98-99
Mary Horlock, 'Glenn Brown', *Turner
Prize*, exhibition catalogue, Tate Britain,
London, 2000
Ian Hunt, *Glenn Brown*, Jerwood
Gallery, London, 1999
Sarah Kent, 'Artificial Intelligence', *Time
Out*, 25 Oct. 2000, pp 20-21

Philip King, *Glenn Brown*, Queens Hall/
Karsten Schubert, London, 1996
Terry R. Myers, *Glenn Brown's
New(Re)Order*, Domaine de
Kerguennec, Bignan, France, 2000
Keith Patrick, 'Formal Dress',
Contemporary Visual Arts, Winter
1999, pp 46 - 51
Joelle Rondi, 'Review: Domaine de
Kerguennec', *Artpress*, Oct. 2000
Mark Sladen, 'The Day the World
turned Auerbach', *Art/Text*, Feb. 1999

CHECKLIST OF WORKS

THE MARQUESS OF BREADALBANE
2000
oil on wood panel oval 96 x 78 cm
collection: Rachel and Jean-Pierre
Lehmann, New York

HEART & SOUL 1999
oil on wood, 102.50 x 84cm
private collection London

BÖCKLIN'S TOMB (AFTER CHRIS FOSS)
1998
oil on canvas, 221 x 330 cm
private collection: Hans-Joachin Sander,
Darmstadt

Works courtesy the artist, Patrick
Painter Inc., Santa Monica, and Max
Hetzler, Berlin

1/4 TON BRIDGE, 1997. 1/4 TON BRIDGE IS AN ENGINEERED ARCHED BRIDGE CONSTRUCTED OF MECCANO AND ERECTOR PARTS. IT IS CAPABLE OF SUPPORTING 500 POUNDS. THE THIN DIAGONAL STRUTS ATTACHING THE DECK TO THE ARCH ACTUALLY TRANFER THE CONSIDERABLE LOAD TO THE ARCH AND PREVENTS THE SPAN FROM COLLAPSING, SHOWN HERE LOADED WITH TEN 50 POUND BAGS OF FERTILIZER.

CHRIS BURDEN

No. 303—Indo-China Bridge.

We are indebted to "Popular Mechanics" for the following description:

"One of the most interesting railway structures of the world is the bridge over the Faux Nam-Ti Gorge in Indo-China, where, owing to the peculiar difficulties in the way of building a bridge of any type, it was necessary to adopt a special design suited to the only method of erection that seemed to be possible. · The sides of the gorge are practically vertical and give no chance of approach to the bridge from either side except through tunnels. The track grade is 335 ft. above the river, so that no system of falsework could be used in building the bridge, while cantilevers were out of the question owing to lack of "elbow room." The design finally adopted consisted of two steel trusses, each hinged at the cliff side, which were erected in a vertical position and then lowered so that the ends met, forming a structure of inverted V-shape. The ends of the two trusses were firmly connected, steel towers were erected on the humps of the trusses and on this support the steel deck truss carrying the track was placed. At the beginning of the work it was necessary to let the workmen down by ropes from the tunnel mouth to prepare the foundations of the supporting trusses. The track trusses were built in the tunnels and were then moved into position on rollers. From end to end this bridge measures 220 ft. 4 in., while the distance between the heels of the supporting trusses is 180⅛ feet."

Here is another proof that the Mysto Erector is highly educational and teaches boys the very fundamentals of bridge building, and bring to their attention the pleasurable side of construction. The ability of the Mysto Erector to duplicate such remarkable structures as this shows its remarkable adaptability. No other construction toy can approach it in the number of models which exactly imitate structural steel.

Chris Burden born
Boston, Massachusetts,
USA, 1946. Lives and
works in Topanga,
California. USA.

SELECTED SOLO EXHIBITIONS

2001 *Chris Burden*, The Arts Club of Chicago, Chicago,
 USA
2000 *Chris Burden*, Gagosian Gallery, London, UK
 Chris Burden: Structures, Crown Point Press, San
 Francisco, USA
1999 *When Robots Rule: The Two Minute Airplane
 Factory*, Tate Gallery, London, UK
 Chris Burden, Magasin 3 Stockholm Kontshall,
 Stockholm, Sweden
1996 *Three Ghost Ships*, Gagosian Gallery, Beverly Hills,
 California, USA
 Chris Burden: Beyond the Limits, Museum of
 Applied Arts (the MAK), Vienna, Austria
1994 *Chris Burden: L.A.P.D. Uniforms, America's Darker
 Moments, Small Guns,* Gagosian Gallery, New York,
 USA
1991 *Medusa's Head*, Brooklyn Museum, Brooklyn, New
 York, USA
1988 *Chris Burden: A Twenty Year Survey*, Newport
 Harbor Museum, Newport Beach, California, USA

SELECTED GROUP EXHIBITIONS

2001 *7th International Istanbul Biennial*, Istanbul, Turkey
2000 *Open Ends*, Museum of Modern Art, New York, USA
1999 *48th Venice Biennale*, Venice, Italy
1997 *Biennale de Lyon*, Lyon, France
 Sunshine & Noir. Art in LA 1960-1997, Louisana
 Museum of Modern Art, Humleback, Denmark
 Whitney Biennial, Whitney Museum of American
 Art, New York, USA. Also included in 1993, 1989
 and 1977
1994 *Hors Limites*, Centre Georges Pompidou, Paris,
 France
1992 *Helter Skelter*, Museum of Contemporary Art, Los
 Angeles, USA
1991 *Dislocations*, Museum of Modern Art, New York,
 USA
1990 *TSWA: Four Cities Project*, Newcastle, UK

SELECTED BIBLIOGRAPHY

Rosanna Albertini, *Chris Burden/ Bill
Viola*, Museo d'Art Moderna, Bolzano,
Italy, 1995
Christopher Knight, 'Chris Burden', *Last
Chance for Eden*, Art Issues Press, Los
Angeles, California, 1995, pp 31-34
Frances Morris, 'Chris burden', *Chris
Burden/When Robots Rule: The Two
Minute Airplane Factory*, Tate Gallery
Publishing, London, UK, 1999, pp 10-28
Peter Noever, 'Assault on Art', *Chris
Burden: Beyond the Limits*, Museum of
Applied Arts, Vienna, Austria, 1996,
pp 8-11
Frank Perrin, *Chris Burden*, Blocnotes,
Paris, France, 1995
Mark Sanders, 'Chris Burden', *Dazed
and Confused*, London, April 1999, pp
110-117
Paul Schimmel, 'Just the Facts', *Chris
Burden: A Twenty Year Survey*, Newport
Harbor Art Museum, California, USA,
1988, pp 15-18
Paul Schimmel, 'Chris Burden/Another
World', *Art Press*, Paris, France, Dec.
1994, pp 24-32
Mans Wrange, 'A Conversation with
Chris Burden', *Chris Burden*, Magasin 3
Stockholm Kontshall, Stockholm,
Sweden, 1999
Charles Wylie, 'AnonymousPower: Chris
Burden's Submarines, Bridges, Ads',
Chris Burden, The Arts Club of
Chicago, Chicago, USA, 2001, pp 7-18

CHECKLIST OF WORKS

1/4 TON BRIDGE 1997
metal toy construction parts (Meccano
and Erector)
83.8 (l) x 17.1 (w) x 33 (h) cm

STATIC TEST 2000
framed colour photograph signed and
dated
59.6 x 49.5 cm

ANTIQUE BRIDGE 1998
metal toy construction parts (Erector-
type 1)
231 (l) x 21.6 (w) x 60.3 (h) cm

INDO-CHINA BRIDGE 2002
metal toy construction parts (replicas of
Erector-type 1, in stainless steel)
113.6 (l) x 21.6 (w) x 38 (h) cm

Works courtesy the artist

JANET CARDIFF + GEORGE BURES MILLER

FADE UP CAR DRIVING SCENE, CUT TO BED- ROOM WITH TELE- PHONE RINGING, MAN LYING ON BED. HE ANSWERS THE TELEPHONE. SCARY MUSIC. WOMAN BESIDE IN THEATRE : IS THERE ANY POPCORN LEFT. MAN: HELLO, YEA, HI FRANK. (LISTENS) YEA I KNOW WHERE THAT IS. YEA, UHUH. WHY WOULD THEY GO WAY OUT THERE I WONDER? OK YOU CAN FORGET ABOUT IT NOW. IT'S TAKEN CARE OF. BUT FRANK,... REMEMBER... THIS TIME YOU BUY DINNER. (LAUGHS). Woman beside in theatre: This isn't the film I thought. Wasn't it supposed to be direct- ed by Orson Welles? Man puts phone back, looks out window. Cut to phono player. Music starts. Cut from phono player to woman dancing as if she's drugged.

JANET CARDIFF

GEORGE BURES MILLER
THE MURIEL LAKE INCIDENT

CHRISTOPH BLASE

We live in a multimedia world that is largely influenced by images. Artists use these images, whether they be from the printed media, film or TV, to be recycled on all kinds of levels. An uncertain memory, the feeling of knowing these images but of never having seen them quite in this way, plays an important role. Images, both still and moving, are explained by the knowledge of other images. But who is in charge of the sound, of the noises? When it comes to sound installations, I have for years had the impression that they have gotten stuck on an abstract, even boring level. The quality of sound in the fine arts, even in large and ambitious video installations, still feels very black-and-white.

With increasing precision Janet Cardiff has for years been working on injecting more colour into this dilemma. In cooperation with George Bures Miller she created fascinating pieces such as *The Muriel Lake Incident* 1999 or *The Paradise Institute* (Venice Biennial, 2001), where the viewer/ listener is introduced to a completely new sound-image-world. You are watching a film, wearing earphones and not just hearing the soundtrack to the film but acoustically drawn into a story happening all about you. The recording technique using several miniature microphones recreates a perfect, three-

dimensional sound. In *The Muriel Lake Incident* one becomes a witness to the shooting of the film operator at the back of the room, then sees the film tear and melt on the screen. For *The Paradise Institute*, an actual small cinema with two rows of seats has been created where it takes several irritating minutes to make sure that the rustling and whispering do actually come out of the earphones rather than from any fellow viewers.

The Muriel Lake Incident, but especially *The Paradise Institute*, are extremely com-plicated installations. In contrast, *Hillclimbing* and *Houseburning* are short video loops that can be presented using a regular video player and headphones. In both tapes the viewer is acoustically transplanted into the actor's position. In *Houseburning*, you are in the country, watching a house burning down, and the arrival of the fire brigade, who seem rather helpless. In *Hillclimbing*, you chase after a small black dog running up a snow-covered hill. Over and over, you fall down into the snow and each time there's someone laughing about it, but you never catch up with the dog. In both videos, you have been a part of the events: you have seen the house burning, you have been running about the snow with that dog. It even seems that you have felt the heat, and the cold. What is left in your mind are not just images, but short moments of (seemingly) actual experience.

Reprinted with permission from Biennale de l'image en Mouvement, exhibition catalogue, MAMCO/ Centre pour l'image contemporaine, Saint-Gervais, Geneve, Switzerland

Translated by Margret Powell-Joss

MURIEL LAKE INCIDENT 1999
WOOD, AUDIO, VIDEO PROJECTION.

Janet Cardiff born Wingham, Ontario, Canada,
1959. Lives and works in Berlin, Germany.
George Bures Miller born Vergerville, Alberta, Canada,
1960. Lives and works in Lethbridge, Canada.

SELECTED SOLO EXHIBITIONS

CARDIFF & BURES MILLER

2002 *Janet Cardiff and George Bures Miller*, Hamburger Banhoff, Berlin, Germany
The Paradise Institute, Luhring Augustine Gallery, New York, USA

2001 *The Paradise Institute*, The Canadian Pavillion, Venice Biennial, Italy
The Muriel Lake Incident, Southern Alberta Art Gallery, Lethbridge, Canada

2000 Kunstraum Munich, Munich, Germany

1999 *La Tour*, Side Street Project, Los Angeles, USA

1997 *The Empty Room*, Raum Aktueller Kunst, Vienna, Austria
The Dark Pool, Morris Healy Gallery, New York, USA

1995 *The Dark Pool*, Front Gallery, Vancouver, Canada

JANET CARDIFF

2002 *Janet Cardiff; A Survey including Collaborations with George Bures Miller*, PS 1, New York, USA

1999 *Missing Voice* (Cased Study B), Artangel, London, UK

1997 Gallery Barbara Weiss, Berlin, Germany

GEORGE BURES MILLER

1999 Owens Art Gallery, Sackville, Canada

1998 Mercer Union, Toronto, Canada

1996 Centre D'Art Contemporain De Basse Normandie, Hérouville Saint-Clair, France
Mercer Union (Window Series), Toronto, Canada

SELECTED GROUP EXHIBITIONS

CARDIFF & BURES MILLER

2000 *Sculpture*, Luhring Augustine Gallery, New York, USA.
Between Cinema and a Hard Place, Tate Modern, London, UK

1999 *6th International Istanbul Biennial*, Istanbul, Turkey
Divine Comedy, Fort Asperen, Netherlands
Voices, Le Fresnoy, Lille, France
Body and Sound, Musée Régional de Rimouski, Quebec, Canada

1998 *Voices*, Witte deWith, Rotterdam, Netherlands; The Miro Foundation, Barcelona, Spain

JANET CARDIFF

2001 *100 Wishes*, Ludwig Museum, Cologne, Germany
101010:Art in technological Times, San Francisco Museum of Modern Art, San Francisco, USA
Elusive Paradise, The National Gallery of Canada, Ottawa, Canada

2000 *Wonderland*, St. Louis Art Museum, Missouri, USA

1999 *The Carnegie International 99/00*, The Carnegie Museum of Art, Pittsburg, USA
The Museum as Muse: Artist's Reflect, The Museum of Modern Art, New York, USA

1997 *Skulptur. Projekte in Münster '97*, Westfälisches

Landesmuseum für Kunst und Kulturgeschichte, Münster, Germany
Present Tense: Nine Artists in the Nineties, San Francisco Museum of Modern Art, San Francisco, USA

1996 *Thinking Walking and Thinking*, a part of NowHere, Louisiana Museum, Humlabaek, Denmark

GEORGE BURES MILLER

1997 *Membra Disjecta*, (two-person show with Gary Hill) Argos Gallery, Brussels, Belgium
LA International Biennial, Richard Heller Gallery, Santa Monica, USA

1996 *Young Contemporaries '96*, The London Regional Art Gallery, London, Ontario, Canada

1995 *Aujourd'hui la vidéo*, in Rencontres Internationales de la Photographie, Arles, France
Press/Enter, The Power Plant Art Gallery, Toronto, Canada

SELECTED BIBLIOGRAPHY

Sara Borins, 'Four Nights in the Funhouse', Saturday Night, 14 July 2001
Ian Carr-Harris, 'The Art of Travel', Canadian Art, Vol. 18, No. 3, Fall 2001
Carolyn Christov-Bakargiev, Janet Cardiff: A survey of works including collaborations with George Bures Miller, exhibition catalogue, PS 1, New York, 2001
Carolyn Christov-Bakargiev, Janet Cardiff, tema celeste, No. 87, 2001, pp 52-54
Robert Enright, 'Pleasure principals: the art of Janet Cardiff and George Bures

Miller', Border Crossings, Issue 79, 2001 pp 24-35
Tim Griffin, 'Aural Tradition', Vogue, Oct. 2001
Michael Kimmelman, 'Janet Cardiff', The New York Times, 30 Nov. 2001, p E36
Richard Lacayo, 'Feast for the Eyes and Ears', Time, 15 Oct. 2001, p 90
Murray Whyte, 'Put on the Headphones but Don't Trust Your Ears', The New York Times, 14 Oct. 2001, P 37
Rachel Withers, 'Janet Cardiff', Artforum, Vol. 38, No. 4, Dec. 1999, p 1570

CHECKLIST OF WORKS

MURIEL LAKE INCIDENT 1999
wood, audio, video projection and steel
184.1 x 229.2 x 157.5 cm
collection: Fondazione Sandretto re Rebaudengo, Italy
courtesy David Zwirner Gallery, New York

WHEN I READ *THE ARABIAN NIGHTS*, I FIND MYSELF IN SEVERAL PLACES AT
ONCE: IN THE DESERT WITH ALADDIN (THE SEllING OF THE STORY), IN THE
ROOM WHERE SHEHERAZADE IS TELLING ALADDIN'S STORY TO THE KING
(THE PLACE WHERE THE STORY IS TOLD FOR THE FIRST TIME), AND IN THE

PATRICK CORILLON

ROOM WHERE I AM READING (WHERE THE STORY IS BEING TOLD TO ME PERSONALLY). Sheherazade's tales are not gratuitous. She tells them both to put off the hour of her death and to seduce the king. Sometimes I read passages that are so engrossing that before I have even finished them, I feel I have to put my book down and walk a little. As if I needed these few steps to give my body too, a chance to stroll through all the different spaces created by my reading. This is the physical type of reading that I would like to develop with *Les Trotteuses*. In their company, I want visitors to become carriers of stories; for them to feel charged with that same presence that accompanies us when we walk alone in the street, still filled with the story we have just read.

THIS PAGE & PREVIOUS PAGES: LES TROTTEUSES
(x 20) 2000 ALUMINIUM AND BATTERY.
FRONT PAGE IMAGE: LES TROTTEUSES (x 20)
2000 (DETAIL)

Patrick Corillon born Knokke, Belgium, 1959. Lives and works in Liège, Belgium and Paris, France.

SELECTED SOLO EXHIBITIONS

2001 *Sur les traces d'Oscar Serti*, Centre George
 Pompidou, Paris, France
 La ferme du Buisson, Noisiel, France
2000 Centre d'Art de la Chapelle de Bindael, Belgium
1999 Villa Arson, Nice, France
 Le sommeil paradoxale, Purple institute, Paris, France
1998 Centre Marcel Duchamp, Yvetot, France
1997 Galerie des Archives, Paris, France
1996 Oakville Gallery, Toronto, Canada
1994 *Victor Brauner*, Centre George Pompidou, Paris,
 France
1993 Kunstraum, Münich, Germany

SELECTED GROUP EXHIBITIONS

2001 *Affinités Narratives*, in Situ, Paris, France
2000 *Bricolages*, Musée des Beaux-Arts, Dijon, France
 Transfer, Ville de Bienne, Switzerland
1999 *Serendipity Watou*, Musée d'Art Contemporain,
 Gand, France
 Faiseurs d'histoires, Casino, Luxembourg, Belgium
 Abracadabra, Tate, London,UK
1998 *Arbres*, Sart-Tilman, Musée d'Art Contemporain,
 Liège, Belgium
1997 *Produire, Créer, Collectionner*, Musée du
 Luxembourg, Paris, France
 Made in France, Centre George Pompidou, Paris,
 France
1995 *Biennale de Lyon*, Lyon, France

SELECTED BIBLIOGRAPHY

Stéphanie Bedat, *Kunst Bulletin*,
September, 1996
Nicolas Bourriaud, 'Entretien', *Ninety*,
1999
Nicolas Bourriaud, 'Patrick Corillon',
Arte Factum, No. 38, May, 1991
Philippe Dagen, 'Le piège à images et à
pensées de Patrick Corillon', *Le Monde*,
4 June, 1997
Catherine Fayet, 'Patrick Corillon',

Parachute, No. 80, Winter, 1995
Cyril Jarton, *Beaux-Arts Magazine*,
Summer, 1996
Bernard Marcade, *Art Press*, No. 160,
Summer, 1991
Jérôme Sans, 'Patrick Corillon/
Hétéronymes à Suivre', *Galeries
Magazines*, December, 1992
Eric Troncy, 'Patrick Corillon', *Flash Art*,
No. 159, Summer, 1991

CHECKLIST OF WORKS

LES TROTTEUSES 2000
aluminium, battery, motor 145 (h) x
53.5 (w) x 28 (d) cm each
courtesy the artist and in Situ, Paris

DEXTER DALWOOD

69

Who is taking the decisions? Is it the CIA? The Kennedys? Multinational corporations, global players or occult religious sects? Did Marilyn Monroe have to die because she knew too much about what was really going on in the White House? Superstitions, speculations and conspiracy theories are ways of imagining the reality of the exclusive social circles where power is exerted and history is written. Although these social circles are far removed from the actuality of the everyday, we still believe them to be infinitely more real than our daily surroundings - since it is these people, hidden in the offices under mirrored glass high up in skyscrapers, who shape reality. Frederic Jameson has argued that popular conspiracy theories seek to grasp what he calls 'the postmodern sublime', [1] global capitalism's vast network of power and control. According to Jameson however, these popular fantasies never even come close to understanding the new world order. Ultimately they are just a neurotic compensation for a general feeling of powerlessness. So are we all going crazy now?

John Fiske says no. According to his point of view conspiracy theories are an expression of what he calls the 'hedonistic scepticism' of popular culture. He argues that people enjoy entertaining the idea that

DEXTER DALWOOD

ARE WE ALL GOING CRAZY NOW?
JAN VERWOERT

the 'higher echelons' use their influence to 'cover up' scandals and political ties. This assumption empowers them to perceive the 'official truth' as fashioned according to personal interests. And once the 'official truth' is perceived to be contingent, it can be unravelled and remade according to one's own desires. Of course people know that the scenarios they invent are imaginary. But if you assume that everything which is said to be true is false, what you imagine might just be real after all. Conspiracy theories thus encourage a 'play of belief-disbelief' in which 'we' constantly re-negotiate our relation to 'them' – the celebrities, politicians, royalties and monopolists who govern our world.[2]

Dexter Dalwood's paintings tap into the rich resources of these popular speculations, as they render images of spaces that everybody has heard of but no one has ever been to. Spaces that are shrouded in mysteries as they have provided the scene for major political decisions or dramatic events that irrevocably changed the path

of history. Take *Stalin's War Room* for example. Everybody must have an image in his or her mind of what this room looks like – although no picture of it actually exists. Whenever a blank like this occurs in the collective imaginary it is immediately filled by numerous fantasies. The production of these fantasies is an ongoing process: as in most cases a final verification is impossible, the imagination will always return to these unsolved mysteries like a tongue to a loosening tooth. As the speculations can never be verified, the images they produce also remain unstable. The same holds true for Dexter Dalwood's paintings: in a weird way they seem both utterly convincing and highly questionable. Once you get engaged in the peculiar 'play of belief-disbelief' it becomes impossible to come to a clear decision: Stalin's war room couldn't possibly have looked the way the painting depicts it – but then again – the red telephone, an ashtray and a map of the world must have been there, that's for sure. So the painting ultimately can't be that far away from the truth.

Another factor that contributes to the weird atmosphere of the paintings is the absence of the powerful and famous themselves from the rooms they are believed to occupy. Only the interiors are depicted like stage sets for a potential drama. And although these rooms are inhabited by powerful or famous people most of them, surprisingly, are not designed for the public representation of power or fame. On the contrary most of them are private spaces with a peculiar melancholic air about them, the spaces the political leaders and popular icons retreat to when they withdraw from the public: *Mao Tse-Tung's Study, Gorbachev's Winter Retreat, The Betty Ford Clinic,* or *Bill Gates' Bedroom.* The outside world is shut out, covered in snow or looked at from under glass.

Mao Tse-Tung's Study is rendered in a way highly reminiscent of the Renaissance painting of Saint Jerome in his study by Antonello da Messina. This motif links the world of postwar-politics to classical ideas of political culture. Here the distinction between public and private space is of crucial importance: Jerome seeks refuge from his official tasks as the principal of various monasteries in the privacy of his study to recenter himself by reading the bible. In the same way Cicero might be visualized in his exile from the Roman Senate as he writes his treaties on the construction of the state and the rhetorical techniques for public speeches. In this context the 'retreat' is traditionally conceived of as the space that allows for political power to become self-reflective

and develop a degree of self-awareness. But even if Dexter Dalwood's paintings give us a clear image of the private domains in which the true nature of power and fame is revealed to the powerful and famous - the content of these revelations still remains a mystery to us. We will never know what goes on in the mind of Bill Gates when he watches late night shows on the tiny TV installed on the bedstead of his tastefully minimalist futon. Is he contemplating the future of Microsoft or just trying hard to get to sleep?

But why painting? Wouldn't a computer simulation of these imaginary rooms render them much more realistic? Maybe yes, but this is not the point. Painting is the ideal medium for exploring the peculiar 'play of belief-disbelief' in all its paradoxies: On the one hand a painting is always already more than just a picture. Due to its tradition as an object of cult and worship – and of course also due to its sheer size – a painting can produce an image that is more intense in its persuasive qualities than a computer simulation could ever be. On the other hand there is no medium that has as often been critically dismantled, de-legitimized, and discredited as painting has been. So paradoxically paintings can be highly persuasive and yet utterly self-destructive all at the same time.

Take *Brian Jones' Swimming Pool* for example: The painting gives you an image of what the pool Brian Jones drowned in might look like. The pool is drained and in a bad state of repair. Fall has begun. A brown leaf lies on the bottom of the pool close to a pathetic little puddle of rainwater. The image conveys an impressive sense of melancholia. The summer of love has surely come to an end. However the illusion of spatiality breaks down when it comes to the shabby colour on the pool's walls. First of all the two-dimensionality of the colourfield contradicts any suggestion of three-dimensionality. Moreover this section of the image is obviously taken from a Clyfford Still painting. At this point the painting openly ridicules itself. It seems to insinuate that the sublimity it invokes is a historical concept that, like the drained pool, has seen better days. So just like in the popular 'play of belief-disbelief' the attraction of looking at the painting is derived from the fact that what you see is never what you get - as the image remains in a continuous state of suspense.

1. Frederic Jameson, *Postmodernism, or, The Cultural Logic of Late Capitalism*; London/New York 1991, p 38
2. John Fiske, *Power Plays, Power Works*, London/New York, 1993, pp 184 & 200

Dexter Dalwood

born Bristol,

England, 1960.

Lives and works

London, UK.

SELECTED SOLO EXHIBITIONS

2002	*New Paintings,* Gagosian Gallery, Los Angeles, USA
2000	*New Paintings*, Gagosian Gallery, London, UK
1995	Galerie Unwahr, Berlin, Germany
1992	Clove Building, London, UK

SELECTED GROUP EXHIBITIONS

2002	*Remix,* Tate Liverpool, UK
2001	*View Five, Westworld*, Mary Boone Gallery, New York, USA
	Generator 3, Baluardo di San Regalo, Lucca, Italy
2000	*Twisted*, Van AbbeMuseum, Eindhoven, Netherlands
	Dirty Realism, Robert Pearre, Tucson, Arizona, USA
1999	*Neurotic Realism: Part Two*, Saatchi Gallery, London, UK
	Caught, 303 Gallery, New York, USA
	Young and Serious, - Recycled Image, Ernst Museum, Budapest, Hungary
	Heart and Soul, 60 Long Lane, London, UK
1998	*Facts and Fictions*, In Arco, Turin, Italy
	Die Young Stay Pretty, Institute of Contemporary Arts, London, UK

SELECTED BIBLIOGRAPHY

Michael Archer, 'Dexter Dalwood: Gagosian Gallery', *Artforum*, Dec. 2000
Luca Beatrice, *Facts & Fictions*, exhibition catalogue, Castelvecci Arte, Turin, Italy, 1999
Patricia Ellis 'Spotlight: Dexter Dalwood' *Flash Art* Nov/Dec 2000
Alison Green, 'We are History', *Twisted: Urban Visionary Landscapes In Contemporary Art*, exhibition catalogue, Van AbbeMuseum, Eindhoven, 2000
Alison Green, 'The Unbearable Lightness of Being', *Untitled*, Autumn 2000, pp 22-23

Dave Hickey, *New Paintings*, exhibition catalogue, Gagosian Gallery, LA 2002
Patricia Kohl, *Young And Serious – Recycled Image*, exhibition catalogue, Ernst Museum, Budapest, Hungary, 1999
Martin Maloney, *Die Young, Stay Pretty*, exhibition catalogue, Institute of Contemporary Art, London, 1998
The New Neurotic Realism, exhibition catalogue, Saatchi Gallery Publications, 1998
Jan Verwoert, *Recent Paintings*, exhibition catalogue, Gagosian Gallery, London, 2000

CHECKLIST OF WORKS

BRIAN JONES' SWIMMING POOL 2000
oil on canvas, 275 x 219 cm

PATTY HEARST'S APARTMENT 1999
oil on canvas, 198 x 335 cm

ULRIKE MEINHOF'S BEDSIT 2000
oil on canvas, 100 x 92 cm
private collection: Milan

STALIN'S WAR ROOM 2000
oil on canvas, 180 x 240 cm
private collection

Works courtesy the artist and Gagosian Gallery, London and New York

HENRY DARGER

Since its discovery in 1993, Henry Darger's *Realms of the Unreal* has come to be regarded as one of the greatest bodies of work produced in the twentieth century. At the same time, many viewers feel that they do not really 'get' Darger's art, that despite the panoramic grandeur of his most ambitious compositions, there is an opaque veil of strangeness and mystery that seems to hang over it, preventing a full understanding of what it's all about. This is because the art has been taken out of the context of Darger's life, the early part of which he recounted in the first 200 pages of his 5,084-page autobiography, *The History of My Life*. And also because the art has been separated from the literary epic from which it grew: *The Story of*

HENRY DARGER

'CRAZY' HENRY: A REMINISCENCE
MICHAEL BONESTEEL

the *Vivian Girls* in what is known as *The Realms of the Unreal, of the Glandeco-Angelinian War Storm, Caused by the Child-Slave Rebellion*, or, for short, *Realms of the Unreal*. It would be unthinkable, of course, for most people to wade through Darger's monumental 15,000-page adventure novel (cited as possibly the longest work of fiction ever created), now housed at the American Folk Art Museum in New York – not to mention his autobiography. Nevertheless, Darger's remarkable visual output cannot be truly comprehended without being seen in the light of both his life and his fictional writings.

Henry Darger earned the nickname 'Crazy' as a youngster, he explained in his autobiography, by trying to entertain his classmates at school with strange noises that emanated from his mouth, nose and throat. He also displayed what he described as 'queer motions' with his left hand. We are

not sure when he began talking to himself in different voices, pitches and dialects, but in many other respects he exhibited symptoms throughout his entire life of what could be considered post traumatic stress disorder. These symptoms were bought about by a succession of tragic occurrences: the death of his mother and separation from his baby sister when he was 4 years old; his placement at age 8 in a Catholic orphanage because of his father's illness; his erroneous and reprehensible commitment at age 12 or 13 to the Asylum for Feeble-Minded Children in Lincoln, Illinios, followed by the inevitable physical, emotional and conceivable sexual abuse endured there; and finally, the death of his father when he was 15. After two attempts to run away from the asylum, Darger succeeded on his third try, relocated to Chicago where he was hired as a hospital janitor, and embarked upon writing and illustrating the magnum opus that would occupy him for the next 60 years.

Borrowing somewhat from Darger's own beloved collection of Oz books by L. Frank Baum, *Realms of the Unreal* is a saga that takes place on another planet and concerns a war between a Satanic nation of evil scoundrels who are enslaving children, and the Christian nations who have come to the aid of a rebel army of children led by seven valiant warrior-princesses, the Vivian Sisters. The story also reflects Darger's long-abiding fascination with American civil war battles and generals, while the child-slave phenomenon echoes the oppression of Africans in the era proceeding the Civil War, and models a number of its characters upon figures in Harriet Beecher Stowe's *Uncle Tom's Cabin* and Booth Tarkington's *Penrod and Sam*. Darger began writing and illustrating *Realms of the Unreal* around 1912, just prior to the outbreak of the First World War, and years later he was still hard at work on his tale, having bound the first

seven volumes of it by hand, but by this time the narrative had become so long and complex, it was very likely getting out of control. He never did get around to binding the remaining seven or eight volumes. His illustrations, on the other hand, were only just beginning to come into their own.

Mary Catherine O'Donnell of Boston grew up during the 1930s and 40s in her grandfather's rooming house on Weber Avenue in Chicago – the very same boarding house that Darger lived in. Born in 1936, she knew Henry Darger from earliest childhood until age 16, when her father, Chicago Police Captain Walter Gehr, sold the building to Nathan Lerner. "He was a recluse and a loner, that's for sure," O'Donnell recalled. "He was odd, eccentric, gruff. We thought he was insane or shell shocked. But he wasn't violent and I never heard of having any problems with him. He never drank or smoked. He always paid his rent on time. He wasn't a problem. If he was, he wouldn't have been allowed to stay there. I'd see him coming home from work. He had a newspaper under his arm. He walked with his head down. Wore the same clothes, the same old army coat. Never took a bath. He never, ever had any visitors."

O'Donnell mentioned that when others living in the rooming house would see him on the street, they would say "Hello, Henry Darger," using his full name. They pronounced his name 'Dar-jer' with a soft 'g', not the hard 'g' pronunciation that he adopted in later years. One can only speculate that when he decided to re-invent himself as Brazillian-born Henry Dargarius, he probably pronounced it with a hard 'g' and then kept it that way when reverting back to the shortened version. He used to eat at Roma's restaurant down the street, and was such a fixture there that the owners named a back room after him, putting up a sign that said "The Henry Darger Room". O'Donnell also remembered that

he liked to read the newspaper while he was walking down the street, even crossed streets with his eyes buried in the paper, oblivious to the traffic. She felt certain that he would get hit by a car one day. In fact, he was struck by a car in the summer of 1969, suffering some injury to his left leg and hip.

"If my father talked to him, he would not make any sense", O'Donnell continued. "It was like he was speaking in tongues or nonsense syllables. He also talked to himself in these different voices and dialects. My brother and I used to sit on the stairs and listen to him. We had four men renting rooms on the top floor and they shared a bathroom down the hall. Before going into the bathroom, Henry would always repeat in a deep voice, 'Ah-bah-suh-duh'. New visitors to the building who heard different voices coming from his room would say, 'That guy down the hall has more visitors than anyone!'" But the company that Darger was keeping was only himself. He did have one good friend with whom he spent many evenings and Sunday afternoons. He was a tall, lanky Lithuanian immigrant by the name of William Schloeder. Darger also got to know Schloeder's three sisters, a niece and nephew. Schloeder eventually relocated with one of his sisters to San Antonio, Texas, and died shortly thereafter.

"Going into his room was like walking into a junk yard", she noted. "But he knew it if you touched something; people weren't allowed to touch anything. He had a table in his room filled with paints and toys. My brother once asked him if he could have one of his matchbox toys. 'No!' he said. He didn't want to have anything to do with children, except for them to stay out of his way. He had several typewriters. You'd hear him typing in his room at night, but not every night. He'd type for an hour or so and then stop. You'd hear him talking to himself. He slept with bricks

in his bed underneath the mattress." The only time O'Donnell could recall Darger reacting strongly to anything was when her aunt insisted on burning his mattress because it was infested with bedbugs. When they removed his mattress, however, he warned them not to take away the bricks. "If molested", Darger wrote in his autobiography, "I was a brick thrower and there are some big bullies who, molesting me, can now if still living, at this time, confirm my statement. I never missed." Still, from all evidence, his temper tantrums never exceeded the temptation to throw a handmade ball of wound up twine at the statue of Jesus on his mantlepiece.

"He had paintings all over the room", O'Donnell said. "Big, brown butcher paper drawings covered a third of the walls. There was one big long one over his bed. I never saw any of his writings. But we saw paintings that had armies of people marching. We saw girls with penises. They didn't scare me. My father just thought he was crazy. He'd say, 'Oh, it's just craziness. It's nothing'. But in the back of my mind, I always thought that those paintings might just be crazy enough to be worth something to someone someday."

After Darger went to a nursing home (shortly before his death at age 81) his landlord Nathan Lerner and another tenant, David Berglund, went in to clean out his room and found, under knee-deep piles of bundled newspapers and detritus, his *Realms* volumes, plus several hundred carbon-traced pencil, watercolour and collage drawings. These were populated by mostly female children and supernatural half-human, half-animal creatures called Blengins, usually engaged in innocent pastimes, but sometimes fighting the force of evil and succumbing to horrific scenes of strangulation, crucifixion and evisceration. The evil and succumbing. The largest of these works, sometimes reaching 12 feet in length, were stitched into three gigantic

mural 'books'. In his most mature art, Darger played with repeated riffs like a musician, using identical appropriated figures as the building blocks of design motifs. This is one facet of Darger's art that begins to resemble the obsessive-compulsive and hypnotically repetitious patterning in the art of the mentally ill (that is: Martin Ramirez, Madge Gill, Adolf Wolfli). Darger was deeply disturbed, certainly, but at the same time he was a self-sufficient and functioning member of society. Without alcohol or pharmaceutical drugs, disciplined solely by a preoccupation with his creative work and attending daily Catholic masses, he fought to keep his emotional problems and quirky behaviour to himself.

Much has been made of Darger's predilection for drawing hermaphroditic little girls. Perhaps the most convincing explanation for this is that he was displaying gender confusion as a result of his childhood trauma. Furthermore, it is likely that all the characters in *The Realms* – from heroes and heroines to perpetrators and victims – were extensions of Darger's own tortured psyche, projected as an epic battle upon the screen of his imagination. His literary saga ends with a Christian victory, although he also supplied an alternate ending that was more ambiguous. Still he went on to write an 8,500-page sequel called *Further Adventures in Chicago*, followed by his 5,000-page *History of My Life*, then a series of six weather journals kept for a period of ten years, and finally a diary of daily activities. Almost to the very end, Darger continued to make art inspired by a new golden age of peace and harmony in *The Realms*, improvising on the world he had created a half-century earlier. Freed from the need to follow a storyline, his children could run free forever in a fantasy landscape filled gentle Blegins and giant flowers.

Henry J. Darger. An Approximate Chronolgy Of The Life Of Henry J. Darger,

As Reconstructed From His Own Diaries And Journals.

From *A Personal Recollection* by Nathan Lerner

CHRONOLOGY	CHECKLIST OF WORKS

1892	April 12, Henry J. Darger born. Lives with father – "a tailor and a kind and easygoing man" in a "small, two-story house on the south side of a short alley between Adams and Monroe," Chicago.	THEY REACH AN IMPROVISED SHELTER JUST IN TIME #322 (side B) n/d watercolor, carbon transfer on paper, 55.9 x 251.5 cm	AT SHORE OF ARONBERG RUN RIVER #260 (side A) n/d watercolour, carbon transfer on paper 61 x 274 cm
1900	Father crippled and goes to live in a Catholic Mission, Little Sisters of the Poor, Chicago.		Works courtesy Carl Hammer Gallery, Chicago
1905	Taken to asylum and works summers on nearby farms. Father dies.		
1908	Runs away from asylum.		
1913	Witnesses the Easter Sunday twister at Countrybrown, Illinios, in which entire town is destroyed.		
1916	Begins typewriting *Realms of the Unreal* on 30 April.		
1917	Drafted. Dismissed from the army for eye trouble. Returns to employment at St Joseph's Hospital. Among other duties, washes Sisters' latrines. Employed Grant Hospital, Chicago. Moves to room on Chicago's north side. Registers for conscription. Employed at Alexian Brothers Hospital, Chicago. Washes dishes, rolls bandages. Forced to retire due to illness, 19 November. After that, he "barely makes it" on Social Security.		
1972	Taken to the Little Sisters of the Poor, Chicago, after lameness and other sickness. Dies 6 months later.		

NINA FISCHER & MAROAN EL SANI

DRIFTING IS A REVOLUTION OF EVERY- DAY LIFE. ART SHOULD BE JUST IN TIME AND UNIVERSAL AT THE SAME TIME. WE DON'T WANT TO MAKE A WORK OF ART SITTING IN A COCOON, HATCHING OUT SOMETHING UNIQUE, AND THEN SAYING: THIS IS IT! OUR ART IS A DRIFT. IT IS INFLUENCED BY EVERYTHING AROUND US. DAILY LIFE, THE PEOPLE WE MEET... A CONSTANT FLOW. AN EXCHANGE. THAT'S WHY WE LIKE TO LIVE AND WORK IN BIG CITIES. IMAGES AND INFORMATION ARE COMING FROM ALL SIDES, AND WE JUST HAVE TO PICK OUT WHAT WE NEED. Like a filter, we catch pieces of information and redesigning it, use it in a different way. Art should be create different points of view. If we invent new work, we always try to see the challenge to start something completely different, even a completely new medium. Art should cross boundaries. It can change shapes, meet its public outside the conventional places of art as well. It`s not just us in our studio, but working together with people. That`s what we like about filmmaking. You're always a team and have to rely on each other. Art should be sexy. Not just some abstract block of material, that keeps you thinking and guessing about the artitst's message. Something easily accessible, but with a secret.

NINA FISCHER + MAROAN EL SANI

THE AURA OF PROFANE ILLUMINATION

BORIS GROYS

One of the central questions of modern art is whether or not all things are equally reproducible. Consequently, this question has been directly or indirectly treated by most artists and theorists of modern times. Undoubtedly the most famous essay discussing this question was written by Walter Benjamin. It bears the title 'The Work of Art in the Age of Mechanical Reproduction'. Benjamin uses the term 'aura' in his essay to mark the limits of reproducibility. In Benjamin's opinion, the aura is the limit of reproducibility, as the aura is the only thing which is not reproducible. In his essay, Benjamin first assumes that it is possible to reproduce all things in a perfect way – in such a perfect manner that there is no discernible physical distinction between the original and the copy. The question Benjamin is asking is the following: Does the erasure of the physical distinction between the original and the copy also mean the erasure of the distinction as such?

Benjamin answers this question with a 'No'. The – at least potential – disappearance of any physical distinction between the orig-

inal and the copy does not obliterate another invisible but no less real distinction between them: the original has an aura which the copy does not have. Benjamin sees the aura as the connection an artwork has with its location – with its historical context.

Benjamin views the distinction between original and copy solely as a topological distinction and as such completely separate from the material core of the artwork itself. The original has a specific location and it is due to this particular location that the original finds its place as a unique object in history. Benjamin's formulation in this context is well known: "There is one thing missing even in the most perfect reproduction: the 'here' and 'now' of the piece of art – its unique presence in its location". On the contrary, the copy is virtual, without location, without history. From the beginning, the copy seems to be a potential multiplicity. The reproduction is a dis-location, a de-territorialisation – it carries the artwork into the net of topologically uncertain circulation. But if the distinction between original and copy is solely topological, then this distinction is determined by the topologically defined movement of the observer alone. If one moves toward a piece of art, then it is an original. If you force a piece of art to come to you, then it is a copy.

In this way, Benjamin's new interpretation of the distinction between original and copy

not only offers the possibility of making a copy from an original but also of making an original from a copy. In fact, provided there is only a topological, contextual difference between original and copy, it is not only possible to dis-locate and de-territorialise an artwork, but also to re-territorialise a copy. Benjamin himself talks about 'profane illumination' in this context and writes at this point: "The reader, the thinker, the waiting person and the flâneur are as much characters of illumination as the opium consumer, the dreamer and the intoxicated". It is noteworthy that these characters of profane illumination are all figures of motion. This applies to the figure of the flâneur above all. The flâneur does not expect that things come to him but he himself approaches them. In this sense, the flâneur does not destroy the aura of things, he observes it – or rather – creates it.

It can then be said that Nina Fischer and Maroan el Sani are, in the context of their 'Aura' research project, embarking on their search for the aura of profane illumination. They seek to discover invisible traces of former, original life in deserted and empty places which remain relatively intact. One can even say that artists create the aura by visiting such places, instead of discovering it. Ghosts, as it is known, do not like to return to deserted rooms as long as these rooms remain unoccupied. Ghosts espe-

78

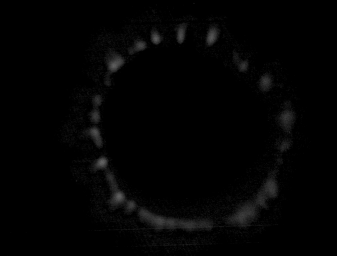

THE NEIGHBOURHOOD, TOKYO 1996 COLOUR PRINT/HIGH FREQUENCY PHOTOGRAPH EINSTEIN'S SUMMERHOME, CAPUTH 1997 COLOUR PRINT/HIGH FREQUENCY PHOTOGRAPH FRONT PAGE IMAGE HONECKERS OFFICE 1997 COLOUR PRINT/HIGH FREQUENCY PHOTOGRAPH WORKS COURTESY GALERIE EIGEN + ART BERLIN/LEIPZIG

cially enjoy haunting when the living visit these deserted rooms for a short or long period of time. One can certainly assume that by reproducing in their photographs the aura created in these rooms, the artists are refuting Benjamin's assertion that the aura is entirely unreproducible. Fischer and el Sani do in fact explicitly connect their project to a earlier, theosophical interpretation of aura, which, to a certain degree, Benjamin left unmentioned in his essay. It is the aura as a visible combination of quasi-abstract colours and forms which surround the human body and reflect the internal state of the soul. A vocabulary of such forms relating to aura was widely used in esoteric circles at the beginning of the twentieth century and was used by artists such as Wassili Kandinsky in an artistic context. Many believed then that the aura could be captured using the so-called Kirlian-Photography technique, which was developed by the Russian photographer Kirlian and his wife at the end of the nineteenth and beginning of the twentieth century. The 'Aura Research' project also explicitly refers to Kirlian-Photography. At this point, however, we cannot talk about a portrayal or reproduction of the aura, because in this case it is actually created by the photographic process itself – the aura not being able to be presented other than through the pho-

tograph. The aura pictures of Fischer and el Sani are therefore no duplicates, no reproductions of an aura that has been there and visible all the time. Rather, they are the documentation of a journey by the artists looking for profane illumination, a journey which resulted in the 'aura' pictures being created by this journey itself.

These aura pictures derive their allure not least from the fact that they are incorporated into the overall context of the documentation of a journey and thereby obtain documentary value. This is exactly what abstract pictures are commonly said to be missing. Following a long history of the ideologically motivated dispute between 'autonomous' abstract painting and 'documentarist' photography, the abstract picture itself turns out to be documentary, due to the concept of 'aura'. It appears as a photographic document of profane enlightenment which has occurred at a certain place at a certain time.

In the last few decades, a migration of interest has taken place within the world of art, moving away from the work of art itself and towards the documentation of it. A work of art is traditionally considered to be something which incorporates art, something that instantly presents art, makes it perceptible, thus illustrating what art actually *is*. Obviously, works of art can, in one way or another, also point

to something which they are not – for example, to objects of reality or certain political issues. But they do not point to art, because they *are* art themselves. Nowadays the traditional notion of going to an exhibition or a museum is becoming more and more misleading. In contemporary art halls, in addition to works of art we are increasingly confronted with art documentations. These appear in the form of pictures, drawings, photographs, videos, texts and installations – that is, the same forms and media in which traditional art presents itself. Yet in this case it is not art itself that is presented by these media, merely a documentation of it. Art documentation is by definition *not* art. It just points to art and thus makes it obvious that art itself is not present and instantly perceptible, but rather removed and out of sight. The abstract painting was long seen as the incorporation of art itself, an immediate manifestation of the aura of art as such. For a long time the abstract painting seemed to have been deserted by its spirit. It was no longer viewed as a real revelation of the unseen but as superficial decoration. Fischer and el Sani return to the abstract picture as a real place and a real document of the aura. This too is a journey in search of profane enlightenment.

Translated by Anglo-German Communications, Sydney

AURA RESEARCH/ **THE POOL** 1996 COLOUR PRINT/HIGH FREQUENCY
PHOTOGRAPH. FRONT PAGE IMAGE: AURA RESEARCH/ HONECKER'S OFFICE
BERLIN 1997 COLOUR PRINT/HIGH FREQUENCY PHOTOGRAPH AND DETAIL.

Nina Fischer born Emden,
Germany, 1965.
Maraon el Sani born
Duisburg, Germany, 1966.
They live and work in
Berlin, Germany.

SELECTED SOLO EXHIBITIONS

2001	*Artists*, Platform, Vasa, Finland
	Palast der Republik, Gallery Eigen+Art, Berlin, Germany
2000	*L'Avventura sensa fine*, Gallery Eigen+Art, Berlin, Germany
	Millenniumania, Goethe institute, Paris, France
1999	*Tsunami*, City Gallery of Contemporary Art, Dresden, Germany
1998	*Klub 2000*, Gallery Eigen+Art, Berlin, Germany
	Aura Research, Metropolitain Musem of Photography, Tokyo, Japan
	Klub 2000, Gallery Miele, Lucerne, Switzerland
1996	*The desire of making the invisible visible*, P-House, Tokyo, Japan
	Be Supernatural, Gallery Eigen+Art, Berlin, Germany

SELECTED GROUP EXHIBITIONS

2002	*Pause*, 4th Kwangju Biennale, Korea
2001	*Quobo – Art in Berlin 1989-1999*, Hamburger Bahnhof, Berlin, Germany
2000	*Autowerke*, Deichtorhallen, Hamburg, Germany
1999	*Trace*, 1st Liverpool Biennial of Contemporary Art, Liverpool, UK
	Welcome to the Artworld, Badischer Kustverein, Karlsruhe, Germany
	Sampling, Ronald Feldman Gallery, New York, USA
1998	*Platform*, Berlin Biennial, Germany
1997	*Correspondences: Berlin-Scotland*, Scottish National Gallery of Modern Art, Edinburgh, Scotland; Berlinische Galerie, Berlin, Germany
1996	*On Camp/ Off Base*, Tokyo Big Sight, Tokyo, Japan
1995	*Beyond the Borders*, 1st Kwangju Biennial, Kwangju, South Korea

SELECTED BIBLIOGRAPHY

Jennifer Allen, 'Nina Fischer and Maroan el Sani', *Artforum*, New York, Mar. 2001, p 154
Anthony Bond, Nina Fischer and Maroan el Sani, *Trace*, exhibition catalogue, The Liverpool Biennial in association with Tate Liverpool, 1999
Nina Fischer, Maroan el Sani, *Klub 2000, Rom-Paris-Marzahn*, exhibition catalogue, MaasMedia, Berlin, 2000
Jorg Heiser, 'Phantom Future', *Quobo, Art in Berlin, 1989–1999*, exhibition catalogue, Institute of Foreign Cultural Relations, Stuttgart, 2000
Harald Kunde, 'Don't trust anything', *Nina Fischer and Maroan el Sani, Tsunami*, exhibition catalogue, Kunst Haus Dresden, Stadtische Galerie fur Gegenwartskunst, Dresden, 1999
Ursula Prinz, 'Letter from Berlin',

Korrespondenzen – Correspondences, 12 artists from Berlin and Scotland, exhibition catalogue, Berlinische Galerie, Berlin, 1997
Jone Scherf, 'Current Media Picture Strategies', *Autowerke II, Contemporary Photography On and Off the Road*, exhibition catalogue, Hatje Cantz, Osterfildern/ Ruit, Germany, 2000
Arturo Silva, 'What is that strange light on the frontier?', *The Japan Times*, 22 Feb. 1998
Krystian Woznicki, 'Nina Fischer and Maroan el Sani', *Frieze*, Issue 48, London, 1999
Krystian Woznicki, 'Artists interview – Discharging History', *Aura Research/ between light and darkness*, exhibition catalogue, Tokyo Metropolitan Museum of Photography, Tokyo, 1998

CHECKLIST OF WORKS

Aura Research:
THE FAMILY INN, Breunsdorf 1994

THE BARBERSHOP, Tokyo 1996

THE DAUGHTER'S ROOM, Tokyo 1996

THE POOL, Berlin 1996

THE NEIGHBOURHOOD, Tokyo 1996

BRECHT'S STUDY, Berlin 1997

NIETZSCHES BAPTIZING CHURCH, Rocken 1997

HONECKER'S OFFICE, Berlin 1997

Each work 2 x photographs (edition of 3), each photograph 154.2 x 104cm framed
Works courtesy Galerie EIGEN+ART, Berlin/ Leipzig

SIMRYN GILL

SIMRYN GILL

A SMALL TOWN AT
THE TURN OF THE CENTURY

B.L. WAGNER

As the title suggests, these photos record staged moments in a small town at the end of last century. In these works, Simryn Gill revisits her old home-town of Port Dickson in Malaysia and transforms the familiar into the strange by way of her humorous intervention. Apparently 'natural' portraiture verges on the absurd with the addition of local produce to the frame. At first sight, it seems as if the heads of the subjects have been substituted by means of computer technology, then it becomes clear that these people are actually wearing headdresses fashioned from fruits, vegetables and flowers from durian to bananas to paw paws to rambutan. Carefully, wonderfully wrought, they are works of art in themselves, and the dressing up a kind of elaborate performance.

Throughout the series, Gill constructs images of Port Dickson which might be read as visual rejoinders to commonly held essentialist notions of 'Asia'. She has posed a range of people from Port Dickson with their various accoutrements – like golf clubs and school uniforms – denoting their status. Even though she provides clues to their social positions, she has deliberately effaced any individuality, since their faces are unreadable under masks. These anonymous or perhaps generic Malaysians could function as symbolic examples of exotica, as luscious and unknown as the skins they inhabit. However comic they may, these figures also retain a certain dignified silence which leaves the viewer guessing.

Within the interiors Gill documents, pattern and ornament proliferate, with many extraneous details surrounding the human subjects, providing us with candid impressions of domestic life. The presence of pets, tea-cosies and vivid floral arrangements gives the indoor shots a depth and richness which is less evident in the spare, uncluttered outdoor photos. Uniformly photographed from head to toe, at a low angle, the figures she records have a substantial aspect. Since their heads are unavailable for

scrutiny, we look everywhere for more information – at their shoes, clothes, backdrops – yet they stay frustratingly aloof, like the very idea of 'Asia' for many Western observers.

Gill divides her time between Australia and Malaysia and travels and works extensively so she is well-placed to explore the complex relationships between communities in the modern world. In its attention to the particularities of the personal and the provincial, Gill's work challenges the ongoing trans-national attenuation of local space. One of her photos which features a motorcyclist wearing a head full of rambutans, standing outside a local shop festooned with advertising, is especially suggestive in this respect. In another shot, a figure in saffron-coloured robes sits peacefully in a verdant garden overshadowed by a factory with candy-striped smoke stacks. While their headgear aligns them with the exotic and the remote, the commercial signifiers behind them attest to Port Dickson's connections with the global economy. Obviously this town has unique qualities but it might also be regarded simply as a single point in the worldwide network of social relations.

At this millennial moment, Gill's gaze is fixed on a marginal community rather than a metropolitan cityscape, where attention is usually focussed at such junctures. We might ask ourselves how this special occasion is understood in Port Dickson by these faceless figures living so far from the self-styled centres of civilisation. Certainly we are not shown enough to be able to make any sort of informed judgement; consequently our view remains tantalisingly opaque.

Yet we can sense different kinds of identity which are intertwined, humorously and profoundly; the individual lives of the members of this small community, recorded in detail; and the typology of fruits for which the region is internationally renowned. It's a kind of portrait of community in flux at the turn of the century, imbricating people themselves with the cultural cliches at large.

Reprinted with permission from *Simryn Gill - A Small Town at the Turn of the Century*, exhibition catalogue, Australian Centre for Contemporary Art, Melbourne, March 2001

Simryn Gill born
Singapore, 1959.
Lives and works in
Sydney, Australia.

SELECTED SOLO EXHIBITIONS

2001 *Dalam* Galeri Petronas, Kuala Lumpur, Malaysia
 A small town at the turn of the century Perth
 Institute of Contemporary Arts, Perth International
 Festival, Australia
2000 *Roadkill,* Project Gallery, CCA Kitakyushu, Japan
1999 *Simryn Gill,* Bluecoat Gallery, Liverpool, UK
 Slow Release, Bishopsgate Goods Yard, London;
 Ikon Gallery, Birmingham, UK.
 Vegetation, ArtPace, San Antonio, Texas, USA
1998 *Self-seeds,* Kiasma, Museum of Contemporary Art,
 Helsinki, Finland
 Forest, Roslyn Oxley9 Gallery, Sydney, Australia
1996 *Blank Verse,* Fort Canning Park, Singapore
 Wonderlust, Art Space, Sydney, Australia
1994 *Heart of the matter,* The Substation Gallery,
 Singapore
1992 *Pooja/Loot,* Experimental Art Foundation, Adelaide,
 Australia

SELECTED GROUP EXHIBITIONS

2001 *Berlin Biennale* (collaboration with Liisa Roberts),
 Berlin, Germany
1999 *Babel,* Ikon Gallery, Birmingham, UK
 Asia Pacific Triennial, Queensland Art Gallery,
 Brisbane, Australia
 Australian Perspecta Museum of Sydney, Australia
1997 *5th Istanbul Biennial,* Istanbul, Turkey
 Cities On The Move, Weiner Secession, Vienna,
 Austria and touring
1995 *Litteraria* South Australian Museum, Adelaide,
 Australia
 TransCulture Venice Biennale, Venice, Italy
1994 *Adelaide Installations* Adelaide Biennial, Adelaide,
 Australia

SELECTED BIBLIOGRAPHY

John Barrett–Lennard, 'A Small Town at
the Turn of the Century', exhibition
catalogue, Perth Institute of
Contemporary Arts, 2001
Barry Craig, 'Inflecting the Museum',
Artlink Vol.15, No.4, Adelaide 1996
Simryn Gill, 'Self Seeding', exhibition
catalogue, *Self Seeds,* Kiasma, Helsinki,
1998
Simryn Gill and Liisa Roberts, 'A letter
to Maaretta Jaukkuri', *Tasapainoilua/
Delicate Balance,* exhibition catalogue,
Kiasma Museum of Contemporary Art,
Helsinki, 2000
Richard Grayson, 'Views from the
Islands', exhibition catalogue, *Simryn
Gill,* Bluecoat Gallery, Liverpool, 1999
Lee Weng Choy, 'Local Coconuts:
Simryn Gill and the Politics of Identity',
Art Asia Pacific, No.16, Sydney, 1997
Hans Ulrich Obrist, 'Roadkill: Repetition
and Difference', *Contemporary Visual
Arts,* Issue 29, London, 2000
Marian Pastor Roces, 'Simryn Gill: Slow
Release', *Art+Text,* No. 56, 1997
Sharmini Pereira, 'A breadth of fresh
air', exhibition catalogue, *Natural
Resemblance,* Experimental Art
Foundation, Adelaide, 2000
Apinan Poshyananda, 'Simryn Gill', *Fresh
Cream,* Phaidon Press, London, 2000

CHECKLIST OF WORKS

A SMALL TOWN AT THE TURN OF THE
CENTURY 1999-2000
series of 41 images, edition of 5
type c-photographs (framed)
91.4cm x 91.4cm (image size)
101.6cm x 101.6cm (paper size)
courtesy the artist and Roslyn Oxley9
Gallery, Sydney

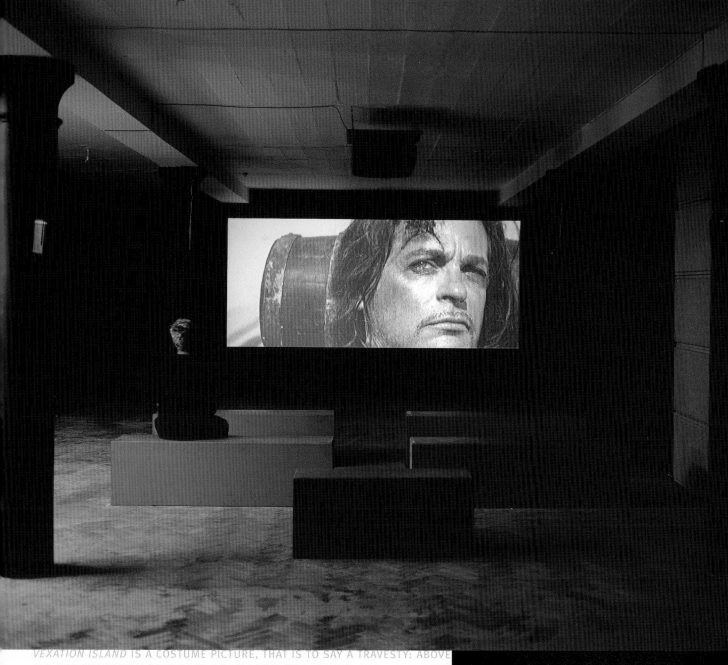

VEXATION ISLAND IS A COSTUME PICTURE, THAT IS TO SAY A TRAVESTY: ABOVE ALL, THE SHORT FILM ASPIRES TO BE AN ACCURATE DIAGRAM, PLEASINGLY RENDERED, OF THE CATASTROPHIC EVENTS THAT CONJOIN STATES OF CONSCIOUSNESS (SHOTS) ACCORDING TO AT LEAST ONE POSSIBLE THEORY. I WISH TO POSIT AN ISLAND, OR RATHER A STRIPPED-DOWN ISLAND ADVENTURE COMPRISING THE NATURAL FLUXES - BIRD-CENTERED, MAN-CENTERED AND TREE-CENTERED - THAT DIVIDE AND REFORM REPEATEDLY ACCORDING TO THE PRINCIPLE OF THE LOOP. In *Cinema 1: The Movement Image*, Deleuze underscores the difference between naturalist and realist violence: the structure of the latter is that of an egg, a vegetative or vegetable pole (permeation) and the animal pole (acting out): "The vegetative pole's movement on the spot is just as great as the violent movement of the animal pole. Spongy permeation has as much intensity as acting-out, sudden extension... Kazan advised that people in conflict should be made to eat together: the common absorption would make the eruption of duels even stronger." *Vexation Island* vibrates between the poles of spongy permeation (me sleeping under a tree) and the eruptive violence whose emblem is the spheroid and actually egg-like bruise above my left eye. My own method performance, immodestly, is to be guided by a creative visualization of Brando's rendering of Fletcher Christian's death surrounded by his crew and the final shot: a pan away towards the sea and to the Bounty herself as the flaming ship and all hope of return to England sinks at last beneath the waves. RODNEY GRAHAM

MR GRAHAM, ON THE BEACH WITH THE COCONUT

REBECCA EPSTEIN

Vienna's cool and all but where's the coast?
The best thing I can say is Sigmund Freud is still the most.
Lyrics from 'Man, I Really Miss the Coast'[1]

Vexation Island is a seamless nine-minute loop produced in 1997 when Rodney Graham was selected to represent Canada at the Venice Biennale. It is a travesty, or costume picture, and is a precise, deliberate study of 'a stripped-down island adventure'[2] that Graham recreates with all the lavishness and texture the film medium allows. As one critic writes: "[O]ne could describe a basic theme of [Graham's] art as the creation of aesthetic surfaces in order to see through the mechanics of their creation."[3] Graham masters the mechanics of the popular island-adventure idiom and from within the aesthetic structure creates a work of art that reflects on the modern human condition arrived at through the lens of Sigmund Freud and Gilles Deleuze.

Although Deleuze and particularly Freud's influences run deep with Graham, for the purpose of citing *Vexation Island* we can focus on Freud's dealings with the relationship among systems, regulations and neuroses to reveal Graham's motivation for the film. Graham states:

> Flows can be regulated but the unpredictable always occur: the clinamen… It was a monograph on the common houseplant cyclamen that set in motion Freud's Dream of the Botanical Monograph. Freud's glimpse of the recent publication in a Vienna bookstore defined the clinamen- the unpredictable veering away of attention - that interposed itself into Freud's daily routine. It is the clinomatic moment… that I desire to place at the exact center of *Vexation Island*… I wish to posit an island… comprising the Natural Fluxes… that divide and reform repeatedly according to the principal of the loop.[4]

According to Freud, the clinamen is a 'veering', a trajectory that is already in motion. When our thoughts are suddenly diverted a stratum of our subconscious is revealed that is seemingly new and caused by the subject of our new attention. The elements of our surroundings reconfigure, the system re-regulates, and we move forward towards the next moment of sudden awareness. This is how Graham centers *Vexation Island* on the clinomatic moment and brief episodes of consciousness that our neurotic hero experiences before falling back into the hands of Nature's alarm clock. By looping the film Graham is able to create and harness the tension between man and nature as it develops with each new layer of awareness.

Vexation Island is effectively a cinematic answer to Daniel Defoe's *Robinson Crusoe*. Just as Robinson Crusoe is recognized as an early modern hero, Rodney Graham is the modern anti-hero. Robinson Crusoe is stranded on a deserted island where he eventually builds a replica of European bourgeois society. This drive to recreate civilization, for order, is a study of economic man which, as time passes, becomes a study of isolated man as our hero turns toward religion, in this case god, for consolation. These same themes develop in Tom Hank's *Castaway*, too. And in *Lord of the Flies*. And on *Gilligan's Island*. None of this happens on *Vexation Island* but that we are aware of what is not happening is crucial to the film's success. Graham seldom, if never, mentions Defoe's novel when he discusses the inception of *Vexation Island*. Although the idiom of Graham's film clearly relies on the cultural trope of the deserted island that Defoe's work helped to establish, *Vexation Island* is not as much a study of modern man as it is a single posited explanation for the particular relationship of things and the clinomatic moment that forces this relationship into motion.

Graham is as equally indebted to the trope of the closed-room mystery as he is to that of the deserted island. *Vexation Island* is, after all, an unresolved conundrum. Our

protagonist is an eighteenth-century English-man (Graham) who we find lying on his back in the shade of a palm tree on a deserted, tropical island. His head rests comfortably on a barrel, his left hand rests peacefully on his chest and a parrot perches nearby. Strangely, a fresh egg-like bruise is over Graham's right eye but there are no footsteps in the sand, no sign of wreckage or other humans. We have only the man, the island, the bird and the bruise.[5] Was he shipwrecked? Attacked by unseen natives? Passed out drunk from the wine in the barrel? It's a closed-room mystery. It's a Technicolor game of Clue. After Graham is awoken by the parrot he shakes the palm tree to free a coconut that falls, hits him on his existing bruise, knocking him out as he collapses onto his back into the same position from which he arose and the coconut tumbles into the ocean as all evidence is erased by the tide. He isn't drunk or beaten. He is marooned and stuck in a self-destructive, self-perpetuated cycle of man striving for survival only to be denied access because of the very steps he takes towards this survival. This is the 'Aha!' moment, the clinomatic moment that we and Graham experience again and again.

In *Vexation Island* the mechanics of the loop accomplishes three things. First, it destroys any semblance of a narrative structure.

My explanation above is tidy because it provides a linearity that the film's installation does not afford. Although the scenario is anecdotal rather than linear, the viewer is aware that the film is repeating with this awareness, understanding of the situation evolves. Second, the repetitive element of the loop suggests the never-ending, eternal quality of Graham's predicament. This is the absurdist existentialist element that includes everything from Sisyphus to the freezing of time to the insane. Freud himself claimed that neuroses could be explained in one way by repetition replacing remembrances of the past. In the case of *Vexation Island* it is Graham who plays the neurotic hero and the viewer who is vexed: will Graham not eventually die of starvation or thirst or is he doomed to awaken and fall unconscious for all eternity? Third, the loop is a decidedly filmic convention that draws attention away from the story and towards the agency by which the image is brought to you. *Vexation Island* is filmed in cinemascope format and in Technicolor on 35mm film by an advertising crew of technicians and directors. Graham wants to you know that what you are watching is illusory and is only one of many possible explanations for a way a specific situation has come to be. What the film therefore lacks in resolve and orientation it makes up for in visual

clarity and its keen reflection on the film industry's tendency towards self-referentiality. But, in the end, what the viewer is left with is a table of evidence: Mr. Graham, on the island, with the coconut. What we lack, and are meant to supply, is motivation.

1. Rodney Graham, *The Bed-Bug, Love Buzz and Other Short Songs in the Popular Idiom*, track 7.
2. Rodney Graham, 'Siting Vexation Island.' *Island Thought I*, no. I. Summer, 1997, pp 9-18.
3. Martin Pesch, 'Speaking in Another Register: Rodney Graham deals with music, film, video'. In *Getting it Together in the Country*, exhibition catalogue, *Some Works with Sound Waves, Some Works with Light Waves and some other Experimental Works*, at Kunstverein Munchen, Munchen, Germany, p 6.
4. Graham, 'Siting Vexation Island', p 15.
5. Graham sites Gilles Deleuze's *Cinema I: The Movement-Image* for the difference between "naturalist" and "realist violence". Realist violence has the structure of a vegetative pole, or permeation, and the animal pole, or acting-out, and vibrates from within the tension of the two poles. In *Vexation Island* the bruise is the emblem of the animal pole while the tranquil setting of Graham sleeping under the tree is the vegetative pole.

Rodney Graham born in
Vancouver, Canada,
1949. Lives and works
in Vancouver, Canada.

SELECTED SOLO EXHIBITIONS

2002/03	Art Gallery of Ontario, Canada, and Madison Arts Center, Wisconsin, USA
2002	Whitechapel, London,UK
2001	*City/ Self, Country Self*, Donald Young Gallery, Chicago, Illinois, USA
	Currents 29: Rodney Graham, Milwaukee Art Museum, Wisconsin, USA
2000	*Some Works with Sound Waves, Some Works with Light Waves, and Some Other Experimental Works*, Kunstverein München; Westfalischer Kunstverein, Munster, Germany
1999	*How I Became a Ramblin' Man*, Donald Young Gallery, Chicago, Illinois, USA
	Rodney Graham – Cinema, Music, Video, Kunsthalle Wien, Vienna, Austria
1998	*Rodney Graham*, Wexner Center for the Arts, Columbus, Ohio, USA
	Rodney Graham: Vexation Island and Other Works, Art Gallery of York University, North York, Ontario, Canada
1997	Vexation Island, 303 Gallery, New York, USA

SELECTED GROUP EXHIBITIONS

2001	*9th Biennial of Moving Images*, Centre pour l'Image Contemporaine, in collaboration with Musée d'Art Moderne et Contemporain, Geneva, Switzerland
	Donald Young Gallery, Chicago, Illinois, USA
	Art/ Music: Rock, Pop, Techno, Museum of Contemporary Art, Sydney, Australia
	010101: Art in Technological Times, San Fransisco Museum of Modern Art, San Fransisco, USA
2000	*Flight Patterns*, Museum of Contemporary Art, Los Angeles, USA
1999	*Millennium My Eye! Head Over Heals A Work of Impertinence*, Musée d'Art Contemporain de Montréal, Quebec, Canada
	Plain Air, Barbara Gladstone Gallery, New York, USA
1998	*Rodney Graham, Stephen Balkenhol*, Galerie Rudiger Schottle, Cologne, Germany
1997	*Past, Present, Future*, Venice Biennale, Italy

SELECTED BIBLIOGRAPHY

Alexander Alberro, 'Rodney Graham's Vexation Island, Loop Dreams', *Artforum*, Vol. 36, No. 6, February, 1998, pp 72-75, 108

Jan Estep, 'Rodney Graham', *New Art Examiner*, February 2000, pp 48-49

Garrett Holg, 'Rodney Graham', *Artnews*, January 2000, p 172

David Humphrey, 'New York Fax', *Art Issues*, No. 52 March/April, 1998, pp 34-35

Island Thought: Canada XLVII Venice Biennale, York University, Toronto, Canada, 1997

'Project Canada', *Art/Text*, November 1997- January 1998, pp 54-59

Alan Riding, 'Arts Abroad: Root and Branch', *The New York Times*, 3 February, 1999

Barry Schwabsky, 'Inverted Trees and the Dream of a Book, An Interview with Rodney Graham', *Art On Paper*, September-October 2000, pp 64-69

Kathy Slade, 'Rodney Graham: Presentation House Vancouver', *C Magazine*, Spring 2001, p 43

James Yood, 'Rodney Graham', *Artforum*, November 1999, p 147

CHECKLIST OF WORKS

VEXATION ISLAND 1997
laserdisk video/sound installation,
dimensions variable
courtesy the artist and Lisson Gallery,
London

VELI GRANÖ

Veli Granö has become known to the Finnish public as a documentarist of art collectors and folk artists. For him, this long project has not been just one of appearing in the context of the arts, within its institutional structures of galleries and museums. Instead, his efforts have resulted in documentary works of wider distribution, such as books and video works presented on television. *Onnela*, a book by Granö on folk artists, appeared in 1989, followed in 1999 by a text version in English entitled *A Trip to Paradise*. He returned to this theme (with other photographers) in *Itse tehty elämä – ITE/DIY Lives (2000)*, an illustrated book published in connection with a major exhibition of folk art. *Onnela* and the *ITE* project launched research into folk art in Finland, and plans are under way for establishing a museum for this area of art. An illustrated work by Granö on collectors, *Esineiden valtakunta -Tangible Cosmologies,* including a CD-ROM, was published in 1997.

Granö's most recent works *Ihmeellinen viesti toiselta tähdeltä (A Strange Message from Another Star)* and *Tähteläinen (Star Dweller)* continue these and similar themes, but now with a completely different focus. The overall themes, however, are the same: a certain alienation and the different world views that it produces. In his earlier works, Granö can be said to have concentrated on everyday life and the micro-level of things, on the world of objects and goods whereby people create or reinforce both their identity and their view of the world and assign meanings to them. It is a world lived in and experienced, a presence, that can be approached both historically and phenomenologically.

VELI GRANÖ

"I RELY ON THE WORLD FOR AID"

OTSO KANTOKORPI

Works of art and objects are physical items that can be organized, they can be historical evidence or create narratives in which an idiosyncratic biography and psychology of an individual can be crystallized through the recent past and history of the nation and the world into a cluster of different forces. It is by no means far-fetched to call the bear sculpture of a folk artist a totem, or the treasure of a collection, a talisman. In *A Strange Message from Another Star* and *Star Dweller*, absence – or its possibility – replaces presence as the factor that creates meaningfulness – it is an awareness of a different kind of reality, a utopia, a desire to be elsewhere, the knowledge that 'I do not belong here' or that 'I belong somewhere else'.

Granö is acutely aware of the influence of different conventions of presentation, the conditions of viewing, and he incorporates this also into his work. Even the making of the artwork involves the artist's own interpretation; each viewer, for example, will have his/her own personal interpretation of a video installation presented in an art museum, of a television programme viewed at home – even though the works might be identical in format. Of greater importance, however,

is the relationship of the document to the original subject.

> When treating an interview made by oneself and editing a film that one has made, the relationship with that original reality is quite loose. When I made the video piece *A Strange Message from Another Star* I felt quite guilty. How is life to be told and recounted? I made a story out of it with a certain logic, structure and culminations.

Granö addresses the performance situation and its different opportunities with an installation of the same title. How are stories told and how can they be told?

> Could there some other way to tell the same story but not in such a fixed manner? I also wanted include authorship; the installation contains material that I used in the shooting, such as my sleeping bag and camera.

This means that the result includes not only the actual material but also the presence of both the person who is the subject and the author. This use of the documentary meta-level is at once alienating and a rhetorically direct statement: this is what happened; these are real people. The evocation of alienation is an artistic tradition employed to break down automatization, things taken for granted, in which slowed or impeded reception is a means to achieve seeing instead of looking. In the words of Tolstoy: "But if no one saw or saw without being aware of it, or if the whole complex life of man passes without awareness, then that life has really never existed".

The same alienating effect applies to *Star Dweller*, in which Granö set out to outline the story of a woman to complement *Strange Message...* In *Star Dweller* the levels of narrative created by the videos, photographs and the installation are more complex, because "the essential point here was this completely different world view. She has produced the whole universe, civilization..." The tragic story of a lost child also placed specific requirements on the form:

> It is however extremely painful and intimate when the viewer encounters it. I didn't want to make any womb-like space; the viewer cannot be endlessly manipulated with emotional issues.

No less important is the fact that, for Granö, the problem of the documentary form is not a theoretical question concerning the problems of narrative, *per se*, but one that concerns the requirements of the material. How can this particular narrative be told? The general level, however – and thereby broader interest – is always composed of special cases. Granö thus deals not only with individual narratives but also with the interface of the conscious and the unconscious specifically through the adopted methods and forms. "It is never in one place. Our reality continually seeks to mark a boundary." Such boundaries are culturally self-evident, unconscious common knowledge that Granö seeks to bring into view. His work thus involves "the questioning of the self-evident".

But who are these people and what are the lives to which Granö is drawn? And why does he do so? Is it just a freak show in which the artist makes use of a group of strange people? Granö neither preaches nor makes propaganda: he does not tell us that there are different kinds of people, asking us to understand them. In fact, he has sought

the company of his peers.

> I've always looked for people who are like me in a certain way... collectors and folk artists. I've learned much more from them than I've ever learned from art or art exhibitions. They have discussed and thought about these things. Their artistry is based on much more than a social calling or demand. They are committed. That thing inside them is always true and strong. I rely on the world for aid.

How about morals? Granö's own commitment? He never uses the people that he films and photographs without their permission, "but it is much more important that the language that you use is such that it gives them satisfaction, even though it could be read in a different ways." Exploitation – if such a word can be used – is mutual. Granö's own status as an artist is also a channel through which the objects of his interest – mostly people marginalized in the social sense – can find new playing fields, audiences, other realities, and also recognition. Art has traditionally made it possible to outline different world views, experiments, play, anarchy and the testing of rules. The rationality of art differs from technocratic rationality, or the rationality of globalized market forces, which makes exceptions a subject of ridicule, unable to function or excluded, thus permitting only one reality. It would be patronizing to imagine that Granö's subjects could not stand being treated as such objects. At issue here is interaction and mutual commitment. In many cases the situation is even reversed: "They sometimes think that I work for them. I perform services for them; I promote their cause."

We must not forget, however, that Granö is an artist and even though he seeks a broader interface through books and television, his audience is primarily an art audience. "On the average my audience is probably a bit smarter than me, which means that I can make things as complex and demanding as the material at hand requires." Being an artist for Granö is not based on his personality or his career but on individual actions: "Each work must redeem and justify its right to exist... there is an extreme responsibility for that. It is also my weakness... I have to construct its meaning each time...".

Things can be mystified in so many ways – and inevitably they are. The myth of the creative genius has been deconstructed long ago, the now hackneyed phrase, the "death of the author" produces its own mythology and mantras of 'correct' art parlance. Even as a social being, the artist is still an individual, in whom the private and public, the particular and the general, are crystallized like in an object in a collection. Life lived and experienced, but also the endlessly varying threads and strands of history. It is useless to pretend that Granö does not reflect upon himself, his own traumas and dreams: "Art is some kind of blooming of a narcissistic disorder. Of course it has a personal link. I use the document, for instance, in the way that someone makes paintings." Documentariness, however, ensures that art will not remain solely an exercise in introspection. And it is precisely in the documentary form that Granö sees the future of art.

A STRANGE MESSAGE FROM ANOTHER
STAR N/D INSTALLATION DETAIL.
PREVIOUS PAGE AND FRONT PAGE
IMAGE: A STRANGE MESSAGE FROM
ANOTHER STAR N/D INSTALLATION DETAIL.

Veli Granö born
Kajaani, Finland,
1960. Lives and works
in Helsinki, Finalnd.

SELECTED SOLO EXHIBITIONS

2000 *The Star Dweller*, Hippolyte Gallery, Helsinki, Finland
1999 *The Tangible Cosmologies*, Oulu Art Museum, Oulu, Finland
1998 *The Son of Moses*, Hippolyte Gallery, Helsinki, Finland
1997 *The Tangible Cosmologies*, Museum of Contemporary Art, Helsinki, Finland
1995 *The Lost Expedition*, TM Gallery, Helsinki, Finland
1994 *The Illuminated Room*, touring exhibition, Finland
1992 *The Solar Eclipse*, touring exhibition, Finland
1991 *A Trip to Paradise "Septembre de la photo"*, Nice, France
 Union, Hippolyte Gallery, touring exhibition, Finland
1986 *Onnela / A Trip to Paradice*, Hippolyte Gallery, Helsinki, Finland

SELECTED GROUP EXHIBITIONS

2001 *LA International Biennal Art*, Los Angeles, USA
 Aurora, Art Gallery of Sudbury, Sudbury, Canada
 Plateau of Humankind, Venice Biennale, Italy
 Empathy, Pori Artmuseum Pori, Finland,
 Surface and Whirlpools, Artmuseum Borå, Sweden
2000 *Manifesta 3*, Lublijana, Slovenia,
 Utopias, Warwick Arts Centre/Mead Gallery, Coventry, UK
1999 *What is Real*, Haus am Waldsee, Berlin, Germany
 Identiteté Fictive, Gallery Contretype, Bruxelles, Belgium
 Edinburgh International Film Festival, Edinburgh, UK
 International Documentary Filmfestival, Amsterdam, Netherlands
 The Kitchen, New York, USA
 Unknown Adventures, Stadtgalerie im Kulturviertel, Kiel, Germany

SELECTED BIBLIOGRAPHY

Gabriel Bauret:, 'Veli Granö & Pekka Turunen', *Camera International*, Vol 30/1991, Paris, pp 50-59
Veli Granö 'Scale model – a tear in the perspective of reality', *Surface and Whirlpools*, exhibition catalogue, Borås artmuseum, Borås, Sweden, 2001, pp 30-31
Veli Granö, 'A Strange Message from Another Star', *Borderline Syndrome*, *Manifesta*, European Biennale of Contemporary Art, exhibition catalogue, Lubljana, Slovenia, 2000, pp 84-86
Veli Granö 'Dear Paavo', *What is real*, exhibition catalogue, Helsinki Arthall, Finland; Haus am Waldsee, Berlin, Germany, 1999, pp 55-57

Veli Granö, 'The Collector Collector', *Things*, Vol. 6, London, 1997, pp 92-99
Veli Granö, 'Tangible Cosmologies', *Unknown Adventure*, exhibition catalogue, Badisher Kunstverein, Karlsruhe, Germany, 1997, pp 40 -43
Hasse Persson, 'Fångad av Finlands hängivna', *Foto*, Vol. 5, 2001, pp 6-17
Helena Sederholm, 'More than just ordinary art', *Plateau of Humankind*, exhibition catalogue, Venice Biennale, Italy, 2001, pp 129-128
Jyrki Simovaara 'A Strange Message from Another Star', *Utopias*, exhibition catalogue, Warwick Arts Centre, Mead Gallery, Coventry, UK, 2000, pp 5-6

CHECKLIST OF WORKS

A STRANGE MESSAGE FROM ANOTHER STAR n/d
audio-visual installation
dimensions variable

THE STAR DWELLER n/d
audio-visual installation
dimensions variable

works courtesy the artist

DAVID HAINES

93

What if the seventeenth century were to erupt into the present, in a place which had never experienced the seventeenth century as such? A place which may have lived, a time which existed unchanged for centuries, possibly millennia, and which was untouched by Europe and its seventeenth century until the eighteenth? For late post-colonial nations, like Australia, the seventeenth century never existed; it haunts the imagination like a phantomatic cipher, part of the baggage of a culture that can't shed the formations that made it. The Baroque with its folds and its torsions sums up a moment of architecture, or a style of drap-ing, dizzy with the romance of repetition which never reiterates. Even in the modern city, in which there is nothing Baroque,

per se, an energy or a force can bear the imprint of a memory bursting through the repressions of modernism. A city might look modern, but it only takes a slight shift, or a juxtaposition of images, to release a tor-rent, which recalls the Baroque.

Cities never stop bleeding into the past and the future, not even the most modern. Time seeps and lingers, as well as acceler-ates, and the shape of a line or a form, of a juxtaposition of forces, is enough to project the imagination backwards as well as forwards. Time can roll backwards in images which return to a place not yet constructed building pasts which are as real as they are imaginary. It's possible to read the Baroque in a modern city, to sense an energetics belonging to an occulted time.

Haines' cloud-like formation is paradoxi-cally solid and pouring, a time-image which could be sculpted in stone, such is the density of his enigmatic matter; it flows upwards against gravity with the slow weight of a lava which billows in a mass too heavy for billowing. The time-image achieves what the Baroque did in stone,

but backwards, folding the ether of cloud back into a concentrate of matter. The cur-rent swirls against the Baroque movement of infusing matter with the lightness of spirit; rather, from nothing, from an unfurl-ing mass of image, there's a sensing of pressures, and a materialisation of force which imposes with the sentiment of mat-ter. The Baroque seemingly presses itself into the present, through a line of recog-nition, which passes 'without touching'.

The image screen of the cityscape relates to the cloud by a seemingly unseen leap of a ratio of forces. Neither image reveals the origin of its energetic system. The city as time-image is not a representation of what Levinas called the 'il y a' ('there is') of things, but one in which origin is always covered over in the movement of time from one moment to the next. Translated into an energetics, less a place than a sys-tem of relay, of pulsations of darkness and light, the city engages with the shadow play assumed in the Baroque. The lights are not merely sparkling; there's a discern-ible pattern, which reiterates the mutating

rhythm of underlying energies.

In Deleuze's theory of the Baroque, there's a stairway of folding leading from matter to the soul, and a whole system of floors; the Baroque is a house stretching into a tower. The principle of immanence, to which Deleuze adhered, is one in which there is no hierarchy of thought over matter, but only relations of strata and enfoldings, and differentials of speed. Turn the fold of matter over into thought: it's a question of point of view and where you place yourself in the strata. How does a surface fold and emanate an energetics? How is it that the Baroque could spiral up through a series of folds that is also depicting the movement of energies, if the folding of planes wasn't enough to create movement?

There are no depths only an unfolding of surfaces. Depth itself is always hidden and can only reveal itself in a series of, or comparison of, surfaces. Haines' city scape emanates a ratio of the modulations of city-as-motion laid out in one surface, while the pouring cloud rears up as a torrent to image the depths of many surfaces.

The Seventeenth Century is multiple not double. If there's a mirroring, it's a mirroring to infinity, in which a differential ratio of distances and angles causes it to exist in more than one 'place' in the energetics of its images. It's time-image, not simply because the images change over time, but because the work fulfils the conditions of the notion as developed by Deleuze in his analysis of cinema: time-image is based on a shift from the linear progression of narrative (movement-image) to the multiplicity of holding different states in time.

One not only senses the force behind the billowing cloud of matter but transposes this feeling between images, sensing both as different states of the same; the city-scape can be thought of as a slowed down spread-out plane; the Baroque spiraling of cloud occupies a strata which is accentuated and accelerated. As such there are no signifiers in circulation, as in the familiar Freudian theory of the unconscious, in which connections are made in the hidden or occulted psychical paths of the unconscious. In Haines' cinema of immanence

there's no unconscious to be dredged. No narrative, no signifiers. There are no stories to be told, rather shifts of intensities pertaining to states. Therefore, there are no people-to-people cathexes or cathexes between people and things (fetishes, fixations). There's rather a Deleuzian geology in which the relation is not even one of thing-to-thing, but rather one of surfaces or planes, and speeds and differential flows. Immanence is the knowledge that rises from the surface of matter, or the surface of a screen, and which, in turn, can fold into the surface of thought. Equally you can think immanence through the 'immaterial' material. You begin with planes and states. Haines, like Deleuze, chooses not to fathom psychical paths for occulted knowledge, but to yield to the principle of immanence for what it displays on the surface.

ATOMIC 2001 PRODUCTION STILL
FROM THE VIDEO INSTALLATION.
FRONT PAGE IMAGE: THE FIFTEENTH
CENTURY 2002 COMPUTER GENERATED
IMAGERY FROM THE ARTIST'S DATE OF
BIRTH, PRODUCTION DETAIL FROM THE
SINGLE CHANNEL VERSION.

David Haines born London, UK, 1966. Lives and works in Sydney, Australia.

SELECTED SOLO EXHIBITIONS

2000 *Atomic*, Blue Oyster Gallery, Dunedin, New Zealand
1998 *Avatar* The Physics Room, Christchurch, New Zealand
 Music's Dead Return, Manning River Regional Art Gallery, New South Wales, Australia
1997 *Medievalism – Musical and Non Musical Kingdoms,* Artspace, Sydney, Australia
1996 *Silver Forest Cemetery & Words become stars,* Artist in residence at the Australia Council's Tokyo Studio, Z.A. Moca Contemporary Art Foundation, Shinjuku, Tokyo

SELECTED GROUP EXHIBITIONS

2002 *The Levitation Grounds*, ARCO, Madrid, Spain
 Undertow (collaboration with Joyce Hinterding and Scott Horscroft), Commissioned work for Federation Square public art program and Cinemedia, Melbourne, Australia
 Deep Space, Sensation and Immersion (collaboration with Joyce Hinterding), The Australian Centre for the Moving Image, Melbourne, Australia
 Problems in Paradise, Scott Donavan Gallery, Sydney, Australia
2001 *Space Odysseys: Sensation and Immersion*, Art Gallery of New South Wales, Sydney, Australia
2000 *Pivot V: about Photography, The Levitation Grounds*, Carnegie Gallery, Hobart, Australia
 The Levitation Grounds (collaboration with Joyce Hinterding), Artspace, Sydney, Australia
 The Bird and the Piano - Harmonia, West Space, Melbourne, Australia
1999 *Museum of Fire included in an Eccentric Orbit*, Museum of Contemporary Art, Sydney, Australia
 Edges - the Cape Bruny Light station project (with Joyce Hinterding), Cast Gallery, Hobart, Australia
1997 *Music's Dead Return*, Side On Gallery, Sydney, Australia
 Medievalism – Musical and Non Musical Kingdoms, Artspace, Sydney, Australia
 Evil Art, Side On Gallery, Sydney, Australia
1996 *Palimpsest – exhibition of artists working with text*, Artspace, Sydney; RMIT, Melbourne, Australia
 The Eastern Dark, Canberra Contemporary Art Space, Canberra, Australia
 Mesh, site specific project, Kitayama, Kyoto, Japan

SELECTED BIBLIOGRAPHY

Adam Geczy, 'Space Odyssey: Light visions', *RealTime* #45 Oct-Nov, 2001
Benjamin Genocchio, 'Mind Altering multimedia mix', *The Australian*, 24 August 2001
Charles Green, 'Review of Levitation Grounds', *Art + Text*, No. 70, August-October 2000
J Haynes, 'D. Haines: Emo', *Wire Magazine, Adventures in Modern Music* Issue 211, September 2001
Peter Hill, 'Vision Shines in Lighthouse', *The Australian*, 30 April, 1999
Bruce James, 'Take a walk on the quiet side of techno-art', *Sydney Morning Herald*, 12 September 2001, p 16
Douglas Kahn, and Fran Dyson, 'The Levitation Grounds', *Eyeline* 43, Spring 2000
Sean Kelly, 'art.buisness@the Lighthouse', *Art Monthly* , No. 119, May 1999, p 20
Diana Klaosen, 'A meta world of watchfulness' *Real Time*, 31, June-July 1999, p 38
Victoria Lynn, *Space Odysseys*, exhibition catalogue, Art Gallery of New South Wales and Australian Centre for the Moving Image, 2001

CHECKLIST OF WORKS

THE 17TH CENTURY 2002
DVD video and sound work
dimensions variable
courtesy the artist

WHEN NEXT IN NEW YORK
WHY NOT MAKE A NOTE
TO VISIT ~~Plato's Cave~~ PLATO'S CAVE
THE NEW BAR IN THE
BASEMENT OF THE
MUSEUM OF CONTEMPORARY IDEAS

Linking Drinking with Thinking

Heroic Amateurism and other SUPERFICTIONS:
Peter Hill interviewed by Jonnie Gimlet on:
http://toolshed.artschool.utas.edu.au/moci/home.html

Jacko's Taxi Service
Intelligent Banter or a
Quiet Ride – your choice!
Phone: Aberdeen 6461 3333
e-mail: wheels on fire@fine.quine.demon.co...

IN 1989 I MAILED OUT THE FIRST IN A SERIES OF PRESS RELEASES FOR A FICTIVE MUSEUM ON NEW YORK'S PARK AVENUE CALLED THE MUSEUM OF CONTEMPORARY IDEAS (MOCI) – NOTIONALLY THE LARGEST NEW MUSEUM IN THE WORLD. ALL OF MY SUBSEQUENT 'SUPERFICTIONS' HAVE BEEN SOURCED FROM THAT ORIGINAL SEVEN PAGE PRESS RELEASE. The characters and fictive organisations in the on-going narrative include the *Cameron Oil* company, based in Alaska; the museum staff (in excess of 500); freelance critics and curators; and a wide range of individual artists and art teams, including: Aloha; Ralph Kapper; Made in Palestine/Made in Israel; Art Against Astrology; Milco Zeemann; The Triplet Twins; Herb Sherman; Hal Jones; and Nouvelle Kunst Faction (NKF). Plato's Cave, in the basement of the museum, quickly became the hippest place to see and be seen in late eighties Manhattan. In Germany, *Wolkenkratzer Art Journal*, having received the first press release, published an article on the museum, believing it to be real. Six years later, these same characters and organisations reappeared in a hybrid superfiction called *The Art Fair Murders*, an on-going novel and installation linked by the Museum of Contemporary Ideas web-site – www.nymoci.com Within this superfiction, the novel is supposedly being written by Jacko, an ex-Goldsmiths graduate from Glasgow who lost his job as an art transporter when a small Lucien Freud painting went missing on its way to the Cologne Art Fair in 1989, the very weekend the Berlin Wall was brought down. Jacko and his mates invented a form of 'art transporter rhyming slang': Georges Braque for 'sore back'; Fra Filippo Lippi for 'hippy'; Damien Hirst for 'First' (as in First Class Honours); and Sir William Russell Flint for 'skint'. Jacko now drives a taxi in Aberdeen, the oil capital of Scotland. It is here that he has teamed up with a science fiction writer called Zoran who is his unpaid adviser to *The Art Fair Murders*. Both men meet every day down at Aberdeen's often storm-lashed beach front, where they discuss the world of writing over all-day breakfasts and surreptitious nips of whisky. *The Art Fair Murders* is set in 1989, the great year of revolutions, the year of the Tank Hero in Tiananmen Square; the fall of the Berlin Wall, and the release of the Guildford Four. Somewhere, out there, a serial killer is at large, criss-crossing the world in 747s as he (or could it be 'they'?) go from art fair to art fair killing their victims in ever more ingenious ways. It all begins in January in Miami, then February in Madrid, Melbourne, London, Frankfurt, Chicago, Basel, and so on through to December in Los Angeles... During the run of the 2002 Sydney Biennale a new clue to *The Art Fair Murders* will be placed on the Biennale and MOCI web-sites every day. An archive tracing 'The Making of The Art Fair Murders' can also be visited at www.nymoci.com

Made in Palestine

The James Lee Byars Fan Club

Made in Israel

The Res Ingold Fan Club

PETER HILL

TRUE LIES AND SUPERFICTIONS

JOHN A. WALKER

Peter Hill's 'Museum of Contemporary Ideas' (MOCI) is an ambitious long-term exploration of fiction and humour within contemporary art. It was conceived in 1986 and the first fictional press releases for the museum appeared in 1989. They were sent around the world, as a mail art project, to press agencies like *Reuters* and *Associated Press*, to Fleet Street newspapers, gallerists, curators, art magazines and friends of the artist.

Hill, an installation artist, writer, art magazine editor and lecturer, was born in Glasgow in 1953 and subsequently travelled the globe. During the eighties, his base was in Scotland and in the nineties he moved to Tasmania, Australia's island state. He is currently based in Sydney where he lectures at the University of New South Wales, College of Fine Art.

Hill invents what he calls 'Superfictions' and, via an Internet encyclopaedia, he has documented over sixty artists from around

the world who work in a similar manner. They include: Guillaume Bijl, Janet Cardiff, Joan Fontcuberto, Rodney Glick, Res Ingold, Ilya Kabakov, Seymour Likely, David Wilson's Museum of Jurassic Technology, SERVAAS, and Alexa Wright.

A Superfiction is a fictional situation or narrative that deceives the eye and mind in the sense that *trompe l'oeil* painting does. Most viewers realize that such paintings – however illusionistic – are representations, but some viewers are fooled into taking the image for reality. The same logic applies to Superfictions.

MOCI is a collection of Superfictions. It is supposedly situated in New York but is really a conceptual/cyberspace phenomenon that can be accessed via a website (while still relying on the conventional postal system for its 'mail art' activities). Masquerade and the adoption of false identities are central to Hill's project. Like bricks-and-mortar museums, MOCI has various departments, such as a press office, shop, portrait gallery and a fashionable Tapas bar in the basement called *Plato's Cave*, where the legend on the beer coasters is 'Linking Drinking with Thinking'. Alice and Abner 'Bucky' Cameron,

the museum's billionaire patrons, are also part of another Superfiction *The Cameron Oil Company*.

In the mid-nineties, Hill launched a Superfiction called *The Art Fair Murders* which claimed that a serial killer was active in the art world. It was part novel, part installation, linked by a website. His starting point was the conjunction of two clichés: the over-use of the mannequin in contemporary installation art and the serial killer from pulp fiction crime stories. Hill began in reverse by writing the sort of 'blurb' normally found on the back of an airport novel and usually written by someone in the marketing department of a large publishing house. This became the template for the on-going narrative. He then prepared two advertisements for *The London Review of Books*. The first[1] stated that *The Art Fair Murders* would be auctioned on the Internet on a certain date and called for expressions of interest. There was no response. The second advertisement[2], placed a few months later, said that bids in excess of $500,000 would be welcome. This was a tongue-in-cheek reference to the furore over Martin Amis' advance of £500,000 for

Art World Fan Club 1988-2001
now showing at:

THE SYDNEY INTERNATIONAL PORTRAIT GALLERY

Fax: (02) 9818 4476
www.nymoci.com

The art team **Made in Palestine/Made in Israel** are based in Antwerp, Belgium. They first came to prominence in 1989 in the exhibition of international art teams called **New Compixies, New Dance Steps**, curated by Eric van Vliet at New York's **Museum of Contemporary Ideas**. By chance, the duo are of Jewish and Muslim descent. By design, they claim "No idea is more important than a human life". Between January 3rd and February 10th 2002 a small selection of their on-going project 'Art World Fan Club, 1988-2001' will also be previewed at The Australian Centre for Phortography in Paddington, Sydney.

An **Art Fair Murders'** Production sponsored by **Cameron Oil**

PRESIDENT GEORGE W. BUS[H]

THE WHITE HOUSE

1600 PENNSYLVANIA AVE[NUE]

WASHINGTON, DC

20500 USA

Concept: Peter Hill **Design:** Three Little Words

his novel *The Information*, and the lack of scandal over Nicholas Evans' more populist *The Horse Whisperers* and its $3 million advance. Immediately, faxes arrived in Hill's office from agents and publishers in Rome, London, Tokyo, and New York. Thus began a critique on the world of publishing as well as the contemporary art world. Faxes, letters, emails and newspaper clippings relating to this can be viewed on the MOCI website at <www.nymoci.com>. When you visit the home page, you will see a museum elevator with different Super-fictions on each floor. To access the archives, take the elevator to the floor marked 'The Art Fair Murders' and then click on 'The Making of *The Art Fair Murders*'.

Peter Hill is currently planning other Superfictions, including a fictional advertising agency, an art school and a soap opera. In progress are two Superfictions relating to 'cultural tourism'. One calls for the establishment of a 'Pacific City of Culture', based on the European model, which will move around the Pacific Rim every year. This has the working title of 'Ocean Necklace'. The other, 'Paintforum International', will be a global forum for painters similar to the

Munster Sculpture Project but held in a different city on each occasion: Amsterdam, Sydney, Edinburgh, Chicago, Wellington, Hong Kong and so on. Fiction, Hill maintains, can produce more dynamic and tenable blueprints for such structures than orthodox channels.

Even though Hill pursues a strategy he calls 'heroic amateurism', philosophers such as Paul Feyerabend, Thomas Kuhn and Karl Popper have influenced his thinking regarding the nature of truth and reality. He has also developed a theory called 'synthetic modernism', based on Apollinaire's quartering of Cubism, that represents the area of overlap between so-called modernism and post-modernism – a zone where the past and the future can co-exist creatively.

Hill deliberately subverts his own projects by feeding bad puns and jokes into his press releases. However, this is a way of using language as a testing device because the puns are seldom picked up in countries where English is not the first language. Language thus becomes the deciding factor in whether or not a Superfiction is considered a hoax or a real event.

A recent project at Oxford's Museum of

Modern Art [3] saw Hill establish a police 'incident room' within the museum, and lay a murder mystery trail through the city. On the final day, he staged his own kidnapping from the podium while giving a performance/lecture to which he had invited everyone with the surname 'Cameron' derived from Oxford's phone book. Each was sent a *Cameron Oil* pen from Australia in advance of the project plus an invitation to attend.

Hill's contributions to the ocean of information are playful but have serious intentions: to mirror and critique the commercial art world, to subvert mass media news reporting and government propaganda by making viewers more alert and sceptical.

1. *London Review of Books*, 14 Dec. 1995, p 27
2. *London Review of Books*, 7 March, 1996, p 23
3. May 2000. Extended from a section in *Art in the Age of Mass Media*, London, Pluto Press, Third Edition, 2001.

MUSEUM OF CONTEMPORARY IDEAS
ALL IMAGES: INSTALLATION DETAILS.

Peter Hill born
Glasgow, Scotland,
1953. Lives and works
in Sydney, Australia.

SELECTED SOLO EXHIBITIONS

2001 *The Art Fair Murders*, MOMA 2000, Museum of
Modern Art, Oxford, UK
2000 *The Art Fair Murders*, RMIT Gallery, Melbourne,
Australia
The Art Fair Murders, Geelong Art Gallery, Australia
1997 *The Art Fair Murders*, Auckland City Gallery, New
Zealand
1995 *Superfictions*, Cullity Gallery, Perth, Australia
Superfictions, University of South Australia Art
Museum, Adelaide, Australia
1994 *Project Space*, Art Gallery of New South Wales,
Sydney, Australia
1989/02 *The Museum of Contemporary Ideas*, on-going mail
art project

SELECTED GROUP EXHIBITIONS

2002 *Stranger Than Truth*, Australian Centre for
Photography, Sydney, Australia
2001 *Hotel Art Fair*, Hubert Winter, Vienna, Austria
1997/99 *Networking*, Hayward Gallery, South Bank, London,
and touring, UK
1996/97 *How Say You?*, Australian Centre for Contemporary
Art, Melbourne, Australia, and touring
1993 *Install x 4*, Plimsoll Gallery, Hobart, Australia
1992 *Seven Disparate Artists*, Deakin University, Geelong,
Australia
1998 *Fruitmarket Open Exhibition*, Edinburgh, Scotland
Crammond Sculpture Park inaugural exhibition,
Edinburgh, Scotland
1984 *Five Artists*, Cite International des Arts, Paris, France
1983 Royal Scottish Academy, Edinburgh, Scotland.
Winner Latimer Award for painting

SELECTED BIBLIOGRAPHY

Andrew Bogle, *The Art Fair Murders*,
exhibition catalogue, Auckland 1997,
pp 1-8
Adrian Heathcote, 'The Rise and Rise of
the Superfiction', *black + white*,
Sydney, February 1995, pp 32-33
Peter Hill, 'Rise of the Superfictions',
The Times Higher Education Supplement,
London, 6 August,1999, p 19

Peter Hill, *Photofile*, guest editor of
'fictions' issue, #59, May 2000
Gabriele Von Knapstein, 'Museum of
Contemporary Ideas', *Wolkenzratzer
Art Journal*, Frankfurt, September -
October 1989, p 54
John A Walker, *Art in the Age of Mass
Media*, third edition, Pluto Press,
London, 2001, pp 169-170

CHECKLIST OF WORKS

BLUE CANVAS 1999
2 works, acrylic on canvas
10.7 x 5.6 cm each

BUBBLE-WRAPPED PACKAGE 1999
wood and glass
297 x 23 x 15 cm

FRAMED AND GLAZED PHOTOGRAPHIC
IMAGES 1988-2002
3 photographs
4.7 x 4.1 cm each

FRAMED CANVAS 1996
acrylic on canvas
7.8 x 6.6 cm

FRAMED CANVAS 1996
acrylic on canvas
9.0 x 7.8 cm

ONE CRATE (MARKED BEUYS) 1989
wood and plastic
2.2 x 2.2 x 1.7 cm

PACKAGE OF 3 STRIPED CANVASES
1995
acrylic on canvas
124.5 x 91.5 x 10 cm

SMALL PACKAGE OF WALL TEXTS 1999
card
30.5 x 23 x 10 cm

GALLERY SIGNAGE 1990-2002
4 works, wood and text
221 x 18 x 7.5 cm each

collection: the artist
courtesy the artist

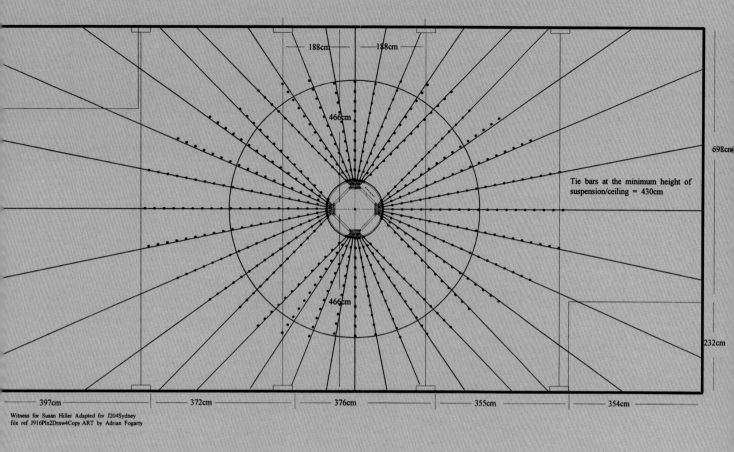

188cm — 188cm

466cm

698cm

Tie bars at the minimum height of suspension/ceiling = 430cm

466cm

232cm

397cm — 372cm — 376cm — 355cm — 354cm

Witness for Susan Hiller Adapted for J204Sydney
file ref J916Pln2Draw4Copy.ART by Adrian Fogarty

WITNESS: NOTES ON THE ARCHIVE / "I FELT SOMETHING LIKE A MAGNETIC FIELD, AN OPPRESSIVE HEAT, A SURREALISM OF SILENCE, AN ATMOSPHERE, A MIST, A LINE OF COLD AIR, A DREAMLIKE STATE. I REPORTED IT TO THE POLICE; I NEVER MENTIONED IT TO ANYONE." *Witness* is an audio-scupture that uses sound to explore that unstable territory where 'the visible' merges with 'the visionary'. Like earlier works of mine, *Witness* reconnects 'objectivity' and 'subjectivity' in its content and intended effect. In the *Witness* files you will hear stories "too strange to tell until now" alongside stories that have been retold over and over again. The stories have been sourced from confessions broadcast on the Internet to anyone who will listen and from eyewitness statements recorded by the police, the army and various investigative bodies. Included in the archive are very embarressing stories, shocking stories, beautiful stories, matter-of-fact descriptions of incredible sights and poetic revelations concerning small incidents. All the stories recount personal sightings and encounters with: (1) strange lights, (2) mysterious flying objects and (3) non-human beings. The *Witness* archive is a multi-lingual polyphony of (social) facts; whether the incidents recounted are empirically verifiable or whether they exist in a different kind of reality altogether is, in my opinion, a separate issue...

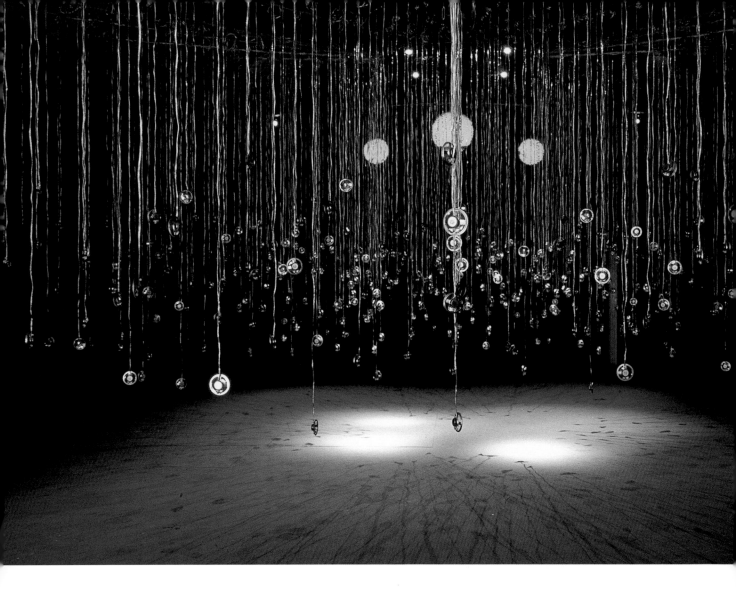

SUSAN HILLER

RACHEL WITHERS

When discussing her work, Susan Hiller is often obliged to remind people of a rather basic point: A work of art's 'subject-matter', and what the work is about, are not the same thing. Spanning nearly thirty years, Hiller's practice constitutes a veritable Wunderkammer of intriguing and entirely idiosyncratic artefacts; browse the shelves, and you'll find recordings of the dead speaking from beyond the grave; Victorian memorial plaques relating tragic instances of heroic self-sacrifice; documents of experiments in telepathy and automatic writing; fictional and real-life tales of children with telekinetic or miraculous powers; hundreds of postcards of stormy waves bombarding the esplanades of British seaside resorts; eye-witness accounts of unexplained image appearing on TV after closedown – to give a very selective list. Putting into practice her own definition of artists as 'experts in their own cultures', Hiller excavates, analyses and archives the treasures lying just beneath the surface of Western modernity: 'lowbrow' material, 'dis-credited' debates and vernac-ular knowledges likely to be classed as irra-tional, superstitious or even trivial according to mainstream intellectual criteria. Which of course makes it terribly attractive and arresting stuff, so it's not surprising that some viewers get hung up on what's apparent. However, Hiller's subjects are essentially devices – rabbit-holes down which attentive viewers chase, to be sent plummeting into realms of revelation, speculation and productive uncertainty.

Witness's subject-matter takes the form of individual testimonies: story upon story of UFO sightings and encounters with alien beings, almost all retold in the first person. Hiller collected the material over several years, scouring books, specialist archives, official records and, most importantly, Inter-net sites (parallels between the mysterious space of the cosmos and the mysterious non-space of the Net aren't hard to dream up). *Witness's* UFOs come in all shapes and sizes: plate-shaped, cigar-shaped, domed and pyramidal; swimming-pool sized and football-pitch sized, their lights are red, blue, white, multicoloured and/or flashing; some convey messages of cosmic harmony while others instil sheer terror. *Witness's* witnesses are a truly international delega-tion, and their experiences are relayed in a multitude of languages: the piece unites a Japanese photographer, a Bengali school-teacher, a New York aviation student, a Spanish shepherd, a British policeman, a Danish nurse, and literally hundreds of other individuals in an extraordinary disembodied colloquy.

Did these visitations really happen? Is there anybody out there? In interviews, Hiller herself patiently insists that the reality or unreality of UFOs isn't the key issue. *Witness's* testimonies exist as social facts, she points out; they are real and available for artistic use, just like Cézanne's apples or the bus tickets Schwitters co-opted into the world of Merz. Hiller's analogies endow her raw material with a reality akin to that of concrete, physical, visible things, and following on from this, we might note that words such as 'witness' and 'testimony' are embedded, via their Latin roots, in Western thought's conflation of knowledge, embod-iment and the visible: If you can see some-thing and touch it, then it must be real. So a little circumspection may be advisable here, because although *Witness* does indeed

present visitors with really real, existent material, it does so primarily through the medium of sound, and our relations with the aural domain are substantially different from those we maintain with the visual and tactile fields. Jonathan Ree observes (in *I See a Voice*, 1999) that sounds are 'wraith-like' compared to the objects of vision; things heard are far less amenable to reality-testing and cross-checking than things seen. (What would it take to make a sound 'unreal'? he ponders.) However, by homing in on tales of UFO sightings, Hiller seems to have located a class of predominantly visual experiences possessing an 'unverifiability' similar to that of aural phenomena. So is *Witness* about 'seeing things' – or hearing things? Once we've got this far, we are already well on our way down the rabbit-hole.

Let's underline the word 'disembodied' in 'disembodied colloquy'. We think we hear voices, but Hiller's installation, a network of fine wires, steel cables and small, opalescent speakers hanging in dimly-lit space, is actually a faceless, lungless, sound-reproducing apparatus. Moreover, the recorded material isn't spoken by the original 'witnesses', but

by volunteer readers who are (in many cases, very beautifully) reconstructing fragments from the artist's archive. From time to time, the hubbub of voices temporarily subsides and the speakers transmit a single message in unison, but most of the time the particular path individual visitors choose will determine what they hear; one may sample the ambient sound, picking out fragmentary phrases above the general hum, or lift a speaker to an ear to focus on a particular testimony. This means that no two experiences of the work will be identical – it's created and re-created, with endless variations, through the processes of moving and listening.

Witness has been characterised as an exploration of the voice both in, and as, representation. But, as Gemma Corradi Fiumara writes (*The Other Side of Language,* 1990) there can be "no saying without hearing, no speaking which is not also an integral part of listening, no speech which is not somehow received"; in the Western tradition, listening is the repressed of speech. The strategy of reinvesting a given binarism's discredited or overlooked term is a cornerstone of Hiller's work: she is committed,

she says, to that which is "out of sight or beneath or beyond recognition within our culture" and "making the negative positive". We can trace the process in Hiller's reanimation of aspects of Surrealism, the troublesome, messy, impure repressed of analytical Modernism; in her persistent preoccupation with the re-evaluation of the feminine; or her attempts to outwit the dialectic of rationality and irrationality. *Witness*'s exploration of sound goes beyond the standard critique of the hegemony of vision, because it redresses the traditionally unequal relation between 'passive' listening and 'active' utterance. Hiller's UFO-spotters are both recipients of extraordinary experiences and tellers of stories: the particular nature of their witnessing synthesises 'passive' reception and 'active' speech. In a parallel synthesis, Hiller's audience 'actively' creates its own aesthetic experience through the 'passive' act of listening. So maybe this is what the work is 'about': refocusing our attention on ourselves as listening bodies, we, *Witness*'s audience, become the key witnesses.

Susan Hiller born Tallahassee, Florida, USA, 1942. Lives and works in London, England.

SELECTED SOLO EXHIBITIONS

2001 Gagosian Gallery, New York, USA
2000 *Witness*, Artangel commission at The Chapel.
 London, UK
1999 Delfina Gallery, London, UK
 Tensta Konsthalle, Stockholm, Sweden
1998 Institute of Contemporary Art, Philadelphia, USA
 Projektgalerie, Leipzig
 Henie Onstad Kunstsenter, Oslo
 Experimental Art Foundation, Adelaide, Australia
1997 Foksal Gallery, Warsaw, Poland
1996 Tate Gallery, (retrospective), Liverpool, UK

SELECTED GROUP EXHIBITIONS

2001 *Empathy*, Taidemuseon, Pori, Finland
2000 *Bienale de Habana*, Havana, Cuba
 *Live in Your Head: Conceptual Art in Britain 1965-
 75*, Whitechapel Gallery, London; Museu do Chaido,
 Lisbon, Portugal
 Intelligence, Tate Triennale, London, UK
 Amateur/Eksdale, Kunstmuseum, Goteborg, Sweden
1999 *The Muse in the Museum*, Museum of Modern Art,
 New York, USA
1998 *Out of Actions*, Museum of Contemporary Art, Los
 Angeles, USA
 In Visible Light, Moderna Museet, Stockholm,
 Sweden
1996 *Inside the Visible*, Institute of Contemporary Art,
 Boston, USA; Whitechapel Gallery, London, UK
 Now/Here, Louisiana Museum, Humlabaek, Denmark

SELECTED BOOKS & MONOGRAPHS

Guy Brett, Robecca Cochran, Stuart Morgan, *Susan Hiller*, Tate Gallery Liverpool, 1996
David Coxhead, Susan Hiller, *Dreams: Visions of the night*, (reprint) Thames & Hudson, London, 1996
Barbara Einzig, ed., Lucy Lippard intro, *Thinking about art: Conversations with Susan Hiller*, Manchester University Press, Manchester, 1997
Jean Fisher, Fiona Bradley, Susan Hiller, *Dream Machines*, South Bank Centre, London, 1999
Tim Guest, Richard Grayson, Denise Robinson and others, *Lucid Dreams*, Henie Onstad Kunstsenter, Oslo, 1999
Matthew Higgs, Chris Turner, *PSI Girls*, Site Gallery Sheffield with Tensta Konsthalle Stockholm, 1999
Susan Hiller, *Freudsche Objekte*, Institute fur Buchkunst, Leipzig Germany, 1998
Susan Hiller, *After the Freud Museum*, Book Works Press, London (paperback reprint), 2000
James Lingwood, Susan Hiller, *Witness*, Artangel, London, 2001
Stuart Morgan, Denise Robinson, *Wild Talents*, Foksal Gallery Warsaw with Institure of Contemporary Art, Philadelphia USA, 1998

CHECKLIST OF WORKS

WITNESS 2000
audio sculpture
approx 9.3 x 18.5 x 4.6 m (high)
commissioned by Artangel, London

JOYCE HINTERDING

JOYCE HINTERDING

AIR-TIME: THE LOGIC
OF THE SUPPLEMENT

ANN FINEGAN

Call it a phenomenon in search of an imaginary. Viewed in itself, as a system which mediates the multiple transformations of energetic states, this is a work bound up in matter-as-phenomenon, or material aggregate. Yet, on the imaginary plane, it is a concrete poem, a machine for manufacturing thoughts. The reply to the questions of 'what is it?' or 'how does it work?', 'what is it for?' etc. return to a thought or a series of thoughts which stimulate the mind. On the one hand there is the raw phenomenon, stripped back to the functionality of a grunge or minimalist technology. Then there are the video screens fictionalising the processes-at-work. The material plane of the phenomenon is thus exchanged for the expressive. This is not illustration in the sense of drawing or reproducing what something looks

like to the eye, as in representing the thing, but a crossing over of the manifestation of a phenomenon (the entire complex of the plasma burning/air time event) into the plane of the imagination. You have to figure out the assemblage and what it is for, then trace lines of linkage which run from material aggregate to the plane of expression. The machinic complex becomes image (rather than the image reproducing the appearance of the machine) and takes off elsewhere into fictive apprehensions of a work which, technically, can't be seen 'on its inside', as process, as functionality. Hinterding is adding the visual supplement of what can only be made up.

The supplement supplements. According to an early Derridian 'law', the supplement is always supplementary to any original, and never its completion. The work of the supplement paradoxically 'adds nothing' to the work as phenomenon, and yet is the addition through which the work disseminates. Science is full of supplements – diagrams, formulas, charts and ideas – without which the work is said to be incomplete, and yet the supplement does not literally

complete it in the same material plane, but rather supplements, extends, explains. It does what the work itself cannot do: translate and inform upon itself.

The phenomenon, then, can't reflect on itself, but can only call upon the supplement to 'duplicate' in translation, in other words, not to duplicate 'per se' but to translate to another plane, that of expression.

Derrida theorizes this somewhat conflictory and contradictory relation. The supplement threatens to take over, usurping the first place of the original. The image supplants the thing, becoming more important. Or does it? Is it really a question of priorities or origins... or rather, the undecidability of an incommensurable relation between two parts of a work, which simultaneously exists in two planes?

Can't a work be said to begin in the middle, in a process of reflection that is as much bound up with material phenomenon, however partially realised, and the play of the idea which is realised by inspiration? For an artist coming upon phenomena, the conceptual process goes both ways, exploring both thing and image. As such

the two aspects of the work, material phenomenon and image plane, can be read from either direction. Beginning with the image, the assemblage comes into being to manifest the idea as supplementary material counterpart; conversely, reading from material assemblage to image, the image becomes supplementary to the machine by explaining it. There's a complementary supplementarity in which both aspects supplement the other. This undecidability links the incommensurable parts, and makes them indispensable to each other. It becomes nonsensical to ask which comes first, thing or image?

Rather, in order to put two and two together you have to mentally image one aspect in the other; the image wraps itself inside the machine in order to mimic, however 'wrongly', for want of a true image, the interior electronic flows; equally, the machine could be said to literally wrap or engulf the image which expresses the content of its processes. Both wrap around each other, confounding the inside/outside relation, whilst remaining absolutely incommensurable.

Thus, the image is both inside and outside the 'work-as-phenomenon': an exterior depiction of what's going on inside. The inside is the outside, and vice versa, but projected as disjunctive surfaces which never match. You can't turn a machine transforming electromagnetic streams inside out like a glove. Instead, there will only be a differential of surfaces and planes.

In a sense, then, it doesn't particularly matter whether one understands exactly what is being produced by the technological apparatus (apparently matter in its fourth state). The work unfolds through the logic of the supplement in which the imaginary informs the material work, at the same time as the material work produces the imaginary, without any sense of equivalence between the processes. There is both translation, from phenomenon to image and from image to phenomenon, as well as the actual states of energetic transfer and transformation going on inside the 'machine'. Even though Hinterding can accurately describe the actual energy transfers and flows inside the 'plasma wave instrument', this is never reproduced

diagrammatically as image. Therefore there's no technical correlation between 'how it works' and the dynamics of the images on the screens which remain purely imaginary. The profound disjunction between image and machine is respected, even though both the material and imagistic planes are inextricably intertwined, one inside the other.

On a technical note, the machine can be described as aberrant TV. Hinterding has taken television's electron-gun or ray technology and unhooked this process from image transmission. What is left is the raw process of transmission itself, matter in its fourth state as plasma detectably burning the air. The reference to 'air-time', is thus to TV's own phenomenon and less about the content of being 'on air'. Air-time is the guts of deviated TV: its stepped up voltage is no longer pumping out high speed electrons to contact a picture screen but generating, instead a pure plasma stream. Paradoxically, Hinterding is imaging that part of the process of TV, which is without image.

Joyce Hinterding born
Melbourne, Australia,
1958. Lives and works
in Sydney, Australia.

SELECTED EXHIBITIONS

2001 *7th Istanbul Biennial,* Yerebetan Cistern, Istanbul,
 Turkey
 *Space Odysseys, Immersion and Sensation, The
 Blinds and the Shutters* (in collaboration with David
 Haines), Art Gallery of New South Wales, Sydney;
 The Australian Centre for the Moving Image,
 Melbourne, Australia
2000 *Pivot V: about Photography 'The Levitation
 Grounds'* Carnegie Gallery, Hobart, Australia
 The Levitation Grounds (collaboration with David
 Haines), Artspace, Sydney, Australia
1999 *Manifesto,* Time Capsule, Experimental Media Arts,
 Span Galleries, Melbourne, Australia
 Edges, Cape Bruny Lightstation (collaboration with
 David Haines), Bruny Island, Tasmania; *CAST,*
 (Contemporary Art Services Tasmania) Hobart,
 Australia
 terra_nova, collaborative web event: *"nervous
 objects"* – http://no.va.com.au/terra – Pekina,
 Central South Australia
1998 *Aeritis,* "Ideal Australia" Publication; Experimental
 Art Foundation, Adelaide, Australia
 Aeriology, V2 Institute for unstable media,
 Rotterdam, Netherlands
1997 *The K Files,* Side on, Sydney, Australia

SELECTED BIBLIOGRAPHY

Susan Best, 'Elemental constructions:
women artists and sculpture in the
expanded Field' *Australian and New
Zealand Journal of Art* ,Vol. 1, No. 2,
2000, pp 147-162
Ann Finegan, *I_TONE aeriology,* exhibition
catalogue, Artspace Sydney, 1997
Peter Hill 'Vision Shines in Lighthouse'
The Australian, 30 April, 1999
Joyce Hinterding, 'Des Funkin Sprunklin
Globus', *Essays in Sound 3,* Contemporary
Sound Arts, 1997, p 113-116
Joyce Hinterding, 'The Oscillators,
Sensitive systems and Abstract machines',
Leonardo Music Journal, Vol. 6, The
MIT Press, 1996, pp 113-114

Joyce Hinterding & Ann Finegan,
'Aeritis', *Ideal Australia,* Experimental
Art Foundation, Adelaide, 1998
Douglas Kahn and Fran Dyson,
'Wrapture', *Artbyte* Sept-Oct 2000
Douglas Kahn and Fran Dyson, 'The
Levitation Grounds', *Eyeline* 43 Spring,
2000
Charles Green 'Review of Levitation
Grounds', *Art and Text,* No. 70,
August-October 2000
Sean Kelly, 'art.buisness@the Lighthouse',
Art Monthly, No.119, May 1999, p 20
Diana Klaosen, 'A meta world of
watchfulness' *Real Time* 31, June-July
1999, p 38

CHECKLIST OF WORKS

THE PLASMA WAVE INSTRUMENT:
AIR TIME 2002
audio-visual installation, dimensions
variable
courtesy the artist

I COMMENT ON REALITY THROUGH MY ORDINARINESS. I WORK AT HOME, FOLLOWING THE RHYTHM OF COMMON-PLACE ACTIVITIES. LIFE AND WORK INTERLINK. BORDERS BETWEEN THEM BECOME BLURRED NOW AND AGAIN. WORK IS THE RESULT OF AND A SUPPLEMENT TO MY EVERYDAY LIFE. IT FILLS UP EVERY SPACE ORDINARINESS HAS LEFT EMPTY. SCULPTURES (OBJECTS) ARE MADE OF MATERIALS THAT CAN BE FOUND IN MY IMMEDIATE SURROUNDINGS. IT TAKES NO EFFORT TO OBTAIN AND GATHER THESE MATERIALS. THEY ARE WITHIN REACH. THEY FREQUENTLY ENTER MY LIFE AS OLD MAGAZINES, AS PACKAGING OF NEWLY BOUGHT ARTICLES. Putting my ideas into practice does not require me to overcome many formal problems. The work itself is not very complicated, either – it results from simple activities such as selecting, segregating, measuring, drawing, cutting and gluing. My immediate surroundings refer not only to a store of materials but also to the inspiration it provides. Blocks of flats that I can see from my window, or standard furniture in the rented flat, initiated my works *Miasto* (City) and *Habitat*. The newspapers, weeklies and advertising leaflets used in my other works come from my immediate surroundings as well. The information they convey prompted me to shape statements about the media and about advertising. Pictures of people cut from magazines in great numbers form *Dywany* (Carpets). Advertising leaflets became *Gry* (Games). I try to bring the goods represented back to life – I give them back their bodily existence, even in the simplest, mechanical form of the cube. Katarzyna Józefowicz/translated by Monika Ujma

KATARZYNA JÓZEFOWICZ

109

KATARZYNA JÓZEFOWICZ

SWEET CAPTIVITY

MAGDALENA UJMA

SCENE

A huge, concrete block of flats, another one close by. A world without the horizon. When you happen to be here, it is inevitable that you become absorbed into the very essence of this place. The pale skies above are spotted with clouds like a nail with speckles of avitaminosis.

Flats in the blocks. Hundreds of flats furnished in a standard manner, with the TV taking up the same corner in each flat. Jokes about a husband coming home at night to a flat that is not his own and waking up beside a wife that is not his own, originate here. A feeling of never-ending *déjà vu*. This must affect the psyche. Do not try and tell me it is not so.

"I have become a slave to building", said Katarzyna Józefowicz. This means that she is a mere pawn in the process of the expansion of matter. In the wearying course of things, no one can ignore this fact. She cannot influence it since it is art that guides her hands and not she who guides art. She needs art to fill up the hours that trickle like water from the tap.

What then, is the relationship between art and life in Katarzyna's case? It can all be readily explained. Surrounded by identical, ugly things, she produced miniature furniture and, not being strong enough to work with other techniques, she decided on paper, which furthermore, was within reach. A nervous being, she took up an art form that requires unremitting labour and infinite patience.

The work of women artists is frequently related to domesticity. It is certainly right to think of this in the case of Katarzyna Józefowicz: a house on the edge of the city, an ugly housing estate. Picture the artist, with a child, enclosed within four walls in a thicket of apartment blocks, beavering away on paper cities – accurate, miniature towers of Babel – or on tiny pieces of cardboard furniture as with the series *Habitat*. All the time she is conscious of the fact that her works must be contained in her tiny flat – that they will be stored in boxes piled by the walls.

Józefowicz herself points out the therapeutic effects of her 'paper mantra'. This work calms her down and alters her inwardly. Besides, this is manual work that leaves no time to think. No time to ponder or brood. Well, we have all experienced this: we know about maximum concentration when it comes to the creative construction

of objects – a concentration combined with the utmost care not to make them crooked or dirty with glue. In point of fact, this work is full of tension. Well, yes…

I have never understood those famous artists and inventors who forgot about everything else when in the frenzy of creation – noting things down, calculating, planning and labouring – who failed to notice the heaped plate placed beside them by some caring soul. I would never forget, even if it was only out of empathy with the person who cared about me. And thus I seem to understand why Katarzyna says that she devotes up to eight hours a day to her work. She controls her working hours, as if in an office. Madness controlled. So typical of womankind! The woman artist cannot neglect to feed her family, to do the shopping, to clean the flat.

But the simplicity of associations is fallacious. Domesticity, life, history – indeed. Inner freedom – certainly. How is it called? Sweet captivity? Wilful captivity? Captivity that sets free?

GIRL

What was she like in her childhood? She must have been dexterous with her hands. She loved constructing doll's houses, transforming wooden toy bricks, bobbins (at that time they were old-fashioned, made

of wood, with a hole), matchboxes (more solid than today) and other little boxes in which medicines and cosmetics were sold, into desks, beds, wardrobes, chairs and tables. Postage stamps served as pictures.

Handicrafts were enthusiastically popularised by German women's magazines available at that time in Poland (and imitated by the Polish ones). There was *Burda* but also the more glamorous *Brigitte* or *Freundin* with models not significantly prettier than we were. The daring ideas which these magazines presented formed a curious mixture with extraordinarily detailed instructions of how to turn them into reality. It took courage to have a try but the effect was very different from the original. T-shirts decorated with fancy paintings, sequined trainers and *papier-mâché* vases belonged to the dream world of the unattainable.

Mag cuttings… Those multitudes of magazines my sisters and I destroyed! Alluring washing machines and fridges, tempting snack-loaded tables! Perhaps Katarzyna surrendered to the embarrassing mania for collecting pictures of idols, cut from magazines and glued into notebooks, the favourite hobby of Polish youth? Did she feel uneasy about the stars, grinning from ear to ear, that would soon end up on a pile of waste paper? No, they were not in danger.

At that time, colourful, foreign magazines were never discarded. They were carefully stored or lent, their creased pages straightened with tenderness, those messengers from a better world where nobody suffered from a lack of attractive things.

So it started then. I will not perish since I have scissors, a needle, a thread and paper.

WOMAN
Her art originates at home, metaphorically and literally. Katarzyna builds, furnishes, glues and weaves. In fact, her works are tapestries. Or vast, formless mounds… anthills, 'termitaries'. All this amounts to the same thing. The spider Arachne, Penelope or Katarzyna – these are names of the same woman, labouring over the same work. Weaving bordering on madness – but it is no more than telling stories which, in a sense, can be identified with real life.

Perpetual misery, mending, tinkering. Her works are patchworks of household remains lying around and littering corners like the fluff and dust that no other soul would care to look at. A perfect housewife knows how to utilise old paper. Nothing is wasted in her household.

Miasta (Cities), *Habitat* or *Dywan (Carpet)* – each suggests a sort of matter that crawls across the floor, climbs the walls and assumes the shape of any room. Hence it

may be compared to shapeless water which flows wherever it can, that fills up the bottle. Or moss.

Expansion, overgrowth, cover. Katarzyna's work occupies empty spaces. People say they comment on mass culture, on the cancerous growth of visual imagery nowadays. She answers however, in an utterly different way: she has just discovered an astonishing property of paper – it is fleshy. As fleshy as young and supple, spontaneously growing matter. Plasma that has neither beginning nor end, neither inside nor outside. Lichen – the longest living plant on earth. It is amazing that the arist, who does such unremitting work demanding the patience of a saint, complains about a lack of energy.

So manual drudgery results from a fear of emptiness.

But it results also from a desire to commemorate these drops that run through our fingers when we read newspapers, have coffee or prattle on the phone, do the washing, scratch our heads, clean, burn milk, or when we send the child to bed and are too tired to think.

Of course, in an inferior way.

Translated by Monika Ujma
*Such standard, huge buildings with a great number of flats naturally belonged, and still do, to cityscapes in Poland.

GAMES 2001-2 PAPER,
INSTALLATION DETAIL
FRONT PAGE IMAGE: MIASTA
(CITY) N/D INSTALLATION DETAIL

Katarzyna Józefowicz
born Lublin, Poland,
1959. Lives and works
in Gdansk, Poland

SELECTED SOLO EXHIBITIONS

2002 Foksal Gallery, Warsaw, Poland
2001 *Untitled*, Foksal Gallery, Warsaw, Poland
2000 *Carpet*, Foksol Gallery, Warsaw, Poland
1998 Galeria Kolo, Gdansk, Poland
1996 BWA Gallery, Bydgoszcz, Poland
1993 Galeria FOS, Gdansk, Poland

SELECTED GROUP EXHIBITIONS

2002 Georg Kargl Galerie, Vienna, Austria
2001 *Berlin Biennale 2001*, Kunstwerke, Berlin, Germany
Woman about Woman, BWA, Bielsko-Biala Poland
In Freiheit, Endlisch!, Kunsthalle, Baden-Baden,
Germany
2000 *In Freiheit, Endlisch!*, National Museum, Warsaw,
Poland

SELECTED BIBLIOGRAPHY

Joanna Mytkowska, 'Intruder-
Storyteller' (interview), exhibition
catalogue, Foksal Gallery Foundation,
Warsaw, 2001

Adam Szymczyk, 'Household Chores',
Katarzyna Józefowicz, exhibition
catalogue, Foksal Gallery Foundation,
Warsaw, 2001

CHECKLIST OF WORKS

CARPET 1997-2000
cardboard, magazine clippings, glue,
4.97 x 4.97 m
collection: Peter Norton, Santa Monica

GAMES 2001-2002
paper,
dimensions variable

Works courtesy the artist and Foksal
Gallery Foundation, Warsaw

No experience is beyond reach.

The increasing reliance on singular recreational experience rather than collective activities has been exploited by the pornography industry which is able to produce live real-time interactivity; the power to transform reality without requiring the suspension of disbelief, but the technological blending of fantasy and reality only reaches absolute seamlessness in the 2230s. Pornography is regulated as a part of the entertainment industry, which leads research into ways of digitising mental experience and recording thought processes of the imagination

EMMA KAY

Western culture has a highly ambiguous concept of memory. On the one hand it is generally accepted that memory is personal. Each individual closely guards his/her own biography. The cult of the private archive encourages individuals to assemble CDs with the music of past decades, books, videotapes, etc. in the attempt to store and rewrite their own history of culture. On the other hand, however, Western culture still clings to the idea of a universal knowledge of the past. Despite all the tendencies to personalise historicising, equal energy is invested in nurturing the phantasmagoria of a collective memory. The belief that advanced computer technology allows the storage of all of humanity's knowledge is widespread. The paradoxes and contradictions that result from the simultaneous appraisal of personal and universal memory very often go completely unnoticed.

It is precisely on this contested cultural territory, where practices of personalised historicising compete with fictions of total recall, that Emma Kay situates her conceptual projects. She conducts experiments that take the contradictory cultural ideals of mem-

EMMA KAY

MIND MUSCLE

JAN VERWOERT

ory seriously – and engages in projects that attempt to reconcile the extremes of personal and collective memory. In *The Bible From Memory* 1997, and *Shakespeare From Memory* 1998, Emma Kay wrote down the contents of the bible and the complete works of Shakespeare respectively without any recourse to reference material, relying solely on her personal memory. The summaries are presented in a matter-of-fact style as simple text pieces. Her accounts are visibly incomplete: the Bible is rendered in a single page, and the reconstruction of Shake speare's plays contains fragments of plotlines and quotes (for some of the plays only the title is given). Both the texts that Emma Kay has chosen to reproduce are metatexts that stand as tokens for an ideal of encyclopedic knowledge and are considered to be cornerstones of a global cultural heritage. By confronting these universal texts with her own fragmentary versions, she exposes the rift that marks the intersection of individual and collective memory.

This rift is further explored in the map series *The World From Memory I, II and III* 1998–99, pencil drawings of all the countries and continents which are beautifully accurate in their many inaccuracies - and *Worldview* 1999, an entire history of the World from the Big Bang to New Year's Eve 2000 retold by Emma Kay and produced as a digital print – 21 columns of text (in a minute typeface) the size of a panoramic painting. Emma Kay's projects might seem quixotic. But this is only because she actually takes on the impossible task set by our culture: to personalise history and at the same time master the totality of encyclopedic knowledge. By acting out these contradictory ideals, she shows that it is only by taking the normative fictions of our culture for real that their discrepancies become manifest.

The Future from Memory 2001, is a projection of a digitally animated text scrolling across a white screen. Just as in the opening credits of Star Wars, paragraphs come into view then recede to a distant vanishing point. Most paragraphs remain visible long enough to be read, others whizz by like meteors and highlight a single future event in a short flash. The text is a comprehensive account of how the future will evolve in the coming millennia. Despite its epic format this description of the future is rendered in a factual tone, the text appearing to be a well-researched historical survey of how things on earth will have changed in the next 4000 (and more) years. It pays close attention to political, economical, technological and medical facts, sometimes rendered with the deadpan style of a newspaper headline: 'Disturbance of the gene pool causes new diseases to emerge'.

In the future, biochips permit interneural communication. Transmigration allows for the transfer of a person's consciousness into another person's (or animal's) body. Transplant technology and the mass cloning of spare organs extend human lifespan to around 120 years. As bioengineering and nanotechnology emerge, production is re-cast in terms of re-production: every conceivable substance can now be generated by the recycling of basic cellular material. Restoration of habitable environment becomes a primary concern since the constitution of the planet is rapidly deteriorating and for some centuries life is only possible in self-sustaining biospheres or interstellar settlements. Major problems occur in the form of sensory wasting, spiritual disorientation, the threat of mutating viruses,

mindjacking, nanoterrorism and the first global nuclear meltdown in 2181. By the end of the 3890s the sun starts to darken and life on earth dies. However, thanks to the heat of a nearby supernova, life on the dead planet earth begins to stir again. It starts to rain for a thousand years and the text-loop starts anew.

In her previous works Emma Kay made it transparent that history was always recounted from her personal perspective and defined by the limits of her background and eduction. In *The Future From Memory* however, the position of the narrator is subtly shifted to the perspective of an impersonal omniscient narrator. An uncanny atmosphere prevails as the viewer is haunted by the question: Who is speaking? One has to assume that the narrator speaks from an infinitely remote point in the future, as this is the only position that would make it possible to look back upon, remember and summarise all the events that occur in the period between the twenty-first century and the sixth millennium. But this assumption is refuted by the cyclical structure of the projection-loop. At the very moment when the earth comes to its end only to come to life anew, the position of the narrator is eclipsed. The end of linear time would have been the point where the book was closed and the storyteller had to step forward to reveal his/her identity. Now that the world ends and starts again, it becomes apparent that the narrator is actually positioned outside space and time. The figure of the narrator is reminiscent of the mysterious black obelisk in Kubrick's *2001*; s/he watches the death and rebirth of the planet from an elevated position sub specie aeternitatis.

In *The Future From Memory* Emma Kay gives a new twist to the conflict between personal and universal memory, putting a hyperbolic spin on the concept of total recall. By inventing an omniscient narrator who recollects centuries over centuries of the future as if it were his/her past, she fictionalises the subject of memory and launches this fiction into overdrive. The ominous impersonal narrator of this history of the future is the embodiment of encyclopedic knowledge, a super-intelligence that resides outside space and time. In this way Emma Kay dares to take Western culture's fantasy of infinite memory seriously and presents us a subject capable of this total recall: an uncanny spectre from another dimension.

Faro Granada Benidorm malaga ⬚MALTA palermo SCICILY
GIBRALTER ⬚GOZO

M E D I T E R R A

Tangier
Fes
MORROCCO TUNISIA Tunis

Imilchil Aljiers

marrakech
Taroodant ALGERIA SUDAN EGYPT

LIBERIA CHAD

El oued ANGOLA BOTSWANA NAMIBIA

ETHIO
Dakar BIAFRA
SENEGAL GHANA UGANDA ZAIRE
SIERRA NIGER
LEONE NIGERIA

GAMBIA GABON
Lagos TANZANIA ZANZIBAR
MAURITIUS

CONGO
Kinshasa Dar es Salaam
IVORY
COAST K E N Y A

Nairobi

NSION
AND

Johannesburg
Freetown
SOUTH
AFRICA

Pretoria

CapeTown
Cape of Good Hope

THE WORLD FROM MEMORY II
1998 PENCIL ON PAPER. FRONT
PAGE IMAGE: THE FUTURE FROM
MEMORY AND DETAIL 2001
PROJECTED DIGITAL ANIMATION.

Emma Kay was born in London, UK, 1961. Lives and works in London, UK.

SELECTED SOLO EXHIBITIONS

2001 UCLA Hammer Museum, Los Angeles, USA
Chisenhale Gallery, London, UK
Laing Art Gallery, Newcastle, UK

1998 The Approach, London, UK

SELECTED GROUP EXHIBITIONS

2001 *ARS 01*, Kiasma Museum of Contemporary Art, Helsinki, Finland
All Systems Go, Contemporary Arts Museum, Houston, Texas, USA

2000 *New Notational Systems for Urban Situations*, TENT Centre for Visual Arts, Rotterdam, Netherlands
On the Edge of the Western World, Yerba Buena Center for the Arts, San Francisco, USA
Orbis Terrarium – Ways of Worldmaking, Plantin Moretus Museum/Antwerp Open, Antwerp, Belguim
British Art Show 5, National Touring Exhibitions/Hayward Gallery, London, UK

1999 *Self-Portrait*, Mercer Union Centre for Contemporary Art, Toronto, Canada
6th International Istanbul Biennale, Istanbul, Turkey
Abracadabra, Tate Gallery, London, UK

1998 *Surfacing*, Institute of Contemporary Art, London, UK

SELECTED BIBLIOGRAPHY

John Roberts, 'The Practice of Failure', pp. 63-67, *Cabinet*, Issue 5, Winter 2002
C Grenier and C Kinley, *Abracadabra*, exhibition catalogue, Tate Gallery Publications, (illustrated), London, 1999
Pippa Coles, Matthew Higgs, Jacqui Poncelet, *British Art Show 5*, exhibition catalogue, Hayward Gallery Publications, London, 2000
Emma Kay, exhibition catalogue, UCLA Hammer Museum, Los Angeles, 2001
Laura Moffat, 'Emma Kay', *Art Monthly*, Issue 222, 2000
Tom Morton, 'Emma Kay - Chisenhale Gallery', *frieze*, Issue 59, May 2000, pp 101-2
Other Arrangements, exhibition catalogue, Stichting Duende Activiteiten, Rotterdam, pp 3-11
Deborah Scholtz, 'Profile: Emma Kay', *Art Monthly*, Issue 244, 2001
Jan Verwoert, *The Future From Memory*, exhibition catalogue, Chisenhale Gallery, London, 2001
6th International Istanbul Biennale, exhibition catalogue, Istanbul Foundation for Culture and the Arts, Istanbul, 1999, pp 106-109, 112-117

CHECKLIST OF WORKS

THE FUTURE FROM MEMORY 2001
projected digital animation, 5 x 3.8 m (projected size)

THE WORLD FROM MEMORY I 1998
pencil on paper, 150 x 110 cm (framed)
collection: Marc Selwyn, Los Angeles

Works courtesy the artist and The Approach, London

Telephone link

Electrostatic 'influence' generators

Glass electrical isolators

New York. Cold.

New York. Hot.

The field of eighty-one 1936 Buick car horns
cast in brass, each with a different reed

The ticker tape recorder

PAUL ETIENNE LINCOLN

NEW YORK–NEW YORK 1987-2002 IS AN INSTALLATION WHICH WILL PROVIDE A PHYSICAL METAPHOR FOR NEW YORK CITY'S CHANGES – NATURAL, CULTURAL AND TECHNOLOGICAL – OVER A PERIOD OF SIXTY YEARS, APPROXIMATELY 1920-1980. THE WORK, BEGUN IN 1987 AND IN PROGRESS, COMPRISES SEVERAL COMPONENTS, SOME OF WHICH ARE INCLUDED IN THE PRESENT EXHIBITION. THE WORK WILL FUNCTION ONLY ONCE IN AN ENORMOUS WATER TUNNEL UNDER MANHATTAN OVER A SIXTY-HOUR PERIOD. THE MODEL SHOWS THE ENTIRE INSTALLATION AS IT WILL BE PRESENTED, WITH A TWENTY-METRE LAKE AT ITS CENTRE. A BRIEF DESCRIPTION OF *NEW YORK–NEW YORK*'S OPERATION FOLLOWS. A TELEPHONE CONNECTED TO THE NATIONAL INSTITUTE OF STANDARDS AND TECHNOLOGY IN WASHINGTON, DC, ACTIVATES THE FOUR ELECTROSTATIC GENERATORS; THESE GENERATORS USE PHONOGRAPHIC DISCS WITH VARIOUS SOUNDS, NATURAL AND MAN-MADE, WHICH HAVE VANISHED FROM NEW YORK CITY. THE RECORDS, NOW UNPLAYABLE, ARE USED AS THE GENERATORS' ISOLATORS; THEY FORM A SYMBOLIC ARCHIVE OF MANHATTAN. THE SOUNDS WERE PREVIOUSLY COPIED BY THE *FRENCH HORN RECORDING PHONOGRAPH*, AND WILL FORM THE SOUNDTRACK TO THE SIXTY-HOUR FILM OF *NEW YORK–NEW YORK*'S SINGLE PERFORMANCE. The generators' charge illuminates the glass coils running either side of the reservoir, this charge then energizes the grid, modeled on the first integrated circuit. This grid in turn activates *New York (Hot)* and *New York (Cold)*, the primary elements of the installation. *New York (Hot)*, an elaborate boiler constructed almost entirely from brass, is essentially a steam-powered organ which will laboriously play one complete revolution of a Regina punched disc encoded with John Philip Sousa's classic march *The Stars and Stripes Forever* through 86 individually tuned brass Buick car horns over 60 hours. As the machine never repeats a single note twice in the same pitch, this mechanical arrangement of Sousa's march transforms the music into an unfathomable form. Made almost entirely from aluminum, *New York (Cold)*'s main activity is the production of finely embossed impressions of five dollar bonds on billets of ice. The aluminum bond-masters are housed in a series of compressors, *The New York Ten*, two examples of which are shown here. At the centre of each bond is a minute vortex of the musical score played by *New York (Hot)*; each unique bond is varied by having three fewer notes than its predecessor. On each hour *New York (Cold)* produces a unique billet and lowers it into the reservoir. The two machines, indeed the entire elaborate performance of *New York–New York*, do not produce any physical resultant: the only product is the intangible metaphor.

PAUL ETIENNE LINCOLN

117

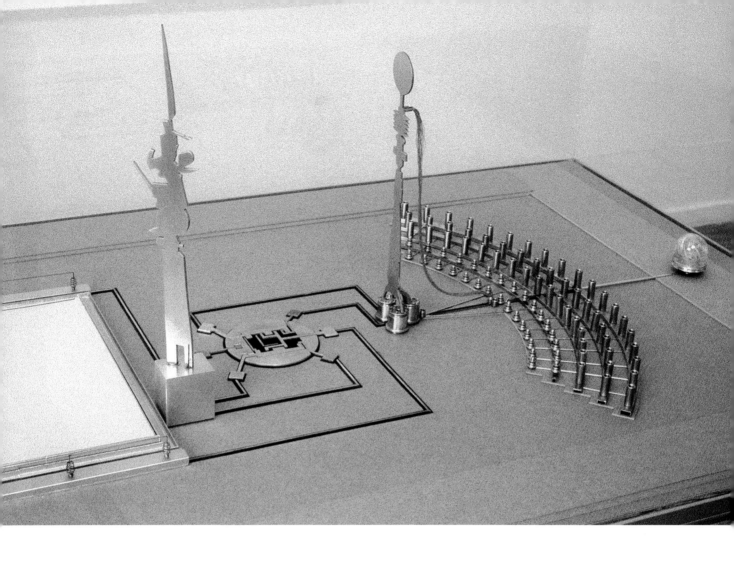

PAUL ETIENNE LINCOLN

KATY SIEGEL

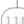
In 1935, at the behest of his New York colleagues, Walter Benjamin set out to synopsize his famously unfinished epic, The Arcades Project. The resulting précis, "Paris, the Capital of the Nineteenth Century," offered a preview of the critic's Herculean attempt to compile all the various majorae and minutiae that gave rise to his own historical moment as revealed in that central symptom: Paris. Like Paris in the nineteenth century, New York was the capital of the twentieth century with respect to certain ideas, objects, and symbols commonly synonymous with triumphant capitalism: not only skyscrapers and automobiles, televisions and telephones, but AbEx painting, Pop art, Minimalism, even postmodernism.

Nine a.m: A phone rings, somewhere in Brooklyn. Behind it, four electrostatic generators use LP records to create electrical charges, then store the energy in Leyden jars. The records are carried down from the Public Library on Fifth Avenue and Forty-second Street each morning in a fur-lined case (fur and vinyl produce static electricity when rubbed together – a specialized fetish to be sure). Each disc features a collection of a different type of sound, indexed chronologically: vanished natural and industrial noises (extinct songbirds, outmoded car engines); A- and B-side popular songs about the city; ill-fated political speeches; high- and low-register vocal performances from the Met. These recordings will eventually serve as the sound track for a sixty-hour film documenting the only performance of Lincoln's current project, New York–New York, begun in 1987 and still under construction.

In its delirious complexity, Paul Etienne Lincoln's magnum-opus-in-progress gives Benjamin's encyclopedic ambition a run for its money. This large-scale, labyrinthine cosmology raises production (industrial age-style) to new artistic heights. Once the ringing phone triggers the four record generators, the accumulated electricity lights up two long strings of twelve glass coils that frame a reflecting pool about forty feet long. This light, energy made visible, sets off a pair of large machine towers – New York (Hot) and New York (Cold) – which are the heart of the work.

New York (Hot) is essentially a big brass boiler that functions as a barrel organ, playing John Philip Sousa's "Stars and Stripes Forever" at excruciatingly slow speed over the work's sixty-hour run. Composed with references to all sorts of machines (Charles Babbage's difference engine, for one), it operates via a system of slide valves that open and close, transferring steam to an arrangement of eighty-six brass 1935 Buick car horns, each tuned to a different note. (Lincoln read somewhere that dinosaurs made sounds not unlike those of a '35 Buick horn; one can imagine the klaxons groaning like a similarly extinct brontosaurus herd.) New York (Cold) is made of aluminum, a chilly, futuristic contrast to the warm, antique-y brass. Each hour, the water it receives from the pool freezes, producing an icy impression of a single five-dollar bond note minutely etched with the score of the Sousa march. The bond then floats

NEW YORK–NEW YORK (MODEL) DETAIL 1999 BRASS, WOOD, ALUMINUM, BOARD, BAKELITE. NEW YORK–NEW YORK (MODEL) 1999 BRASS, WOOD, ALUMINUM, BOARD, BAKELITE. PHOTOGRAPHY: ORCUTT & VAN DER PUTTEN.

down the reflecting pool, where it melts. The element connecting these hot and cold machines is a hugely enlarged integrated circuit (a copy of the first one made in the United States), which feeds them alternately. When *New York (Cold)* issues its frozen certificate, it completes the circuit, lighting up the glass coils on their course back to the telephone, and begins another round. Through-out, temperature and production readings are taken and punched into a ticker-tape machine. And there you have a primitive sketch of the workings of *New York–New York*, minus its ten compressors, pigeon timer, cloud chamber, tailor-made transfer gramophones, accompanying book and record editions, and of course, drawings.

The finished piece promises to be a unified, closed system, one that, however complex and fanciful, runs on its own internal logic. In this respect, *New York–New York* recalls Duchamp, Beuys, and Tinguely, all of whom invoke mechanical allegories. Lincoln is particularly interested in mechanical representations of human experience. His work renders the intangible tangible: Feelings, social constructs, ideas become concrete physical processes. Water moves a lever, the lever triggers a wheel, energy becomes light and, as such, travels visibly. Beautiful objects in themselves, Lincoln's machines also make things more accessible, more in sync with the simpler mechanisms of the past that we can relate to intuitively. These archaic contraptions provide a comforting sense of mastery in contrast to current digital technologies – systems too large and too small to see, much less to comprehend. You don't know what you've got till it's gone: circuits, mechanical (not electronic) cars, rotary telephones, vinyl records, municipal bonds, Sousa, the five-day workweek, stocks, ticker tape, time card-punching, nationalism. The solid and permanent turns out to be fragile and provisional. But the lost past is not really lost; it is with us today, in a different form, still making our world. The Paris arcades of the nineteenth century produced or at least pointed to the shopping, glass architecture, and filmic reconstitution of the masses that character-

ized the early twentieth century. Yesterday's industrial production, phones, and records are the telecommunications, digital networks, and CDs of today. Lincoln's work draws on nostalgia, but it also illuminates the present; *New York - New York* figures, and in so doing renders material, the electronic transfer and storage of information that exists, in literal and virtual archives, all around us.

To use the vinyl of old recordings to generate new electricity is to convert an obsolete mode of communication back into a generalized flow of power – a kind of controlled entropy – that in turn enables new communication. In a rethinking of the progressive model of history, the past creates the present, but the form that the present takes is unpredictable. This unpredictability is what we want from art as well; like *New York–New York*, it connects to various traditions of making and thinking, but nonetheless is something we never could have imagined.

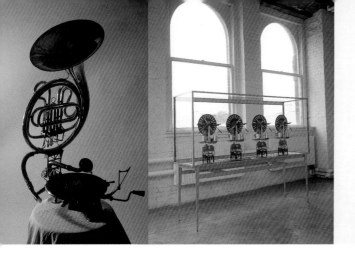

Paul Etienne Lincoln

born London, UK, 1959.

Lives and works in

New York, USA

SELECTED SOLO EXHIBITIONS

2000 *Equestrian Opulators*, Alexander and Bonin, New
York
*Equestrian Opulators at the House of Approximate
Odds,* Saint Paulinus Projects Catterick Racecourse,
North Yorkshire, England
Ignisfatuus, Alexander and Bonin, New York
The World and Its Inhabitants, Christine Burgin
Gallery, New York

1999 *The Enigma of Marie Taglioni*, Church of St.
Paulinus, Catterick, England (presented as part of
the *Here and Now* exhibition series, Henry Moore
Institute, Leeds, U.K.)

1996 *Ignisfatuus*, The Conservatory, Druid Hill Park,
Baltimore

1993 Prodomo, Vienna

1992 Galerie Hubert Winter, Vienna

1991 *In Tribute to Madame Pompadour and the Court of
Louis XV*, Christine Burgin Gallery, New York

1990 Galleria Victoria Miro, Florence; Victoria Miro
Gallery, London

1985 Coracle Press, Kettles Yard, Cambridge, England

SELECTED GROUP EXHIBITIONS

2001 *Crossing the Line*, Queens Museum of Art, New
York

2000 *Greater New York*, P.S.1., Long Island City, NY

1999 *Sculpture Biennial 1999 im Münsterland*,
Westfälisches Landesmuseum, Münster, Germany

1995 *In Search of the Miraculous*, Starkmann, London

1993 *Prospect 93*, Frankfurter Kunstverein, Frankfurt

1992 *Currents '92: The Absent Body*, Institute of
Contemporary Art, Boston, USA

1990 *VII Biennale de Arquitectura de Quito*, Quito,
Equador

1981 *Young Contemporaries*, Institute of Contemporary
Art, London

SELECTED BIBLIOGRAPHY

Paul Etienne Lincoln, 'Equestrian
Opulators at the House of Approximate
Odds'. North Yorkshire: St. Paulinus
Projects, 2000
Paul Etienne Lincoln, 'A Violet
Somnambulist Spiriting the Fugacious
Bloom', New York: Christine Burgin,
1997-2000
Paul Etienne Lincoln, 'The World and its
Inhabitants', London, Bookworks, 1997
Paul Etienne Lincoln, 'A Transcript of
Unrequited Euphoria, Galerie Hubert
Winter, Vienna, 1992
Eleanor Heartney, 'Paul Etienne Lincoln
at Christine Burgin and Alexander and

Bonin', *Art in America* Vol.88 No. 11,
November, 2000, pp 168-169
Michael Kimmelman, 'Art in Review',
New York Times, 14 June 1991, C24
Elisabeth Kley, 'Sunbeams from
Cucumbers', *Parkett* No. 61, 2001,
pp 6-17
Rhonda Lieberman, 'Paul Lincoln,
Christine Burgin Gallery', *Artforum*,
September 1991, p 30
Nancy Princenthal, 'Artist's Book Beat',
Art On Paper, July, 1999, pp 67-69
Katy Siegel, 'City Light: Paul Etienne
Lincoln's "New York – New York"',
Artforum, September 2000, pp 160-165

CHECKLIST OF WORKS

BRASS VITRINE HOLDING A
MAHOGANY INSTRUMENT CASE
from *"New York-New York"* 1998
brass vitrine
167.6 x 213.5 x 61 cm

FRENCH HORN RECORDING
PHONOGRAPH c.1995
brass and aluminum in vitrine of glass
and brass
167.6 x 213.5 x 61 cm

ELECTROSTATIC INFLUENCE
GENERATORS FOR NEW YORK-NEW
YORK 1997-2000
brass vitrine
167.6 x 213.5 x 61 cm

NEW YORK-NEW YORK (MODEL) 1999
aluminium vitrine
114.3 x 61 x 183 cm
edition of three

WORKING DRAWINGS AND EDITIONS
FOR "NEW YORK-NEW YORK" 1987-
2002
pencil and ink drawings in aluminum
and plexiglass vitrine
114.3 x 61 x 183 cm

ONE OF THE NEW YORK TEN 1990-91
aluminum and compressor unit on
cement base
approx 101.6 cm high
edition of ten

30 GLASSINE BONDS FROM "NEW
YORK-NEW YORK" 1990
ink and varnish on glassine
each approx. 6.9 x 15.2 cm

NEW YORK-NEW YORK 1990
approx. 36.8 x 31.8 cm (closed)
edition of 3, 36.5 x 31.5cm

NEW YORK HIGH - NEW YORK LOW
1990
approx. 39 x 33 cm (closed)
edition of 3

Works courtesy the artist and
Alexander and Bonin, New York

ROBERT MACPHERSON

121

ROBERT MACPHERSON

RICHARD GRAYSON

Robert MacPherson likes lists – and he takes pleasure in the thoughtful accretion that constitutes the act of listing. The simple act of gathering together the representations of groups, clustering objects or events (the names of frogs for instance, or metrological signs for cloud formations or collections of naval flags) becomes the starting point and engine for one of the toughest – and tenderest – bodies of work being developed today.

Initially MacPherson's approaches appear severe or at least restrained. We can feel the slight reserve of the craftsman or artisan who uses the minimum of means to achieve the maximum outcome. The reduced stylish movements that a skilled workman will make to trim and install a fence post generates, when repeated, a fence that can describe a boundary hundreds of miles long. Any act repeated – no matter how pared back – becomes a system, and systems in turn bring into being their own

territories and expanding universes. Much of the power of MacPherson's work comes from the tension between an awareness of the work itself *as* a practice within the matrix of international contemporary arts production. It has grown out of the application of certain Greenbergian tenets but applied in such a way that the outcomes have a commonality with some post-Duchampian practices – and, of course, incorporates the protean outcomes that systems make possible. In *"Red Raddle: 18 frog poems for Mary Lake and Connie Sparrow" 1992-1995"* he paints the names of foodstuffs commonly eaten in the Australian past onto cotton tablecloths: "Plum Duff", "Johnny Cakes", "Burdekin Duck", "Spotted Dick", "Cocky's Joy". One way to read this is to focus on the words, the names themselves. This reading invites the reader/ viewer to construct other taxonomies within the set: perhaps classifying them according to their animal reference (Burdekin Duck and Cocky's Joy), or their anatomical connotations (Tear-Arse, Bunghole), suggesting some fantastic universe. Another reading of the list takes us in another direction, to the more con-

crete and specific – the tablecloths record and celebrate the staples that nourished previous generations of Australians. Further, the work may invite us to consider complex references to art history and practices that the work engages with.

Another work, *Sundog: 12 Frog poems (Green Whizzer) for J.B.'* exhibits loaves of bread in conjunction with international meteorological abbreviations for cloud formations, thus making a link between the variously rounded shapes of the bread and the representation of clouds by scientific notation. This combination brings to mind the gaseous broiling and boiling that the formation of both bread and clouds have in common, as well as referring to images located within Constructivist or Arte Povera traditions.

Responses to the mechanisms used by MacPherson can be charged with a spark that is almost atavistic. It links with the awe we feel faced with the generative possibilities of language as well as the implication of the existence of some higher organising principle or power that lurks behind every list or index. We need only to think of the

way that the British Domesday book sought to list all that lay in the Norman King's new domain, and the way that lists are often to be found in hymnal or religious tracts. This is not to suggest an eschatological drive behind MacPhersons practice, rather to provide a possible context for a more recent development.

Lately MacPherson has been showing work made by Robert Pene – an historical alter ego who is a 1940's fourth grade primary school student from St Joseph's Convent School, Nambour, a country town in Queensland. The works in this series are aged and stained, and some carry stamps indicating praise from an invigilating teacher. Robert Pene is the author of a quite a number of works on different themes reflecting the world around him. Among them are two series of drawings *23 Famous Kidman Drovers* (1993-1994) and *184 Frog Poems: 184 Boss Drovers*. A drover is someone who drives herds of cattle or sheep over long distances. Once a common and highly respected occupation in rural Australia, the drover's place in history and their mythological status has now shifted –

from being living heroes in the eyes of a ten year old boy in 1947, to characters who now engender a powerful, iconic, mythological past.

The works have as their premise the proposition that the artist is ten years old and that they were made in the past. In addition, as John O'Brien points out, [1] "all the images – and there are now well over two thousand of them – are dated to Valentines Day 1947."

Pene seems initially to be a surprising development in MacPherson's practice, given its systematic rigour. But I would suggest that Pene is a strategem which lets the artist feed back into his own practice and some of the histories and effects that have until now, remained the realm of the commentator or viewer. This essay touched briefly on the aura and wonder that the work and its mechanisms can engender and, it would seem, the Pene drawings provide a possible archaeology for this element. And what better background for such a mindset than that of a ten year old boy at a Catholic school for such an approach? This is a time when the

world begins to manifest itself. It is also a world full of lists – either on the blackboard in front of us, or in the form of the collections which kids surround themselves with – when what later may seem local appears immense, when the specific becomes universal. And then there is the pedagogic context of a Catholic school that suggests that behind everything is a plan and structure. The 'Pene work' then, like the 'MacPherson work', is concerned with the ontological, but it allows the work to be explored and explained differently. In this there is perhaps a parallel with the way that *Etants Donnes* allowed Duchamp to re-animate – in a sometimes contradictory and perverse form - the concerns that had animated *The Large Glass*. 'Robert Pene' too, gives the artist permission to look again, to re-articulate, and to deny knowledge of past narratives and histories as – from the position of 1947 – many of these developments are yet to come.

1. John O'Brien, 'The Unusual Truncatory of Words', *Robert MacPherson*, exhibition catalogue, Trevor Smith (ed), Art Gallery of Western Australia, 2001

Robert MacPherson

born Queensland,

Australia, 1937.

Lives and works in

Brisbane, Australia.

SELECTED SOLO EXHIBITIONS

2001 *Robert MacPherson,* Art Gallery of Western
Australia, Perth, Australia
Robert MacPherson, Museum of Contemporary Art,
Sydney, Australia
1999 *Murranji,* Artspace Sydney; Institute of Modern Art,
Brisbane; John Curtain Gallery, Perth; Experimental
Art Foundation and the University of South
Australian Art Museum, Adelaide, Australia.
1997 *"Mayfair: 4 Signs, 10 Paintings, 6 Abstractions for
Nifty, Retchless, Snowy, Biggy, Cribby, Pricey and
Young Skeets (1958-1963)",* Yuill/Crowley, Sydney
1996 *Litteraria,* Experimental Art Foundation and South
Australian Museum, Adelaide, Australia
1995 *Robert MacPherson 1978-1995,* National Gallery of
Victoria, Melbourne, Australia
*"Mayfair: Thirty Five Paintings, Thirty Five Signs in
Memory of G.W. and Reno Castelli",* Yuill/Crowley,
Sydney, Australia
1994 *The Described the Undescribed,* Art Gallery of New
South Wales, Sydney, Australia
A Proposition to Draw 1973-78, University Art
Museum, University of Queensland, Brisbane,
Australia

SELECTED GROUP EXHIBITIONS

2000 *Das Liede von der Erde,* Museum Fridericianum,
Kassel, Germany
Terra Australis, Centre for Visual Arts, Cardiff, Wales
Landfall, (with Bea Maddock), 12th Biennale of
Sydney, Ivan Dougherty Gallery, Sydney, Australia
1998 *every day,* 11th Biennale of Sydney, Sydney
*All This and Heaven Too: Adelaide Biennial of
Australian Art,* Art Gallery of South Australia,
Adelaide, Australia
On the ashes of the stars... Stéphane Mallarmé,
Monash university Gallery, Melbourne, Australia
1997 *Archives and the Everyday,* CSIRO Division of
Entomology, Canberra Contemporary Artspace,
Canberra, Australia
Lightness and Gravity, Museum of Modern Art at
Heide, Melbourne, Australia
1994 *Virtual Reality,* National Gallery of Australia,
Canberra, Australia
1990 *The Readymade Boomerang: Certain Relations in
20th Century Art,* 8th Biennale of Sydney, Art
Gallery of New South Wales, Sydney, Australia

SELECTED BIBLIOGRAPHY

Peter Cripps, *Robert MacPherson:
Survey Exhibition,* exhibition catalogue,
Institute of Modern Art, Brisbane, 1985
Gary Dufour, 'Attentive vision',
Lightness & Gravity, exhibition catalogue,
Museum of Modern Art at Heide,
Melbourne, 1997
Michele Helmrich, 'Against the grain of
illusion', *"Nine Frog Poems: Nine Skies,
Nine Airs for B.A" ',* exhibition catalogue,
Institute of Modern Art, Brisbane, 1992
Ewen McDonald, 'Robert MacPherson
watching the edge of the world', *World
Art,* Vol. 1 No. 2, March 1994,
John O'Brien, 'The Unusual Truncatory
of Words', *Robert MacPherson,* exhibition
catalogue, Art gallery of Western
Australia, Perth, 2001

Ingrid Periz, 'Unpainting painting: The
work of Robert MacPherson', *Binocular:
Focusing-Time-Lapses,* Moët &
Chandon Contemporary Edition/
Edition Contemporaine, 1992
Ingrid Perez, *Robert MacPherson: The
described the Undescribed,* exhibition
catalogue, Art Gallery of New South
Wales, Sydney, 1994
Trevor Smith, 'The World in my Paint-
brush', *Robert MacPherson,* exhibition
catalogue, Art Gallery of Western
Australia, Perth, 2001
Ian Still, 'Robert MacPherson', *Art and
Australia,* Vol. 15. No. 4, Winter, 1978
Daniel Thomas, 'Everybody sing: the art
of Robert MacPherson', *Art and
Australia,* Vol. 33, No. 4, Winter 1996

CHECKLIST OF WORKS

"1000 FROG POEMS: 1000 BOSS
DROVERS ("YELLOW LEAF FALLING")
FOR H.S." 1996-2002
graphite, ink and stain on paper, 1000
units, 30 x 42cm each
courtesy the artist and Yuill/Crowley
Gallery, Sydney

LLEYTON HEWITT/
PETE SAMPRAS
US Open, New York, 2000.

PETE SAMPRAS/
ROY EMERSON
Melbourne Park, Australia,
2000.

ROY EMERSON/ROD LAVER Wimbledon, 1971.

ROD LAVER/KEN ROSEWALL
Photo: Fred Kaplan

"YOU CANNOT TELL ONE STORY WITHOUT TELLING OTHERS." KEN HOLLINGS.

ALEKSANDRA MIR

HELLO IS A PHOTOGRAPHIC DAISY-CHAIN LINKING PEOPLE WITH OTHER PEOPLE THEY HAVE MET IN VARYING CIRCUMSTANCES, SPANNING A WIDE GEOGRAPHIC, HISTORICAL AND SOCIAL SPECTRUM. IT INVOLVES NOT ONLY THE FAMOUSLY FAMOUS FROM ALL POSSIBLE ARENAS – SPORTS, POLITICS AND ENTERTAINMENT – BUT ALSO THEIR FANS, FAMILY, FRIENDS, ENEMIES AS WELL AS PEOPLE THEY HAVE NEVER MET, INCLUDING MY OWN FAMILY AND FRIENDS AND THEIR FURTHER RELATIONS. COLLECTIVELY, THESE IMAGES FORM AN UNBROKEN CHAIN OF HUMAN ENCOUNTERS WHERE NEW STORIES AND SUBTEXTS EMERGE WITH EACH NEW IMAGE ADDED TO THE CHAIN. IT IS A SIMPLE IDEA, BUT WITH ALL THE VARIABLES THE COMPLEXITY EXPANDS ENORMOUSLY AND THE PROJECT EASILY BECOMES A LIFE-TIME COMMITMENT, THEORETICALLY ENCOMPASSING THE WHOLE PHOTOGRAPHED POPULATION ON EARTH. *HELLO* is made by, for and about the general public. Besides calling on everyone I know, contributors and resources range from families around the world and their private photo albums to public photographic archives and corporate PR departments. I am grateful to have received materials from the Smithsonian, The NYC Historical Society, Kentucky Fried Chicken, The Jim Henson Company (*Muppet Show*) Hulton Getty, AUSPIC, Allsport, The Press Association, The All England Lawn Tennis and Croquet Club (Wimbledon) as well as from numerous individual contributors. Thank You. ALEKSANDRA MIR

KEN ROSEWALL/
LEW HOAD
early 1950's.

LEW HOAD/TONY TRABERT
Davis Cup, 1953.

TONY TRABERT/VIC SEIXAS
White City Tennis Courts, Sydney 1955.

VIC SEIXAS/
MAUREEN CONOLLY
at the Wimbledon ball
6th July 1953.

MAUREEN CONOLLY/HELEN WILLS
1951

KARLHEINZ STOCKHAUSEN,

THE OUTER UNIVERSE AND ME

KEN HOLLINGS

The photograph of Stockhausen and me standing together in the late afternoon was taken on Friday, March 12, 1999. The photographer, Philip Lethen, used infrared film. We are in the car park outside the town hall in Kürten, a tiny village in the hills outside Cologne in Western Germany. Behind us is a mobile recording studio on loan from radio station WDR Eins, which Stockhausen had been using to mix down versions of his Helikopter-Streichquartett for release on his own label that summer. The work was completed a few minutes before Philip and I arrived by car from central Cologne. The huge semi-trailer had been parked there since the middle of February and would be gone the next day. It was all a matter of convenience. Not everything is significant.

I was there to interview Karlheinz Stockhausen for *The Wire*, a magazine that specializes in modern music. I hadn't slept much in the previous 48 hours, having left Heathrow Airport on a very early flight that morning. Philip was due to pick me up from my hotel in the mid-afternoon. By then I had already broken down, sobbing uncontrollably in the suite's tiny window-less bathroom. I don't know why.

You cannot tell one story without telling others. The hotel was on the corner of Ursulaplatz, just a few doors down from the church where the bones of St Ursula and the 1000 virgins who were slaughtered along with her are kept neatly stacked and wrapped in lace and dark velvet inside a special Golden Chamber, a kind of room-sized refrigerated safe I had visited a few years before. Across from my hotel window was a huge billboard advertising light bulbs with the word 'LICHT' spelled out in huge white letters. I'd brought with me an original 1977 American paperback copy of Robert Anton Wilson's book, *Cosmic Trigger:*

The Final Secret of the Illuminati, which a friend had given me before she left London to live in Canada and which I'd been reading the night Tim Leary died. Its references to the coincidence of Sirius with an expanded history of human consciousness seemed appropriate to a conversation with Karlheinz Stockhausen.

Right at the start of the interview, as soon as my tape machine had been switched on, the pen in my hand started leaking. Stockhausen was wearing crisp white jeans, a white Indian cotton shirt and a fluorescent orange cardigan. We were sitting side by side in his home on what looked like a white patio sun lounger upholstered in pastel shades. The room was immaculately clean and tidy with bright white walls. I had black ink all over my fingers. At the end of the interview Stockhausen looked me straight in the eyes. 'I like you,' he said.

Back at the hotel I found that my copy of *Cosmic Trigger* had gone missing. It was about 4.30 in the morning and I couldn't

HELEN WILLS (20)/
SUZANNE LENGLEN (27)
The Carlton Club in Cannes,
France 1926.

SUZANNE LENGLEN/RENÉE LACOSTE
1925.

RENÉE LACOSTE/JEAN BOROTRA
1920's.

JEAN BOROTRA/
BILL TILDEN
Davis Cup, 1930.

BILL TILDEN/
CHARLIE CHAPLIN.

sleep anymore. I went through the contents of the entire room trying to find the book but it had vanished completely. So I channel surfed for a while until I found a programme showing satellite footage taken from space of the surface of the Earth accompanied by ambient techno music. Was it broadcast live? A caption on the screen revealed that we were passing over the Arizona desert. It was a dusty ethereal brown. I remembered how Stockhausen had responded when I suggested that we tended to pay cultural homage to space travel nowadays because it seemed more unattainable than ever. 'No, it's absolutely clear,' he said with an enthusiasm that seemed to come from somewhere deep inside him, 'I don't know if you know the new books from the Hubble telescope, publications from NASA, but it's absolutely clear that they will be on Mars in 2012... I know that they are going to go very quick now into the solar system.' I loved that moment. It was my favourite part of the entire interview.

The next morning I retraced my path around Cologne from the night before, starting with the moment I last knew I had *Cosmic Trigger* in my possession. Not a sign of it anywhere. A big Kurdish demonstration was taking place that afternoon to protest against the treatment of Kurds in Turkey. It began with a thin amplified wailing that echoed across the rooftops and concrete balconies. The men marched separately from the women and children. Their chants were different too. Riot cops in heavy green armour leaned against the sides of trucks in side streets like muscular impassive robots, while kids skateboarded on the pedestrian walkways above them. Cable news carried reports that night of a bomb attack on a supermarket in Istanbul.

Back in my hotel room I started crying again. I just couldn't stop.

On television, two girls with headsets gave rundowns on new websites, featuring one where you can calculate how much you weigh on the different planets of the solar system. As if their viewers were preparing for the great leap into space. A future that

can be fully described has already happened and, as such, is already compromised. Stockhausen had told me of his desire to be reborn towards the centre of the universe to continue with his music.

When I got back to London I wrote to my friend in Canada, apologizing for having lost the book she had given me, explaining the circumstances to her. She made some reply about a dead hand on my shoulder. You give up one thing to get another. On October 13, 2001 I became married to Rachel Keen. Rachel and I first met in London in 1992, shortly after she had returned from living in Sydney, Australia for a couple of years. As a wedding present, my friend in Canada sent us another 1977 American paperback copy *Cosmic Trigger*. But the world had changed a lot by then.

CHARLIE CHAPLIN/IGOR STRAVINSKY
1937

IGOR STRAVINSKY/
KARLHEINZ STOCKHAUSEN
Donaueschingen, 1958.

KARLHEINZ STOCKHAUSEN/
KEN HOLLINGS
Kürten, 1999.

KEN HOLLINGS/HIS WIFE RACHEL
on their wedding day
October 13, 2001.

RACHEL KEEN/
HER FRIEND MELINDA HEISE
Bondi Beach, Sydney, August 1996.

Aleksandra Mir born
Lublin, Poland, 1967.
Lives and works in
New York, USA

SELECTED PROJECTS

2002 *Plane Landing*, public commission by the Compton
Verney House Trust, UK
Smash Patriarchy, public commission by Cubitt,
London, UK
Corporate Mentality, book project, published by
Lukas & Sternberg, New York, USA

2001 *Wildflower meadow*, public commission by the
Rebuilding the Gorbals Partnership, Glasgow, UK
(cancelled 10/2001)

1999 *First Woman on the Moon*, public commission by
Casco Projects, Utrecht, on location in Wijk aan Zee.
Netherlands

1998 *Bingo Blues*, 45 rpm vinyl record, commission by
Transmission Gallery, Glasgow. UK
*Cinema for the Unemployed - Hollywood Disaster
Movies (1970 -1997)*, public commission by
Momentum, Moss, Norway

1997 *Fashion Hats*, public project, Fashion Hats, Inc. and
The New Museum of Contemporary Art, New York,
USA

1996 *New Rock Feminism (We Want More Female bands!)*
public commission by Update and the Roskilde
Festival, Roskilde, Denmark

1995 *Life is Sweet in Sweden*, guest bureau, intervention
with tourist office and hostessing crew during the
World Athletic Championships. Independent
production, Gothenburg, Sweden

SELECTED GROUP EXHIBITIONS

2002 *HELLO*, How wonderful that the world exists!,
CCAC Wattis Institute, San Francisco, USA

2001 *HELLO*, Aleksandra Mir, Nick Relph & Oliver Payne'
Gavin Brown's enterprise, New York, USA
HELLO, Pyramids of Mars, Trapholt Art Museum,
Denmark
HELLO, Pyramids of Mars, Brabican Art Center,
London, UK

2000 *HELLO*, Pyramids of Mars, Fruitmarket Gallery,
Edinburgh, Scotland

SELECTED BIBLIOGRAPHY

Juliette Garside, 'Drug hangout set for
art revamp', *Sunday Herald*, Glasgow,
19 August, 2001.
Alex Farquharson, 'Pyramids of Mars',
Art Monthly, No. 3, 2001.
Aleksandra Mir, 'Icelandic Love
Corporation', *Kunstforum International*,
152, Köln, 2000.
Merry Meikle, 'Video has an aesthetic
all to itself', *NY Arts magazine*, Vol. 5.
No. 1, 2000.
Diana Stigter and Jaqueline van Elsberg,
'Overture: Aleksandra Mir', *Flash Art*,
No. 3-4, Milan, 2000.

Lars Bang Larsen, 'The 90's, what was
it all about?', *NU: The Nordic Art
Review*, Vol. 1, No. 11, Stockholm,
2000,
Lars Bang Larsen, 'First Woman on the
Moon', *frieze*, No. 50, 2000
Lars Bang Larsen, 'Social Aesthetic: 11
examples in the light of parallell histo-
ry', *AFTERALL*, No.1, London, 1999.
Diane Eddisford, 'Building Castles in the
Sand', *MUTE*, No.14, London,1999.
Lotte Sandberg, 'On going beyond the
local context', *SIKSI - The Nordic Art
Review*, No. 3-4, Helsinki,1998.

CHECKLIST OF WORKS

HELLO (excerpt) 2000 and ongoing
print project, dimensions variable

A TURTLE WHICH EXPLORER CAPTAIN COOK GAVE TO THE KING OF TONGA IN 1777 DIED YESTERDAY. IT WAS NEARLY 200 YEARS OLD. THE ANIMAL, CALLED TU'IMALILA, DIED AT THE ROYAL PALACE GROUND IN THE TONGAN CAPITAL OF NUKU, ALOFA. THE PEOPLE OF TONGA REGARDED THE ANIMAL AS A CHIEF AND SPECIAL KEEPERS WERE APPOINTED TO LOOK AFTER IT. IT WAS BLINDED IN A BUSH FIRE A FEW YEARS AGO. TONGA RADIO SAID TU'I-MALILA'S CARCASS WOULD BE SENT TO THE AUCKLAND MUSEUM IN NEW ZEALAND. — AUCKLAND/REUTERS, 1966

MIKE NELSON

129

MIKE NELSON

RACHEL WITHERS

Once upstairs, my fearful hand switched on the light a second time. The nightmare that had fore-shadowed the lower floor came alive and flow-ered on the next. Here there were either many objects, or a few linked together. I now recall a sort of long operating table, very high and in the shape of a U, with round hollows at each end. I thought that it was maybe the bed of the house's inhabitant, whose monstrous anatomy revealed itself in this way, implicitly, like an ani-mal's, or a god's, by its shadow. From some page or other of Lucan there came to my lips the word 'amphisbaena', which hinted at, but which cer-tainly did not exhaust, what my eyes were later to see.
(from J. L. Borges: *There are More Things*, trans. Alastair Reed, Penguin 1979)

Yarl's Wood, Britain's flagship asylum detention centre, last night lay in smok-ing ruins after a breakout attempt by detainees left £35m worth of devastation. The privately-run "immigration removals centre" near Bedford held 384 people out of a potential 900 capacity. The incident was supposedly triggered by an argument over the alleged handcuffing of a woman,

aged 55, who required medical attention. A UK Immigration Advisory Service spokes-man suggested the disturbance was fuelled by the government's decision to step up the pace of deportations:

> When a situation is driven by 'how many can we get rid of' stupid decisions will be made." Local people, who had been assured there would be no escapes from Yarl's Wood, were furious. Last night police warned residents not to open their doors. Security at the centre, which is surrounded by a 16ft-high razor-wired fence, is said to be comparable to a category B prison. But managers insisted it did not have "prison levels of security" or a "prison regime".
> (from reports by Alan Travis and Steven Morris, *The Guardian*, Saturday 16 February, 2002)

(An unspecified location, Biennale of Sydney, May 2002.) Hmm. You peer into the tank. No signs of life. You know you shouldn't tap the glass, but who cares – the place seems deserted. Wakey, wakey! Ah, what was that? Something living, hidden under the tank's 'naturalistic' sprinkling of sand, stones and dead branches? No – it's just a reflection, something behind you catching the light. The tank is empty, like the other enclosures in this disappointing, decrepit, distinctly unofficial-looking 'zoo'. Small

animals must have been kept here; scraps of picked-over foodstuffs indicate meat-eaters, so, probably, cold-blooded specimens – maybe reptiles, or even carnivorous insects like bird spiders. Non-indigenous creatures like that would no doubt take a degree of looking-after, but it's clear the keeper went AWOL weeks or even months ago. Or, you speculate ghoulishly, he chose the wrong moment to put his hand in a tank... Maybe the creatures (whatever they were) starved to death. But, thank Christ, there's no sign of any bodies – human or other-wise – in this out-of-the-way spot. Maybe the captives broke loose. Maybe – another creepy thought – they were *turned* loose. Some might be miles away by now, mak-ing themselves at home in the garden sheds of Sydney. But some might still be – oh no, just wait a second, the reflection in the glass, what was...? Painfully slowly, you turn, and discover –

In the spirit of the original, let's leave the story incomplete. Over the last decade, Mike Nelson has become known as a maker of observed, detail-perfect slices of alternative reality which miraculously appear, then van-ish. Nelson observes that his works invite a

certain level of absorption, or suspended disbelief; however, any impression of containment or completion is superficial. His installations operate under the signs of repetition and the fragment, ensnaring visitors in meshes of clues which invite the conscious recycling of endless, incomplete narratives. Small laboratories for the scrutiny of shared myths, they hybridise motifs derived from a fantastic variety of sources: classical and ancient legends, modern literature, pulp fiction, folk tales, historical and art-historical texts, commercial and independent film, TV, the electronic media, the daily news.

The artist's own past work should be added to that list – Nelson's recent pieces have showed an increasingly autophagic tendency. For instance, a section of *Nothing is True, Everything is Permitted* 2001 (Institute of Contemporary Arts, London), was devoted to the (re)construction of an unrealised piece that Nelson planned to show in 1993. The earlier work traced a link between news reports of George Bush's bombing of Baghdad, and Hollywood fables of the 'avenging hero' formula. Installed just as the bombing of Kabul started, it high-lighted a savage convergence of Oedipal and public-relations imperatives – the son's need to outdo the father's performance of potency. Simultaneously, it allowed Nelson to reconsider his current work's origins by creating its own history in the present. In lieu of a catalogue, the ICA published Nelson's *A Forgotten Kingdom*, a book composed of fragments of other books on which he's drawn; Borges' story *There are More Things* makes an anticipated appearance. Borges noted that the twin-headed amphisbaena (from the Greek: 'goes both ways') is an ambiguous beast: vicious and malevolent, it also possesses medicinal properties. Spitting poison from both ends of its body, it might have served as a mascot for the dynastic violence Nelson's work identified. In its ability to exercise both fore- and hindsight, it might be seen as embodying the corrective benefits of reflection and historical awareness.

Roland Barthes' seminal 1957 essay 'Myth Today' characterised myth as stolen language, a form of speech that twists history into empty gesture. Surveying the uses of myth in 2002, one notes with sinking heart the continuing survival of 'evil' – that inevit-able, primordial, mysterious force propelling the actions of individuals and nations – as a highly effective smokescreen for the dehumanising effects of nationalist or sectarian ideologies, the imperatives of capitalist pro-duction, or crushing global inequality. Nelson hints that his Biennale project will review and reinvent some familiar Nelsonian motifs – the lair, the cage, the fear of the 'evil' Other – in the context of contemporary events. Classic Modern horror meets today's front-page news in shock revelation! Might Nelson's work be an example of radical myth? Barthes would probably have said not. Radical myth, he argued, can only be a poor threadbare thing: "It lacks a major faculty, that of fabulising". But, he insisted, to refuse to fabulise is equally to lie – that is, to perpetrate an ideological reduction. Nelson's razor-wire tightrope-walk is impossible – but nevertheless it must be attempted, and re-attempted. "It would seem", Barthes's essay concludes, "that we are condemned for some time yet always to speak excessively about reality".

Mike Nelson born
Loughborough, UK,
1967. Lives and works
in London, UK.

SELECTED SOLO EXHIBITIONS

2001 *Nothing is True. Everything is Permitted.* Institute of
Contemporary Art, London, UK
The Deliverance and The Patience, Peer Commission
for the 2001 Venice Biennale, off-site project at The
Old Brewery, Giudecca, Venice, Italy
The Coral Reef, Matt's Gallery, London, UK

1999 *TOURIST HOTEL*, Douglas Hyde Gallery, Dublin,
Ireland
To The Memory of H.P. Lovecraft, Collective Gallery,
Edinburgh, Scotland

1997 *Master of Reality*, Berwick Gymnasium Gallery,
Berwick-upon-Tweed, UK
Lionheart, Galerie im KunstlerHaus, Bremen, Germany
The Amnesiacs, Campbells Occasionally, Copenhagen,
Denmark

1996 *TRADING STATION ALPHA CMa*, Matt's Gallery,
London, UK

1995 *Agent Dickson at the Red Star Hotel*, Hales Gallery,
London, UK

SELECTED GROUP EXHIBITIONS

2001 *The Cosmic Legend of the Uroboros Serpent*, Turner
Prize, Tate Britain, London, UK
Intentional Communities, Rooseum, Center for
Contemporary Art, Malmo, Sweden

2000 *New Settlements*, Nikolaj Contemporary Art Center,
Copenhagen, Denmark
British Art Show 5, National Touring Exhibitions for
Hayward Gallery, London, sited at multiple venues
in Edinburgh, Southampton, Cardiff, Birmingham
Another Place, Tramway, Glasgow, Scotland

1999 *Holding Court*, Entwistle, London, UK
*Word enough to save a life, Word enough to take a
life*, Clare College Mission Church, London, UK
It's Immaterial, Chiltern Sculpture Trail, UK
The Office of Misplaced Events (Temporary Annexe),
Lotta Hammer, London, UK

1998 *Grey Area* - Andrew Bannister/Philip Lai/Mike
Nelson, Bonnington Gallery, Nottingham, UK

SELECTED BIBLIOGRAPHY

Claire Bishop, 'Master of Reality',
Untitled, No. 22, Summer 2000
Claire Bishop, *The Evening Standard*, 31
August 2001
Richard Cork, 'Too many tours spoil the
broth', *The Times* 2, 13 June 2001
Mark Currah, *Mike Nelson* [www.
londonart.co.uk] April 2000
Charles Darwent (and Artist's pages),
Modern Painters, October 2001

Marcus Field, *The Independent on
Sunday*, 10 June 2001
Mark Godfrey, 'Venice Biennale',
Untitled, No. 25, Summer 2001
Jonathan Jones, 'Species of Spaces',
frieze, July – August 2000
Jonathan Jones, *The Guardian*,
September 2001
Chloe Kinsman, 'Mike Nelson', *Tate
Magazine*, Winter 2001

CHECKLIST OF WORKS

24A ORWELL STREET 2002
installation, mixed media
dimensions variable

courtesy the artist and Matt's Gallery,
London

CHUC MUNG NAM MOI! (IN VIETNAMESE, HAPPY NEW YEAR!)

JUN NGUYEN-HATSUSHIBA

133

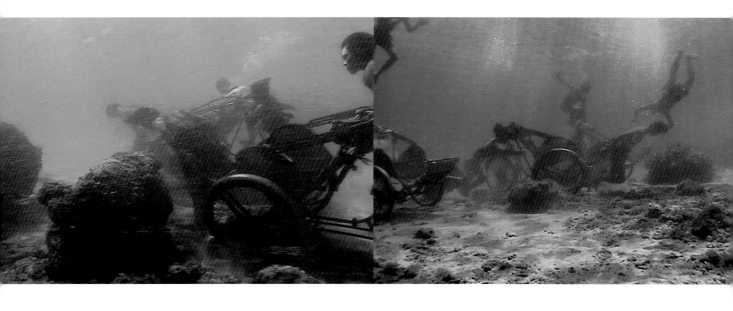

TOWARDS THE COMPLEX

ROGER MCDONALD

Mosquito nets, instant noodles, newspaper, business cards, rice, posters, cyclos. These are some of the diverse materials which Jun Nguyen-Hatsushiba has used in his work. Apart from the cyclos, they read like a list evoking South East Asian cities in all of their unique and complex modernities. Tradition side by side with the tools of trade and consumption. Such words set off a chain of images which make it possible to think about the present in different ways. Moreover, they also act as triggers for the memory, evoking historical resonances or distant reflections. The interconnectedness of words, senses, images and memories is made manifest in the works of Jun Nguyen-Hatsushiba. He is an artist who at once brings disparate elements together in specific formations and from them produces echoes. Everyday things take on a capacity to become memorial and witness to recent and present histories.

Jun Nguyen-Hatsushiba was born in Tokyo, Japan. He shares Vietnamese, Japanese and American heritage. He is thus an artist who works from a place of difference and contradiction. Born in 1968 when the Vietnam War was still being fought, Nguyen-Hatsushiba is from a generation that does not directly know of the conflict. Rather his memories are closer to the postwar situation in Vietnam – the plight of the so called 'Boat People' and Vietnam's slow emergence from years of conflict. Educated at art school in the United States, Nguyen-Hatsushiba has experienced living in Vietnam, America and Japan for at least seven years each. His experiences straddle three countries which were direct theatres of operation in the Vietnam War. Although commonly imagined as a war concentrated in Vietnam and America, its impact within Asia and beyond, on multiple levels, was enormous – including of course the direct combat involvement of Australia.

Nguyen-Hatsushiba's work does not deal directly with this history in the sense of representing it through recognisable images and words. His practice has rather been one of finding resonances. Much of his work draws on the testimony of those who experienced the war and its aftermath, or re-visitations of traditional Vietnamese life. His work is therefore based strongly on memory and recollection, but also possible futures. Through such processes Nguyen-Hatsushiba moulds his own unique forms of memorial which, when translated into art works, give voice to give voice to the concerns and memories of many Vietnamese. And in this respect Nguyen-Hatsushiba's work continues to respect ritual as a potent possibility for art. His work does not emphasise intrinsic auratic qualities, in the way that Walter Benjamin noted. Nor does he emphasise singularity by focusing on unique works – he has instead adopted a flexible approach to media including installation, the use and re-working of so called 'ready-mades' and printing.

The ritual in Nguyen-Hatsushiba's work is not overt, but remains potent. He has performed riding a cyclo across a shallow water fountain, and there are figures in his videos who act out struggles and releases. His aims for an element of ritual are deliberately kept at a distance. It is precisely this distance which gives viewers the chance to engage with the works at different levels, never collapsing the cultural signs or memories into too specific a language. Nguyen-Hatsushiba has spoken of the importance of the avoidance of specificity as "allowing contemplation in me".

The cyclo has been a constant element in many of Nguyen-Hatsushiba's works. This traditional Vietnamese pedal-pow-

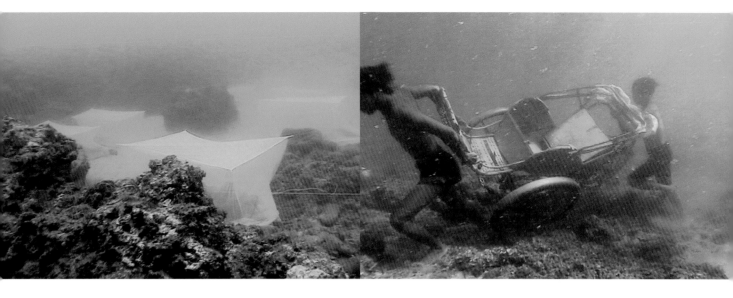

ered taxi transport, roughly equivalent to the Japanese rickshaw, can still be seen in Hanoi or Ho Chi Minh City. Cyclos define the Vietnamese city in many ways, limited speed and rythmical back and forth movement. During the Vietnam War they were used as carriers of secret messages by both sides, notes curled and stuffed into their steel piped structure. Nguyen-Hatsushiba states that recently, with the nationwide reforms in Vietnam and the consequent increase in cars, the cyclo has begun to be pushed aside. At a time when the government is stressing economic reform, the cyclo is seen as a relic of the past, an embarrassment which slows down the city streets. That Nguyen-Hatsushiba works with cyclos is thus appropriate, for in many ways it has become a point of focus for Vietnam's past, a carrier of deep cultural and historical meanings which have become disjointed in the present.

Nguyen-Hatsushiba has worked on a project which involves traditional cyclo makers in small factories producing entirely new cyclos. Working under the title *The Making of Alternative History*, he has produced four new models. Each has a slightly different design, using reflective polished steel – one incorporating hints from the French colonial period. This re-inven-

tion of the cyclo is, for Nguyen-Hatsushiba, one way to acknowledge what is happening to this mode of transportation now. Using limited means, he teams up with welders and builders to re-imagine the traditional vehicle and give it a new face, perhaps more in tune with today's young urban Vietnamese, attracted by the new and the glossy. On accompanying posters which show the shiny new cyclos Nguyen-Hatsushiba inserts the word; "Reflect".

As well as producing new cyclos, Nguyen-Hatsushiba has engaged in a parallel project of interviewing cyclo drivers, many of whom were forced into this poorly paid job after the Vietnam War. This cross-generational work is at once archive and testimony, telling the stories of the drivers in a direct way. Nguyen-Hatsushiba produced a series of highly designed posters to accompany the 'new' cyclos, each one showing a portrait of a driver together with his recollections.

Nguyen-Hatsushiba's most recent work using cyclos was shown last year at *The Yokohama Triennale* 2001 and is shown in this year's Sydney Biennale. Titled *Memorial Project Nha Trang, Vietnam – Towards the Complex – For the Courageous, the Curious and the Cowards*, it is a large single screen projection work. The video was shot

entirely underwater on location in Vietnam, with the help of several of Nguyen-Hatsushiba's friends and an entire group of local fishermen, who played the main 'characters'. They are seen through clear blue waters pushing old cyclos on the sandy ocean bed. Without air tanks, they are forced to rise to the surface every few seconds, repeating this action of diving and rising throughout the film. Towards the end of the film several mosquito nets appear tied to the ocean floor, swaying slightly in the currents. Nguyen-Hatsushiba stated that the cyclo drivers make a pilgrimage towards the nets, their memorial site. The nets are empty, like shrouds, or small houses for the ghosts of those lost at sea while trying to escape after the war. The film's binding element is the open ocean, an endless stage on which the cyclo drivers push with a certain kind of heroism and futility, a resolute dignity and humiliation. And yet Nguyen-Hatsushiba's sublime ocean stage is not only one of awe and frightening beauty, it is also deeply embedded in the present, echoing history and shedding new light – a very different light to that which we experience above water – on its readings.

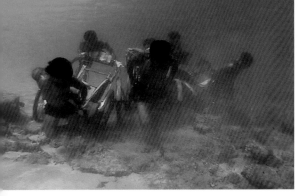

ALL IMAGES TAKEN FROM
MEMORIAL PROJECT NHA TRANG,
VIETNAM -TOWARDS THE COMPLEX
- FOR THE COURAGEOUS, THE
CURIOUS AND THE COWARDS
2001 INSTALLATION/ DVD.

Jun Nguyen-Hatsushiba born Tokyo, Japan, 1968. Lives and works in Ho Chi Minh City, Vietnam.

SELECTED SOLO EXHIBITIONS

2002 *Towards the Complex* (video screening), De Appel, Amsterdam, Netherlands

2000 *Xich Lo 2001 – The Making of Alternative History,* Mizuma Art Gallery, Tokyo, Japan

1998 *In Between,* Shiseido Ginza Art Space, Tokyo, Japan (catalogue)
Individuals-Collections, Mizuma Art Gallery, Tokyo, Japan
WWW.XEOM.COM, Blue Space Gallery, Ho Chi Minh City, Vietnam

1997 *Dream,* 29 Hang Bai Exhibition House, Hanoi, Vietnam

1996 *The Mosaic Series Exhibition*, Dallas Visual Art Center, USA
Studio Gallery/ Sculpture Garden, Center For the Arts, Brookhaven College, Dallas, USA
Trammell Crow Pavilion Gallery, Dallas, USA

1995 *Photographs from Vietnam*, SGI-USA Dallas Culture Center, Texas, USA
New Works 95:02, Jun Nguyen-Hatsushiba, ArtPace, San Antonio, USA (catalogue)

SELECTED GROUP EXHIBITIONS

2002 *25th Sao Paulo Biennial*, Brazil, (catalogue)
Cutting Edge:Tokyo, ARCO 02, with Mizuma Art Gallery, Madrid, Spain (catalogue)

2001 *Yokohama 2001, International Triennale of Contemporary Art,* Japan (catalogue)

2000 *Invisible Boundary: Metamorphosed Asian Art,* Utsunomiya Museum of Art, Japan (catalogue)
Niigata Prefecture Art Museum, Niigata, Japan
3rd Gwangju Biennale, Gwangju, Korea (catalogue)

1999 *Gap Vietnam,* The House of World Cultures, Berlin, Germany (catalogue)

1996 *Critic's Choice*, Dallas Visual Art Center, Texas, USA (catalogue)

1995 *Members Invitational*, The McKinney Avenue Contemporary, Dallas, USA
Art in the Metroplex 95, Texas Christian University, Fort Worth, USA

SELECTED BIBLIOGRAPHY

Daniel Birnbaum, 'Best of 2001,' *Artforum*, Dec, 2001.
Massimililano Gioni, 'Speaking in Tongues,' *Flash Art International*, Nov.-Dec. 2001, pp 74 -77.
Hideki Kawahara, 'Voices of Hamatori,' *Bijutsu Techo*, vol. 53, no. 812, Nov. 2001, pp 129-136.
Christopher Phillips, 'Crosscurrents in Yokohama,' *Art in America*, Jan. 2002, pp 84-91.
Jennifer Purvis, 'The Making of Alternative History,' *The Japan Times* (Arts Section), 3 Sept. 2000, p 14.
Arata Tani, 'Jun Nguyen-Hatsushiba,' *Shinano-Mainichi Daily Newspaper*, 23 July 2001, p 13.

Exhibition catalogues:
Yokohama 2001, International Triennale of Contemporary Art, Japan, 2001.
Invisible Boundary: Metamorphosed Asian Art (addendum), Utsunomiya Museum of Art, Utsunomiya, Japan, 2000.
Invisible Boundary: Metamorphosed Asian Art, Utsunomiya Museum of Art, Utsunomiya, Japan, 2000.
Man & Space, 3rd Kwangju Biennale, Kwangju, Korea, 2000.
Gap Vietnam, House of World Cultures, Berlin, Germany, 1999.
Jun Nguyen-Hatsushiba: In Between, Shiseido Ginza Artspace, Tokyo, Japan, 1998.

CHECKLIST OF WORKS

MEMORIAL PROJECT NHA TRANG VIETNAM-TOWARDS THE COMPLEX-FOR THE COURAGEOUS, THE CURIOUS, AND THE COWARDS 2001
video installation/ DVD
dimensions variable

courtesy the artist and Mizuma Art Gallery, Tokyo

REFLECTING BANALITY:

OLAF NICOLAI'S *PORTRAIT OF THE* *ARTIST AS A WEEPING NARCISSUS*

HARALD FRICKE

The myth is a type of literary narration which perpetuates itself by continuous re-interpretation. In this way the myth maintains its contemporary form. This applies to the arts as much as to the sciences. For instance, in one poem, the German poet Rainer Maria Rilke compared Narcissus with heliotrophic plants, which must constantly keep their flowers facing the sun in order to survive. Freud sees narcissism as a psychological disturbance, part of a misguided projection of one's parents. The formation of ideals by a child, who is supposed to develop into someone special, fails to be tempered by the reality principle in his self-perception. In harking back to a literary formulation one could use Rimbaud's words: "Myself is someone different", but someone whose perfection appears unattainable.

According to Freud this leads to quasi-schizophrenic states. It is exactly this state

that the fine arts manage to portray. For in the portrayal of Narcissus as the eternal self-observer, the observer of the work recognises the unity of the self and the mirror image, which Narcissus can no longer comprehend. This may be the reason that so many artistic depictions of Narcissus are interpreted as self-portraits, in the sense that each portrayal aims for a perfect representation. It can be seen from the self-portraits of Van Gogh that such an approach even by the most gifted artist may fail. A portrayal of Narcissus always serves as a symbol of the struggle between the general principles of representation and a claim to reality. What we have here is a dual visibility, of that which exists and of that which could exist. Olaf Nicolai, however, took on this topic under specific historical conditions. In Berlin the opposition of realism and abstraction has always been a head-on fight between political ideologies from the east and the west. Nicolai anticipates this cultural struggle to some degree in his sculpture *A Portrait of the Artist as a Weeping Narcissus*.

The artist, originating from East-Germany, produced a life-sized wax-mould of himself, directly relating the old conflict – that is, the dogma of socialist realism, to his own

body and thus making it a subject of discussion. In a period where the traditional idea of painting in 'figuration retro-style' is booming, this is more than just an ironic comment on the long since displaced master class discourse.

In reality, however, the reverence to the figurative style displayed by Nicolai is an entirely conceptual one. He uses the wax model of his body as a model for the intertwining of art and the public - the object is a representative of the paradox relationship between individual artistic expression and the normed codes of society. While the work follows conventional representation as far as its form is concerned, the situation it represents removes itself from exactly this visibility. Narcissus extricates himself from his real environment the moment he sees himself – he is no longer part of that which constitutes reality. Narcissus falls in love with his mirror image on the water's surface and thus becomes unable to relate to the world.

Nicolai emphasises this gap even more through the ordinary clothes in which he veils his figure – that is, jeans, shirt and joggers. The every day nature and banality of his figure's outer appearance is a result of the insight that in Nicolai's words, "the

narcissistic character of the artist is not just a stereotype but has become a commercial stamp on the product". Indeed, the sculpture is a prefabricated model in the mould of a representative or doppelganger, similar to the group presented by the American artist Charles Ray at *documenta* (Kassel/Germany) in 1992. The group consisted of seven copies of the artist's own body copulating with each other.

However, the artist has built a trap into this simplified way of looking at his work – a tear drops from the eye of the sculpture every few seconds, down into the water puddle in front of it. The self-referencing system which Nicolai has designed as a fragment of an artificial landscape is thus broken. If you follow the logic of the myth, the mirror image will become blurred by the tear falling onto the water's surface. The absolute beauty observed by Narcissus becomes invisible. According to Nicolai this moment has already occurred seconds earlier because a person cannot recognise things, at least not clearly, with tears in their eyes.

It is obviously not only the relationship between the artist and his environment that is broken down, but the desired object which he has designed for himself is also

removed from his perception. This is the beginning of a response to Lacan's theory of the formation of the 'Ego-function' in the mirror state. Nicolai commented on this in his catalogue essay titled 'Show Case' in 1999 as follows: "The subject's position is not determined by what he sees but by what he misses, by the blind spot."

In relation to Nicolai's Narcissus, the 'blind spot' is in fact his own creative production. This statement may be in line with the common idea of the artist as an outsider. Nicolai, however, turns this into the basic question of what the standing of art itself is. For art's system of operation revolves around the idea of the artist as a star, particularly since Pop Art first appeared. The artist has to represent a public image. [The presentation of] Jeff Koons is quite similar to Madonna's shows. Matthew Barney appears in his videos very effectively as a well-endowed satyr or as the mass murderer turned cult figure Gary Gilmore. However, media image campaigns are nowadays no longer seen as the sole field of operation for the artist, as people increasingly look for social competencies.

Nicolai does not reject this claim, but rather searches for the consequence of this definition. In these current times of

the New Economy, creativity has come into focus as the real engine propelling the service industry, start-up enterprises and the production of goods. Consequently, the artist cannot remain untouched by this attribution: in the confusion of the new market it is the duty of the artist to develop "attention resources" (Nicolai).

Due to the fact that the dividing line between the fine arts and visual culture has all but dissolved, there is longer any vantage point outside of the omnipresent information society – the interior is the exterior and vice-versa. In Nicolai's work, this coupling results in an object which is apparently subject-focussed. His Narcissus is not a utopian model, rather an entropic one. The realistic surface does not lead back to the individual or even the author. Rather, it is the result of abstraction – a standardisation in dealing with constructions of the self.

Narcissus is another, and all others as well.

Translated by Anglo-German Communications, Sydney

Olaf Nicolai born
Halle/Salle, Germany,
1962. Lives and works
in Berlin, Germany.

SELECTED SOLO EXHIBITIONS

2001 *Enjoy Survive Enjoy*, Migros Museum fur
Gegenwartskunst, Zurich, Switzerland
favorites, Galerie fur Zeitgenossische Kunst, Leipzig,
Germany

2000 *Pantone wall, instrumented and odds and ends
(Editionen 1994 – 2000)*, Kunstverein Bonn, Germany
...fading in, fading out, fading away..., Westfalischer
Kunstverein, Munster, Germany

1999 *Labyrinth*, Galerie fur Zeitgenossische Kunst,
Leipzig, Germany
Parfum fur Baume, Bundesgartenschau Magdeburg,
Germany

1999 *landschaft. metaphysisch + konkret*, Kunstverein
Ulm, Germany

1994 *Sammlers Blick*, Lindenau-Museum Altenburg,
Germany
Memory, The Approach, London, UK

SELECTED GROUP EXHIBITIONS

2001 *Venice Biennale*, Venice, Italy
Sous les ponts, le long de la Riviere..., Casino
Luxembourg, Luxembourg, Belgium
Casino 2001, Stedelijk Museum Voor Actuelle
Kunst, Gent, Belgium

2000 *What If – Art on the verge of Architecture and
Design*, Moderna Museet, Stockholm, Sweden
La Ville 1998, le Jardin 2000, la Memorie 1999,
Villa Medici, Rome, Italy

1999 PS 1 Museum, New York, USA
Empty Garden, Watari-Um Museum, Tokyo, Japan

1998 *Berlin Biennale*, Berlin, Germany

1997 *documenta X*, Kassel, Germany

1994 *WELT-MORAL*, Kunsthalle Basel, Switzerland

SELECTED BIBLIOGRAPHY

Harald Fricke, 'Olaf Nicolai at Galerie
Eigen+Art', *Artforum*, Summer 2001, p
195
Thomas Irmer, 'Natur Gestalten', *Neue
Bildende Kunst*, Issue 1, 1997
Olaf Nicolai, *...Fading In, Fading Out,
Fading Away...*, exhibition catalogue,
Westfalischen Kunstverein, Munster,
Germany
Olaf Nicolai, *show case*, Verlag fur
Moderner Kunst, Nurnberg, Germany,
1999
Olaf Nicolai, *Sammlers Blick*, Verlag der
Kunst, Amsterdam and Dresden,
Germany, 1994
Annelie Pohlen, 'Language of Colour',
Olaf Nicolai, 30 Farben, Bonner Kunst-
verein, Salon Verlag, Bonn, Germany,
2000
Christoph Siemes, 'Torwandschiessen
mit Andy Warhol', *Die Zeit*, 5 April 2001
Raimer Stange, 'Bedurfnis nach
Bedurfnis?', *Kunstbulletin*, April 2001
Raimer Stange, 'Olaf Nicolai', *Artist*,
May 2000
Jan Wenzel, 'Gesprach mit Olaf
Nicolai', *Spector (Cut + Taste)*, March
2001

CHECKLIST OF WORKS

A PORTRAIT OF THE ARTIST AS A
WEEPING NARCISSUS 2000
polyester figure: 85 (h) x 170 (w) x 60
cm stand (inclusive pond): 40 (h) x 180
(w) x 270 (l) cm

courtesy the artist and Galerie
EIGEN+ART, Berlin/ Leipzig

PAUL NOBLE

141

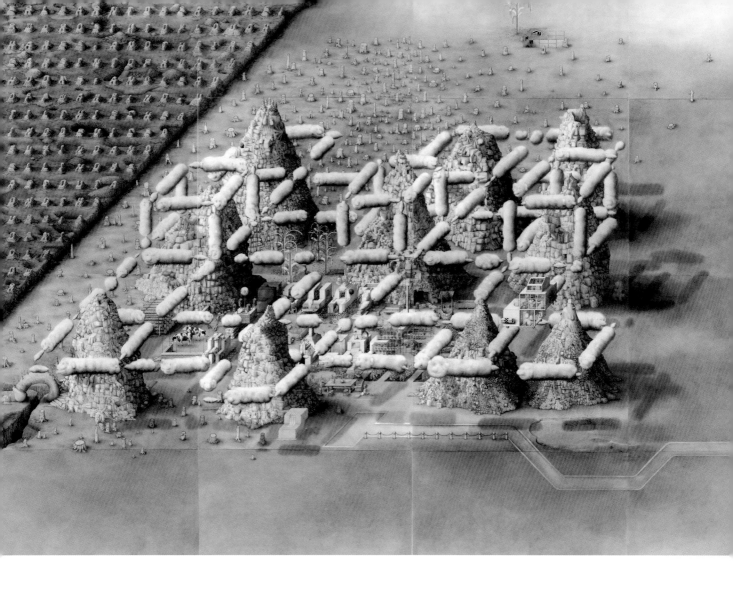

PAUL NOBLE

NON ACCIDENTS SED ERRORES

ANTHONY SPIRA

Paul Noble began his plans for a fictional town called Nobson Newtown in 1995. The project has since developed into 27 large scale graphite drawings of buildings and places which range from the Nobspital to the Nobslums via Nobwaste. Other features include Nobson Central (the town centre), the Public Toilet, the Shopping Mall, the Squat and the Cemetery (Nobsend). Noble also wrote and designed an accompanying book that provides a 'historical' account of the town's social, cultural and geological development.

The book, also called *Nobson Newtown*, explains that, before the old town was demolished, residents were asked to complete a detailed list that would provide all the requirements for a healthy urban centre and that their decisions were unanimous. We are also informed that...

What resulted was a very modern slum but with a touch of poverty that perfectly combined the dual directions of time. On the one hand, the very modernity of these slums suggests a progressive, and positively redemptive aspect to this kind of living. On the other hand, the obvious calculated neglect and creeping seediness could be taken to suggest that despite youthful optimism in the goodness of mankind and that all change is for the better, the truth is that wherever man goes, destruction and sadness aren't too far behind.

The origins of the entire project lie in a special font and map that Noble designed while he was invigilating at the artist-run gallery City Racing in London. He undertook the painstaking task of personalising a font based on the forms of classical modernist architecture on a computer and hand-drew a map with all the buildings he would like to design. During this period, he regularly played *Sim City*, a computer game which is programmed to allow you to design and run a simulated city.

This exhibition includes two large drawings, *Public Toilet* and the squatter camp, *Acumulus Noblitatus*. Both sites are social spaces where all people are deemed equal

- a communal sentiment which spreads through the whole project. This particular public convenience may be construed as a celebration of our rare 'animal' moments whereas the squat remains altogether more ambitious. The grid of fluffy clouds that frames the summits of the pyramids in the squat is a technical device used to provide an illusion of depth and an introduction to an important duality that runs throughout *Nobson Newtown*. Whereas the geometric formation of the clouds suggests a threatening higher order, their anthropomorphic and scatological features are drawn from cotton wool and derived from children's animations. The presence of such contradictory potential through a mixture of fear and fantasy or control and freedom is one that is central to every reading of Noble's designs.

In the squat, as in the other drawings, the central architectural features double up as letters that name the site. In *Nobson Newtown*, language is literally the 'building block' of civilisation and the foundation of society. By conflating a living space and a

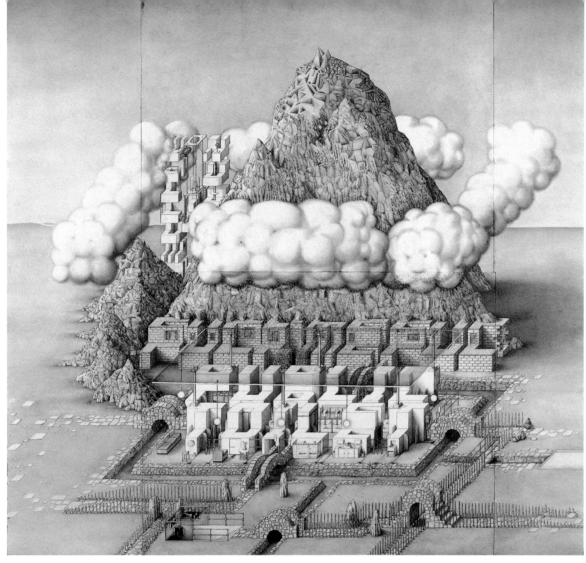

ACUMULUS NOBLITATUS 2000/2001 PENCIL ON PAPER. PUBLIC TOILET 1999 PENCIL ON PAPER.

communication tool into one, Noble takes 'concrete' poetry to its almost literal conclusion. An earlier drawing, *Nobson Central* presents a wasteland in architectural ruins that conceals short extracts from Eliot's famous poem.

These urban 'textscapes' are almost illegible, constructed as they are by a personalised set of hieroglyphs. The reduced ability to decipher this ideolect has a regressive effect that tempers the viewer's in-take and stands in defiance of globalisation. This defamiliarisation (of language) presents a return back to basics, with language as the building blocks of our childhood. Communication breakdown (or slowdown) conjures a Reichian vision of utopia, a return to innocence and to an edenic pre 'civilisation'.

Given that we are provided with a key map in several of the artist's books, Noble's texts present a ludic endurance test that seeks out like-minded initiates for his utopian community. Like an illumination in a medieval manuscript, the overall design is developed around language and en-

trenched in a message. The ploughed fields in the top left hand corner of *Acumulus Noblitatus* repeat the words in a letter from Gerard Winstanley to Oliver Cromwell written in 1652. Winstanley, an early pacifist who recognised the dangers of capitalism, warned that...

> the nations of the world will never learn to beat their swords into ploughshares, and their spears into pruning hooks, and leave off warring, until this cheating device of buying and selling be cast out among the rubbish of kingly power.

The selection of this text confirms Noble's sympathy with Winstanley's pre-industrial era and the town itself emerges as a monument to human decadence. The various clues littered around Nobson Newtown reveal a self-destructive society where the ravages of deforestation and the exhaustion of natural resources are the inevitable eventualities of human evolution. There may be small hints of leisure activities that testify to the good times but these are abandoned and the teapot in the foreground, for example, has gone cold. As a reminder of our personal and

collective responsibilities, the 'oblique projection' of each drawing offers a god's eye view of the town of our own creation.

One of Nobson Newtown's mottoes reads: *non accidents sed errores* - no accidents, only mistakes. Rather than ranting against our misfortunes, the implication is one of self-determination and an acceptance of human frailties and failures. As a riposte to Bosch's fearful warnings against human nature, Noble's creations are a celebration of human decadence and a rallying cry for solidarity. Despite the apparent desolation of the town, the ambitious synthesis of architecture, drawing and prose, the grand-eur of the drawings and their unerring execution reveal a veritable labour of love. This aesthetic attention powerfully counters their dysfunctional appearance and instils the drawings with affection. These are neither utopian nor dystopian visions but pragmatic testaments to the state of our time where 'youthful optimism' remains harnessed to the 'truth' of 'destruction'.

ACUMULUS NOBLITATUS
(DETAIL) 2000/2001 PENCIL ON PAPER.
FRONT PAGE IMAGE: UNIFIED NOBSON
2001 PENCIL ON PAPER.

Paul Noble born
Northumberland, UK,
1963. Lives and works
in London, UK.

SELECTED SOLO EXHIBITIONS

2002 Albright Knox Gallery, Buffalo, New York, USA
2001 Maureen Paley Interim Art, London, UK
 MaMCO, Geneva, Switzerland
2000 Gorney Bravin+Lee, New York, USA
1998 Maureen Paley Interim Art, London, UK
 NOBSON, Chisendale Gallery, London, UK
1996 *Doley*, Maureen Paley, Interim Art, London, UK
1995 *Ye Olde Worke*, Cubitt Gallery, London, UK
1992 *Toilet Rolls*, Archbishop Tension School, London, UK
1990 City Racing, London, UK
1989 North East London Polytechnic, London, UK

SELECTED GROUP EXHIBITIONS

2002 *Contemporary Drawing: Eight Propositions*, Museum
 of Modern Art, New York, USA
2001 City Racing, ICA, London, UK
2000 *Protest & Survive*, curated by Paul Noble and
 Matthew Higgs, Whitechapel Gallery, London, UK
 Out of Place: Memory, Imagination and the City,
 The Lowry, Manchester, UK
 *Future Perfect: art on how architecture imagined
 the future*, Centre for Visual Arts, Cardiff, UK
 As it is, Ikon Gallery, Birmingham, UK
 Manifesta 3, Ljubljana, Slovenia
 British Art Show 5, touring exhibition, UK
1999 *Abracadabra*, Tate Gallery, London, UK
 *Carroll Dunham, Paul Noble, Daniel Oates, Peter
 Saul,* Gorney Bravin+Lee, New York, USA
1998 *The Last Show*, City Racing, London, UK
 Social Realism, Stephen Friedman Gallery, London, UK

SELECTED BIBLIOGRAPHY

Nobson Central, monograph, Verlag der
Buchhandlung, Walter König, Cologne,
2000
Introduction to Nobson Newtown,
monograph, Salon Verlag, Cologne,
2000
Claire Bishop, 'Paul Noble Interim Art',
Flash Art, Vol. XXXII, No. 206, May
June 1999
Holland Cotter, 'Paul Noble', *The New
York Times,* 10 March, 2000.
Jonathan Jones, 'Five-card trick', *The*

Guardian Weekend, 30 September, 2000
Dennis Kardon, 'Noble Dystopia',
Artnet.com, 17 March, 2000
Jeffrey Kastner, 'Paul Noble', *Artext,*
No. 70, 2000
Carol Kino, 'Paul Noble at Gorney
Bravin+Lee', *Art in America,* No. 10
October 2000
Tom Morton, 'Bleak Houses', *frieze,*
Issue 65, March 2002
Gilda Williams, 'Paul Noble', *Art
Monthly,* No. 252, Dec.-Jan. 2002

CHECKLIST OF WORKS

ACUMULUS NOBLITATUS 2000/2001
pencil on paper
390 x 550 cm
collection: John Smith & Vicky Hughes,
London

THE BRIDGE TO CAMP ACUMULUS
NOBLITATUS 2002
pencil on paper
47 x 76 cm
collection: Cranford Collection, London

PUBLIC TOILET 1999
pencil on paper
275 x 275 cm

courtesy the artist and Maureen Paley
Interim Art, London

MORE THAN 30 YEARS AGO, I MADE A FISH AND CALLED IT "WHALE". THE FISH LOOKED
LIKE A ROUNDED SQUARE BOX WITH A TAIL ON ONE END AND A FIN ON TOP OF IT. THE
BIG BOX COULD BE SEEN AS A KITCHEN, HIGH ENOUGH TO STAND UP IN, AND IN THE
TAIL THERE WAS SPACE FOR AN ENGINE. THE FIN ON TOP OF THE ROOF BECAME A
CONNING TOWER WITH PERISCOPE. TWENTY-FIVE YEARS LATER I WALKED PAST A SHOP ON THE DOCKS IN ANTWERP
AND SAW THIS MAGNIFICIENT GREEN, COMPACT ELECTRIC GROUP DIESEL MOTOR AND GENERATOR. "17 KILO-
WATTS," THE MAN IN THE SHOP SAID, "A LISTER PETTER, THE ROLLS-ROYCE OF DIESELS, RUNS ALL DAY AND NIGHT,
NO TROUBLE, ELECTRIC STARTER, BATTERY ETC." I decided to build a submarine around it in the style of the engine and
keep the interior of the boat in the same green. The motor weight was 500 kg and was standing in the middle of the ground
floor in my old rat house in the Biekorfstraat. I thought it was going to crash into the cellar. Little did I know that a few
months later, a 3000 kg submarine would be hanging from a wooden beam on the ceiling, being rotated with chain hoists
in all kinds of positions while it was being banged on with sledgehammers. After a time of welding, cutting and bending
tons of steel plates, me and some companions at the time, began fantasizing about a trip with it to Spitsbergen. A 3000
km-long voyage from Antwerp to the poles. Because what could be better for such a journey, than an all-storm-proof boat
like this submarine? What a view it must be, standing in the conning tower, gliding slowly by the onlookers gaping in awe
on the quays of the river Scheldt. Up to Spitsbergen, yes! Surprisingly, it was quite simple to get the submarine in the
water; it could be done practically overnight at the Royal Boating Club. They had all the facilities and, so they said, since
the boat is no longer than 7 meters, with a speed no more than 10 km/h, you don't need any permits whatsoever. (What a
wonderful, free country Belgium must be! Hip hip hurray!) Equally surprising was the fact that, suddenly, for one reason or
another, the submarine crew disappeared. Well that taught me that you never should make something that you cannot use
alone, because I could not wobble alone over the North Sea in this floating pill box bunker. So I spoke to the city brass and
told them that they could have the boat for a long while, if they found a good place for it on the river banks, and they
accepted. But city brass entails city civil servants and, as everybody knows everywhere, another bunch of good for...

PANAMARENKO

145

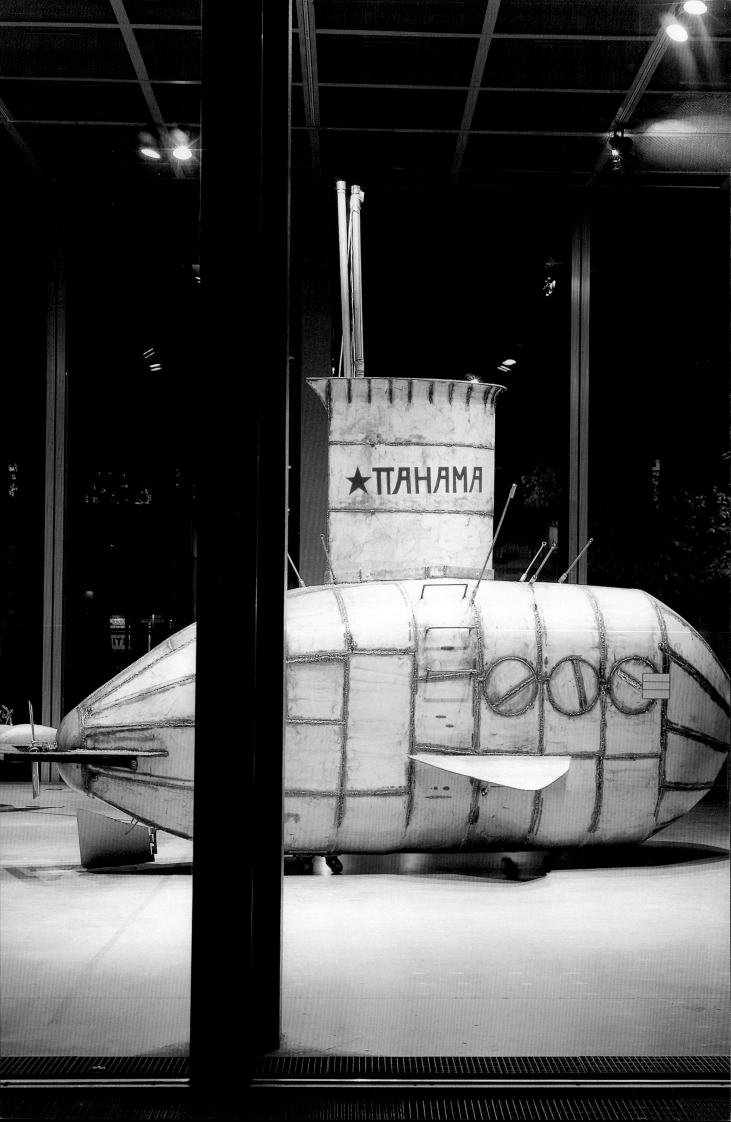

BERNOUILLI 1 & 2

FLYING PLATFORMS. WHAT IS BAD ABOUT A MOTORIZED BALLOON? ITS SIZE – IT DOES NOT MATTER MUCH IF YOU MAKE A BALLOON FOR ONE OR TWO PERSONS, EVEN FOR ONE IT WILL STILL BE ENORMOUS. BALLOON FOR ONE PERSON, SIX METERS DIAMETER, FILLED WITH HELIUM OR HYDROGEN. A BIT MORE THAN SEVEN METERS IS GOOD FOR TWO. BOTH GIGANTIC THINGS JUST AS WIDE AS THEY ARE HIGH, NOT SOMETHING ONE CAN TIE DOWN WITH A ROPE FOR A MONTH IN THE BACKYARD. BALLOONS OF ONLY TWO METERS OR SO CAN BE LEFT OUTSIDE, EASIER.

Gas is constantly diffusing through the hull. For a little balloon that is no big deal: just inflate it again, like a kid's balloon. For a big one, a costly helium refill. Small balloons can be used to stabilize a platform. Suddenly, nothing is needed anymore, no steering stick, no electronics, no concentration. The platform lifted by a couple of counter-rotating propellers is autostable, even with one little balloon on a pole above the craft. To steer, walk a step in any direction and the platform will gently incline and follow.

Bernouilli 1 was made with two pepper-box protecting cages around the propellers; Bernouilli 2 has a high pole and looks like a ship. PANAMARENKO, *For Clever Scholars, Astronomers and Doctors*, Edition Ludion, Ghent-Amsterdam, 2001

DAS FLUGZEUG 1967 INSTALLATION
VIEW AND DETAIL. PREVIOUS PAGE,
LEFT: PANAMA SPITSBERGEN, NOVA
ZEMBLAYA 1996, PHOTOGRAPHY:
FONDATION CARTIER. PREVIOUS PAGE,
RIGHT: BERNOUILLI 1 & 2, 1995,
PHOTOGRAPHY: D&D/ STUDIO 101.
FRONT PAGE IMAGE: PANAMA
SPITSBERGEN, NOVA ZEMBLAYA 1996,
PHOTOGRAPHY: MAARTEN DE SMIT

Panamarenko born
Antwerp, Belgium,
1940. Lives and works
in Antwerp, Belgium.

SELECTED SOLO EXHIBITIONS

2002 *Panamarenko*, Reina Sofia, Madrid, Spain
 Panamarenko, S.M.A.K., Ghent, Belgium
2001 *Orbit - Panamarenko*, Dia Center for the Arts, New
 York, USA
2000 *Panamarenko*, Museum Jean Tinguely, Basel,
 Switzerland
 Panamarenko, Hayward Gallery, London, UK
1998 *Panamarenko*, Fondation Cartier, Paris, France
1997 *Panamarenko*, Fondacio Mies van der Rohe,
 Barcelona, Spain
1995 *Panamarenko, Autovision*, Stadtische Galerie,
 Nordhorn, Germany
1992/3 *Retrospective Panamarenko*, Tokyo-Osaka, Toyama,
 Kamakura, Japan

SELECTED GROUP EXHIBITIONS

1999 *Monde Réel*, Fondation Cartier pour l'art
 contemporain, Paris, France
 Biennale of Venice, Italy
1998 *Watou 98*, Watou, Belgium
1997 *Future Present Past*, Venice, Italy
1996 *23e Bienal Intenacion*, Sao Paulo, Brazil
1991 *Irony by Vision*, Watari, Tokyo, Japan
 L'art en Belgique, Musée d'art moderne, Paris, France
 Metafor och Materia, Moderna Museet, Stockholm,
 Sweden

SELECTED BIBLIOGRAPHY

Panamarenko, *For Clever Scholars,
Astronomers and Doctors*, Edition
Ludion, Ghent-Amsterdam, 2001
Jon Thompson, *Panamarenko*, Hayward
Gallery, London, 2000
Michel Baudson, *Panamarenko*
(monograph), Edition. Flammarion,
Paris, 1996
Hans Theys, *Panamarenko* (monograph),
Brussels, 1992
F Bex, L Grisebach, PH Hefting, C Hirsch,
J Leering, R Oxenaar and P Van Daalen,
Panamarenko, Brussels-Berlin-Oterloo,
1978

CHECKLIST OF WORKS

SCHELPVORMIGE RUGZAK (SHELL-SHAPED
RUCKSACK) 1986
air conducts of epoxy and glass fibre,
perspex current benders, Bakelite fan, balsa
wood, double pastillemotor and painted
wire netting, 58.5 x 64 x 56 cm
private collection

PANAMA, SPITSBERGEN, NOVA ZEMBLAYA
1996
steel, video camera and monitor, plexiglass
600 (h) x 705 (l) x 344 (w) cm
collection: Fondation Cartier pour l'art
contemporain, Paris

BLUE ARCHAEOPTERYX (THEYS #186) 1991
balsa, iron, strings, 6 servomotors, 2 x 12
solar cells, tape and beads
39 (h) x 30 x 30 cm
private collection: Mark Deweer, Otegem,
Belgium

PUK BOT (ARCHAEOPTERIX) n/d
mixed media 22 (h) x 35 (l) x 10 (w) cm
private collection: Simone & Jacques Leiser,
Belgium

BERNOUILLI 1995
250c Motot 35 PK, two propellers, PVC,
wood and iron, 230 x 600 x 300 cm
private collection

PEPTO BISMO "JAPANESE PACK" n/d
drawing-pencil, orange and red felt tip pen
on paper and white paint
41 x 33 cm; framed 48 x 42 cm
private collection: Paul Lannoy, Belgium

SUBMARINE PHASE 3 n/d
drawing- pencil, grey and silver paint
40 x 30 cm; framed 49 x 38 cm
private collection: Paul Lannoy, Belgium

SUBMARINE HALF OPEN 1995
drawing- pencil, green crayon, white paint
and red felt tip pen
31 x 29 cm; framed size 55 x 55 cm
private collection: Paul Lannoy, Belgium

MACHINES THAT WALK n/d
drawing- pencil, corrector, blue and pink
crayon, red and green felt tip pen and
orange carton collage
33 x 40 cm; framed 42 x 50 cm
private collection: Paul Lannoy, Belgium

THE SMALL PLUMBIT MOTOR n/d
drawing- pencil, silver, green and gold
paint, red felt tip pen
40 x 29 cm; framed 49 x 39 cm
private collection: Paul Lannoy, Belgium

IN PURSUIT OF NOVELTY AND AMUSEMENT
1) AEROMODELLER BLIMP; 2) PORTUGUESE
MAN OF WAR; 3) THE BIG ELBOW n/d
drawing- pencil, silver paint, red, blue,
green and orange crayons
47 x 32 cm; framed size 56 x 42 cm
private collection: Paul Lannoy, Belgium

SILVER BACKPACK n/d
drawing - pencil and silver paint
20 x 29 cm; framed 28 x 38 cm
private collection: Paul Lannoy, Belgium

PROJECT BERNOUILLI 1 n/d
drawing - pencil, corrector, red felt tip pen
41 x 29 cm; framed 70 x 59 cm
private collection: Paul Lannoy, Belgium

ZIP BANGALORE n/d
drawing - pencil, corrector, silver paint,
yellow and red crayon,
41 x 33cm; framed 68 x 64 cm
private collection: Paul Lannoy, Belgium

NO.9 A MAN POWERED AIRCRAFT n/d
drawing - pencil, yellow, orange, red and
green paint, 21 x 33 cm; framed 29 x 42 cm
private collection: Paul Lannoy, Belgium

K3 JUNGLE CAR AND THE PORTUGUESE
MAN OF WAR n/d
drawing- pencil collage, white and gold paint
22 x 26 cm; framed 57 x 51 cm
private collection: Paul Lannoy, Belgium

ARCHAEOPTERYX (2 DRAWINGS) n/d
drawing - pencil and corrector drawing
2 pieces 20 x 33 cm each; framed 67 x 54 cm
private collection: Paul Lannoy, Belgium

MATCHBOX MOTOR (SMALL NOISY
MOTOR) n/d
drawing - pencil, corrector, red and blue
felt tip pen, grey and orange
21 x 29 cm; framed 30 x 38 cm
private collection: Paul Lannoy, Belgium

Works courtesy the artist and Ronny Van
de Velde, Antwerp

THE CONSOLATION OF PHILOSOPHY PIKO NEI TE MATENGA: WHEN
OUR HEADS ARE BOWED WITH WOE¹ — THE TITLES OF THESE WORKS
ALL REFER TO PLACES IN FRANCE AND FLANDERS WHERE THE
PIONEER MAORI BATTALION MADE A CONTRIBUTION IN WORLD WAR I.

MICHAEL PAREKOWHAI

DURING THE GREAT WAR MOST MAORI SOLDIERS WERE NOT CONSCRIPTED INTO THE ARMY BUT 'VOLUNTEERED' FOR
MILITARY SERVICE. THE RIGHT TO TAKE UP ARMS AND FIGHT FOR GOD, FOR KING AND FOR COUNTRY WAS REGARD-
ED BY MANY BOTH AS A SACRED OBLIGATION AND AS AN OPPORTUNITY FOR ADVENTURE. DEATH ON THE KILLING
FIELDS OF WESTERN EUROPE WAS BELIEVED TO BE A 'JUST PRICE' WHICH WOULD SECURE FOR MAORI THE SAME
PRIVILEGES AND RECOGNITION THAT PAKEHA ALREADY ENJOYED AT HOME. This work is also about how Maori initia-
tives that help to shape the course of mainstream history-making have a tendency to get 'left out' of popular accounts of
the fact. Not many people know that it was Maori skill in engineering and logistics while under prolonged bombardment
and gas attack which gave the Anzac troops the nickname, 'Digger' ². However, the use of flower symbolism in this work
memorialises much more than just the war exploits of our glorious dead. It is also about re-claiming a pre-Pakeha Maori
appreciation of the floral as an authentic badge of masculinity. Our family name 'Pare-kowhai' literally means 'Garland
of yellow' (kowhai of course) and was won for us by a great warrior, who was as much a conqueror in the field of love, as
he was a conqueror in the field of war. In this work the ability to express a sensitivity to, and a respect for, 'flowers' is seen
as a staunch affirmation of manliness made only by true sons and grandsons of 'real' men. M & C PAREKOWHAI

ON THE WHITENESS OF THE WHALE

BENEDICT REID

Whoever deeply searches out the truth
And will not be deceived by paths untrue,
Shall turn unto himself his inward gaze,
Shall bring his wandering thoughts in circle home
And teach his heart that what it seeks abroad
It holds in its own treasure chests within.[3]

Michael Parekowhai is a Maori artist. While this assertion may seem entirely self-evident it is an assumption that merits restating as it is fundamental to any informed discussion of his work. Without an awareness of the concerns and experiences of contemporary Maori, Parekowhai's primary audience, there is a risk of misunderstanding essential motivations in his art.

Perhaps the aspect of Parekowhai's work that Eurocentric art critics find most confusing is the specifically political and intellectual nature of his pieces. As Francis Pound says,

We tend to imagine that art speaks to us, as it were, naked and alone.[4]

This attitude is at odds with Parekowhai's work which continues the tradition of Maori art being a tool for communication, an initiator of debate or a reminder of the past's relevance to the present. Maybe this explains why Parekowhai chooses not to sign his art, like the tribal craftsmen whose journey he continues. Parekowhai prefers to remain anonymous, allowing the focus to be on the work itself.

The Consolation of Philosophy seeks to use the full range of implements found in the archetypal 'white box' (artist statements, titles and not forgetting of course the art) in order to help elucidate the work. Yet still, it was possible for New Zealand Herald art critic T J McNamara to neglect the explicitly stated link between the images and the Maori Pioneer Battalion[5]. The sense of loss that is expressed in these photographed floral arrangements is located by the work's title to a specific time, a specific place and a specific people.

'Boulogne', 'Etaples', 'Passchendaele', 'Le Quesnoy' and 'Flers' are French and Belgian place names, when associated with 'Turk Lane' it becomes clear that the work refers to locations where the New Zealand (Maori) Pioneer Battalion dug trenches during 1916 and 1917. However, this is no monumental war memorial. The grief that is expressed is not the academic patriotism of the cold concrete towers to 'the glorious dead' found throughout Australasia. Instead there is a more personal regret, for what may have been.

There is a bittersweet quality to Parekowhai's memorial. What is at first glance a series of classically arranged floral tributes is on closer inspection a selection of suburban kitsch. Fake flowers in plastic and silk arranged in scaled-up versions of Crown Lynn ceramics.[6] The sense of loss is real, but questions are raised about how we have viewed this loss.

Perhaps we have been beguiled into looking too closely at the flowers alone. The truly dominant feature in all these works is the white fields that surround the arrangements. As Herman Melville wrote:

Though in many natural objects, whiteness refiningly enhances beauty, as if imparting some special virtue of its own…there yet lurks an elusive something in the innermost idea of this hue, which strikes more of panic to the soul than that redness which affrights in blood.[7]

But these are works about Maori who fought in a European war. The white is not just a reference to the spiritual link between white and death (as in the tunnel of light which it is said is seen at the moment of death).

That ghastly whiteness it is which imparts such an abhorrent mildness, even more loathsome than terrific, to the dumb gloating of their aspect. So that not the fierce-fanged tiger in his heraldic coat can so stagger courage as the white-shrouded bear or shark. [8]

To the modern reader of *Moby-Dick* there is a certain discomfort in the references to the 'Maori' character Queequeg as a 'wild cannibal' and yet throughout the book there is an extraordinary lack of awareness that far more dangerous mammals other than bears and whales can be white.

Boethius wrote *The Consolation of Philosophy* while imprisoned in the time between his condemnation and execution. In it he attempts to merge his own Christian ideas with what Greeks philosophers had been writing a thousand years earlier. This experiment in biculturalism includes a number of strong anti-war statements, but in matching Aristotle's ideas of the impossibility of

perfection with Christian notions of good and evil, Boethius reaches his own unique conclusion: What you achieve is far less important that what your 'mind's eye' thought you would achieve.[9]

Young Maori flocked in droves to volunteer for the Great War, setting aside their differences with the Pakeha and hoping to prove that they were worthy subjects in the British empire. The New Zealand Pioneer battalion is an example of a utopian dream. Under Lieutenant-Colonel King the membership of the battalion was approximately half Maori and half Pakeha. King's last act before being transferred to the command of a new battalion was to post the surviving Pakeha to different battalions. And so the Maori pioneer battalion was formed. But Parekowhai's works all reference places where the Pioneer battalion worked as a bicultural unit.

Two months after taking up his new command, Lieutenant-Colonel King was killed by 'friendly fire', and the Maori lament for a fallen chief, *Piko nei te matenga* was sung at his burial. Parekowhai's bouquets are not exclusively for fallen Maori warriors but are a gentle reminder to all New Zealanders that no one ever wins a war.

The Consolation of Philosophy was made during a year in which New Zealanders once again clashed over our views of history. The Prime Minister came under intense public pressure to reprimand a MP from her own party, simply because that MP used the accurate description 'holocaust' when discussing the nineteenth-century cultural displacement and mass murder of Maori by Pakeha during the Land Wars. This incident confronted New Zealanders with the realisation that as a nation we still have a long way go before we can ever be reconciled with our past. Parekowhai's work could be viewed in the context of this debate and the extent to which a liberal coat of whitewash has been applied to the collective memory, making the past an abberration most Pakeha would prefer to forget.

A generation of Maori leaders died on the battlefields of Europe in order to affirm their nationhood with the Pakeha. Yet race relation arguments in New Zealand still tend to revolve around the old dichotomies of right and wrong, without acknowledging that the origins of these disputes have a harrowing and complex history. In a seemingly non-confrontational way, Parekowhai directs our attention to this past in the hope that it may show us some path to the future.

> Man is the prey of lion fangs and snake,
> Of man as well? Why does he battles make
> And long to perish by another's blade?
> Because his manners differ – just for this?
> No just cause there for blood and savageness.

1. Lament sung by the men of the Pioneer Maori Battalion on the occasion of the burial of their Commanding Officer, Lieutenant-Colonel George King 'killed by British supporting artillery fire' during the battle of Passchendaele, 12 October 1917. Christopher Pugsley, *Te Hokowhitu a Tu: the Maori Pioneer Battalion in the First World War*, Reed, Auckland, 1995, p 67
2. 'The New Zealand Pioneers' work in building the communication trenches – first 'Turk Lane' and then its companion 'Fish Alley' – would earn them the sobriquet 'Diggers'. The British units they served coined the term on account of the Pioneers' exploits as the 'Digging Battalion'. 'Digger' was adopted by the rest of the New Zealand Division in 1916. By 1917 the name had spread from the New Zealand Division to the Australian Divisions in the two Anzac Corps (somewhat ironically, it might be said, for the Australians never set great store by the pick and shovel, and this was always a cause of complaint when the Pioneers took over from an Australian unit!)', Ibid, p 55
3. Boethius, *The Consolation of Philosophy*, trans. V E Watts, Penguin, Middlesex, 1969, p 108
4. Francis Pound, 'The Words and The Art', *Headlands*, Museum of Contemporary Art, Sydney, 1992, p 185
5. T J McNamara, 'Photographs cover all the angles', *New Zealand Herald*, Auckland, 19 March, 2001, p 86. McNamara says these flowers are 'some sort of memorial' and are 'associated with the First World War' but he fails to mention any Maori connection.
6. While Crown Lynn ceramics are beautiful, in New Zealand they have become regarded as kitsch because of their previous ubiquity. See for instance 'Ordinary Crown Lynn', '*N Z House and Garden*', Dec. 2001, p 67 in which Maurice Bennett is quoted saying "Everyone's grandmother had a piece of this white Crown Lynn. It is part and parcel of us as New Zealanders".
7. Herman Melville, *Moby-Dick* Penguin, Middlesex, 1981, p 287-8
8. ibid, p 288-9
9. Boethius *The Consolation of Philosophy* trans. V.E. Watts, Penguin, Middlesex, 1969, p 13

Michael Parekowhai

born Porirua,
New Zealand, 1968.
Lives and works in
Auckland, New Zealand.

SELECTED SOLO EXHIBITIONS

2002 *All there is,* Gow Langsford Gallery, Auckland;
Jonathan Smart Gallery, Christchurch, New Zealand
2001 *Patriot: Ten Guitars,* The Andy Warhol Museum,
Pittsburg, USA
The Consolation of Philosophy, Gow Langsford
Gallery, Auckland; Jonathan Smart Gallery,
Christchurch, New Zealand
2000 *The Beverly Hills Gun Club,* Gow Langsford Gallery,
Auckland, New Zealand
True Action Adventures of the Twentieth Century,
Jonathan Smart Gallery, Christchurch, New Zealand
1999 *Patriot: Ten Guitars,* Artspace, Auckland, New
Zealand, and touring: *Beyond the Future/ The Third
Asia-Pacific Triennial,* Queensland Art Gallery,
Brisbane, Australia; City Gallery, Wellington; Govett-
Brewster Art Gallery, New Plymouth; Dunedin Public
Art Gallery, Dunedin, New Zealand
Kitset Cultures, djamu Gallery, Australian Museum,
Sydney, Australia
1997 *Recent Paintings,* Gow Langsford Gallery, Auckland;
Jonathan Smart Gallery, Christchurch, New Zealand
1994 *Kiss the Baby Goodbye,* Govett-Brewster Art Gallery,
New Plymouth; Waikato Museum of Art and History,
Hamilton, New Zealand
A capella, Gregory Flint Gallery, Auckland, New
Zealand

SELECTED GROUP EXHIBITIONS

2001 *Bright Paradise: The First Auckland Triennial,*
Auckland Art Gallery Toi o Tamaki, New Zealand
Prospect 2001, City Gallery, Wellington, New Zealand
2000 *Flight Patterns,* Museum of Contemporary Art, Los
Angeles, USA
Old Worlds / New Worlds, Art Museum of Missoula,
USA
The Numbers Game, Adam Art Gallery, Wellington,
New Zealand
1999 *Wonderlands: views on life at the end of the century,
at the end of the world,* Govett-Brewster Art
Gallery, New Plymouth, New Zealand
1996 *The world over / de wereld bollen: art in the age of
globalisation,* City Art Gallery, Wellington, New
Zealand and Stedelilk Museum, Amsterdam,
Netherlands
1995 *Cultural Safety,* Waikato Museum of Art and History,
Hamilton; City Gallery, Wellington, New Zealand;
Ludwig Forum, Aachen; Frankfurter Kunstverein,
Frankfurt, Germany
1992 *Headlands: Thinking Through New Zealand Art,*
National Art Gallery, Wellington, New Zealand;
Museum of Contemporary Art, Sydney, Australia

SELECTED BIBLIOGRAPHY

Jim and Mary Barr, 'The Indefinite
Article', *Art Asia Pacific*, 23, p 72-76
Connie Butler, West of Everything',
Parkett, No. 57, p 189-194
Gregory Burke, 'Michael Parekowhai',
Art & Text, No. 69, May 2000
Gregory Burke, *Cultural Safety,* exhibition
catalogue, Frankfurter Kunstverein,
Frankfurt, City Gallery, Wellington, 1995
Jeff Gibson, 'Third Asia-Pacific Triennial
of Contemporary Art', *Artforum
International*, January 2000
Robert Jahnke, *Korurangi,* exhibition
catalogue, New Gallery, Auckland, 1995
Robert Leonard and Lara Strongman,
Kiss the Baby Goodbye, exhibition
catalogue, Govett-Brewster Art Gallery,
New Plymouth and Waikato Museum of
Art and History, Hamilton, New
Zealand, 1994

Robert Leonard, *Patriot*, exhibition
catalogue, Gow Langsford Gallery and
Artspace, Auckland, 1999
Localities of Desire, Museum of
Contemporary Art, Sydney, Australia,
1994
William McAloon, *Vogue/Vague*, CSA
Gallery, Christchurch, New Zealand, 1992
Maud Page, *Kitset Cultures,* exhibition
catalogue, djamu Gallery, Sydney, 1999
Francis Pound, *Flight Patterns*, Museum
of Contemporary Art, Los Angeles,
USA, 2000
Allan Smith, 'Michael Parekowhai: Kiss
the baby goodbye', *Art New Zealand*,
No. 72, Spring 1994, pp 64-67
Allan Smith, *The Nervous System,*
exhibition catalogue, Govett-Brewster
Art Gallery, New Plymouth, New
Zealand, 1995

CHECKLIST OF WORKS

LE QUESNOY from the series 'The
Consolation of Philosophy' 2001
ETAPLES from the series 'The
Consolation of Philosophy' 2001
FLERS from the series 'The Consolation
of Philosophy' 2001
PASSCHENDAELE from the series 'The
Consolation of Philosophy' 2001
BOULOGNE from the series 'The
Consolation of Philosophy' 2001
TURK LANE from the series 'The
Consolation of Philosophy' 2001
c-type photographic prints (each an
edition of eight); framed 150 x 120 cm
courtesy the artist and Gow Langsford
Gallery, Auckland, Sydney

BILL JARVIS from the series *The Beverly
Hills Gun Club* 2000
powder coated aluminium and sparrow,
20 x 12.5 x 25.5 cm
collection: Chartwell Collection,
Auckland Art Gallery Toi o Tamaki

PAT COVERT from the series *The
Beverly Hills Gun Club* 2000
powder coated aluminium and sparrow,
130 x 15 x 10 cm
collection: Chartwell Collection,
Auckland Art Gallery Toi o Tamaki

JEFF COOPER from the series *The
Beverly Hills Gun Club* 2000
powder coated aluminium and sparrow,
20 x 83.5 x 10 cm
collection: Chartwell Collection,
Auckland Art Gallery Toi o Tamaki

LES BAER 1911 THUNDER RANCH
SPECIAL from the series *The Beverly
Hills Gun Club* 1999-2000
powder coated aluminium and rabbits,
45 x 76 x 210 cm
collection: Chartwell Collection,
Auckland Art Gallery Toi o Tamaki

CRAIG KELLER from the series *The
Beverly Hills Gun Club* 2000
Neil Keller from the series *The Beverly
Hills Gun Club* 2000
Elmer Keith from the series *The Beverly
Hills Gun Club* 2000
colour photographs, each 107 x 126.5
x 5.7 cm
collection: Chartwell Collection,
Auckland Art Gallery Toi o Tamaki

PHILIPPE PARRENO

153

No Ghost Just a Shell is the title of a joint project by Philippe Parreno and Pierre Huyghe but each has also produced a film with the same cartoon character, AnnLee, bought from the catalogue of a Japanese firm that sells characters to publishers and to the Manga industry. Parreno's film, *Anywhere Out of the World*, and Huyghe's *2 Minutes*

PHILIPPE PARRENO

THE NEW STORYTELLER

PEIO AGUIRRE

Out of Time, were first shown simultaneously at different galleries in Paris. A breath of fresh air – the double presentation of a fictional character's identity without differences of style between the films, merely a slight redesign of AnnLee's image and a new scenario. Later, Parreno and Huyghe offered AnnLee to others artists: for instance Dominique Gonzalez-Foerster and Liam Gillick have both created their own stories.

Interest in AnnLee as a character lies in her potential to generate more stories. Her life in the commercial circuit of the Manga industry depends on her capacity and adaptability to resist the scenarios and the extreme situations to which she is exposed. In Parreno's film, AnnLee talks about herself as a product that is for sale and, given the melancholy expression that acompanies her sad 'misadventures', she doesn't appear to be very happy about it.

These different works and reconfigurations, show the potential of images when new narrative models are no longer associated with specific media. Concepts taken directly from the language of advertising, cinematography and literature are adapted to Parreno's processes – for instance, aspects of scenarios, and scripts, commercials, consumer product promotion, soundtracks, fictional characters, ellipsis, atmospheres and versions. The artist sets up different ways of questioning the production and standardisation of forms of communication independent of the specific media: whether it be film, video, writing or installation. In this context, time is an active and dynamic element.

Philippe Parreno has been collaborating with other artists for a long time. His work owes much to this and leads to productions based on an interpersonal exchange and a collective subjectivity. For example, some years ago, a Parisian museum presented an exhibition alongside Huyghe and Dominique Gonzalez-Foerster where, it was not obvious where one individual work began and another finished.

Another film by Parreno and Charles de Meaux, *Le Pont du Trieur,* explores the boundary between fiction and documentary in a fascinating and poetic way – half experimental half art, both cinema and essay. Conceived as a radio transmission from Paris, it describes the reality of the Pamir – "that country of which the West does not have an image" – an authentic no-man's land located somewhere in the Republic of Tadjikistan. The vastness of the landscape, the testimonies of its people and an emphasis on the 'empty space of representation' (the blank screen of projection, the empty set of a radio) suggests an approach that breaks with the conventions of narrative.

Another more recent work, *The Dream of a Thing,* can be described as the beginning of a fairytale, as the first page of a story (retold each time) is repeated. This one-minute film – shown for the first time as a 'commercial' in the middle of the commercial break in some Swedish cinemas – was shot in a Norwegian fjord in golden summer light. The film shows a remote and beautiful landscape, but as soon as the viewer realises what it's about it ends – with handmade visual effects set to the rhythm of a deconstructive soundtrack. In this work, the artist continues to explore links between art and text – here the text is an imaginative, endless narrative that is re-written each time… not unlike a children's story.

Some experimental aspects like the diversity of narrative structures explored by film and video artists and characteristic of contemporary art have found their way into mainstream films and commercials. Indeed, some of these projects have been produced by Anna Sanders Films, a company created by a group of artists (among them Parreno) with other collaborators and friends. Anna Sanders is an imaginary character but some people, fascinated by her anonymity, defined her in 1998. First, her identity was outlined in a magazine and then her name was registered and a bank account opened. The role of this character is to find ways "to realise the dreams of children…" to continue telling stories.

Working simultaneously within and outside the structures of art, Philippe Parreno shifts constantly from documentary to fictional history; from digital animation to fantasy narration. Everything is sampled: popular literature, TV, films, newspapers, conversations and cinema. This suggests a parallel analysis of communication structures and media, and the need to develop new and refreshing narrative possibilities.

My name is Annlee! Annlee!
You can spell it however you want!
It doesn't matter! No it does not.

I was bought for 46000 Yen

46000 Yen, paid to a design
character company. "K" works!
I ended'up, I ended'up, like some
others, in a catalogue.
Proposed to cartoon producers
and comic book editors.
Yea! Like hum... like Drop dead
in a comic book!

Some other characters had the ...
Some other characters had the
possibility of becoming a hero.
They had a long psychological
description, a personal history,
material to produce a narration.
They were really expensive when
I was cheap!
Designed to join any kind of story,
but with no chance to survive any
of them.

I was never designed to survive...

It's true, everything I am saying
is true!
Some names have been changed,
to preserve the guilty!

I am/ a product
a product freed from the market
place I was supposed to fill.
Drop dead in a comic book.
I will never forget.
I had just a name and an ID

My name is Annlee!
My name is Annlee!
Spell it however you want!
It doesn't matter. No it does not.

After being sold, I was redesigned!
Funny! I can even say now! look!

That's how I used to be!
And this is how I look now.
It's like when you point out an
old photo

Oh! Yeah! I forgot to tell you, the
voice through which I'm talking to
you now, was never my voice.
I have no voice! Her name is
Aniela.
She is looking at me now!
She is a model. She is not used
to speaking.
She is an image, just like me.
She is used to selling products
When I've got nothing to sell.
And I will never sell anything,
How can I? 'Cause I'm the product!

I was bought, but
strangely enough
I do not belong to anybody.
I belong to whom is ever able to fill
me with any kind of imaginary
material.
Anywhere out of the world.

I am an imaginary character.
I am no ghost, just a shell.

PHILIPPE PARRENO
ANYWHERE OUT OF THE WORLD,
2000

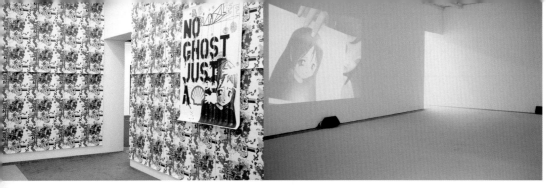

ANYWHERE OUT OF THE WORLD
2000 INSTALLATION VIEW.

Philippe Parreno born
Oran, Algeria, 1964.
Lives and works in
Paris, France.

SELECTED SOLO EXHIBITIONS

2002 Portikus, Frankfurt-D, Germany
Musée d'Art Moderne de la Ville de Paris, Paris,
France

2001 *In Many Ways the Exhibition Already Happened*,
Institute of Contemporary Art, London with Pierre
Huyghe; M/M Paris, François Roche, France
El sueno de una cosa, Museet Project, Moderna
Museet, Stockholm, Sweden
*One Thousand Pictures Falling from One Thousand
Walls*, Friedrich Petzel Gallery, New York, USA
Anywhere out of the world, Institut of Visual
Culture, Cambridge, UK

2000 *No Ghost Just A Shell: Anywhere Out of the World*,
Air de Paris, Paris, France
No Ghost Just A Shell: Anywhere Out of the World,
Schipper und Krome, Berlin, Germany
*One Thousand Pictures Falling from One Thousand
Walls*, MAMCO, Geneva, Switzerland
*Dominique Gonzalez-Foerster, Philippe Parreno,
Pierre Huyghe*, Kunstverein in Hamburg, Hamburg,
Germany

SELECTED GROUP EXHIBITIONS

2001 *Tele(visions),* Kunsthalle Wien, Austria
7th International Istanbul Biennal, Istanbul, Turkey
EGOFUGAL, Tokyo Opera City Art Gallery, Tokyo,
Japan
Dedallic Convention, MAK, Vienna, Austria
Animations, PS1, New York, USA
Mouvements immobiles, Musée d'art moderne,
Buenos Aires, Argentina
Neue Welt, Frankfurter Kunstverein, Frankfurt am
Main, Germany
Intentional Communities, Rooseum Art Center,
Malmö, Sweden
Let's entertain, Kunstverein Wolfsburg, Ludwigsburg,
Germany
Au-delà du spectacle, Centre Pompidou, Paris, France

SELECTED BIBLIOGRAPHY

Nicolas Bourriaud, '*Le réalisme opéra-
toire*', *Parachute*, 85, January., 1997,
pp 8-10
Holland Cotter, 'Philippe Parreno', *NY
Times*, 27 April 2001, p E31
Dean Inkster, 'Défense de la lecture: le
procès de Pol Pot', *Art Press*, No. 21,
Paris, 2000
Philippe Parreno, 'Speech Bubbles', *Les
Presse du Réel*, Dijon, 2001
Mai-Thu Perret, 'Philippe Parreno',
Frieze, March 2001.

Elisabeth Wetterwald, 'Philippe Parreno,
L'exposition comme pratique de liberté',
Parachute, No. 102, Apr., 2000, p 32-43
F. Poli, 'Philippe Parreno, - Air de Paris',
tema celeste, No. 82, 2000, p 90
Eric Troncy, 'hors champ', *Les inrock-
uptibles*, Paris, 14 Nov., 2000
Eric Troncy, 'No Ghost, just a shell', *Art
Press*, No. 260, Paris, Sept. 2000, pp
82-83
Philippe Vergne, 'Speech Bubbles', *Art
Press*, No. 264, Jan. 2001, pp 22-28

CHECKLIST OF WORKS

ANYWHERE OUT OF THE WORLD from
the project *NO GHOST, JUST A SHELL*
2000
mixed media, video projection surround
sound, carpet, dimensions variable
courtesy the artist and Air de Paris,
Paris

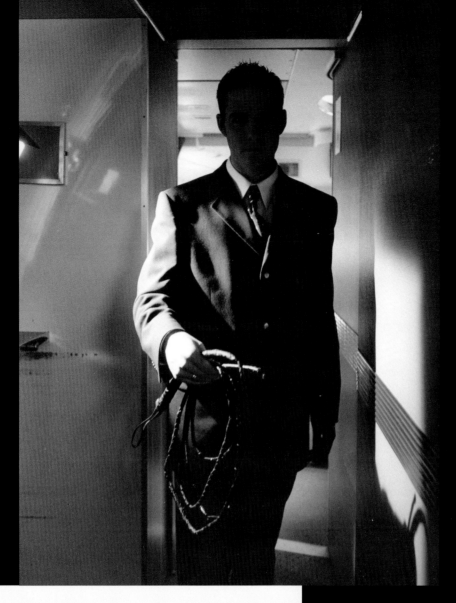

SIMON PATTERSON

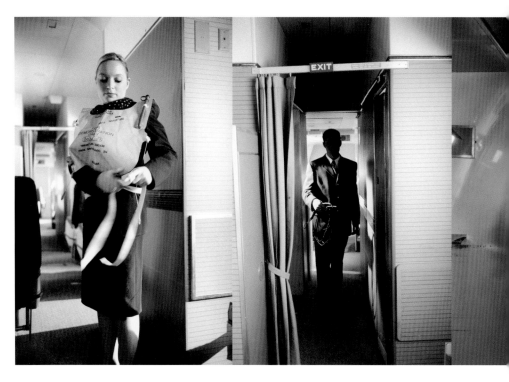

Far from being the simple expression of individual emotions, magic takes every opportunity to coerce actions and locutions. Everything is fixed and becomes precisely determined. Rules and patterns are imposed. Magical formulas are muttered or sung on one note to special rhythms… Gestures are regulated with an equally fine precision. The magician does everything in a rhythmical fashion as in dancing: and ritual rules tell him which hand or finger he should use, which foot he should step forward with. When he sits, stands up, lies down, jumps, shouts, walks in any direction, it is because it is all prescribed. Even when he is alone he is not freer than the priest at his altar… Moreover, words are pronounced or actions are performed facing a certain direction, the most common rule being that the magician should face the direction of the person at whom the rite is aimed.[1]

SIMON PATTERSON

ESCAPE ROUTINE
IAN HUNT

Harry Houdini, inventor of a modern form of magic, debunker of spiritualism and improver of police handcuffs on several continents, featured amongst the earliest works of Simon Patterson. These were the 'Name Paintings' – a modern form of portraiture consisting of the name in American typewriter script, silk-screened onto prepared canvas. As a student at Goldsmiths College, London, Patterson had been intrigued by a performance by Jon Thompson on the theme of escape, and followed it up through conversation with Thompson and by reading Houdini's books on magic in the college library. Over a decade later, in the research and making of *Escape Routine* – a long-meditated piece in which Houdini's classic tricks are relocated to the aisle of a civilian aircraft – Patterson has gone so far as to claim that in a way Houdini has functioned

as a kind of alter-ego for him.

This is a striking thing for an artist to say. What does Patterson mean by it? Not knowing much about Houdini, I turned to a book. *Houdini's Box: On The Arts of Escape* (Faber, 2002), by the psychotherapist Adam Phillips, is a fascinating retelling of Houdini's life and captures well what was so original about the satisfaction his escapes offered to a paying audience. A man, getting into containers and restraints he had himself designed or had adapted from those in use by the police, prisons and psychiatric hospitals, and then getting out of them, unchanged. A man whose skills made him sought after by criminals seeking private lessons wherever he went, but whose appeal was not that of the law-breaking itself – he was a respectable son, husband and father. A man who came to Britain to see Blériot's flight across the English Channel in 1909, and came to Australia in 1910 to make what he hoped would be the first public flight there; a modern magician who recognized that powered flight transformed for good, one age-old dream of escape.

Phillips writes: "For Houdini the way to be a good man in a bad time was to be an honest magician." That construction, 'an honest magician', perhaps reverberates with the choices facing contemporary artists. Patterson's works have succeeded in retaining an honesty about what kind of escape or mental flight or pleasure art can offer; they are tricks carried out in full view of the audience, with, intentionally, nothing concealed from view. His means as an artist are nevertheless quite different, as are the times. In varying ways he likes to cross-wire systems of thought so that the brain is licensed to seek connections, and to enjoy

the peculiarities of recall and association; though this takes place in contexts that often stress route-finding, intellectual order (the periodic table, for example) and standardisation. In three works the Pantone system of colour identification has been linked with the ordered tones of football score announcements on the radio and the evocative power of football club names, present and historic, in Scotland, England and France. An airline and a tube map have been recast so that each node or destination on a possible journey is replaced with a name to be retrieved, or not, from somewhere in one's brain: Amy Johnson, Fred Quimby, Oliver North. These works are highly popular with audiences, who return to them, and it is worth asking what they are returning to in these lucidly presented collisions of sense and order with the illicit forms of mental and linguistic activity that names call forth. (Who *was* Fred Quimby and why, while we are trying to remember, does his name possess such aesthetic rightness? That honest monosyllable paired with the surname that sounds like an adjective that should exist: 'I'm feeling a bit Quimby today.' The name deserves a footnote in this case as it is relevant to the popular arts of escape. Quimby is the last name you see on the credits of Tom and Jerry: modern creatures who, having got into awful scrapes, come back for more with unabated enthusiasm. They are some of the only analogues Phillips finds, in his book, for the strangeness of what Houdini was actually doing for his audiences.)

Escape Routine, the work finally made as a result of Patterson's interest in Houdini, is built around dualities. It is in two sections, not quite repetitions of each other, and begins with stock footage of the take-off

ESCAPE ROUTINE 2002 DVD VIDEO PROJECTION (STILLS) PHOTOGRAPHY: PATRICIA BICKERS/LOCUS+.

of a Boeing 747-400. Two male and two female flight attendants, in dark blue livery, demonstrate some of the familiar safety routine, a procedure that in many aircraft now is replaced by video instruction. The first half is narrated by Dilly Barlow in English, the second half is narrated by Togo Igawa in Japanese, and is subtitled in English; bland music is heard throughout. Sometimes you are strongly aware of passengers acting as an audience for the flight attendants, sometimes the aircraft appears strangely empty and the strongly directed gaze of the crew singles you out as a spectator. "It is far more difficult to give a trial show to a house full of seats and one manager than to a packed house and no manager", the narration informs us: for the safety announcements are interspersed with extracts from Houdini's writings offering practical advice and instruction to performers. The escapes, when they happen, are done in a no nonsense way – "In winning your audience remember that 'manners make fortunes'." Though a man wriggling out of a straitjacket or a mail sack will always present the disturbing spectacle of a temporary maniac; we imagine that a transformation must surely be taking place, out of view, but when he emerges the man can only be himself again.

Transformation of a different kind is nevertheless offered in *Escape Routine*. When the aircraft fills with smoke, in imitation of a fire, it clears to reveal the flight attendants relocated to the stage of a theatre. (It can be revealed that two of the performers are actual escapologists, two are actual flight attendants, and that each had to learn each other's routines. It is not quite clear if Patterson intends us to use this knowledge as we watch, and try to

imagine who is the 'real' escapologist, the real flight attendant, or whether it was simply a part of the conception for the piece and a way of ensuring a degree of authenticity in the performances of both roles.) A Navy Colt pistol on what Patterson describes as a Wild West cushion – that part of the world where the law is being defined being a significant part of Patterson's imaginary, explored in many works – appears before us. It is employed by the flight attendants in the catching of a bullet between the teeth. The sugar glass between the shootist and the 'catcher' shatters. At the end of the second section, the smoke filling the aircraft fades to the same blue curtain and gold proscenium, but the performance that takes place is one of Houdini's classic escapes. It is performed by Shahid Malik, an exceptional contemporary escape artist based in the north of England, assisted by his wife Lisa. Malik's feet are chained and he is hoisted aloft. When free from the jacket after wild wriggling he must use his powerful stomach muscles to bend up to release his feet, before the chain can be lowered. He comes forward, as if to take a bow, but then simply holds himself proudly. The curtain – bearing the legend 'SAFETY CURTAIN' – is lowered. (Malik originates from Pakistan, and it is no accident that all the other performers are white Europeans. Malik's participation in the work invites comparison of his career as an escap-ologist with that of Houdini, born Ehrich Weiss to a not especially successful family of Hungarian Jewish immigrants.)

Patterson's integration of safety instruction and escape is a re-invention, for him, of the bringing together of dualities on which his work is based. Safety routines in

air travel are a secular rite, a prescribed formula that assures by its familiarity as much as by what it teaches. The passing of the tradition of performance by flight attendants in favour of the video version can be mourned, for in that slight embarrassment with which the seated passengers become a temporary audience, they take part in the rite, and the journey by air is confirmed as a potentially transformative experience. For professional escapologists, on the other hand, no longer familiar figures in popular entertainment, escape is necessarily a routine, something known, practised and understood so that its real risks can be controlled. *Escape Routine* – a title that reverberates in a similar way to the phrase 'an honest magician' – is a revealing and unusually personal work for its maker. Amongst other matters it asks us what and perhaps whether we wish to escape, and it also confirms air travel, aided by carriers in their thousands of varied liveries, as a modern experience of possible transformation. But my interpretations are intended as hesitant, and are offered cautiously. And Patterson himself can only show, not interpret; when he does talk about his own work, and this is curious, it is as though he is talking about it from the position of the audience rather than the maker. It is the quality of the showing that takes place in his work that is really of interest. Indeed, in the production of the work in Newcastle, Patterson has himself mastered the wordless art of escaping from a straitjacket.

1. Marcel Mauss, *General Theory of Magic* [1950] trans. Robert Brain, London: RKP, 1972, p 58

ESCAPE ROUTINE 2002 DVD VIDEO
PROJECTION (STILLS). FRONT PAGE
IMAGE: ESCAPE ROUTINE 2002 DVD
VIDEO PROJECTION (STILLS) PHOTO-
GRAPHY: PATRICIA BICKERS/LOCUS+.

Simon Patterson born
Leatherhead, UK, 1967.
Lives and works in
London, UK.

SELECTED SOLO EXHIBITIONS

2001 *Simon Patterson,* Sies+Hoeke Galerie, Duesseldorf, Germany
2000 *Manned Flight,* fig–1 Gallery, London, UK
1999 *Enter the Dragon,* Magazin 4, Bregenz, Austria
1998 *Name Painting,* Kohji Ogura Gallery, Nagoya, Japan
1997 *Wall Drawings,* Kunsthaus, Zurich, Switzerland
1996 *Simon Patterson,* Lisson Gallery, London, UK
1995 *Simon Patterson,* Roentgen Kunst Institut, Tokyo, Japan
1994 *General Assembly,* Chisenhale Gallery, London, UK
1993 *Monkey Business,* The Grey Art Gallery, NYU, New York, USA
1989 *Simon Patterson,* The Third Eye Centre, Glasgow, Scotland

SELECTED GROUP EXHIBITIONS

2000 *Lisson Gallery at Covent Garden,* London, UK
1999 *Projects 70,* The Museum of Modern Art, New York, USA
 Sensation, Brooklyn Museum, New York, USA
1998 *Modern British Art,* Tate Gallery, Liverpool, UK
1997 *Magie der Zahl: in der Kunst der 20. Jahrhunderts,* Staatsgalerie Stuttgart, Germany
1996 *The Turner Prize,* Tate Gallery, London, UK
1994 *Mapping,* The Museum of Modern Art, New York, USA
1993 *Aperto,* XLV Biennale di Venezia, Venice, Italy
1992 *Doubletake: Collective Memory and Current Art,* The Hayward Gallery, London, UK
1988 *Freeze,* PLA Building, London, UK

SELECTED BIBLIOGRAPHY

Michael Archer, 'Jesus Christ in Goal', *frieze,* No. 8, Feb. 1993
Patricia Bickers, 'General Assembly: The Power of Association', *Simon Patterson* exhibition catalogue, Mitaka City Art Center, Tokyo, 1998
Patricia Bickers, 'Joking Apart', *General Assembly,* exhibition catalogue, Chisenhale Gallery, London, 1994
Bernard Fibicher, 'In the Name of...', and Iwona Blazwick, 'Widescreen Visions', *Simon Patterson,* Patricia Bickers (ed), Locus+, London, 2002
Bernard Fibicher, 'Simon Patterson interview', *Wall Drawings,* exhibition catalogue, Kunsthaus Zurich, 1997, pp 8-21
Sarah Greenberg, 'The Word According to Simon Patterson', *Tate Magazine,* issue 4, Winter, 1994, pp 44-7
David Musgrave, 'Simon Patterson', *Distinctive Elements,* catalogue essay, National Museum of Contemporary Art, Korea, 1998, pp 142–52
John D. Quin, 'How did they ever make a painting of Lolita?', *Nabokov's World (Volume 2: Reading Nabokov),* Jane Grayson, Arnold McMillin and Priscilla Meyer, Palgrave, 2002, pp 186-203
James Roberts, 'What's in a Name?', *Simon Patterson: Name Painting 1987–1998,* Kohji Ogura Gallery, Nagoya, 1998
Robert Storr, 'The Map room: a visitors guide', *Mapping,* exhibition catalogue, Museum of Modern Art, New York 1994

CHECKLIST OF WORKS

ESCAPE ROUTINE 2002
DVD projection dimensions variable, courtesy the artist
produced by Locus+, Newcastle upon Tyne in association with Jay Film & Video, Newcastle upon Tyne

ACKNOWLEDGMENTS
ESCAPE ROUTINE. A work by Simon Patterson. Produced by Locus+ in association with Jay Film & Video.
Director and Editor: Sharon Summers, Director of Photography: Ken Dodds, Magic Consultant: Richard James, Performers: Shahid and Lisa Malik, Richard James, Laura McAnelly, Andrea Lewis, Richard Lemin.

www.locusplus.org.uk

Photo credit: Patricia Bickers/Locus+

MISTER WAS WRITTEN FOR THE VOICE OF MICHAEL SCOTT – AN ULSTERMAN I HAD KNOWN FOR YEARS, WHO IS NOT A PROFESSIONAL ACTOR. I WANTED THE VOICE TO BE THE PERFORMANCE OF AN AMATEUR BUT, ON THE OTHER HAND, I HIRED A PROFESSIONAL PUPPETEER TO MANIPULATE THE SHOE. UNFORTUNATELY, HIS PERFORMANCE TO THE

JOÃO PENALVA

RECORDED VOICE WAS DISASTROUS. ALTHOUGH AN EXCELLENT PUPPETEER AND HAVING HEARD THE TAPE FOR TWO WEEKS, THE RHYTHMS OF MY TEXT PROVED TOO DIFFICULT FOR HIM TO MASTER. IN ALL FAIRNESS, THE TEXT WAS MINE AND ONLY I COULD MOVE THE SHOE'S 'MOUTH' IN SYNCH WITH THE VOICE IN THE THREE DAYS ALLOTTED FOR SHOOTING. SO I SET TO IT, BUT IT TOOK A LOT OF STRENGTH FROM THE FOREARM AND HAND MUSCLES TO ARTICULATE A SHOE SOLELY BY THE REPETITIVE MOVEMENT OF OPENING AND CLOSING FOUR FINGERS TOGETHER, WHILE MY THUMB, INSIDE A STRAP FIXED TO THE SOLE'S UNDERSIDE, HELD IT FIRMLY ONTO THE STAGE AND STOPPED IT FROM MOVING AND REVEALING THE HOLE IN THE BOARDS THROUGH WHICH MY ARM ENTERED FROM BELOW. My first attempt lasted only ten minutes; my hand went numb, my arm hurt so badly that I feared I would never be able to do it continuously for the full twenty-seven minutes of the text. But, as there was no question in my mind that this video should be the unedited record of a live performance, I covered my arm with a gel for sport injuries, bandaged it and put it on a sling for the next twenty-four hours, and hoped for the best. The second day went better than the first, but although I understood which muscles were indispensable and how to use my energy sparingly, my arm gave up after some fifteen minutes. On the third day I stopped at a chemist on the way to the studio and bought a box of *guarana* vials. When I asked the chemist how many I could take at once, he replied with a straight face: "One". When enquired what would happen if I took three, he said he didn't know but he wouldn't try it. I stopped next at a supermarket and bought two cans of Red Bull – a high-energy drink saturated with sugar. With this little chemical help I did get to the end, and just in time to rush to the airport and get on to a plane I couldn't miss. *Mister* has its roots in a small and funny incident. Years ago, as I was leaving a London pub, I overheard an English and drunken-sounding woman commenting on me to her companion. She said: "There goes another lost soul... Another Paddy." I don't drink, I don't look Irish, and that she could have taken me for an Irishman was so baffling that it started the idea of me being Irish as a role I might want to play in my work. Eventually, *Mister* took shape, and I wasn't surprised when the trials of its making echoed Mister's own troubles. JOÃO PENALVA

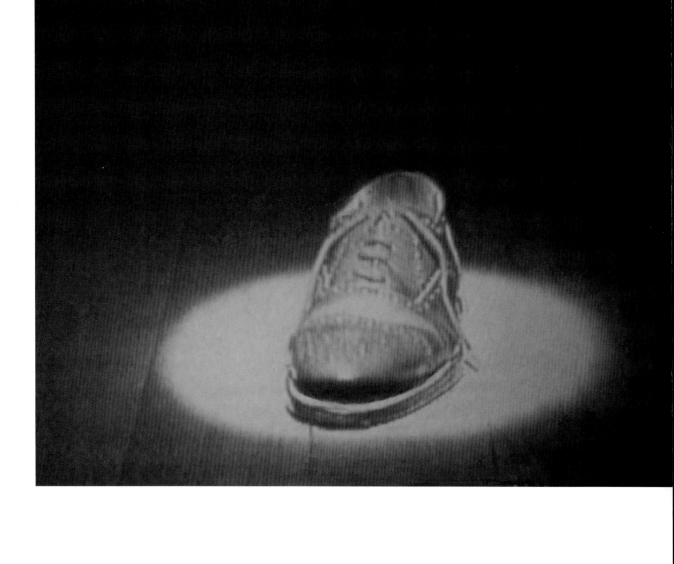

JOÃO PENALVA

SPINNING YARN

FRANCIS McKEE

Haroun often thought of his father as a Juggler, because his stories were really lots of different tales juggled together, and Rashid kept them going in a sort of dizzy whirl, and never made a mistake. Where did all these stories come from? It seemed that all Rashid had to do was to part his lips in a plump red smile and out would pop some brand-new saga, complete with sorcery, love-interest, princesses, wicked uncles, fat aunts, mustachioed gangsters in yellow check pants, fantastic locations, cowards, heroes, fights, and half a dozen catchy, hummable tunes. 'Everything comes from somewhere,' Haroun reasoned, 'so these stories can't simply come out of thin air...?'¹

In *Mister*, João Penalva offers a curious explanation to Haroun's questions, suggesting that stories can erupt from the

moments of loss and decay that pepper our lives. As the performance progresses the brogue recounts the accidents and physical failures that divest the body of it's limbs until only the shoe and the voice remain. As the body has been whittled away, the stories have grown – a compilation akin to a series of phantom limbs.

It is as if the telling of tales could forestall death or blossom with the contemplation of death. Certainly this is a theme that seems pivotal in some of the greatest collections of tales. *The Thousand and One Nights*, for instance, depends on Scheherazade entertaining a prince with a story each night to defer the death of her and her sister. Boccaccio's *Decameron* is an equally long set of stories narrated by courtiers hiding in the countryside from the Black Death. Discussing the origins of *Mister*, Penalva places it squarely in this tradition:

This is not a piece I would have done in my thirties, nor in my forties. I am fifty and many of my friends have been ill, some have died, and the experience of illness, suffering, and death is no longer the distant, pathetic and comic performance of old people when they meet at street corners. "How did it go at the hospital?", "Did you get the test's results yet?", "I'm not doing so well this week", were words that I used to overhear and laughed about in my days of youthful arrogance, when old age is so far away that it is impossible to imagine it ever as one's own. Those are words that I have now said myself, or were said to me. Old age – something that would certainly be different in one's case – is not different at all. It becomes a story of malfunctioning bodies, hilarious only if you can stomach its gruesomeness.²

What also becomes clear about such stories is their power, not only to forestall death, but to ease the pain of life itself. Or it may be that they simply function as a distraction or escape from reality. One of the great modern storytellers – Jorge Luís Borge – describes the hazy genesis of this

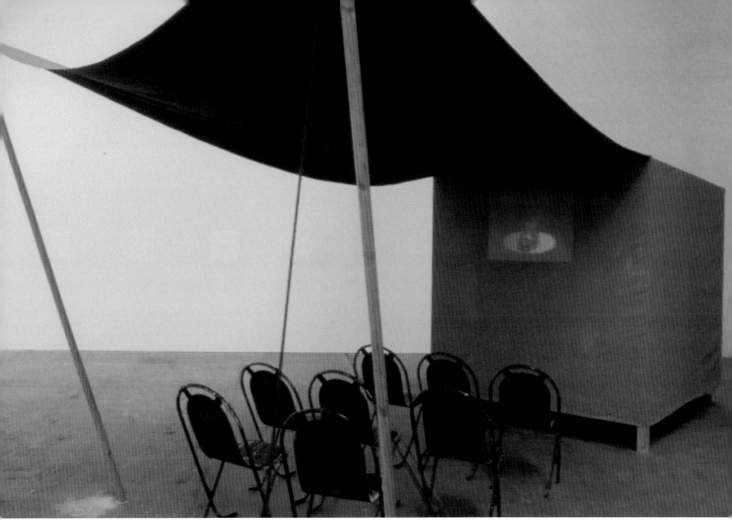

tradition in this way:

> Now, a curious note that was transcribed by the Baron von Hammer-Purgstall, an Orientalist cited with admiration by both Lane and Burton, the two most famous English translators of *The Thousand and One Nights*. He speaks of certain men he calls *confabulatores nocturni*, men of the night who tell stories, men whose profession it is to tell stories during the night. He cites an ancient Persian text which states that the first person to hear such stories told, who gathered the men of the night to tell stories in order to ease his insomnia, was Alexander of Macedon.[3]

It is difficult to know if the storytellers here function as entertainers or healers and it is likely that the two roles have often been confused. *Mister* demonstrates this perfectly. The work betrays a variety of influences and small homages that intertwine and acknowledge both dimensions of the tale.

There are, for instance, distant echoes of Samuel Beckett in the work – the gallows humour, the brogue recalling the tramps' discussion of boots in *Godot*, the spotlit mouth from *Not I* and the indomitable desire to survive despite all. These are, though, superficial resemblances. The roots of such imagery lie more in music-hall and early cinema – influences shared by both Beckett and Penalva.

The installation of *Mister* resembles a small field hospital or a travelling show booth. The khaki tent and rough chairs have the makeshift appearance of a travelling cinema show from the handcranked era when film speeds varied with the projectionist's discretion. The talking brogue appears on a small stage like a music hall turn – perhaps an illusionist's trick like those created by the popular magician George Meliès before he bought his first cinema camera in 1896. Such a comparison might be reinforced by the knowledge that illusionists traditionally used the skeleton and images of the grim reaper in their tricks. The *memento mori* lent a frisson to even the slightest deception,

reminding the audience of the oblivion that lurks behind an apparently solid world, something early anatomists also used in their public dissections.

In its guise of travelling show, *Mister* also declares itself parochial – part of the rural folk tradition as opposed to the urban multiplex phenomenon. Like some other works by Penalva, it is a story told in an accent, pulling it away from cultural centres and rooting it in older, more enduring traditions. It is a Book of Job in miniature, dwelling on age and physical decay, celebrating the stubborn humanity of *Mister* in the face of absurd obstacle.

1. Salman Rushdie, *Haroun and the Sea of Stories*, Granta Books, 1990
2. João Penalva, *An Introduction to Mister*, unpublished, London, 2000
3. Jorge Luís Borges, 'The Thousand and One Nights' in *Seven Nights*, Faber and Faber, 1986

LM44/EB61 1995 MIXED MEDIA,
INSTALLATION DETAIL. FRONT
PAGE IMAGES: (LEFT TO RIGHT)
R. 2001 VIDEO STILL; R. 2001
VIDEO STILL; KITSUNE (THE
FOX'S SPIRIT) 2001 DVD STILL

João Penalva born in
Lisbon, Portugal,
1949. Lives and works
in London, UK.

SELECTED SOLO EXHIBITIONS

2002 Rooseum, Malmö, Sweden
 Barbara Gross Galerie, Munich, Germany
 XLIX Biennale di Venezia, Italy
 Galerie Volker Diehl, Berlin, Germany
 fig -1, London, England
2000 Tramway, Glasgow, Scotland
1999 Camden Arts Centre, London, England
 Frac Languedoc-Roussillon, Montpellier, France
1998 Centro Cultural de Belém, Lisbon, Portugal
1996 XXIII Bienal Internacional de São Paulo, Brazil

SELECTED GROUP EXHIBITIONS

2002 *Perth International Arts Festival*, Curtin University
 Gallery, Perth, Australia
 This side and beyond the dream, Sigmund Freud-
 Museum, Vienna, Austria
2001 *Cine y Casi Cine*, Museu Nacional Centro de Arte
 Reina Sofia, Madrid, Spain
 Total object complete with missing parts, Tramway,
 Glasgow, Scotland
 Berlin Biennale 2, Berlin, Germany
2000 *Art & Industry 2000 Biennial*, Christchurch, New
 Zealand
1999 *East Wing Collection*, Courtauld Institute of Art,
 London, UK
 Signs of Life, Melbourne International Biennial,
 Melbourne, Australia
1998 *La sphère de l'intime,* Le Printemps de Cahors,
 Cahors, France
1997 *Urban Mirage*, Hiroshima Art Document '97,
 Hiroshima, Japan

SELECTED BIBLIOGRAPHY

Marjorie Allthorpe-Guyton, 'João
Penalva – *Kitsune*', *ARCO Noticias*, No.
21, July, Madrid, 2001
Guy Brett, 'To be Penalva's public', *João
Penalva*, Electa, Milan, 2001
Iwona Blazwick, 'Wallenda', *João
Penalva*, Centro Cultural de Belém,
Lisbon, 1999
Dan Cameron 'A slip in time', *João
Penalva*, Centro Cultural de Belém,
Lisbon, 1999
Juliana Engberg, 'Cinema Chartreuse'
João Penalva, Centro Cultural de
Belém, Lisbon, 1999
Annie Fletcher/João Penalva, 'A
conversation', *Berlin Biennale 2*,
Oktagon Verlag, Cologne, 2001
Sarah Kent, 'False perspectives', *Time
Out*, 12 January, London, 2000
Sebastien Preusse, 'Nichts ist, wie es
scheint', *Berliner Zeitung*, 2 June,
Berlin, 2001
Andrew Renton/João Penalva, 'So you
still don't believe me...', *João Penalva*,
Centro Cultural de Belém, Lisbon, 1999
Veronika Schöne, 'Moderner Sisyphos.
João Penalvas "Wallenda" in der Galerie
Barbara Gross', *Süddeutsche Zeitung*,
22-23 December, München, 2001

CHECKLIST OF WORKS

MISTER 1999
video projection installation
duration 27 minutes
courtesy the artist and Barbara Flynn,
Sydney and New York

STILL LIFE WITH STEM CELLS. STEMS CELLS ARE BASE CELLULAR MATTER
BEFORE IT IS DIFFERENTIATED INTO SPECIFIC KINDS OF CELLS LIKE SKIN,
LIVER, BONE OR BRAIN. PURE UNEXPRESSED POTENTIAL, THEY CONTAIN
THE POSSIBILITY FOR TRANSFORMATION INTO ANYTHING. THEY ARE THE

PATRICIA PICCININI

BASIC DATA FORMAT OF THE ORGANIC WORLD. LIKE DIGITAL DATA, THEIR SPECIFICITY LIES IN THAT, WHILE THEY ARE
INTRINSICALLY NOTHING, THEY CAN BECOME ANYTHING. THEY ARE BIOMATTER FOR THE DIGITAL AGE. This changes our
idea of the body. Already our awareness of the human genome leads us to imagine that we understand the construction of
the body at its most intimate level. The stem cell provides us with a generic, plastic material from which we can construct
it. In the last ten years, the body has gone from something that is uniquely born to something that can be reproduced. This
transformation has already occurred, with very little fuss given its magnitude. The question of whether this is a good or a
bad thing is both too simplistic and a little academic. As with so much of this biotechnology, the extraordinary has already
become the ordinary. *Still Life with Stem Cells* presents one ordinary moment from this extraordinary world.

A child aged about 7 or 8 sits on the floor and plays with a number of… mmm… what are these things?… balls, forms, lumps? The child plays with lumps, I think we might say. Lightly furry, flesh coloured, textured like skin: some with moles and other skin markings: meaty. They have the feint hint of the kind of veins we sometimes observe in heads of newly born babies, which make these like-life forms seem utterly vulnerable and fragile.

Each has little wrinkly bits – derme folds – and the skin, therefore, appears to exist over a skeletal frame. They are like small foetal animals, as yet not quite formed: no eyes, mouths, ears, any sex. In fact there is no real indication if we are seeing body or head, both, or neither. And while it's true

PATRICIA PICCININI

STILL LIFE WITH STEM CELLS

JULIANA ENGBERG

they share qualities and attributes with hairless rats, cats, dogs, baby mice and piglets, they appear to have a closer affinity to humans than any other kind of animal one can think of. They seem both cursed and potential.

The child has arranged the… I think we should give them a name… these dermoids into groupings that have meaning for her. She has set up relationships and communications. A family arrangement and a social engagement that in her mind have a logic and emotion. For the little girl these possibly potential lives already live in a kind of communion and she seems fondly and tender towards them, even though, it must be remarked, because of their mutant form they have an alarming effect on those who observe this scene of play.

The child is a sculpture. Still, and even while artfully lively; ultimately inert. This is a weird arrangement where the more 'normal' life form of the human seems oddly alien, while the distinctly ambiguous; perhaps even frightening synthetic life forms have a greater veracity. Once more, as she

has done many times, artist Patricia Piccinini takes us to the edge of the bioethical/biotechnological frontier and we must gaze over its slippery surface and wonder about the ground we stand upon.

In an exhibition that proposes the concept of the potentially 'fantastic', Piccinini asks us to remember for a moment that the genre fantastic is, more often than not, attached to myth, horror, science fiction and made into bed-time fables. She reminds us too, that the concepts with which we currently grapple – those of moral, religious and scientific ethics – have always created the philosophical foundation for tales that probe the next dimension of tolerance.

Piccinini's work falls within the category 'science-fiction' which has been strangely attractive to female writers who have used its far-fetchedness to hypothesise about weird places and people, and, most particularly, about laboratory creation myths. Like her famous literary precursor, Mary Shelley, whose vivid humanism gave life to the world of Victor Frankenstein and his 'creation', Piccinini, in her own works fearlessly combines the clarity of dispassionate investigation with the emotionality and fear of the irrational.

Shelley wrote her story at a time of scientific distinction. The traces of Erasmus in Darwin's *Zoonomia* and *The Temple of Nature*, in which he espoused adventurous thoughts on the interrelations between religion, botany, technology and medicine, even postulating the possibility of man-made life forms, appear in her narrative.

Shelley's famous *Frankenstein* book was conceived during a time in which the humanist desire for empirical knowledge and experiments into alchemical phenomena brought into question creation myths, and consequently, introduced a form of scientific-led heretical thinking that forever destabilised the absolute belief systems of religion. Her text is a compendium of the enlightened discussions and experimental speculations that characterised the thinking of her time. It is informed too, by the populist and often ghoulish accounts of body snatching and the moral debates that

surrounded the use of cadavers for medical and scientific research.

Piccinini also works in a time of scientific eminence, and horror, and her projects tend to point to the fact that we must now encounter the previously unimaginable as absolute possibilities. Piccinini's *Still Life with Stem Cells* with its very compassionate sense of interrelation must prompt us to consider the debates that rage about the usefulness of stem-cell replacement therapies for persons debilitated and rendered immobile by illness and accident. There is no haphazardness in the way the vivaciousness of her synthetic life forms deliberately play off the 'stillness' of her human subject. In making her stem-cells so compellingly real Piccinini makes it impossible for us to shy away from the very problematic realisation that stem-cells are living organisims – lives, but not as we know them.

Ultimately though, Piccinini is developing an argument about symbiosis. These cute little stem-cells, animated though they might be, need the human to realise their full potential as useful organisims, to be a helpful part of the community. There is cause and effect in operation. This is one of the central tenants of Piccinini's practice throughout her entire catalogue of strange, yet needful forms, from LUMP to SO2.

It is to the future that Piccinini directs us. As she has done many times before, employing the emotionality of the embryonic to reinforce our natural sympathy and empathy for these perpetually infant progenies of science and biology.

Looking at *Still Life with Stem Cells* I am reminded of the works of French enlightenment painter, Chardin, who often depicted children engrossed in the gentile games of making houses-of-cards and blowing soap bubbles. These sweet and innocent paintings were both infant genre portraits and clever instructions about a growing interest in the laws of physics. Piccinini continues this admixture of genre, science, innocence and fiction, and, without moralising, encourages us to come with an open heart and mind to the place where children play.

THE BREATHING ROOM 2000
VIDEO STILLS FROM THE VIDEO
INSTALLATION. FRONT PAGE
IMAGE: PART I: LABORATORY
PROCEDURES 2001 DIGITAL
C TYPE PRINT.

Patricia Piccinini born Freetown, Sierra Leone, 1965. Lives and works in Melbourne, Australia.

SELECTED SOLO EXHIBITIONS

2001 *One Night Love,* Tolarno Galleries, Melbourne, Australia
The Breathing Room, The Tokyo Metropolitan Museum of Photography, Tokyo, Japan
Superevolution, Centro de Artes Visuales , Lima, Peru

2000 *Swell,* Artspace, Sydney, Australia
Desert Riders, Roslyn Oxley9 Gallery, Sydney, Australia

1999 *Truck Babies,* Tolarno Galleries, Melbourne, Australia
Plasticology, NTT ICC, Tokyo, Japan

1998 *Sheen,* Project work, 1998 Adelaide Festival, Adelaide, Australia

1996 *Natural Beauty,* The Basement Project, Melbourne, Australia
Your Time Starts Now, Contemporary Art Centre of South Australia, Adelaide Institute of Modern Art, Brisbane, Australia

SELECTED GROUP EXHIBITIONS

2001 *Berlin Biennale,* Kunst-Werke + Postfuhrant, Berlin, Germay
Australia Projects, Melbourne Festival, Melbourne Zoo and RMIT Gallery, Melbourne, Australia

2000 *Songs of the Earth,* Museum Fridericianum, Kassel, Germay
Kwangju Biennale, Kwangju, Korea
Sporting Life, Museum of Contemporary Art, Sydney, Australia
Flow, National Gallery, Kuala Lumpur, Malaysia
Akihabura TV 2, Akihabura electrical stores, Tokyo, Japan
Terra Mirabilis, Centre for Visual Arts, Cardiff, Wales
Passing Time- Moët & Chandon Exhibition, Art Gallery of New South Wales, Sydney, Australia

1999 *Melbourne International Biennial; Signs of Life,* Melbourne, Australia

SELECTED BIBLIOGRAPHY

Juliana Engberg, Atmosphere, *Atmosphere/Autophere/ Biosphere,* Drome publications, 2000, p 4
Ted Colless, 'Biophere', *Atmosphere/ Autophere/Biosphere,* Drome publications, 2000, p 38
Peter Hennessey, 'Patricia Piccinini; installations', *What is installation?* Power Publications, Sydney, 2001, p 301
Frank Hoffman, 'Report from Kwangju; Monoculture and its Discontents', *Art in America,* Nov. 2000, p 74
Kim Hong-hee, 'Kwangju Biennial', *Flash Art,* Summer 2000, p 100
Michael Hutak, 'Perfect Planet, Professionally Reproduced', *Australian Art Collector,* issue 18, Oct. 2001, p 65
Linda Michael, 'One Night Love', exhibition catalogue, Tolarno Galleries, Melbourne, 2001
Jacueline Millner, 'Love in the Time of Intelligent Machines', Artlink, vol. 21 no. 4, p 42-47, 2002
Mark Pennings, 'Enchantment, techno-science and desire', *Art and Australia,* vol. 37 no. 4, 2000, pp 556-565
Hiroo Yamagata, The NESS Project and the Birth of Truck Babies, Atmosphere/ Autophere/Biosphere, Drome publications, 2000, p16

CHECKLIST OF WORKS

STILL LIFE WITH STEM CELLS 2002
installation: silicone, acrylic, human hair, mixed media, dimensions variable
courtesy the artist and Tolarno Galleries, Melbourne

ACKNOWLEDGMENTS
sculpting and modeling: Sam Jinks
model: Jaslyn Goette
thanks to Peter Hennessey and the Fitzroy Community School, Melbourne

POPE ALICE/LUKE ROBERTS

PLANET EARTH IS THE COSMOLOGICAL EQUIVALENT OF A PROVINCIAL TOWN — THE CONTINENT OF LEMURIA (MU) WAS AN ISLAND, WHICH LAY BEFORE THE GREAT CATACLYSM IN AN AREA WE NOW CALL THE PACIFIC OCEAN. SO GREAT AN AREA OF LAND THAT FROM HER EASTERN SHORES THOSE BEAUTIFUL SAILORS JOURNEYED TO THE SOUTH AND NORTH AMERICAS WITH EASE IN THEIR SHIPS WITH PAINTED SAILS. To the west, Asia and Africa. Across a short strait of sea miles the Great Egyptian Ages which are remnant of the Lemurian Culture. All the gods that play in the mythological dramas, in all the legends from all lands, were from Lemuria. Knowing her fate Lemuria sent out ships to all corners of the Earth. On board were the twelve; the poet, the farmer, the physician, the scientist and the other so-called gods of our legends, though gods they were. And as the Elders of our time choose to remain blind, let us dance and sing and ring in the new era and hail Lemuria. POPE ALICE (in response to Donovan's Atlantis/ Epic Records, November 1968)

ALOHA ELOHA. – (aloha, an Oceanic greeting, meaning 'love' in Hawaiian; eloha, singular of 'elohim,' in Hebrew, referring to those who came from the sky)

Of all the inhabitants of Planet Motown – a wonderland of slippery rhythms, intoxicating harmonies, and the new urban/ urbane, black hi-style – Marvin Gaye was the most cerebral and perplexing. Shortly after his death in 1984, a journalist commented that he was "a sensualist who claimed divine guidance... a star only half-committed to stardom [who] could talk about the demands of art and the need for total commercialism in the same breath."[1]

STARMAN – (series of performance works by Luke Roberts in the 1970s).

Those who are familiar with Luke Roberts' work will recognise similar non-conformist traits, and those arriving (on 'Planet Luke') for the first time may raise these questions. What separates Roberts' work from art-as-strategy (for its own sake) is what separated Gaye from another former Motowner, Michael Jackson. Guided by faith and driven by some demons, Gaye's vision took unexpected turns, but always allowed entry into his world. Our own world is altered as expressions of common sentiment (for example, *I Heard It Through the Grapevine)* are actualised and conflated. Michael Jackson, in contrast, fabricated a suffocating Rococco pop-spectacle for himself. You can love it as indulgence, or ignore it, but you cannot

POPE ALICE/LUKE ROBERTS

THE WORLD MAY BE MARVIN GAYE

IHOR HOLUBIZKY

believe in the World of Thriller. The perplexity of believing reigns freely in Luke Roberts' world as two-way traffic. He does not come by it with ease, but as in Umberto Eco's coined phrase, with a "cosmic shamelessness".[2]

AGIOS LUKE OF ALPHA: ALOHA – ("holy," from the Greek word *hagios*, often used to infer sainthood).

Roberts' birthplace of Alpha, a small town in central Queensland, has been reoccupied in the generative cosmology of his adopted alter-altered ego, Pope Alice. As the story goes, she fell to Earth from the Doomed Planet Metalluna and declared "Planet Earth is the cosmological equivalent of a provincial town".[3] So began the reign of the holy fool, the World's Oldest Living Curiosity, to transform through consciousness-raising, rather than colonisation.

GET FROCKED – (a Pope Alice truism, and Luke Roberts – installation title, 1982).

Marvin Gaye embarked on his true calling after an honourable discharge from the Air Force which stated that he could not "adjust to regimentation and authority".[4] In early adulthood, Roberts felt a discomfort with the orthodoxy of Australian modernism: what art should look like, and how artists should behave. This lead to a rebellious

reaction, and to rage against the machine, the conservative policies of 1970s Queensland government. When the moment arrived as a 'once upon a time', Roberts moved outside of dressing up – his childhood imaginative play, and his mid-1970s Alice Jitterbug performative persona – to embark on an in-body and out-of-body relationship with Pope Alice.

POPE ALICE CORPORATION – (PAX)

Luke Roberts is not Pope Alice, no more than Marvin Gaye was the Black Moses (Isaacs Hayes grabbed that mantle, but diminished it by over-dressing). The back cover of his 1999 *Vanitas* monograph declares "Pope Alice presents Luke Roberts", and Roberts states that "[Pope Alice] allows me to speak of myself in the third person".[5] Hence, she is an entity unto ETself, as the Pope's appearance reveals her as an Extra Terrestrial. The Pope Alice Corporation, if a body of one, and not an elected corporation, conducts business. There is communion for those who chose to enter into the corporate body and sacrament without edifice.[6]

GREETINGS FROM AMNESIA – (an outer region of Greater Mu).

What the Pope delivers, as things and events, cannot be bracketed within the terms that the art world constructs. Rather, the events are populist; Pope Alice is the "parade marshal" for the Sydney Gay and Lesbian Mardi Gras; has been sighted in Madrid, New York, Tokyo and Venice; and appears in the throng gathered for the 1999 ("alternative culture and music") Livid Festival (Brisbane). The Livid crowds parted so as not to be run over by the lumbering Pope-Mobile/Love-Machine. She has infiltrated other domains, as the spiritual adviser for the Institute of Modern Art in Brisbane, an otherwise secular, contemporary art centre. Yet according to Pope Alice, science replaces religion. Pope Alice embraces all.

KAHLONES, AND SIGHTINGS – (two photographic performance series by Luke Roberts).

A photographic record (paparazzi evidence) has accumulated over the years; Pope Alice encounters the named, artists Gilbert and George, and Pierre et Gilles; and author Quentin Crisp; and 'ordinary' people who have no shame or inhibitions. In a suite of 1988 photographic performances, Roberts shape-shifts into mythic time: Pope Alice cradles the nude and bloodied body of Frida Kahlo, breathing life into her for Kahlo's 'subsequent' appearances with Australian outlaw-hero Ned Kelly. Pope Alice visits her namesake towns in Texas, USA, and the Northern Territory, Australia... the boiling mud pools of Aotearoa/New Zealand, and other sacred sites.

ALICE BEAUTIFICATION COMMISSION (ABC), a subsiduary of PAX.

In concurrent mythic time, Roberts' wunderkammer/kunstkameras have presented the curiosities of the world we know, and those we overlook. These are the Corporation's cultural and political embassies, its

storehouse and clearing house. And in defiance of what constitutes painting currency, Roberts has generated other hearsay/heresy moments, such as the unimaginable life and times of Mother Mary MacKillop, the first canonised Australian. MacKillop appears riding astride a horse 'bringing more Joeys to Central Western Queensland'. In another, she "appears" out of frame as the Bishop of Brisbane screams at her, via Velasquez, via Francis Bacon. In another cycle of paintings, the poodle-and-sign of the Pink Poodle motel – in the ocean side resort of the Gold Coast, Queensland – comes to afterlife.

SACRED GEOMETRY, CROP CIRCLES AND ECHO TOURISM – (ET).

The Pope Alice Corporation is ripe with visual puns and manifestations, questionable behaviour, and distended linguist, numerical codes. Like all sacred things, the burden of secular proof is irrelevant. Proof exists in yet other worlds, those of General Idea, Zush, Sun Ra... and Marvin Gaye.[8] The key to raising consciousness is optimism, not cynicism or belief that this is tomfoolery. Roberts is interested in what unites us, not dwelling on what divides us. We have dual and multiple citizenship, and on return, we "confront [our] known world in some cognitive way".[9]

GIVING BIRTH TO THE GODS.

"Marvin [Gaye] loved to shock... who else would move from a masterwork of high social consciousness to a celebration of wild eroticism?" [What's Going On to Let's Get in On] [10] Who but Pope Alice could mount a Henry Moore sculpture (outside of the Art Gallery of New South Wales, Sydney) in a laconic-erotic way, and remain divine? Who but Pope Alice could orchestrate Mu consciousness, thereby 'uniting' the Zen Buddhist concept of 'nothingness' with the lost continent of the Pacific.

1. W Kim Heron, *Detroit Free Press*, 8 April 1984
2. Umberto Eco, *Travels in Hyperreality*, Harcourt Brace & Company, 1986, p 38
3. *Vanitas*, I M A, Brisbane, 1999, p 10
4. David Ritz, 'The Very Best of Marvin Gaye', www.sdf.se/~simon/marvin/biography.html
5. *Vanitas*, p 61
6. In John Huston's film *Wise Blood* 1979, a "war veteran with no beliefs" becomes a preacher for The Church Without Christ. (1995 edition of the Halliwell's Film Guide).
7. The poodle was a leitmotif of the past, present and future for General Idea, a Canadian artist collective, (1969-1994). "Note the poodle... its instinct to please: those that live to please must please to live." *FILE magazine*, special issue "Mondo Cane Kama Sutra"), vol 5, no 4, 1983, np
8. Spanish-Catalan artist Zush (an adopted name, born 1946), created the Evrugo Mental State; Musician/composer Herman "Sonny" Blount (1914-1992) changed his name to Sun Ra in 1952, declared himself a citizen of Saturn, and a thousand years old.
9. Robert Scholes, *Structural Fabulation*, University of Notre Dame Press, 1975, p 29
10. Ritz, ibid.

Paragraph headings courtesy of the Pope Alice Corporation

170

MU PAVILON 2001 FOUND INSTALLATION, BRISBANE AUSTRALIA 2001, 4 PHOTOGRAPHS FROM THE *WUNDERKAMERA* SERIES.

THE *WUNDERKAMERA* SERIES DOCUMENTS MY VIEW OF SOCIAL SCULPTURE.
IT INVESTIGATES THE WORLD AND ITS INHABITANTS AS A MUSEUM.

The *Wunderkamera* is a photo-based work and is directly linked to my *Wunderkammer* installations which are object-based. Both works have HDH Pope Alice as a guiding force.

The Wunderkammer installations and Pope Alice sightings/appearances are connected: one (ad)dresses social space, the other is about 'dressing up' in social spaces/ places. With the Wunderkammer, selected objects are placed *in* — Pope Alice is about putting *on*.

LUKE ROBERTS

1 + 1= 8 SERIES, PIETA 1993/2001, PHOTOGRAPHIC PERFORMANCE. FRONT PAGE IMAGE ENCOUNTER SERIES: SIGHTING/ POPE ALICE, GOLD LAKE, OREGAN USA 2000, PHOTOGRAPHIC PERFORMANCE.

Pope Alice is a member of the Eternal Elohim. **Luke Roberts** born Alpha, Australia, 1952. Lives and works in Brisbane, Australia.

SELECTED SOLO EXHIBITIONS

2001 *1+1=8*, Bellas Gallery, Brisbane, Australia
2000 *Ecce Homo: These are our bodies, this is our blood*, Artspace, Sydney, Australia
 Dressed up for Paradise (Beyond the Great Divide), Bellas Gallery, Brisbane, Australia
1999 *Forbidden Universe*, Bellas Gallery, Brisbane
1997 *Mu Consciousness Raising Exercises and Pope Alice Sightings...* Sala Diaz, San Antonio and Texas, USA
1996 *Clutch*, Institute of Modern Art, Brisbane, Australia
1995 *Wunderkammer/Kunstkamera*, Gallery 14, Queensland Art Gallery, Brisbane, Australia
1992 *18 Paintings in search of a Glossary (Life)*, Sutton Gallery, Melbourne, Australia
1991 *The Veto of Reason*, Bellas Gallery Brisbane, Australia
1982 *Luke Roberts*, Institute of Modern Art, Brisbane, Australia

SELECTED GROUP EXHIBITIONS

2002 *Stranger Than Truth*, Australian Centre for Photography, Sydney, Australia
1999 *The Divine Pope Alice*, Livid Festival, Brisbane, Australia
1998 *Re-Thinking the Avant Garde*, De Montfort University, Leicester, UK
1997 *21st Annual Studio Exhibition*, PS1Contemporary Art Centre, Clocktower Gallery, New York, USA
 The Andy Factor, Australian Centre for Contemporary Art, Melbourne, Australia
 The Second Asia-Pacific Triennial, Queensland Art Gallery, Brisbane, Australia
1995 *Australian Perspecta*, Art Gallery of New South Wales, Sydney, Australia
1992 *You Are Here*, Institute of Modern Art, Brisbane, Australia
1991 *Australian Perspecta*, Art Gallery of New South Wales, Sydney, Australia
1989 *All Souls Day*, Artspace, Sydney, Australia

SELECTED BIBLIOGRAPHY

Artists Cards, 'Pope Alice Sez', Series 1,2,3, Amsterdam, 1987. *Eyeline*, No.s 1 & 2, 1987
Artist Pages, *Eyeline*, No.s 4,5,7, 1988. No. 10, 1989; 'Christ & Kahlo', *Tension*, No. 20, March, 1990, p 72; *Art & Text*, No. 40, 1991, p 20-21
Nicholas Baume, 'Australian Perspecta 1991', *Art + Text*, No. 41, January 1992, p 104
Campion Decent, 'Divine Madness', *Blue* 1995
Michele Helmrich, 'Luke Roberts, A Black Swan of Trespass', *Little Red Book*, Institute of Modern Art, 1996

Donna McAlear, 'Show me where the mystery has left', exhibition catalogue, Queensland Art Gallery, Brisbane, 1994
Vanitas: Pope Alice presents Luke Roberts, monograph, with essays by Alejandro Diaz and Alice Jitterbug, Michele Helmrich, Ihor Holubizky, interview by Nicholas Zurbrugg, Institute of Modern Art, Brisbane, 1999
Tim Morrell, 'The People's Pope', *Art & Australia*, Vol. 35, No. 2, 1998
Ingrid Periz, 'Is the Pope Alice?' *Art + Text*, No. 51, 1995
Urszula Szulakowska, 'Luke Roberts', *Eyeline*, #10, December 1989

CHECKLIST OF WORKS

GREETINGS FROM AMNESIA: MU PAVILION @ 4 AM 2002
installation, including:

POODLE SCULPTURES 2002
13 sculptures, mixed media, wood and cowrie shells, dimensions variable

CANOPIC CASES 2002
13 vitrines containing 52 cookie/ 'canopic' jars glass, ceramic, wood, metal each vitrine: 43 x 37 x 162 (h) cm

AKIRI GIVENS 2002
13 paper lanterns dimensions variable

FLOWER PAINTING (AMNESIA) 2002
enamel on wood 488 x 244 cm

FLOWER PAINTING (ALOHA) 2002
enamel on wood 488 x 244 cm

FLOWER PAINTING (MU) 2002
enamel on linen 180 x 180 cm

FLOWER PAINTING (LEMURIA) 2002
enamel on linen 180 x 180 cm

ENCOUNTERS 2002
4 offset lithographs, edition of 60, 48 x 65 cm

MU PAVILION 2002
2 offset lithographs, edition of 60, 48 x 65 cm

1 + 1 = 8 2001
12 giclée prints on arches watercolour paper, edition of 30, 30 x 31 cm

PACIFICA
video compilation, including *Lemuria*, *Wait for me Juanita* (Conway/Flett) and *Wangaratta Wahine* (Conway/Flett) remix

Works courtesy the artist and Bellas Gallery, Brisbane

ACKNOWLEDGMENTS
Michael Littler (assistant), Peter Bellas, Josh Milani, Alex and Kitty Mackay, Ralph Tyrrell/ Videola, Mic Conway's National Junk Band, Blizzard Media, Livid Festival, Karen Hewett, Joanna Meighan, Paul O'Brien, Tora Blackman, Ihor Holubizky, Ric Aqui, Stephen Crowther, Lae Oldmeadow, Marie Madden, Simon Arnold.

'Lost' is a state of existence between 'some-wheres' – a point of transition between demarcated emotional and geographical territories. To be lost is to be disorientated from the familiar, to be at a distance from that which went before and from that which is to come. According to the heroic narrative of Colonialism, redemption from being lost may only be achieved through discovery, consequently it is cast as a condition to be challenged, and if encountered should be obliterated through established processes of mapping.

In early twenty-first century culture, a climate characterised by art historian Irit Rogoff as one in which loss has become one of the "constituent components of cultural experience",[1] it could be claimed that 'being lost' is a desirable state of exis-

KATHY PRENDERGAST

CLARE DOHERTY

tence. It offers a moment of reflection, a place of contemplation where historical paradigms might be reconsidered. When in 1964 Yoko Ono coaxed her participants to "draw a map to get lost in", she was invoking the potential of 'going astray', of finding something missing. It is at this site of potential reconfiguration that the work of Kathy Prendergast can be found.

An encounter with one of Prendergast's works is essentially one of disorientation. She summons familiar associations and then triggers a double take between that instant of recognition and its concomitant de-famil-iarisation. What results is an experience of the uncanny – "a class of the frightening which leads back to what is known of old and long familiar"[2] – brought on by a sur-realist process characterised by André Breton as "the marvellous faculty of attaining two widely separate realities without departing from the realm of our experience, of bringing them together, and drawing a spark from their contact."[3] Her works are at once witty and distressing, precisely because they are delivered intimately, without spectacle. They seem somehow both vulnerable and treacherous, as if, despite their fragile appearance, they were instruments of undoing.

This uncanny consequence is achieved through Prendergast's use of the kinds of common objects which customarily furnish our existence and become ritualised through everyday use – a cotton reel, a blanket, a pair of gloves, a pillow, a map. In their un-adult-erated forms they offer comfort, warmth, rest, a way home. Yet via Prendergast's trans-formative process, they become impostors. Rendered useless, they are literally and meta-phorically objects unmade.

Whilst Prendergast's *Lost* works (begun in 1999) and her epic series of panoramic city drawings (begun in 1992) are distin-guished from her collection of emotive objects by dimension (we move from the microscopic body – the multiple strands of hair in the objects – to the macroscopic, the skeins of a river on the maps), she main-tains the intense intimacy of engagement. Prendergast' takes the groundwork – the city's organic form, the continent's geo-logical formations – and produces startling reconfigurations, which seem to reveal the inherent nature of civilisation and conse-quently the relative frailty of the human condition. The collection of city drawings, stripped of extraneous detail, now sequen-tially play against each other as if collating to form a catalogue of dislocated or mis-placed conurbations rendered in graphite.

In her series of maps and atlases, titled *Lost*, Prendergast posits a new cartogra-phy, acknowledging only those locations named Lost – Lost Rivers, Lost Lakes, Lost Springs and Lost Creeks, Lost Parks, Lost Forests, Lost Cities and Lost Nations. Here, classification occurs at the point at which absence is evoked. Collectively the places summon the violent history of settlement, the erasure of indigenous life, through language. As in the city drawings, the pres-ent recedes and in its place the Lost sites articulate new relations to one another. The fact of there being something missing is the only criteria for inclusion in this strange new worldview.

The *Lost* maps resonate within the par-ticular cultural context of the West post September 11th. Considering the ubiquity of the word 'lost' and the ways in which it has necessarily become a euphemism for 'dead', the map of North America seems to trace a psychology of place, marking

out the states as sites of cumulative loss. They seem to inscribe the inevitability of death on the topographical surface. What remains literally invokes Susan Stewart's assertion that "each material thing contains within its future, the inevitable narrative of the loss of the past".[4]

This perception of the cyclic nature of time lies at the heart of Prendergast's endeavours. In *The End and the Beginning II* 1997, a cotton reel is bound with the hair of her mother, herself and her son. Prendergast uses hair in her work as a material of desire, to leave a trace, to imbue the static object with a tremor of human contact. Works such as *After*, *Love Object* and *Love Table* (all 1999) and *The End and the Beginning I* 1997, are fetish objects of a sort in which the hair appears feral, moving over the objects as if colonising them. In contrast *The End and the Beginning II* is a contained, controlled work, with the hair wound tightly around the small wooden reel. The strands of three generations of hair form a series of graduated ridges of colour, as if mimicking a tree's concentric circles of age. It is here in the cylinder of the reel that the cyclic nature of existence and the impossibility of repetition are played out against one another.

Prendergast is captivated by the evidence of time and, in particular, by the moment and which the past and the future might collide, the in-between state. *The Endless Goodbye* 1998, a set of two photographs, shows the blurred action of a waving hand. Here is preserved a moment of loss in duplicate. The action being played is a perpetual state of being lost.

1. Irit Rogoff, 'Getting Lost', *LOST*, Ikon Gallery, exhibition catalogue, 2000, pp 73-82
2. Sigmund Freud, "The Uncanny", *Standard Edition of the Complete Psychological Works*, vol. XV11, trans. James Strachey, *et al*, The Hogarth Press and The Institute of Psycho-Analysis, 1953
3. André Breton in *Les Champs magnétiques*, 1921
4. Susan Stewart, 'Art and the Experience of Time', *LIKE*, Melbourne, 1999, p 3

Kathy Prendergast

born Dublin,
Ireland, 1958.
Lives and works in
London, UK.

SELECTED SOLO EXHIBITIONS

2000	*The End and the Beginning*, Irish Museum of Modern Art, Dublin, Ireland
1999	*Land*, Angel Row Gallery, Nottingham, UK
1997	*City Drawings*, Art Now Project Room, Tate Gallery, London, UK
	Angles Gallery, L.A. International, Los Angeles, USA
1994	Royal Festival Hall, South Bank Centre, London, UK
1991	Camden Arts Centre, London, UK
1990	Douglas Hyde Gallery, and touring

SELECTED GROUP EXHIBITIONS

2001	*Fresh, Recent Acquisitions*, Albright-Knox, Buffalo, New York, USA
	By Hand, University Art Museum, California State University, USA
	Works on Paper, Kerlin Gallery, Dublin, Ireland
	In/Print, The Ferrans Art Gallery, Oriel 31, Wales, Centre for Visual Research, Dundee, Scotland
2000/01	*Shifting Ground: Fifty Years of Irish Art*, Irish Museum of Modern Art, Dublin, Ireland
1999/01	*Irish Art Now: From the Poetic to the Political*, McMullen Museum of Art, Boston College; Art Gallery of Newfoundland and Labrador; Chicago Cultural Center; Irish Museum of Modern Art, Dublin, Ireland
1999	*From a Distance – Approaching Landscape*, Institute of Contemporary Art, Boston, USA
	0044, PS1, New York & Albright-Knox Art Gallery, Buffalo, USA; Crawford Municipal Art Gallery, Cork, Ireland
1997	*Selections Fall '97*, Drawing Center, New York, USA
1995	Irish Representative, *Venice Biennale*, Venice, Italy

SELECTED BIBLIOGRAPHY

Shane Cullen/ Kathy Prendergast, Venice Biennale, 1995
At One Remove, Henry Moore Institute, Leeds, 1997
Penelope Curtis, *Strongholds*, Tate Gallery, Liverpool, 1991
Jo Anna Isaak, *Laughter Ten Years On*, Hobart & William Smith Colleges Press, 1995
Conor Joyce, *Kathy Prendergast*, The Douglas Hyde Gallery, Dublin, 1990

Language, Cartographie et Pouvoir, Orchard Gallery, Derry, 1996
Declan McGonagle, 'Inheritance and Transformation', Irish Museum of Modern Art, Dublin, 1991
Francis McKee, *The End and the Beginning*, Irish Museum of Modern Art, Dublin, 1999
Frances Morris, Tate Gallery, London, 1997
Dorothy Walker, *Modern Art in Ireland*, Dublin, 1997

CHECKLIST OF WORKS

CITY DRAWINGS - A SERIES OF DRAWINGS OF CAPITAL CITES OF THE WORLD 1994-1999
pencil on paper, each 32 x 24 cm
collection: Irish Museum of Modern Art, Dublin

courtesy the artist and Kerlin Gallery, Dublin

it would be a miracle if you can sleep tonight

MIGUEL ANGEL RIOS

177

MIGUEL ANGEL RIOS

RAUL ZAMUDIO

Miguel Angel Rios' participation in the 2002 Biennale of Sydney consists of a video projection *Los niños brotan de noche*, and an audio-installation *Toloache, Mapping with the Mind #1*. Based on Rios' experiences with hallucinogens administered by indigenous Mexican shamans in their native cultural contexts, the works occasionally seem to operate in tandem via ostensibly similar thematic direction and formal articulation. Their immediate points of narrative entry concern psychotropic customs used by Mexican Indians in order to know the self and the world. Thus Rios' works initially present themselves as commentary on alternative epistemologies that exist outside the West, but they are also a poetic and critical reflection on a convergence of themes that transcend cultural practices and their geocultural origins. Some of these themes address the social basis of perception, the ideological nature of aesthetics, and philosophical questions that interrogate Western Cartesian dichotomies of mind/body and self/other and transpose them into other equally ideologically imbued polarities such as center/periphery, history/myth, and culture/nature. Subtle, yet complicated and demanding, Rios' works are outwardly executed with the simplest of means that self-reflexively comment on contemporary artistic practice that has occasionally succumbed to a technological fetishism, where the spectacle becomes a formal end in itself.

Los niños brotan de noche, for example, introduces itself through video conventions that have become all too familiar: overtly recognizable in the projection format is the perpetual shift between an optical experience to a phenomenological one. As is the case with most projections, the locus of artistic experience and visual consumption is the eye. Yet by virtue of the enveloping presence of the projected image, the body is subsumed by it in the act of viewing. The effect is not unlike monumental minimalist sculpture that puts the viewer in subordination to it. In the opening sequence of *Los niños brotan de noche*, Rios is walking while a dog crosses his path. This ephemeral encounter serves as one part of the work's formal and narrative bracket, where in the other that functions as the work's coda, Rios is similarly strolling nonchalantly through a misty and deserted, nocturnal cityscape. Sandwiched between these two formal poles are various video and cinematic tropes that serve to highlight the sensorial multidimensionality that helps to formally drive the video's myriad, narrative directions.

As the video unfolds, Rios' role as protagonist and participant in the ingestion of hallucinogens, under the guidance of a native Mexican *curandera* or healer, is articulated via an uncanny anti-visual strategy: an empty screen interspersed with dialogue. In looking at the void replete with dialogue that ensues between participants of the collective, hallucinogenic experience, one is confronted by an absent presence. The effect at first is vertiginous; whereas one expects to encounter images in a video, one is compelled to engage the work piecemeal. For whatever is occurring in the video during its blacked-out sequence is now dependent on the viewer for completion. The dialogue does guide the viewer to assume certain things, though through poetic ambiguity

the viewer is situated in a kaleidoscope of Borgesean possibilities filtered through spatial incongruity and psychological displacement. At one point a female voice, the *curandera*, says "there are men with rifles... and it stinks... stinks... stinks of death... ".

Rios' general narrative focus on native epistemological practices that predate the arrival of Europeans as well as the deployment of vanguard video strategies locate this particular piece in an historically idiosyncratic, visual trajectory. This eclectic lineage consists of early conceptual video work, experimental films of the 1950s and '60s, the structuralist aesthetics of Chris Marker, and Western horror films where the indigene as Other becomes the embodiment of an imaginary evil. There is also a slight *faux* documentary dimension to the work that fleshes out questions of the power differential between the viewer as body-double for the foreign, ethnographic investigator and its native object of study. If, as Laura Mulvey states, cinema "poses questions about the ways the unconscious structures ways of seeing and pleasure in looking", what would be the ramifications when the

lights of Rios' phantasmagoria are turned off – severing the cinephile's most cherished obsession pleasurably attained and mediated through the sense of sight, that is to say, voyeurism and scopophilia? The undermining of traditional cinema by the empty screen is an emphatic denial of a resemblance theory of the moving picture. Since in the main sequence there is no image, there can be no collusion of verisimilitude to the referent or mimetic pretensions to the real. The empty screen as lack, as trauma, is further accentuated by Rios' negation of the Renaissance trope of spatial perspective that is germane to conventional cinema. Dismantling the viewer's potential for identification within the video by way of the literality of the empty screen, where the self meets its other, where life meets death, is the formal counterpart to the conceptual thrust of the work. If *Los niños brotan de noche* destabilizes Western dichotomies by interrogating the visual relationship between viewer and work of art, then *Toloache, Mapping with the Mind #1* offers a phenomenological exploration by incorporating the corporeal as an aesthetic experiential receptor. It offers a alternative modality

into the consumption of art that critically reiterates what Duchamp had construed as Modernism's artistic bias for the optical.

Like Rios' video projection, the audio-installation *Toloache, Mapping with the Mind #1* does not solely concern itself with themes that are culturally specific. The architecture of the 'house' where one enters to hear the disembodied utterance of an indigenous language is formally and conceptually offset by the perpetual reconfiguration of the structure's physical constitution. Originally shown at the Havana Biennial, *Toloache, Mapping with the Mind #1* was constituted from the wooden detritus found around the city. In its recent incarnation, materials used in its previous exhibition context remain, added to new elements culled from Sydney which magnify its inherent nomadic quality and capacity for social absorption. As is, the audio-installation becomes a perpetual site-specific piece that drags its own peripatetic history; leaving in its wake an index where its sojourn is etched in the memory of its viewer/participant.

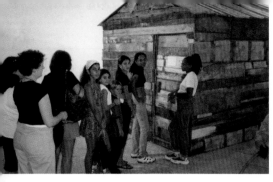

Miguel Angel Rios

born Catamarca,
Argentina, 1943. Lives
and works in Mexico
City & New York.

SELECTED SOLO EXHIBITIONS

1999 *Miguel Angel Rios Manhattan Codice*, John Weber
 Gallery, New York, USA; Museo Carrillo Gil, Mexico
 City, Mexico
1998 *Los Vientos del Sur*, Ruth Benzacar Gallery, Buenos
 Aires, Argentina
1996 Oddi Baglioni Gallery, Rome, Italy
1995 Drawings, Galerie Wohn Maschine, Berlin, Germany
 John Weber Gallery, New York, USA
1993 A Survey of the Work of Miguel Angel Rios, 1979-
 1993, Museo de Arte Moderno, Mexico City, Mexico
 John Weber Gallery, New York, USA

SELECTED GROUP EXHIBITIONS

2001 *Special Projects,* PS 1 Contemporary Art Center,
 New York, USA
2000 *Drawing*, Trans Hudson Gallery, New York, USA
 7th Havana Biennial, Havana, Cuba
 5 Continents and 1 City, Museo de la Ciudad,
 Mexico City, Mexico
 Kwangju Biennial
 The Edge of Awareness, PS 1 Contemporary Art
 Center, New York, USA
 Transatlantica, Museo de Arte Contemporaneo,
 Canary Islands, Spain
1997 6th Havana Biennial, Havanna, Cuba
1994 *Mapping*, The Museum of Modern Art, New York,
 USA
1993 *Trade Routes*, The New Museum of Contemporary
 Art, New York, USA

SELECTED BIBLIOGRAPHY

Francine Birbragher, 'Miguel Angel
Rios', *Art Nexus*, Vol. 7, Jan-Feb. 1993,
p 151
Dan Cameron, 'Facing Territory',
Trans>, Vol. 5, 1998
Frederick Castle, *Art in America*,
Summer, 1990, p 177
Lebenglik Fabian, 'Los Usos y Husos del
mapa', *Plastica*, November 1998, p 12
Jonathan Goodman, 'Amnesia
Exhibitions', *Contemporary Visual Arts*,
28, 2000, pp 60-61
Julieta Elena Gonzalez, 'Manhattan
Codice', *Atlantica Internacional*, No. 24,
November 1999, pp 106-129
Pablo Helguera, 'The Discovery of the
Amazon', *tema celeste*, Jan-Feb. 2001.
pp 48-49
Roberta Smith, *The New York Times*, 9
July 1999

CHECKLIST OF WORKS

TOLOACHE: MAPPING WITH THE MIND
#1 2000
audio installation
500 (l) x 250 (w) x 300 (h) cm

LOS NIÑOS BROTAN DE NOCHE (THE
CHILDREN THAT SPRING OUT AT
NIGHT) from the series *Mapping with
the Mind* 2001
video audio installation
2 x 3 m

Works courtesy the artist

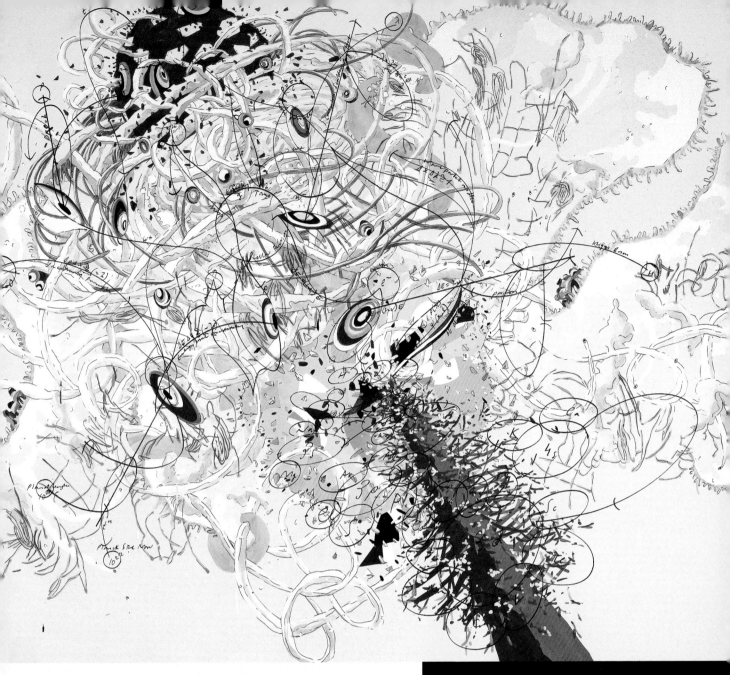

MATTHEW RITCHIE

It was the end of January, Saturn was in the house. Angled shafts of soft winter twilight slanted through blurred glass, illuminating the ghosts cast out by their breath in the empty rooms. There was no electricity or heat in the old farmhouse. With its stone floors, oil lamps, root cellars and blackened hearths, it was a frozen relic from another time. A past accelerating away at a thousand miles an hour. The farmland where my great-grandfather had grown apples had been sold to make way for a new thing. With typical family foresight, he had declined the opportunity to buy the land some years earlier, since he was making a healthy profit just leasing it. After all, there was always more farmland. Now the land had been sold to the government for use as an airport, soon to be known as *Heathrow*. The massive explosion of the suburban zone around Heathrow meant there was suddenly no more farmland to rent, not around there anyway. How do you like them apples?

Just another family story; we've all got them. Failure, violence, abandonment, genetic deformities, madness, depressions

MATTHEW RITCHIE

THE FAMILY FARM

MATTHEW RITCHIE

182

and drownings. What family cannot lay claim to a rich and storied past, since in the end we're all related. We're all kissing cousins, whose common ancestors were migrants swept from the sea on the great plume of clearances that forced generations from their ancient homes and ancestral ways. Their stories – the wounded king and his wasted land, the green man and the severed head, the cauldron of plenty and the great hunt – came with them and were, like their tellers, changed by the new world. It was the time of the 'tuirgin', the transmigratory cycle of investigative experience. A circuit from form to form, an endless and circular chain of birth and rebirth. Their sign was the unravelled knot that twists into a labyrinth, that grows into a serpent, that consumes itself. DNA, the coiled dimensional instruction book that can build a living world from dust and as easily dissolve it back again.

Above all, they were adaptable: they became shape-shifters, speakers of tongues, survivors. Mountain lions, marmosets, parrots, goats, coypu, salamanders, peacocks, antelope, porpoises, mole-rats, foxes, pigeons, crocodiles, otters, zebra, chameleons, ducks, rats, kangaroos, herons, manatees, frogs, eagles, platypi, bears, tigers, penguins, dogs, okapi, pigs, squirrels, rabbits and on and on and on, always changing, becoming everything, every possibility, every dream of survival. And of course in the end, they became the monkeys.

Through it all, they carried their secret ocean inside them. The hidden sea that connects us all, whose tropical and sluggish tides ebb and flow through the caldera of the skull, trawling the shoals of memory, leaving driftwood carved in fantastic and familiar shapes. A sea filled with iron, salt and lust. You can't leave your blood behind.

In 1687, the final volume of Newton's 'Principia' was published. The story of the young Newton observing a falling apple and deducing, in a moment of revelation, the existence of gravity is almost certainly fabricated. The true nature of gravity is also still open to question. Although the tidal effects of that mysterious force can be felt everywhere, the means of transmission remain hidden, an invisible ocean of *gravitons*, still waiting to be found. They are, like ninety percent of the universe, still missing from our ambit. How do you like them apples?

The boundary between 'pure', quantum information and the real world is a threshold environment. Inside it, new narrative conventions are constantly evolving to handle the possible outcomes of all that mutability. The polymorph inside us, the trans-human, routinely sublimates the body, inscribing it into space and time. Ontology becomes architecture, the X-Y-Z axes become indices of possibility. Space must be considered foremost as a potential resource. Categories like inside and outside, order and disorder, become an option, rather than a necessity. The geometry of space-time is inside us, is us, growing geometrically stronger the smaller it gets. At the heart of things, on the quantum threshold where the atomic lattice dissolves back in to the universal primary material, a dance through multiple dimensions takes place in double time. Gravity folds into waves; energy and matter swap places and apples, airplanes

and monkeys are all equally likely, just waiting for that secret tide to blow them into being. We change and change again, growing along invisible lines of dimensional adaptation, as that familiar wind blows at our back.

Back at the farm, the geometry of the house shifted as a stern north-easterly leaned in hard against the ancient frame. The house had been built, like its owners, only well enough to last a certain amount of time.

The builders and their predecessors, the Normans, Saxons, Danes, Romans, Celts, Picts and the stone age peoples who came before even them, too young and carefree to have names, had worked this land hard for thousands of years. No molecule of it had not felt the greedy caress of hands, not been used and reused. Foreign organisms had been introduced, abandoned and replaced over and over again, until finally, the apogee of agriculture had been reached. The apple is the hardest of all fruits to cultivate from the wild, the very summit of the great farming civilizations.

Now the land quivers under the buffeting winds of the jet streams, the windows are shaken by the sonic booms. Less than three hundred years from Newton in Cambridge to the Wrights at Kittyhawk. Another revelation, an eye opening. The gleaming wet pupil so soft and different from the skin that covers it that it seems like a wound seen in a dream, a priceless jewel dropped in from a different order of being. Flight, a revelation, the unbelievable inversion of the universal descent. The renunciation of gravity, converted back and up through pressure, mass and energy, into a hurricane of dreadful and sublime desire, a storm that heralds endless and total change.

The nor'easter got into the attic through a missing slate and wrestled with the old timbers for a while. The house creaked and groaned half-heartedly, as if it couldn't decide whether it was fed up with waiting to die, or was already dead, with a few choice words for the living. You've felt that wind before, on certain days, when just walking down the street feels like you're swimming in blood.

It is your future, waiting to fall.

New York City 2002

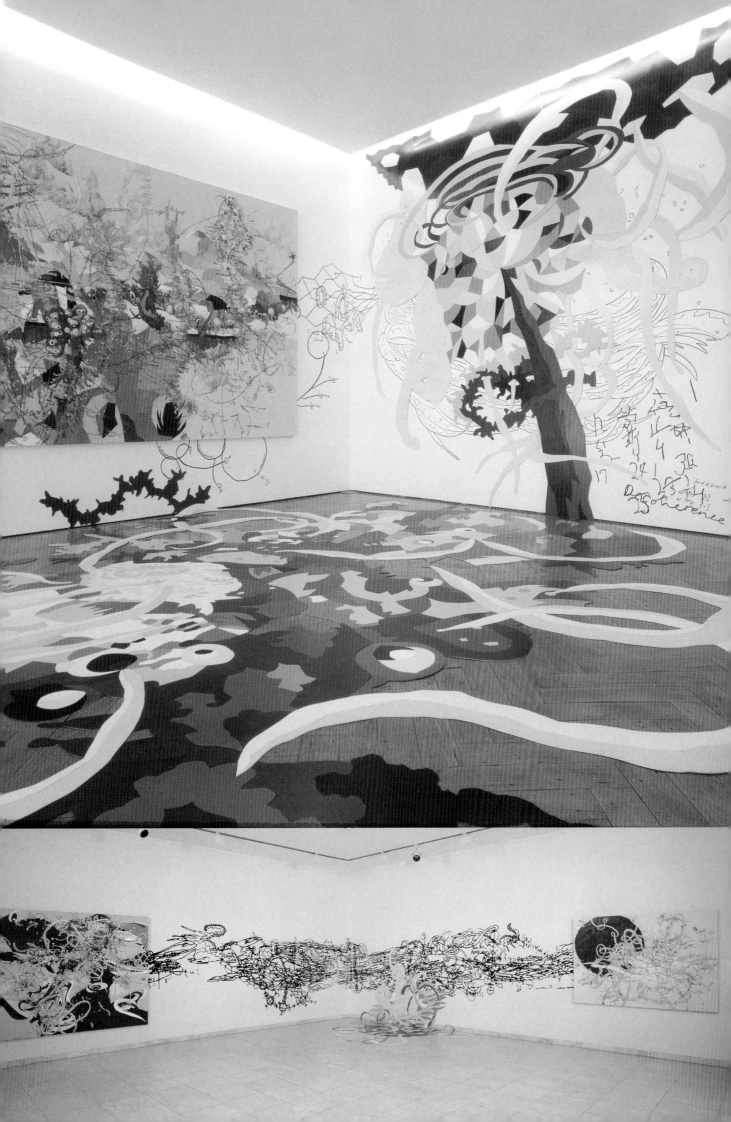

ESTABLISHING SHOT 2001 (DETAIL)
OIL AND MARKER ON CANVAS.
FRONT PAGE IMAGE: ESTABLISH-
ING SHOT (DETAIL) 2001 OIL AND
MARKER ON CANVAS.

Matthew Ritchie born

London, UK, 1964.

Lives and works in

New York City, USA.

SELECTED SOLO EXHIBITIONS

2001 *The Family Farm,* White Cube, London, UK
 The Slow Tide, Dallas Museum of Art, Dallas, Texas,
 USA
 Parents and Children, Andrea Rosen Gallery, New
 York, USA
 The Fast Set, Miami MoCA, Miami, USA
1999 *The Working Group*, c/o Atle Gerhardsen, Oslo,
 Norway
 The Big Story, Cleveland Center for Contemporary
 Art, Cleveland, Ohio, USA
1998 Fundação Cultural de Distrito Federal, Brasília, Brazil
 Galeria Camargo Vilaca, Sao Paolo, Brazil
 The Gamblers, Basilico Fine Arts, New York, USA
 Mario Diacono Gallery, Boston, USA

SELECTED GROUP EXHIBITIONS

2002 *Urgent Painting*. ARC, Musée d'Art Moderne de la
 Ville de Paris, France
2001 *Form Follows Fiction*, Castello di Rivoli, Torino, Italy
 The Mystery of Painting, Sammlung Goetz, Munich,
 Germany
 01/01/01: Art in Technological Times, SFMoMA, San
 Francisco, USA
2000 *Hypermental: Rampant Reality,1950-2000,*
 Kunsthaus Zurich, Switzerland
 Unnatural Science, Mass MoCA, North Adams, MA,
 USA
 Vision Machine, Musee des Beaux-Arts de Nantes,
 Nantes, France
1999 *Best of the Season*, Aldrich Museum of
 Contemporary Art, Ridgefield, CT, USA
1998 *Parallel Worlds*, South East Center for
 Contemporary Art, Winston-Salem, NC, USA
1997 *1997 Biennial*, Whitney Museum of American Art,
 New York, USA

SELECTED BIBLIOGRAPHY

Bonnie Clearwater, 'Matthew Ritchie:
21st Century Artist',*The Fast Set*, Miami
MoCA Spring, 2000, pp 4-5, 25-33
Patricia Ellis. 'Matthew Ritchie: That
Sweet Voodoo You Do', *Flash Art*,
November-December, 2000, pp 88-91
Patricia Falguieres, 'Views of the
World', *Urgent Painting*, ARC, Musee
d'Art Moderne De La Ville De Paris,
Spring 2002, pp 19-31
Laura Heon and John Ackerman,
Unnatural Science, Mass MoCA, Spring,
2000-2001, pp 54-57,123.
Jeffrey Kastner, 'An Adventurer's Map
to a World of Information', *The New
York Times*, 15 October 2000, p AR37

Benjamin Nugent, 'Innovators. Time
100: The New Wave', *Time Magazine,*
October, 2001, pp 162-169
Nancy Princenthal, 'The Laws of
Pandemonium', *Art in America*, May,
2001, pp 144-149
Cay Sophie Rabinowitz. 'Not Two, Not
Three, Not Even Four Dimensions',
Collaboration: Matthew Ritchie, *Parkett*
no. 61, 2001, pp 138-141
Jerry Saltz, 'Matthew Ritchie: Out
There', *Village Voice*, 28 November
2000, p 79
Suzanne Weaver, 'The Deep Six', *The
Slow Tide*, Dallas Museum of Art,
Spring, 2001, pp 8-9

CHECKLIST OF WORKS

THE FAMILY FARM 2001
mixed media installation, five parts:
ESTABLISHING SHOT 2001
(left wall)
oil and marker on canvas
182.9 x 304.8 cm
THE FAMILY FARM 2001
(rear wall)
nine lightboxes with lambda prints on
duratrans
each box: 96 (h) x 142 (w) x 20 (w) cm
GERMINAL 2001
(right wall)
oil and marker on canvas
182.9 x 304.8 cm
THE FAMILY FARM 2001
(floor, ceiling and walls)
enamel on sintra, acrylic and marker
on wall
dimensions variable

THE FAMILY FARM 2001
ink and graphite on mylar
(framed) 74.6 x 176.2 cm
THE MAIN LINE (SYDNEY VERSION)
2002
acrylic and marker on wall
dimensions variable

Works courtesy the artist, Andrea
Rosen Gallery, New York and White
Cube, London
Photography: Oren Slor; Stephen
White; Achim Kukulies

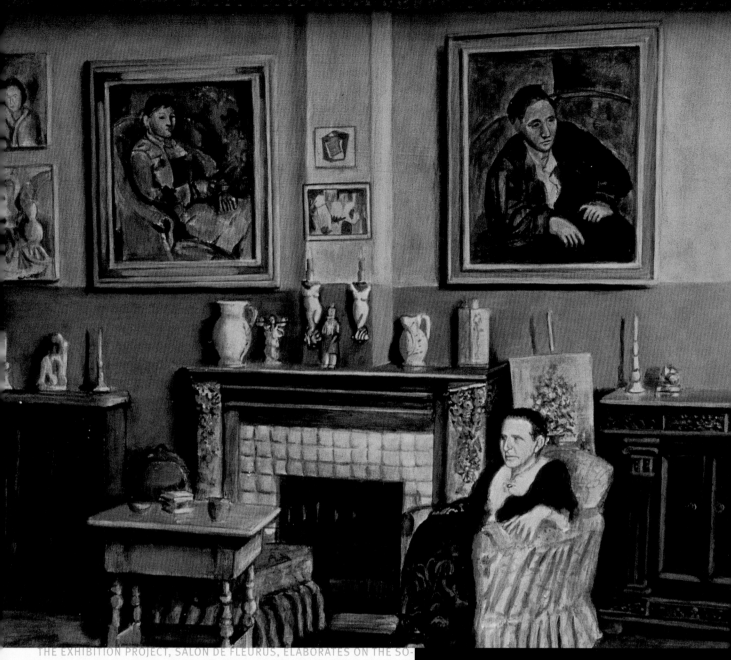

SALON DE FLEURUS

THE EXHIBITION PROJECT, SALON DE FLEURUS, ELABORATES ON THE SO-CALLED TACTICAL POSITION OF THE ARTIST WHO CONCEALS HIS OWN IDENTITY, THE STRATEGIES OF POSTMODERN ART, AND THE POST-SOCIALIST CONDITION OF ART. AT THE VERY MOMENT IN WHICH POST-MODERNISM PROCLAIMS THE 'DEATH OF THE AUTHOR' AND THE RISE OF ANTI-AURATIC ART IN THE PUBLIC REALM, THE ART MARKET BECOMES EVER MORE CONSCIOUS OF THE MONOPOLISING POWER OF THE ARTIST'S SIGNATURE, AND QUESTIONS OF AUTHENTICITY AND FORGERY. Within the metaphors and fictions of postmodern discourse much is at stake, as electronic technology seems to rise, unbidden, to pose a set of crucial ontological questions regarding the status and power of the human being. It has fallen to science fiction to repeatedly propose a new subject that can somehow directly interface with – and master – the cybernetic technologies of the Information Age. We can perhaps suggest that the Salon de Fleurus project may be re-read or revealed as a daemon, as something that disturbs the linearity of history, of art, of science. The best-known examples are Maxwell's daemon, Gödel's trickster, and Haraway's coyote. Science and literature generate icons, agents, monsters that help us to interface with the world. In Salon de Fleurus the philosophical questions of plausibility and implausibility override those questions concerning what is true and what is false. The shift of interest from the thing to its representation, and especially from space to time, leads to a shift from the old black-and-white, real/figurative dichotomy to the more relative condition actual/virtual. In Salon de Fleurus, the real-time image is more important than the thing represented: subsequently, real time prevails over real space, virtuality dominates actuality, turning the very concept of reality on its head. Marina Grzinić – curator

FICTION RECONSTRUCTED –
THE LAST FUTURIST SHOW[1]

THE LAST FUTURIST EXHIBITION
ARMORY SHOW – SALON DE FLEURUS

MARINA GRZINIC

In Ljubljana in the 1980s, Salon de Fleurus realised several projects based on the idea of reconstructions of works of art from the avant-garde tradition. The 'originals' included in these projects are reproductions, reconstructions and copies of works shown before and during the First World War, between 1906 and 1915 – specifically: the collection of Gertrude and Leo Stein (initiated around 1905-6 in Paris); The International Exhibition of Modern Art (The Armory show) shown in New York in 1913; and The Last Futurist Exhibition by Kasimir Malevich, originally displayed in St Petersburg in 1915.

The project FICTION RECONSTRUCTED restages these three seminal exhibitions from the beginning of the twentieth century – exhibitions that ultimately influenced the concept and structure of modern art and the avant-garde.

The first project, The Last Futurist Exhibition by Kasimir Malevich (from Belgrade), took place in a private apartment in Belgrade from December 1985 to February 1986. The second, The International Exhibition of Modern Art (Armory Show), was also held in Belgrade, in the Salon space of the Museum of Contemporary Art in September 1986. The projects were re-staged again in Ljubljana in 1986 at Gallery Skuc.

The third project of FICTION RECONSTRUCTED is the most bizarre. Titled Salon de Fleurus, it is the representation of one of the most significant collections of modern art – the collection established by the American author and literary critic Gertrude Stein (1874-1946) with the help of her brother Leo Stein, in their Paris apartment at 27 rue de Fleurus, between 1906 and

1922. Named after the Stein's address, Salon de Fleurus, set up in a private apartment in Manhattan, New York, has been opened to the general public since 1993. This re-construction of the flat, a shift from Paris to New York almost a century later, recalls the fact that most of the known pieces of modern art by Matisse, Picasso et al., were originally hung together in the Stein's salon, a 'tea party' space. The public came to visit Gertrude Stein and while drinking tea were able to admire the collection that ultimately would shape the very idea of modern art and further, the Museum of Modern Art itself as an institution.

The author(s) of these three projects remain anonymous... although it may be more accurate to say that they are not essential to the understanding of the project. Yet they are present: in the exhibition titles and signatures – often by signing the works with the names of famous and deceased painters and philosophers, or with pseudonyms. For instance, THE LAST FUTURIST EXHIBITION is signed 'Kasimir Malevich' but

with the detail 'from Belgrade' added.

Certainly works by Picasso, Cézanne and Matisse comprise the exhibition before us, but rather than being concerned with them as discrete items, the concern is with the system. The exhibition projects are more than specific reconstructions of a particular space or installation, they focus on a system of thinking which established the institution of modern art as we know it today. Therefore, in the New York Salon, one can purchase not only paintings but also furniture and other items from both rooms. Every painting sold is substituted with either a copy of the same one or with another from the same period. Thus the Salon continuously regenerates and transforms itself at the same time.

What we have here are copies... but copies containing the physical content of each painting and much more – the idea itself and the act of copying are equally significant. Questions such as the relation between the original and the copy, truth and falsehood, sense and non-sense, are

legitimate subjects for philosophical discussion. These are actually anti-historical works. Copies exist in their own right and time: they do not necessarily originate from an opposition between themselves and the original, nor do they refer directly to pictorial invention. This suggests a completely anti-historical reading which does not believe in the disappearance of things, in a linear genealogy, or in homogenous time without interruptions. The copy confronts us with forms of historicity and/or anti-historicity, of the visual and virtual/cyber world.

It is important to realise that the New York project Salon de Fleurus at 41 Spring Street stays open at the same time as projects are realised in other towns, galleries or museum spaces. This will be the case with the Whitney Biennial version, New York, 2002. The curator Lawrence Rinder selected Salon de Fleurus to be part of the Biennial but the collection of paintings and artworks will be installed as in all the previous cases – Ljubljana and Celje in 2001; Budapest at Muscarnok/Kunsthalle, in 2001; and Belgrade

at the Museum of Contemporary Art in 2002. At the same time the same works can be seen in the New York apartment. This will also be the case with Salon de Fleurus at the Biennale of Sydney 2002.

Salon de Fleurus behaves like a virus of modern art! It is not just the copying process itself that is important, but the whole system that is replicated and redistributed in art spaces around the world, where artefacts and art works can be seen simultaneously in real time!

1. FICTION RECONSTRUCTED - THE LAST FUTURIST SHOW is a three part exhibition project consisting of The Last Futurist Exhibition, Armory Show and Salon de Fleurus, conceived and curated by Lubljana-based Marina Grzinic, in collaboration with Salon de Fleurus, New York.
FICTION RECONSTRUCTED was intitially produced by two Slovenian institutions: Gallery Skuc, Ljubljana, and the Gallery of Contemporary Art, Celje (a town 60 km from Ljubljana in Slovenia). The exhibition took place there between January and March, 2001.

Salon de Fleurus/

Marina Grzinic (curator

of the project) born in

Rijeka, ex-Yugoslavia,

1958. Lives and works

in Ljubljana, Slovenia.

SELECTED SOLO PRESENTATIONS

FICTION RECONSTRUCTED – THE LAST FUTURIST SHOW

2001/02 FICTION RECONSTRUCTED – THE LAST FUTURIST SHOW, Museum of Contemporary Art, Belgrade, Serbia

2001 FICTION RECONSTRUCTED – THE LAST FUTURIST SHOW, curator: M. Grzinic, Mucsarnok-Kunsthalle, Budapest, Hungary
FICTION RECONSTRUCTED – THE LAST FUTURIST SHOW, Gallery of Contemporary Art, Celje, Slovenia

2000/01 FICTION RECONSTRUCTED – THE LAST FUTURIST SHOW, Gallery Skuc, Ljubljana, Slovenia

2000 Salon de Fleurus, Apexart exhibition space, New York, USA

1993 Salon de Fleurus, private apartment, permanent view, 41 Spring St. 41, New York;

1986 *The Last Futurist Exhibition*, private apartment, Belgrade, ex- Yugoslavia
Armory show: The International Exhibition of Modern Art, Gallery Skuc, Ljubljana, Slovenia
The Last Futurist Exhibition, Gallery Skuc, Ljubljana, Slovenia
Armory show: The International Exhibition of Modern Art, The Salon of the Museum of Contemporary Art, Belgrade, ex-Yugoslavia

SELECTED GROUP PRESENTATIONS

FICTION RECONSTRUCTED – THE LAST FUTURIST SHOW

2002 FICTION RECONSTRUCTED – THE LAST FUTURIST SHOW: The Last Futurist Exhibition, Armory Show, Salon de Fleurus, Biennale of Sydney
Salon de Fleurus, Whitney Biennial of American Art, Whitney Museum, New York

1997 Salon de Fleurus, part of the collection at Karl Ernst Osthaus –Museum, Hagen, Germany

1987 The Last Futurist Exhibition, Trigon, Graz, Austria

SELECTED BIBLIOGRAPHY

Marina Grzinic, Gallery SKUC Ljubljana 1978–1987, Sinteza, Ljubljana 1988
Marina Grzinic ed. (texts by Steyerl, Schollhammer, Keser/Ilic, Boubnova, Milevska, Scherlock and Grzinic), Gallery Dante Marino Cettina – Future perspectives, Gallery Marino Cettina, Umag, Croatia 2001
Marina Grzinic, *Fiction Reconstructed. New Media, Video, Art, Post Socialism and the Retro - Avant Garde. Essays in Theory, Politics and Aesthetics*, Koda Ljubljana, 1997
Marina Grzinic, *Fiction Reconstructed. Eastern Europe, Post-socialism and The Retro-avant-garde*, Edition selene in collaboration with Springerin, Vienna, 2000
Marina Grzinic, 'Salon de Fleurus' in

ARS VIVENDI, Ljubljana 1993
Marina Grzinic, 'Spectralization of Europe', Net_Condition, eds., Peter Weibel and Timothy Druckrey, Cambridge, Mass: MIT Press and ZKM, Karlsruhe, 2000 and *The Last Futurist Show*, ed. Marina Grzinic, (texts by Druckrey, Steyerl, Schollhammer, Klonaris and Thomadaki, Djordjevic, IRWIN, 0100101110101101.org, Fehr, Manovich and Grzinic), MASKA, Ljubljana 2001
Kim Levin, Review of the Salon de Fleurus, *Village Voice*, 19 January, 1993.
THE REAL, THE DESPERATE, THE ABSOLUTE, Marina Grzinic, ed. (texts by Dimitrijevic, Dyogut, Govedic, Jovanovic Milevska and Grzinic), Gallery of Contemporary Art, Celje, Slovenia 2001

CHECKLIST OF WORKS

FICTION RECONSTRUCTED COLLECTION I. / THE INTERNATIONAL EXHIBITION OF MODERN ART (ARMORY SHOW) 1986/2001
mixed media installation dimensions variable

FICTION RECONSTRUCTED COLLECTION II. / THE LAST FUTURIST EXHIBITION BY KASIMIR MALEVICH 1986/2001
mixed media installation dimensions variable

FICTION RECONSTRUCTED COLLECTION III. / SALON DE FLEURUS 1992/2001
mixed media installation dimensions variable

Works courtesy Gallery Skuc, Ljubljana and Gallery for Contemporary Art, Celje, Slovenia

JIM SHAW

IN THE QUIET SUBURBS AND SMALL FARM COMMUNITIES THAT SURROUND THE BUSTLING MODERN METROPOLIS OF OMAHA, NEBRASKA, LIE THE QUIET REMNANTS OF WHAT WAS ONE OF THE MOST SUCCESSFUL AMERICAN UTOPIAN COMMUNITIES. BEST KNOWN FOR THE HIGH QUALITY OF THEIR DAIRY PRODUCTS AND WOOL, FEW PEOPLE KNOW ABOUT THE UNUSUAL RELIGION PRACTISED BY THE LOCALS. IT IS AN ODYSSEY THAT BEGINS AT LEAST A THOUSAND MILES AWAY IN THE QUIET HAM-LET OF PENN YAN IN UPSTATE NEW YORK. ONE HUNDRED AND FIFTY YEARS AGO THE AREA WAS KNOWN AS THE 'BURNT-OVER' REGION BECAUSE IT HAD SURVIVED SEVERAL SUCCESSIVE WAVES OF COMPULSIVE RELIGIOUS REVIVALS THAT BEGAN IN THE EARLY 1800S. As many as 20,000 attendees – including adherents, curious bystanders, and hecklers – are reported to have congregated in open fields where the newly converted were sent into paroxysms of revelation, giving testimony of their spiritual awakening to the gathered faithful. These sudden and, in their day, massive convergences of people, such as the 1843 meeting at Canandagua, were the likely breeding ground for a young preacher's daughter named Annie O'Wooten, though Annie herself claimed to have gained her spiritual enlightenment while holding a battery-like vessel she dug up near the shores of Keuka Lake. While the Oists are most commonly known for their long red hair or the unusual structure of their families, the gospels revealed to Annie tell the lesser known saga of a great indigenous civilization's rise and fall at the dawn of history. The Oists consequently believe that America is the lost continent of Atlantis, Mu or Thule. These stories have been kept secret from non-initiates ever since Annie and her followers were driven out of Penn Yan by an angry mob of local Christians. The result was a gruelling trek across the American frontier which landed the hapless Oists in the then distant and isolated state of Nebraska. It was Annie's claim that the saviour – better known as 'O' (not exactly a name, Annie explained, but "The unnamable symbol of the divine spirit") – was a virgin who gave birth to herself 5000 years ago inside a well at the precise moment that time reversed direction, and who subsequently led the nomadic, shepherding people to found the first matriarchal, agrarian civilization whose overflowing granaries needed, at the pinnacle of its power, a legion of scribes to write down the quantities of food tithed to the beneficent. The royalty was matriarchal and consisted entirely of amazon sisters. Unfortunately, the records were kept on perishable paper, so the only indication that there actually is a lost meso-American civilization are the revelations of O'Wooten. Today the remaining adherents to the Oist religion downplay these originary stories as quaint myth, like Christians downplay the story of Adam and Eve, but, even as I write, their historians and archeologists are searching out proofs of their cosmology. The Oists auxiliary society, popularly known as the Whirling Dervishes, or Adherents of the 360 Degrees, operate a chain of thrift stores found throughout Nebraska and Iowa, called HTGT (for Here Today, Gone Tomorrow), where most of these paintings were found.

JIM SHAW

ANOTHER STORY OF O

DOUG HARVEY

One of the most important functions of Jim Shaw's artworks is to operate as baroque rationalizations for the making of artworks. His *My Mirage* series 1986–1991, an enormous compilation of popular visual facsimiles outlining the fictional biography of Billy, archetypal American teen of the 1970s, and the self-explanatory *Dream Drawings and Dream Objects* 1992-2001, were projects that allowed Shaw not only to produce a large and various amount of traditionally handcrafted art objects under a complex narrativist conceptual umbrella, but to address his creative attention toward

increasingly inclusive models of the world. Having achieved, in his *Dream* works, un-censored access to whatever his culture-riddled unconscious could throw up at him, and permission to realize these visions into the world of consensus reality, Shaw has recently turned his attention to a more exteriorized, social site of psychic eruption, in the form of the mysterious American vernacular revelatory religion of Oism.

As described by Shaw, Oism is a religious movement dating to mid-nineteenth cen-tury America – a sort of parallel-universe Mormonism where the central deity is an unnamable Goddess symbolized by an 'O'; a virgin who gave birth to herself from a well 7,000 years ago, reversing the flow of time (which we misperceive as continuing to move forward) and occasioning the de-velopment of agriculture and writing. The

embattled Amazon-like matriarchy founded on a now-lost island continent sent forth the remnants of their culture in vessels shaped like the speciously parthenogenetic Paper Nautilus, landing in prehistoric America and vanishing from memory. Until, of course, the prophetess O'Wooten channeled the Book of Oism, spawning the movement that has grown to encompass a powerful fra-ternal organization with secret rites based on the Isis and Osiris mythology, a string of rest homes where departing souls are captured in mason jars, nail salons where the faithfuls' clippings are disposed of in the scripturally prescribed manner, and the omnipresent 'Here Today Gone Tomorrow' thrift stores, from whence the current col-lection was allegedly gleaned.

Oism is similar to Shaw's previous strat-egies of authorial displacement, firstly in

NAIL SALON WITH RITUAL PYRE ACRYLIC ON CANVAS.
OIST DOLLAR CHANGING HANDS ACRYLIC ON CANVAS BOARD.

its function as a matrix of plausible denia-bility to which an infinitely diverse body of works may be attributed: in addition to the intricately self-referential thrift store paint-ings (undermining the ambiguous author-ship of the artist's most famous curatorial project with their forged anonymity), Shaw has staged an elaborate initiation ceremony conducted by the aforementioned fraternal organization – designing uniforms, build-ing musical instruments shaped like body parts, and directing a documentary video. Several other groups of artworks are under-way, including ironic student paintings by fallen members of the faith who have found their way to art school, and the *oeuvre* of Malcolm O, conceptual aperturiste extra-ordinaire, who drilled circular holes in every-thing until his career was cut tragically short (or reached its logical culmination) by an

inspired act of self-trepanation. Plans for other works include posters, tracts ('circu-lars'?), rock operas and a children's TV program, as well as the recovery of the original scriptures and the establishment of an operational storefront Oist church.

Oism also resembles familiar Shavian motifs in the Modernist-mimicking, crippled transcendentalism it depicts. Shaw's interest is directed not so much in the mythological or ritual content in this religion or the aes-thetic relics of its devout founders (though these play a major role in subsequent icon-ography), but in the proliferation of visual and cultural material generated by the movement in its degraded, secularly com-promised, contemporary state, just short of assimilation. Many of the subtle critiques of organized religion implicit in the material legacy of Oism may be applied tellingly to

the dissipated and dismembered sect under whose auspices it is being brought to view. As in much of Shaw's work, this seeming indictment of the failed transcendentalism of Modernism actually indicates a nexus of profligate heterogeneous creative activity, a flaw in the plan for the Great Escape that leaves us stranded here within our vast and variegated sensorium. Neither crossing over into the pure white light, nor fully absorbed into anesthetic materialism, Shaw fixes our attention at the point where the revolutionary deluge has trailed off into innumerable rivulets of idiosyncratic self-expression. Which may not sound like good news to true believers, but at least gives us a reason to continue making art.

THE DONNER PARTY ACRYLIC ON CANVAS. OIST DOLLAR CHANGING HANDS ACRYLIC ON CANVAS BOARD. THE GREAT DISCOVERY ACRYLIC ON CANVAS. FRONT PAGE IMAGE: MAN ENTRAPPED BY NIPPLE ACRYLIC ON CANVAS.

Jim Shaw born in Midland, Michigan, USA, 1952. Lives and works in Los Angeles.

SELECTED SOLO EXHIBITIONS

2000 *Jim Shaw: Thrift Store Paintings*, Institute of Contemporary Arts, London, UK
1998 Frankfurt Kunstverein, Frankfurt, Germany Rupertinum, Salzburg, Germany
 Everything Must Go, Casino Luxembourg, Luxembourg; Musée d'Art Moderne et Contemporain, Geneve; Contemporary Arts Center, Cincinnati, Ohio, USA (catalogue)
1997 Galerie Praz-Delavallade, Paris, France (and 1999, 2002)
1995 *What Exactly is a Dream and What Exactly is a Joke...*, Donna Beam Fine Art Gallery, University of Nevada, Las Vegas, UK
1994 *Dreams That Money Can Buy*, Rena Bransten Gallery, San Francisco, USA
1992 Metro Pictures, New York, USA (and 1993, 1996, 1999, 2001)
 Galleria Massimo de Carlo, Milan (and 1996)
1991 *Jim Shaw: My Mirage*, St. Louis Museum of Art, St Louis, USA
1990 Matrix Gallery, University Art Museum, University of California, Berkeley, USA

SELECTED GROUP EXHIBITIONS

1990 *Video and Dream*, The Museum of Modern Art, New York, USA
 Recent Drawings: Roni Horn, Charles Ray, Jim Shaw, Michael Tetherow, Whitney Museum of American Art, New York, USA
1991 *1991 Biennial Exhibition*, Whitney Museum of American Art, New York, USA (catalogue)
1992 *Helter Skelter: L..A. Art in the 1990s*, Museum of Contemporary Art, Los Angeles, USA (catalogue)
 American Art of the 80s, Museo d'Arte Moderna e Contemporanea di Trento, Italy (catalogue)
1993 *Der Zerbrochene Spiegel (Thrift Store Painting Collection)*, Staatliche Akademie der Bildenden Kuenste, Vienna; Deichtorhallen, Hamburg, Germany (catalogue)
1997 *Sunshine & Noir*, Louisiana Museum of Modern Art, Humlebaek, Denmark; Kunstmuseum Wolfsburg, Germany; Castello di Rivoli, Rivoli, Italy; Armand Hammer Museum of Art and Cultural Center, Los Angeles (catalogue)
1998 *I Rip You, You Rip Me (Honey, We're Going Down in History)*, Museum Boijmans Van Beuningen, Rotterdam
 From Head to Toe: Concepts of the Body in 20th Century Art, Los Angeles County Museum of Art, USA
2000 *la Bienniale de Montreal 2000*, Montreal, Canada

SELECTED BIBLIOGRAPHY

Rosanna Albretini, 'Jim Shaw: Rêveries d'un Artiste Conceptual Artist,' *Art Press*, April 1997, pp 47-51
Neal Brown, 'A Noble Art/Jim Shaw,' *Frieze*, March 2001, pp 104-5
Mason Klein, 'Jim Shaw - Metro Pictures', *Artforum*, Summer, 2001, pp 184
Rachel Kushner, 'A Thousand Words: Jim Shaw Talks About His Dream Project', *Artforum*, Nov. 2000, pp 128-9
Jerry Saltz, 'Lost in Translation: Jim Shaw's Frontispieces', *Arts Magazine*, Summer, 1990
Jerry Saltz, 'Jim Shaw, 'The Sleep of Reason', *Time Out New York*, 17-24, Oct. 1996

Mark Van de Walle, 'Jim Shaw: Metro Pictures,' *Artforum*, March 1997, New York, pp 90-1
Jan Verwoert, 'Jim Shaw: Casino Luxembourg,' *Frieze*, Nov-Dec 1999, pp 99
Dreams, 1995, Smart Art Press, Santa Monica, California
Everything Must Go: Jim Shaw 1974-1999, essays by Doug Harvey, Noelle Roussel, Fabrice Stroun, Amy Gerstler; interview with Mike Kelly, 1999, Casino Luxembourg, Luxembourg
Thrift Store Paintings, 1990, Heavy Industry Publications, California

CHECKLIST OF WORKS

PAINTINGS FOUND IN OIST THRIFT STORES 2000-2001
mixed media, dimensions variable
courtesy the artist and Metro Pictures Gallery, New York

THE FILM *QM I THINK I CALL HER QM* WAS BORN OUT OF THE MEETING OF TWO
RATHER IMPROBABLE CHARACTERS. QM STANDS FOR QUEEN OF MUD AND IS A
ROLE THAT ANN-SOFI SIDÉN PLAYS HERSELF. IT IS A CHARACTER ANN-SOFI SIDÉN
HAS BEEN WORKING WITH IN VIDEOS AND PERFORMANCES SINCE 1989 WHEN IT
MADE ITS FIRST APPEARANCE AT THE BEAUTY COUNTER AT STOCKHOLM'S MOST EXCLUSIVE DEPARTMENT STORE.
The psychiatrist *Dr Ruth Fielding* is a character based on an actual person, Alice E.Fabian, whose personal history bears a
lot of resemblances with the fictional character. In 1994 Ann-Sofi Sidén was invited to do an exhibition in an empty house
in New York that resulted in the show "Who has enlarged this hole?" In the house she found the property left by Ms Fabian
including notes, tapes and psychiatric literature which all pointed to a life evolving around paranoid thoughts about people
in her environment... about being taped and monitored herself and how in turn, she had structured her life by controlling
her environment. SOFIA BERTILSSON

ANN-SOFI SIDÉN

193

ANN-SOFI SIDÉN

JOHN CONOMOS

Ann-Sofi Sidén's mesmerizing *film QM, I think I call her QM* 1997, is a highly engaging, multi-layered work that deftly explores questions of paranoia, power, fact and fiction. As an experimental narrative film *QM, I think I call her QM* draws upon numerous generic conventions and themes from classical cinema (David Croenberg, Alfred Hitchcock, David Lynch, Michael Powell/Emeric Pressburger and Francois Truffaut), as well as (video) installation and performance art (Vito Acconci, Matthew Barney, Paul McCarthy, and Tony Oursler). We encounter a female psychiatrist Dr Ruth Fielding (Kathleen Chalfant) who needs to classify and control a mud covered being (played by the artist) living in her apartment under the bed. This desire clearly suggests disturbed obsessive behaviour.

QM – the mud woman (played by the artist) – refuses to be either identified or dominated by the psychiatrist. Immediately,

we are located in a labyrinthine world of reason, madness, science and pseudo-science. Things are not what they seem to be: it is a world vividly captured not only by the chaotic mise-en-scene of the psychiatrist's apartment with its surveillance video cameras and monitors, but also by the psychiatrist's paranoid delusions that greet any outsider who wishes to enter her apartment. This again is highlighted by the visit of the unsuspecting telephone repairman (played by Dennis Reid). and significantly, by the Doctor's obsessive tape-recording of her own observations and interactions with QM.

This is a world that is best represented by the abject contours (of control and power) that colour the psychiatrist's own bedroom which, in the artist's words, functions as a "test-room", a hybrid mix of personal space and interrogating cell that connotes (in Foucault's sense) institutional spaces like an asylum, an office or a laboratory.

It is important to note that the creation of Dr Ruth Fielding is an elaborate extension of Sidén's earlier creation, the deceased Dr

Alice Fabian, whose personal notes and recordings feature in a project that began in 1994 called *It's by confining one's neighbour that one is convinced of one's sanity*. The psychotic Dr Fielding of this recent film is also based on a real-life paranoid doctor as well.

Sidén's art (irrespective of the medium: film, installation, performance) consists of this complex, playful dialectic between reality and non-reality, biography and fiction. Through film, story-telling and role-playing, Siden is able to dramatically delineate (in a seamless fashion) complex but interlocking ideas of abjection, science, power and paranoia.

The idea of a deranged psychiatrist wishing to dominate her own primordial alter ego (QM) suggests the aesthetic and narrative ideas and motifs of Robert Wiene's 1919 German Expressionist classic *The Cabinet of Doctor Caligari*. Arguably, Sidén's film has numerous points of commonality with Wiene's film: not least, that the spectator encounters a world of deception and madness. The obsessive surreal personal world of a paranoid doctor struggling to dominate

a mud-covered being (QM) – which mirrors the world at large, her curious neighbours for instance – is acutely captured by her own intense video surveillance of her surrounds.

The opening scenes of Dr Fielding in her bed recording her latest observations about her dreams and QM are powerfully rendered by Steve Kazmierski's fluid visual camerastyle and Jonathan Bepler's dramatically coloured film score. And QM's first pointof-view of the doctor's hand dangling over her bed (which she touches) followed by the doctor's legs and then her inverted head over the edge of the bed (in order to observe QM), are powerful scenes that astutely signal the doctor's obsession and the film's overall atmosphere of sanity/insanity. Time and again, the spectator is asked to immerse themselves in the topsyturvy illogical world of the characters' own intense fascinations and values.

Relatedly, an early key scene of the doctor coming down to ground level – to QM's point-of-view – armed with a leash to take QM to another room in the apartment, succinctly captures QM's phenomenological perspective of the mad doctor/patient relationship. Likewise, the ill-fated encounter between the obliging male escort Ted Jones (Emanuel Xeureb), who is seated according to the demands of the doctor's experiment, and QM. According to the doctor, she is 'on heat': QM crawls towards him like a giant mud-covered lizard and proceeds to smell him – an echo (for this viewer) of the chilling lizard bedroom scenes between the protagonist child and the zealous doctor/father in Powell's *Peeping Tom* 1959.

The brief documentary street scenes at the opening of the film that precede the paranoic intensity of the psychiatrist's chaotic domestic space, compounds the anxiety and blurs the border between the private and the public. As the film unfolds we encounter the psychiatrist becoming the object of her obsessive investigations as she retreats from the world. In one symbolic scene we see her blocking out a window with a huge stack of her own books. And in another, equally paranoic in its focus, we see the telephone man doing his repairs in the doctor's backyard but from the doctor's vantage point: spying on him from behind a window.

Throughout *QM, I think I call her QM* the dramatic emphasis is on the psychiatrist's point-of-view despite several key scenes depicting QM's point-of-view. In this critical sense, we can keenly appreciate the doctor's own developing pathology as a disturbed person. QM, on the other hand, remains relatively unknown: suggesting, on one level, the inability of reason/science to reveal certain things about our personal and social universe.

Given this important focus, it is interesting to observe the film's attendant fluidity and the artist's ability to traverse complex socio-cultural themes. *QM, I think I call her QM* explores distinctions between fact and fiction, science and myth. The film is a rich, allusive work that elaborates upon the human condition and the power of fiction, probing links between artist, culture and society.

Ann-Sofi Sidén born
Stockholm, Sweden,
1962. Lives and
works in Stockholm,
New York and
Berlin.

SELECTED SOLO EXHIBITIONS

2002 *Warte Mal!: Prostitution after the Velvet Revolution*,
Hayward Gallery, London, UK
2001 *Fidei Commissum*, Christine König Galerie, Vienna,
Austria
Station 10 and Back Again, Norrköpings
Konstmuseum, Norrköping, Sweden
Ann-Sofi Sidén - The Panning Eye Revisited, Musée
d'art moderne de la ville de Paris, France
2000 *2 DVD Installations: Eija-Liisa Ahtila & Ann-Sofi
Sidén*, Contemporary Arts Museum, Houston, USA
*Who is invading my privacy, not so quietly and not
so friendly?*, The South London Gallery, London, UK
1999 *Warte Mal!*, Wiener Secession, Vienna, Austria
Galerie Barbara Thumm, Berlin, Germany
Who told the Chambermaid? & The Preparation,
Galerie Nordenhake, Stockholm, Sweden
1995 *It is by confining one's neighbor that one is
convinced of one's own sanity*, Galerie Nordenhake,
Stockholm, Sweden

SELECTED GROUP EXHIBITIONS

2001 *Trauma*, Dundee Contemporary Arts; Firstsite,
Colchester; MOMA, Oxford, UK
Berlin Biennale für zeitgenössische Kunst, Kunst
Werke, Berlin, Germany
2000 *Through Melancholia and Charm - Four
Installations*, Galerie Nordenhake, Berlin, Germany
Wanås 2000, Knislinge, Sweden
Kwangju Biennale 2000, Kwangju, South Korea
Organising Freedom, Moderna Museet, Stockholm,
Sweden
1999 *Carnegie International 1999/2000*, Pittsburgh, USA
dAPERTutto, La Biennale di Venezia, Venice, Italy
1998 *XXIV Bienal de São Paulo*, Brazil
Manifesta 2, Luxemburg

SELECTED BIBLIOGRAPHY

Daniel Birnbaum, 'Shrink Rap', *Artforum*,
New York, summer 1999, pp 138-141
Laurence Bossé, Julia Garimorth,
Gertrud Sandqvist, Alain Didier-Weill &
Gregory Volk, *Ann-Sofi Sidén - The
Panning Eye Revisited*, exhibition
catalogue, Musée d'art moderne de la
ville de Paris, 2001
Susan Ferleger Brades, Robert Fleck &
Ann-Sofi Sidén, *Warte Mal ! –
Prostitution after the Velvet Revolution*,
exhibition catalogue, Hayward Gallery,
London, 2002
Robert Fleck, 'Who told the
Chambermaid?', *La Biennale di Venezia
48, d'APERTutto*, exhibition catalogue,
Venice, 1999, pp 182-185
Harald Fricke, 'Market for thoughts:
Interview with Ann-Sofi Sidén', *Kunst-
Bulletin*, Zürich, January/February 2000,
pp 10-17
Madeleine Grynsztein, 'CI:99/00',
Carnegie International, exhibition
catalogue, Pittsburgh, 1999/ 2000,
p105
Maria Lind & Mats Stjernstedt, *XXIV
Bienal de São Paulo*, exhibition
catalogue, Moderna Museet,
Stockholm, 1998
Mats Stjernstedt, 'Ann-Sofi Sidén,
Norrköpings Konstmuseum', *Artforum*,
New York, September 2001, pp 204-205
Gregory Volk, 'On Ann-Sofi Sidén's
'Fideicommissum', *Camera Austria*,
Graz, November 2000, pp 97-99
Erik van der Heeg, *Warte Mal!*,
exhibition catalogue, Wiener Secession,
Vienna, 2000

CHECKLIST OF WORKS

QM, I THINK I CALL HER QM, 1997
Co-directed by Tony Gerber
DVD of 35 mm colour film with sound
28 minutes, edition of ten.
With Kathleen Chalfant, Ann-Sofi
Sidén, Emanuel Xuereb, Dennis Reid,
Paul Giangrossi and Ulf Lovén
Cinematographer: Stephen Kazmierski

courtesy the artist and Galerie
Nordenhake, Berlin

MY WORKS ARE TIMED EXPOSURES AND ARE NOT SUPERIMPOSED AS MANY THINK. THIS IS DELIBERATE ACT AS MY WORK ADDRESSES THE NOTION OF TIME IN RELATION TO INTER-TEMPORALITY, IN THIS WAY IT IS MEANT TO BE ALLEGORICAL. My work is simply about the perceptions and misperceptions of others, in particular those who are marginalised. It addresses the notion of the stereotype and asks the viewer to question those stereotypes, which I believe we all have. I think we all make perceptions of others, and this is formulated from our own social conditioning. The irony of this is that this statement is a perception or misperception in itself. DARREN SIWES

DARREN SIWES

LEST WE FORGET:

THE PHOTOGRAPHIC ART OF DARREN SIWES

CHRISTINE NICHOLLS

Artist Darren Siwes began taking photography seriously in his second year of art school at Adelaide's University of South Australia. Siwes, who is of Indigenous (Ngalkban, from near the Katherine region in Arnhem Land, Northern Territory) and Dutch descent is now in his thirties, and working as a lecturer in photography at Tauondi College. Tauondi is an all-Indigenous independent post-secondary education and training provider situated in Adelaide's northern suburbs. In recent years Darren Siwes has emerged as one of Australia's leading young contemporary photographers, and his work is becoming widely known and exhibited throughout Australia and, increasingly, in Europe.

Siwes' distinctive images of Adelaide's urban milieux, landmarks and cultural land- scapes, into which he interpolates his own image as a kind of uncanny, ghostly *memento mori*, and simultaneously, as an epiphanic, contemporary Indigenous presence, have become emblematic of his photographic art. What renders these photographs 'distinctly Siwes' is his refusal of the stereotype, along with his insistence on the continuity of the past with the present. Siwes' *Indigenous figure in the landscape* most emphatically *does not* stand on one leg, naked save a loincloth, clutching a fistful of boomerangs and spears whilst gazing towards the wide brown land of the Adelaide Plains. Instead, Siwes' Indigenous Man announces himself as an elegant, contemporary, postcolonial presence. Usually wearing a suit and tie, but sometimes garbed 'a la mode' in a greatcoat, The Man looks for all the world like he would be equally at home in the privileged world of Vogue fashion shoots, attending long business lunches or at church on Sunday. In fact, the persona being projected is somewhere between the younger versions of Jeff Kennett[1] and Jimmy Little[2] – conservative, quietly composed and in control, calmly engaging the eye of the viewer. An unequivocally contemporaneous presence, this man belongs in the world that he has created with his camera.

The fact that the spectral figure (Siwes) wears a well-tailored suit is significant in terms of the meaning and deconstructive purpose of his photography, because even a generation ago suits were affordable by relatively few Australian Aboriginal people. There exists a plethora of early colonial photographs showing Aboriginal men wearing the cast-off, ill-fitting hand-me-down suits of well-heeled middle-class whites, and Siwes' photographs intrinsically challenge that historical and optical legacy.

Siwes' figure in the landscape has dignity and authority, and his vestimentary code confirms and enhances his claim on the social space. Siwes' photographs have the capacity *par excellence* to disrupt powerful and entrenched stereotypical thinking about Indigenous Australians and their contemporary identities.

Siwes arranges each of his photographs with a high level of intentionality. Every shot is lovingly and painstakingly composed. Darren Siwes always carefully selects his sites. Nothing is left to chance in terms of where Siwes places his camera in relation to the buildings and monuments that he photographs.

Siwes deliberately and strategically juxtaposes 'his' Indigenous figure in relation to what could be regarded as the most representative 'sacred sites' 'belonging' to the white man in the Adelaide area – for instance, Adelaide's famous North Terrace. The buildings and monuments lining North Terrace are expressions, or 'symbols', of South Australian colonial identity and they also speak to the continuing hegemony of the Adelaide establishment. It is this dubious visual and material cultural record of (South) Australian colonial history that Siwes seeks to critique by means of his photography. In all of Siwes' photographs, no matter what the location, there is evidence of a pre- and still- existing Indigenous presence. That presence is a confident one, and certainly not that of an apologetic shade.

CHURCH 1 2000 CIBACHROME PRINT ONE NIGHT AT MT LOFTY 2001 CIBACHROME PRINT

Siwes refuses to let us forget that Adelaide is the home of the Kaurna people. Whether he is photographing the Old Gum Tree at Glenelg, site of the proclamation of South Australia in 1836, or Rundle Mall's famous 'Beehive Corner', a popular meeting place for members of the Adelaide bourgeoisie, or the city's solid Victorian buildings, the stately private homes of its respectable burgers, Darren Siwes honours that enduring Indigenous occupancy, which he does not regard as something consigned to the past. His photographic art constitutes an implicit challenge to what has been described as 'the white blindfold view of history', and to the doctrine of *terra nullius*. By compressing time and space through the camera's eye, Siwes interrogates all of the colonizers' major institutions: the Christian Church, a predominantly white spiritual meeting place in what has been described as 'the City of Churches'; and even that holy of holies, the War Memorial, where the heroic deeds of the (mostly) non-Indigenous dead, the fallen, are enshrined and commemorated.

As Catherine Speck has written with regard to Siwes' work *Stand (monument)*:

...the Australian landscape is dotted with war memorials to men who fought in the First World War: monuments that became the public art of the era. Darren Siwes's photographic image of himself inserted into such a landscape in *Stand (monument)* points to the tenuous place indigenous soldiers have in the public memory,
which honours Australians who went to war.[3]

While the buildings, sites and precincts that Siwes' focuses on in his photography are representative of the colonial project, his works are not documentary in style. Neither are they photorealist or neo-realist. By incorporating his own figure into the landscape Darren Siwes' photographs attain a cinematic, dream-like, even surreal quality. In some respects they bring to mind some of the work of late nineteenth/early twentieth century French photographer Eugene Atget, who photographed Parisian streets and buildings, leaving an ever-so-faint, liminal trace of his own figural presence in some of his works. Siwes' photography also evokes certain works by Tracey Moffatt (notably her *Pet Thang* series and some of her films, particularly the trilogy *BeDevil*, in which she brilliantly evokes the ghosts of the past). Moffatt also happens to be an artist greatly admired by Siwes. However, Siwes cites his most important influences as being Jeffrey Smart and Piero della Francesca:

...These two artists in particular have influenced me most as they both paint urban landscapes, buildings signs and so forth, with people placed in them. I also like Jeffrey Smart's work on the conceptual level...

For Siwes, making photographs is a very labour intensive process, which he describes in the following terms:

...My photographs are timed exposures, which
are taken generally at night. These exposures vary in time somewhere between 30 seconds to 5 minutes, depending on the source of light. Although an image is a result of one shot, it usually takes a few nights to get the right image, as the first shot is often not quite right.[4]

In his work, Darren Siwes manages to be intensely personal yet also to speak on a broader artistic level. For Siwes, the personal is political. Moreover, whilst his locations are instantly recognizable to people living in Adelaide, it is quite possible to appreciate Darren Siwes' remarkable photographic images with little or no understanding of Adelaide's cultural geography. Siwes' photographic subject – The Man in the Landscape – acts simultaneously as a kind of Indigenous Everyman, a narrator who challenges his viewers to come to terms with the legacy of Australian history, encouraging us to understand it not as a series of past events, but as a palimpsest. Lest We Forget.

1. Former long-term premier of Victoria, known for his well-cut suits and immaculate grooming.
2. Famous Aboriginal singer, who often dressed formally in suits.
3. Catherine Speck Review of 'Chemistry: Art in South Australia 1990-2000', Art Gallery of South Australia, 16 Sept- 5 Nov 2000, in *Art Monthly Online*:
online@artmonthly.org.au, www.artmonthly.org.au
4. Personal communication, Darren Siwes to Christine Nichols, 5 January 2001.

Darren Siwes born
Adelaide, Australia,
1968. Lives and works
in Adelaide.

SELECTED SOLO EXHIBITIONS

2001 *Mis/Perceptions,* Greenway Art Gallery, Adelaide,
 Australia
 Mis/Perceptions, Nellie Caston Gallery, Melbourne,
 Australia

SELECTED GROUP EXHIBITIONS

2001 *ARCO International Art Fair,* Madrid, Spain
2000 *Across,* Canberra School of Art Gallery, Canberra,
 Australia
 *State of My Country: a survey of Contemporary
 Aboriginal Art,* Hogarth Gallery, Sydney, Australia
 Chemistry, Art Gallery of South Australia, Adelaide
 *Beyond the Pale: Adelaide Biennial of Contemporary
 Art,* Art Gallery of South Australia, Adelaide,
 Australia
1999 *Living Here & Now: Art & Politics/ Perspecta,* Art
 Gallery of New South Wales, Sydney, Australia
1998 *15th National Aboriginal & Torres Straight Islander
 Art Awards,* touring exhibition, Museum and Art
 Gallery of the Northern Territory, Darwin, Australia
 Three Views of Kaurna Territory Now, Artspace,
 Adelaide Festival Centre, Adelaide, Australia
1996 *Guddhabungan,* Jabal Centre, Australian National
 University, Canberra, Australia

SELECTED BIBLIOGRAPHY

Hannah Fink, 'Darren Siwes', *Beyond
the Pale: Contemporary Indigenous Art:
2000 Adelaide Biennial of Australian
Art,* Brenda Croft (ed), Art Gallery of
South Australia, Adelaide, 2000
Anita Heiss, 'Profile: Darren Siwes',
ARTforce, No.109, 2001
John Kean (ed), *Three Views of Kaurna
Territory Now – Agnes Love, Nicole
Cumpston and Darren Siwes,* exhibition
catalogue. Adelaide Festival Centre,
1998

Jim Moss, 'A Ghost in the Machine:
Darren Siwes', *Broadsheet,* Vol. 30, No.
3, September-November, 2001
Christine Nicolls, *Darren Siwes:
Mis/Perceptions,* exhibition catalogue.
Greenaway Art Gallery, Adelaide, 2001
Russell Smith, *Samstag: The 2002 Anne
& Gordon Samstag International Visual
Arts Scholarships,* Samstag Program,
University of South Australia, Adelaide,
2001

CHECKLIST OF WORKS

from the series
MIS/PERCEPTIONS 2001:

NO ENTRY

HIGH STATUS

GIVE WAY

TRAINED MAN

BEACON

STAND

ONE NIGHT AT MOUNT LOFTY

I AM EXPECTING

VISIONS

CHURCH 1

ON THIS SPOT

cibachrome phototgraphs
(editions of six plus two A/Ps)
each 100 x 120 cm

works courtesy the artist and Greenaway
Art Gallery, adelaide

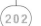
YUTAKA SONE

CYCLES AND LOOPS

GREGORY MONTREUILL

The work of Yutaka Sone defies easy categorization. Born in Japan in 1965 and now living in Los Angeles, he studied architecture in Japan. Using varied forms; including sculpture, video, and performance, he has the distanced view of a man without borders. Touching on ideas of adventure, amusement, growth cycles, absurdity and chance, Sone treads significant ground in our increasingly globalized planet. People, trains, planes, satellites, boats, automobiles, buildings, and nature are being tossed together in an ever more fluid and mobile mix. Using these elements of contemporary life, Sone creates situations that are oblique and active. Part playground, part puzzle, events develop that explore the complex and often incomplete relationships between

nature and civilization. The surprising results often raise more questions than answers, forcing the viewer to actively interpret. Using indirect tactics, Sone reveals aspects of impossibility and paradox which could be missed by the casual observer.

In *Hong Kong Island*, a glistening white block of marble rises knee high off the floor, frozen in time yet futuristic. Monumental in feel though not in scale, the flat upper surface is a scale model of the island of Hong Kong complete with minute skyscrapers and topographic details. A Chinese craftsman has been employed to carve the stone into a glittering heavenly paradise, the antipodes of the contemporary metropolis. The urban growth contained within the island stirs wonder.

The scale model, tabletop sized sculpture of a roller coaster, titled *Amusement*, has an obtuse presence. Playful, yet classical, it is a hybrid. The icy roller coaster has tiny cars carved in place at their upper most

position on the ramp. From here the decent begins into stomach churning ecstasy. A roller coaster forces changing perspectives. Heightened sensation and cyclical movement merge. The title of the work calls the idea of amusement into question. How does amusement differ from entertainment? The difference involves the mind and its perceptions, its facility to make sense of things. Amusement comes into play through the sense of appreciation found even when the logic of the associations is impossible or absurd. Entertainment implies something more passive and less engaging.

Both marble sculptures involve things that are in a state of motion, but transposed into the static and immobile medium of stone. Hong Kong is considered one of the fastest cities in the world, ceaseless. The roller coaster is also in motion but never goes anywhere only looping around in futile cyclical movement. Sone has also made a walking sized version of a roller coaster where perceptions literally change

for the participants as they walk up, down, and around the determined path.

In the performance piece *Throw of the Dice* real time becomes a building block. Dice, associated with gambling and games of chance are employed. These dice, made of foam rubber, have become soft but monumental in dimension. Participants become part of the performance and play the determining role in the outcome of the piece itself. "A central motif in this cryptic work is the contingency that exists at the moment of hesitation before an important decision".[1] Dice represent things on the verge of change. Chance can also produce a more cerebral form of heightened sensation and exhilaration much like a roller coaster.

The audience set the super-sized dice in motion in Hannover Germany, at the Expo 2000 performance. This participation was initiated but not determined by the artist. The use of chance has had a large place in the recent history of art. It is often used to

give up control and encourage variety. Chance can be used as a way to function in real time. This performance piece also engaged broader issues of adventure, luck and risk.

Notions of determined result are questioned and negated. Indeterminacy is seldom employed in collective action. The involvement of a group in the process of chance is subversive. Who is responsible for the result? Does the result bind all involved? The use of randomness undermines ideas of self-determination. Patterns are explored for possible future applications that more closely mimic the state of the world situation today. More collective forms of action shake the fundamental notions of reality and call them into question.

Sone's work affects the foundations of our reality, through its exploration of paradoxes and contradictions. With the use of shifting scale and contrast, ideas and relationships are playfully questioned, but never spelled out. The absurd remains

a valid option. Growth and movement, recurring themes in the works, are intrinsically linked. Time becomes an element to manipulate; it can be suspended for detailed observation or incorporated as a real element through the involvement and participation of the audience. With cross-cultural references, urban jungles are compared with natural jungles, active patterns are detected. Form and content circle each other as cycles and loops trying to find their proper places, but remain ever shifting. Yutaka Sone is a time traveler who raises important questions through his exploration of multi-level ideas.

1. Wilfred Dickhoff and Kaspar Konig (eds), *In Between. The Art Project of Expo 2000*, Hannover, Germany, EXPO 2000.

Yutaka Sone born
Shizuoka, Japan, 1965.
Lives and works in
Tokyo, Japan.

SELECTED SOLO EXHIBITIONS

1999 David Zwirner, New York, USA
 Alpine Attack, Sogetsu Art Museum, Tokyo, Japan
1997 At *the End of All the Journeys,* Hiroshima City
 Contemporary Art Museum, Hiroshima, Japan
1994 *Space Luxury Art,* Hosomi Gallery, Tokyo, Japan
1993 *Her 19th foot,* Contemporary Art Center, Art Tower
 Mito, Mito, Japan

SELECTED GROUP EXHIBITIONS

2001 *Public Offerings,* The Museum of Contemporary Art,
 Los Angeles, USA
2000 *In Between. The Art Project of Expo 2000,* Expo
 2000, Hannover, Germany
1999 *Unfinished History,* Museum of Contemporary Art,
 Chicago; Walker Art Center, Minneapolis, USA
1997 *Skulpturen Projekte,* Munster, Germany
1995 *Ripple Across The Water,* The Watari Museum of
 Contemporary Art, Watari-um, Tokyo, Japan

SELECTED BIBLIOGRAPHY

Klaus Bußmann, Kasper König, Florian
Matzner (eds), *Sculpture. Projects in
Münster 1997*, exhibition catalogue,
Verlag Gerd Hatje, Münster, Germany
1997
'Muenster Sculpture Projekt, Yutaka
Sone', *Kunstforum*, 1997, p 344-345
Holland Cotter, 'Yutaka Sone', *The New
York Times.* 27 September 1999, p E36
Wilfried Dickhoff and Kasper König
(eds), *In Between. The Art Project of
Expo 2000,* exhibition catalogue, EXPO
2000, Hannover, Germany
Yuko Hasegawa, *Fancy Dance -
Contemporary Japanese Art After 1990*,
exhibition catalogue, Artsonje Museum
and Artsonje Center, 1999.
Kathleen McLean & Pamela Johnson
(eds), *Unfinished History,* exhibition
catalogue, Walker Art Center,
Minneapolis, Minnesota, USA, 1998
Gregory Monteuil, 'Yutaka Sone', *New
Art Examiner,* Dec/Jan 1999-2000, p 54
Min Nishihara, 'Tokyo by Night', *Siksi.*
Summer 1998, pp 48-51
Min Nishihara, *Building Romance*,
exhibition catalogue, Mitaka City Arts
Foundation, Tokyo. Japan, 1996.
Hiromi Ohashi (ed), *Alpine Attack,*
exhibition catalogue, Sogetsu Art
Museum, Tokyo, Japan, 1999
Howard Singerman (ed), *Public
Offerings*, exhibition catalogue, Los
Angeles, CA. Museum of Contemporary
Art, 2001
Linda Yablonsky, 'Yutaka Sone', *Time
Out NY,* 23 September 1999), p. 63

CHECKLIST OF WORKS

TWO FLOOR JUNGLE (EDITION 3/3)
1999
carved marble, 30 x 35 x 40 cm
collection: Fondazione Sandretto re
Rebaudengo, Italy

AMUSEMENT (EDITION 1/3 - 3/3) 1998
marble, 47.9 x 60.0 x 190.0 cm
collection: Dean Valentine and Amy
Adelson, Los Angeles

HONG KONG ISLAND (CHINESE)
(EDITION 1/3 - 3/3) 1998
marble, 65 x 120 x 80 cm
collection: The Museum of
Contemporary Art, Los Angeles, gift of
Audrey M Lucas

DICE PROJECT - HANNOVER AND ART
PACE, TEXAS 2000
video

THROWING THE DICE (PERFORMANCE)
2002
performance- Sydney Opera House

Works courtesy the artist and David
Zwirner Gallery, New York

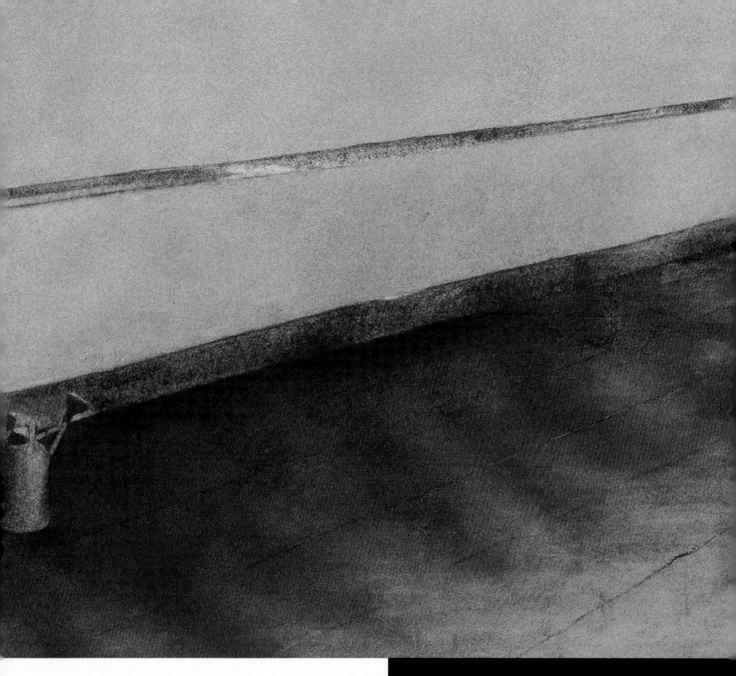

at Manchester College of Art and a few other places. I also
continued my own work as an artist.

By the time I did manage to break away to New York
again, the atmosphere had changed drastically since my
first trip. It was 1969: an attempt had been made on War-
hol's life; Bobby Kennedy had been assassinated; the Viet-
nam War was raging. Shortly after my arrival, the School of
Visual Arts gave me a teaching job, and then I found myself
taking part in things like the Artists' Strike and the Art
Workers' Coalition. Looking back, I can say that I did get
carried away with it all; yet it was a dream we all believed
in, almost religiously, and some positive effects may in fact
have come out of our protests. But in retrospect, they were
lonely, frustrating years of conflict for everyone.

The premature death in 1973 of the great American
sculptor Robert Smithson was a turning point in my life. I
had grown very close to him, and he had invited me to
Amarillo, Texas, where he was doing a project. It was there
that his fatal airplane accident occurred. Smithson was a
very clear-minded artist, a lucid writer full of awareness,
and a great person to be around. And in a way, his death did
not seem tragic because the work he left was so awesome
and extraordinary. But I knew that my way of thinking
about the art world had been changed for good. Coming
back into Manhattan from the airport that week, the first
thing I saw was a large graffito on an Upper West Side wall:
"FIGHT BACK."

Zadik Zadikian

Aram

1 9 8 2

One artist whom I met in that period is part of my gal-
lery today. The sculptor Richard Serra introduced me to
Zadik Zadikian in 1973, and I was impressed by Zadik's fan-
tastic visionary power and by his feeling for life. Richard
and I both got excited just watching him work. For one
thing, he decided to transform the whole interior of his
house and studio into a magical space by gilding every inch
of it. The result was electrifying. It was a good example of
the abhorrence of "angst" and any expression of life in pain
that has always characterized Zadik's view of art. This kind
of single-minded dedication to everything that's glorious and
heroic in art was very moving for me.

I began to find my own work as an artist more and more
frustrating; for the most part the art world appeared to be at
a standstill. Then in 1976, word came to me that a major
museum of contemporary art was being created in Teheran.
I had always dreamed of such a cultural exchange, an

opportunity to bring artists from America to the land where I was born. The idea inspired me. I was awakened by the thought of what I could contribute to the project. Such a museum could be the perfect bridge to the West; I plunged in wholeheartedly.

As the museum project got underway, the word "work" took on a new meaning for me: it came to signify the ability to touch important works of art, a new kind of contact with living artists. The responsibility of choosing these works was exhilarating in itself. It was the first time that I had worked with dealers. I now went back to artists who had been my friends to choose examples that would epitomize the art of our time, what had gone on in the immediate past. It was a question of recognizing the major artists of the past twenty years. One lesson I learned then has served me well today: choosing works should not be a matter of likes and dislikes, but rather a natural reflex, a shutting off of the esthetic principles that we all carry around with us. It's very hard to keep an open mind, but only in taking that larger view can we transcend our own expectations and really surprise ourselves.

In a very short time we acquired excellent works by Rauschenberg, Johns, Warhol, Lichtenstein, Oldenburg, Stella; later on, Robert Morris, Sol LeWitt, Keith Sonnier, and others. One of the best museum collections anywhere in the world was coming together under the auspices of the empress and her museum director, Kamran Diba. Then, in 1979, impulsively and without foreseeing the consequences, I went ahead and opened a gallery in Teheran. No one had any idea of how suddenly and disastrously the political climate of Iran would change. Within a few weeks the country was in chaos, and that was the end of another chapter, another dream. Fighting my disappointment, I came back to New York and put together a semiprivate gallery on Lexington Avenue, a portfolio in a sense, a place to experiment.

Those last days of the seventies saw many changes in the art world. New artists fresh off the street were beginning to offer the public a new kind of metropolitan view. The routines of the old guard were beginning to falter; a whole new world of possibilities in art making suddenly opened up to anyone who had the drive to take advantage of it.

One day a young man named Keith Haring came to help me install exhibitions, and he worked like a wizard, quickly and efficiently. I knew he was a student of Keith Sonnier at

"HOW CAN YOU GO TO A POLICE STATE LIKE IRAN?" SOME ENGLISH JOURNALIST IS SAID TO HAVE ASKED A MEMBER OF WARHOL'S ENTOURAGE, WHO HAD STOPPED OFF IN LONDON ON THE WAY TO TEHRAN. "BY JET", WAS THE SUCCINCT REPLY. FRONT PAGE IMAGE: REVOLUTIONARY DEGAS 2002, WORKING DRAWING FOR BIENNALE EXHIBITION PROJECT

Michael Stevenson

born Inglewood, New Zealand, 1964. Lives and works in Berlin, Germany.

SELECTED SOLO EXHIBITIONS

2002 *An evening with Jörg Immendorff*, former Regent Hotel, Auckland, New Zealand
Immendorff in Wellington, Hamish McKay Gallery, Wellington, New Zealand

2000 *Call Me Immendorff*, Galerie Kapinos, Berlin, Germany
Daily Practice (with Danius Kesminas), Australian Centre for Contemporary Art, Melbourne, Australia; Art Space Auckland, New Zealand
Slave Pianos Internationale Biennale 2000 – Songs of Life, RMIT Gallery, Court House Hotel & Australian Centre for Contemporary Art, (with Slave Pianos) Melbourne, Australia
Genealogy (with Steven Brower), Govett-Brewster Art Gallery, New Zealand
Separated at Birth, Lombard-Freid Fine Arts, New York
Slave Pianos (with Slave Pianos), China Art Objects Gallery, Los Angeles, USA

1999 *The Music of the City* (with Slave Pianos), Darren Knight Gallery, Sydney, Australia
Slave Pianos! Emancipate the dissonance! (with Slave Pianos), Lombard-Freid Fine Arts, New York, USA

1998 *The Gift of Critical Insight*, Lombard-Freid Fine Arts, New York, USA

1997 *Pre Millennial* (with Ronnie van Hout), Contemporary Art Centre of South Australia, Adelaide; Australian Centre for Contemporary Art, Melbourne; Darren Knight Gallery, Sydney, Australia

SELECTED GROUP EXHIBITIONS

2002 *Prophets of Boom*, Kunsthalle Baden Baden, Germany
Profiler, Künstlerhaus Bethanien, Berlin, Germany

2001 *Canceled Art Fair*, China Art Objects Galleries
Audit, Casino Luxembourg forum d'art contemporain, Luxembourg

2001 *Retake/Wiederaufnahme* (with Slave Pianos), Neuer Aachener Kunstverein, Aachen, Germany
Superman in Bed, Kunst der Gegenwart und Fotografie Sammlung, Shurmann, Museum am Ostwall, Dortmund, Germany
The Broccoli Maestro. A Chamber Opera in Two Acts for Six Voices and Six Players, Libretto by Slave Pianos in collaboration with Chamber Made Orchestra, Melbourne, Australia

2000 *Non-Objective Brass*, Slave Pianos with The Burley Griffin Brass Band, National Gallery of Australia, Canberra, Australia
Slave Pianos, 4th Sergey Kuryokhin Festival, Lenningrad Palace of Youth, St Petersburg, Russia
Rent, Overgaden, Copenhagen, Denmark

1999 *What Your Children Should Know About Conceptualism*, Neuer Aachener Kunstverein and Brandenburgischer Kunstverein, Potsdam, Germany
Toi, Toi, Toi, Museum Fridericianum, Kassel, Auckland Art Gallery, New Zealand

1998 *Ground Control*, Lombard-Freid Fine Arts, New York
Entropy at Home, Neue Galerie, Ludwig Museum, Aachen, Germany

1999 *Seppelt Contemporary Art Award 1997*, Museum of Contemporary Art, Sydney

SELECTED BIBLIOGRAPHY

Rex Butler, 'Mike Stevenson: Accidental Artist', *Australian Art Collector*, July 1997
David Craig, 'Taranaki Gothic: Stalking the Grotesque in Provincial Art', *The Seppelt Contemporary Art Award 1997*, Museum of Contemporary Art, Sydney, 1997
David Greason, 'Mike Stevenson', *1996 Adelaide Biennial of Australian Art*, exhibition catalogue, Art Gallery of South Australia, 1996
Giovanni Intra, 'Hangover', *Art + Text*, No. 54, May, 1996
Giovanni Intra, 'For Paranoid Critics', *Pre Millennial*, exhibition catalogue, Contemporary Art Centre of South Australia, Adelaide
Robert Leonard, 'Mike Stevenson, Steven Browner', *Artext*, No. 71, November 2000
Chris McAuliffe, 'The Illuminarti', *World Art*, No. 2, 1996, pp 22-27
Justin Paton, 'Frequent Flyers. Toi Toi Toi in Auckland', *Art New Zealand*, No. 92, Spring 1999
Andrew Sayers, 'Two Drawings by Mike Stevenson', *artonview*, National Gallery of Australia, No. 5, Autumn, 1996
Marina Sorbello, 'Michael Stevenson', *tema celeste*, March 2001

CHECKLIST OF WORKS

CAN DIALECTICS BREAK BRICKS? 2002
mixed media installation
dimensions variable
courtesy the artist and Darren Knight Gallery, Sydney

ACKNOWLEDGEMENTS

Jennifer Tobias
Zadik Zadikian
Mark Thompson
Cornelia Schmidt-Bleek
Darren Knight
Wilhelm Schürmann
Center for Land Use and Interpretation
Maggie Topliss

MY RECENT WORKS INVESTIGATE THE NOTION OF SPACE AND, IN PARTICULAR, THE SPECIFICITY AND THE MOVABILITY OF SPACE. MY OWN PERSONAL EXPERIENCE OF A TRANSCULTURAL DIS-PLACEMENT IS WHAT MOTIVATES, IN A FUNDAMENTAL WAY, MY INQUIRY INTO THE NOTION OF SPACE. I EXPLORE THE STRUCTURE OF THE PERSONAL SPACE AND THE POSSIBILITY AND THE IMPOSSIBILITY OF SUCH INDIVIDUALIZED SPACE: HOW MUCH SPACE DO I AND CAN I CARRY WITH MYSELF? WHAT IS THE SIZE OF MY PERSONAL SPACE? HOW MUCH SPACE DOES ONE NEED? WHAT IS THE SPACE THAT DEFINES A PERSON, OR A GROUP OF PERSONS? I am interested in the space that surrounds me and moves with me both physically (clothing, house) and mentally (space of memory). My desire to guard and carry around my very own intimate space makes me perceive space as infinitely movable. I experience space through, and as, the movement of displacement. Space, for me, becomes intrinsically transportable and translatable. What concerns me most fundamentally in my exploration of the various dimensions of the personal space is the relation between individuality, collectivity, and anonymity. The permeability of the boundaries between the one and the other and between the one and the many is what I seek to articulate through my works.

DO-HO SUH

DO-HO SUH

JENNY LIU

Do-Ho Suh's work is an encounter with the barely-there: both a materialization of hope, and a memory of places in the past. Home should be a refuge, ease and shelter from the betrayals of the outside world, but the home Suh has fashioned is mostly one of the mind, composed of sheer sheets of silk which unfurl in whispers and gathers. Suh's home is a ghost, a remembrance, an exact scale replica of the walls and ceilings of his New York apartment and outer hallway, hand-sewn in translucent pink and blue fabric, and complete with shadowy window details, spectral radiators, and insubstantial plumbing fixtures. Seemingly made up of round, smooth, exceptionally still nuclei, and mostly innocent of the error of matter, Suh's home rests lightly on the ground, suspended by wires. Even as one walks down the pink corridor, and anticipates entering the silvery blue apartment already visible through transparent veils, all the while awareness has been doubled between these and the larger enclosing gallery space. Stirred by the air currents and the passage of people, the walls' transparency knits the home into its surroundings, yet nonetheless remains definitively separate. Discretely remote from confusion, dysfunction, traffic and tumult, the walls' surfaces are only lightly grazed by the clamor of crowds, and by speech more generally: all in all, Suh's is a curious tension between there and not-there, existing and disappearing, serenity and disquiet.

Suh's apparition aims at nothing less than memory made material, its filmy silk surrounding you in the marvellous, and enwombing you in the uncanny. It ties and unties and ties again, tightens and loosens, and recovers loss at repeated intervals, but without recuperating it. It is an imagined home, but one that now exists, in these times of endless migration and travel, in the psyche alone. Planes and computers deliver you to the contingent and unfamiliar, to the permeability of borders, of skins, and of lives: a world that rustles like silk walls, expanding and contracting, as slowly and inexorably as the movement of bodies and the migration of cultures across real and virtual distances. In this world, the idea of home resides solely in memory and metaphor.

Suh's work is entitled *348 West 22nd St., Apt. A, New York, NY 10011 at Rodin Gallery, Seoul/ Tokyo Opera City Art Gallery/ Serpentine Gallery, London/ Biennale of Sydney*, and the title is itself a history of movement, reflecting not only the original inspiration for, but also the subsequent installations of the piece. Longing, separation, and nostalgia can only be retrieved, although not necessarily assuaged, as by reinstalling the work in venues across the globe. Both space and a commensurate sense of place have become transportable. Born in Korea in 1962, Suh moved to the United States when he was 29, and has since done more than his fair share of shuffling among low-rent apartments, rehearsing in his own life the same separations and dislocations that characterize a world of refugees and immigrants, mass migrations and other diasporic movements, more generally.

Because it is so ephemeral, Suh's *West 22nd St.* escapes the imperfect, stuttering translation of selective memories, and

thereby circumvents the infidelities of any work that, in its arrogance, perhaps, would purport faithfully to propound any fixed or given truth. Suh's piece is a place of temporary escape, and shelter, from the endless transitions, displacements and dislocations not only of global movements but also of the individual family. What is sought – the home that never was, but exists only in nostalgia – Suh exactly renders in kind. Only barely, tenuously visible, merely the slightest effort of memory will bring it forth. Unlike the recent trend in art that pointedly underlines the lessons of home as ones of dysfunction and pain – this art which searches out what is always inappropriate and unfailingly disappointing – Suh's is the ideal home: the one that should be, that we deserve. Stripped of specificity, its barely material presence manifests the subtle pleasures of the liminal and, in the best sense of the word, even of the generic.

Contrast the anonymous Western space of *West 22nd St.* to a similar work, *Seoul Home/L.A. Home/New York Home/Baltimore Home*. With its Korean-specific green coloring, and Asian-influenced windows and dimensions, *Seoul Home* is indelibly marked as a culturally specific space and place. By contrast, *West 22nd St.* is unidentifiable, and could be anywhere small, cramped and urban, in New York, Mexico City, or Berlin, perhaps. Here, Suh reproduces not the furnishings and idiosyncratic detritus of any particular life, but rather the unenhanced walls and the fixtures that come with any ready-to-move-in apartment. Lack-ing any personalized markers, the imagined inhabitants – the lives that would fill this home – could be anyone. In this sense, *West 22nd St.* becomes a kind of Rorschach against which we measure, and into which we read the specificity of our own past and present.

This anonymity, and its consequent erasure of specifics, ties *West 22nd St.* to Suh's other body of work, wherein individuality is similarly leveled and reduced through his practice of abstraction, generalization and multiplication. Thus, in *Floor*, hundreds of thousands of tiny plastic figures are amassed caryatid-like to hold up the giant glass floor upon which we walk. Similarly, *Who Am We?* reconstitutes thousands of minuscule portrait photographs from Suh's high school, as wallpaper, while *Some/One* is an imposing over-sized robe made up of multitudes of shiny dog tags. In each work, the individual has been subsumed in the service to a larger project: the collective good which demands anonymity, and so abandons specificity. Like these figurative works, and the primacy they too afford multiplicity, *West 22nd St.* not only requires an effort of self-effacement most commonly associated with Asian cultures, but also, like the rest of Suh's work, it eschews mummificatory presentations of authenticity in favor of a wider, more generous staging of the global.

In a life of leave-taking and impermanence, Suh's rehabilitation of loss dismisses the grossly material for what is infinitely transportable, evocable, and fragile, yet once made resident in the mind, these accrue as indestructible. Suspended in memory, the home drifts, and its walls move in perfect stillness, yet connote a sense of isolation and confirmation: a recognition of something which both has been lost, yet can almost be found.

Do-Ho Suh born
Seoul, Korea, 1962.
Lives and works in
New York City, USA

SELECTED SOLO EXHIBITIONS

2002 *The Perfect Home,* Kemper Contemporary Art
 Museum, Kansas City, Missouri , USA
 Seattle Art Museum, Seattle, Washington, USA
 Serpentine Gallery, London, UK
2001 *Some/One,* Whitney Museum of American Art at
 Philip Morris, New York, USA
2000 Lehmann Maupin, New York, USA
 Seoul Home/ L.A. Home, Korean Cultural Center,
 Los Angeles, USA
 Sight-Seeing, NTT InterCommunication Center,
 Tokyo, Japan

SELECTED GROUP EXHIBITIONS

2001 *Lunapark: New Contemporary Art from Korea,*
 Württembergischer Kunstverein Stuttgart, Stuttgart,
 Germany
 Venice Biennale, Venice, Italy
 Uniform, Order and Disorder, Stazione Leopolda,
 Florence, Italy; PS 1, Long Island City, New York, USA
 About Face, The Museum of Modern Art, New York,
 USA
 BodySpace, The Baltimore Museum of Art,
 Baltimore, Maryland, USA
2000 *Greater New York*, PS 1, Long Island City, New York,
 USA
 Koreamericakorea, Art Center Sonje, Seoul, Korea;
 Sonje Art Museum, Kyung-joo, Korea
 Open Ends, The Museum of Modern Art, New York
 My Home is Yours. Your Home is Mine, Rodin
 Gallery; Samsung Museum, Seoul, Korea; Tokyo
 Opera City Art Gallery, Tokyo, Japan

SELECTED BIBLIOGRAPHY

Katie Clifford, 'A Soldier's Story,'
ArtNews, January 2002, pp 102-105
Holand Cotter, 'Do-Ho Suh', *The New
York Times*, 29 September, 2000, p E31
Glenn Harper, 'Do-Ho Suh', *Sculpture*,
January/February 2001, pp 62-63
Edward Leffingwell, 'Do-Ho Suh at
Lehmann Maupin', *Art in America*,
November 2000
Jenny Liu, 'Do-Ho Suh', *Frieze*, January/
February 2001, pp 118-19
– *Lunapark: Contemporary Art from
Korea,* exhibition catalogue,
Württembergischer Kunstverein
Stuttgart, Germany, 2001
Priya Malhotra, 'Do-Ho Suh', *Tema
Celeste*, January – February 2001, pp
52-55
Paola Morsiani, *Subject Plural: Crowds
in Contemporary Art*, exhibition
catalogue, Contemporary Arts Museum,
Houston, USA, 2001
Francis Richard, 'The Art of Do-Ho Suh:
Home in the World', *Artforum*, January
2002, pp 114-118
Audrey Walen, 'Do-Ho Suh/Whitney at
Philip Morris', *Sculpture*, October 2001,
pp 72-73

CHECKLIST OF WORKS

348 WEST 22ND ST., APT. A, NEW
YORK, NY 10011 AT RODIN GALLERY,
SEOUL/ TOKYO OPERA CITY ART
GALLERY/ SEPENTINE GALLERY,
LONDON/ BIENNALE OF SYDNEY
translucent nylon edition 1/3 LM2946
430 x 690 x 245 cm

348 WEST 22ND ST., APT. A, NEW
YORK, NY 10011 AT RODIN GALLERY,
SEOUL/ TOKYO OPERA CITY ART
GALLERY/ SERPENTINE GALLERY,
LONDON/ BIENNALE OF SYDNEY (COR-
RIDOR)
translucent nylon edition 1/3 LM4683
168 x 1240 x 245 cm

Works courtesy the artist and Lehmann
Maupin, New York

VIBEKE TANDBERG

213

VIBEKE TANDBERG

LARS BANG LARSEN

Vibeke Tandberg is not only up to and including her own, but also other people's limits. She portrays the interplay of visual identities in an everyday space that resonates with images of pop culture and art history. In her work, the presence of the artist herself could be said to take the form of cameo appearances in projections of her own desire and her biographical sphere of friends and family.

The five photos of the *Line* series 1999 are a mixing in of her own facial features – nose, mouth, and eyes – with those of her friend Line. Vibeke is in love with Line, even if only in the friendly, Platonic sense of the term, but the innocence of this rapport has an underflow of an almost cannibalistic logic that predicates the visual code of the series. Is this a benign cross between personalities, or is it body-snatching? Projection

embodied, the Vibeke/Line hybrid looks innocent enough: easily balanced in different contrapostos, a fragility that comes forth as flirtatious or 'girlish', creased white top and pale skin allows you to enter the image but stops you short again with an assertive blue gaze under brown or black eyebrows. Slight Photoshop irregularity focuses the same facial elements manipulated in each photo, variations over an identifiable personality rather than the carving out of an archetype. The depiction of the way face and name are exchanged in a private economy raises the stakes beyond how much is Line and how much is Vibeke. A free space between the two women is allowed to unfold in a fantasy, mediated by their living bodies as irreducible signifiers. But still, the figure doesn't come down to being Line + Vibeke. She is the embodiment of a third desire, the doppelgänger of them both.

Perhaps the *Line* Series is a portrayal of psychic damage control in the face of the crisis that the unbalanced – Freud said halfway psychotic – state of being in love

brings about. The loved one's personality is usurped in a response to straighten out this, for the ego control mechanisms, unfortunate condition. In other works employing the same strategy, Tandberg waxes schizophrenic. In *Faces* 1998, she has portrayed personality's transparency by using the people who came and went during a certain period of her life, by morphing a series of different acquaintances' faces with her own, at no point allowing the viewer to discern who is 'Vibeke'. *Faces* is them superposed on Vibeke, the *Line* series is Vibeke on Line. In *Dad* and *Jumping Dad* (both 2000), the merging of personas as an elementary biographic fissure even messes up the genealogy and gender divisions of the nuclear family, as the artist explodes Oedipal hierarchy by showing herself dressed up in her father's flesh and clothes, assuming more or less reverential poses as this composite daughterdad figure. Here, personal family details become background information for the reading of the photo, decoded as quickly as any main-

DAD #1-6 2000 C-PRINTS, COMPUTER MONTAGES.

stream film.

Vibeke Tandberg's stabs at (her own) visual identities are far from traumatic, but rather the expression of the necessity and pleasures of wishful thinking. If subjectivity cannot be conceived of as unique, her artistic rationale seems to be, then one should at least deal with it in a productive and imaginative fashion. This process may not be entirely pleasant as different properties of identity fight it out amongst themselves, as in *Boxing* 1998, a 16 mm film that shows the artist shadowboxing with herself. She wins, she loses. In her work, the merging of personas bespeaks a personality split and healed with neutral technology in painterly photographic formats. What Boris Groys has called the ideological illusion of authorship - the fact that immaculate production cannot take place but only reproduction, combination, contextualisation and appropriation - has here become a dynamic concept met with a positive response.

Often, the continuous versioning of identity in Tandberg is quite up in the air. In *Beautiful* 1999, the simple effect of dressing up in a wig denotes a stereotypical, blond feminine desirability that drowns out the facial features of the artist in the flowing locks of a Medusa's head. The almost Art Nouveau-esque cliché sexiness of the portrait – woman as the privileged site of a hazardous consummation of desire – is revamped into an image that works a little like a perfume ad where the accoutrements, the *nebenwerk*, have taken over and have displaced the subjectivity of the portrayed person as well as that of the viewer. With this suicide blonde wigging it out, any final consummation (of the beautiful as a sexually invested or as an aesthetic criterion) is indefinitely postponed and rests in the self-referential fascination of curls and swirls, literally blowing in the wind.

Tandberg is on the quest for psychological material in a post-Cindy Sherman era of manipulated photography and film. However, she does not operate with the same high, postmodernist stakes in terms of representation and gender. If Sherman belongs to the first generation of American artists who grew up with disembodied representations of the human subject in 'the society of the spectacle' then, for Tandberg, mass media's endless phantasms and cultural determinants are not as promiscuous and threatening as before. Hence, perhaps, a more directly communicating artistic vision. Rather than portraying the absence of a self caught up in a repertoire of simulacra, she deals with the authenticity of a slippage between memory and projection, me and you, by privileging the sphere of intimacy and its subtle exchanges as the locus for identity's permutations. Here, being someone doesn't refer to a notion of stability – in fact, it should never be uttered in the singular, but as an open field of many possibilities, to desires that are as frail, decisive and multitudinous as microcultures that are being moved by the force of human relations.

Vibeke Tandberg born
Oslo, Norway, 1967.
Lives and works in
Oslo, Norway.

SELECTED SOLO EXHIBITIONS

2002 Gagosian Gallery, London, UK
 Gallery c/o, Berlin, Germany
 Klosterfelde, Berlin, Germany
2000 Tomio Koyama Gallery, Tokyo, Japan
 Kunstmuseum Thun, Switzerland
 Yvon Lambert, Paris, France
 Gio Marconi, Milan, Italy
1999 Andrea Rosen Gallery, New York, USA
 Nicolai Wallner, Copenhagen, Denmark
 Rogaland Kunstmuseum, Stavanger, Norway

SELECTED GROUP EXHIBITIONS

2001 *Footloose*, Stedelijk Museum, Amsterdam,
 Netherlands
 Interference, Palazzo delle Papesse, Sienna, Italy
 Endtroducing, Villa Arson, Nice, France
2000 *Ich ist etwas Anderes*, Kunstsammlung Nordrhein-
 Westfalen, Dusseldorf, Germany
 Organising Freedom, Moderna Museet, Stockholm,
 Sweden
1999 *Digital Photography*, Deichtorhalle, Hamburg,
 Germany
 Can You Hear Me, Ars Balticum Phototriennale, Kiel
1998 *Remix*, Musee des Beaux Arts, Nantes, France
 Berlin/ Berlin, Berlin Biennale, Germany
 Pakkhus, Momentum 1, Moss, Norway

SELECTED BIBLIOGRAPHY

Ekman Bartas, 'The Double – The
Embodiment of Mimesis', *Index
Magazine*, No.1, Stockholm, 1998
Alexandre Bohn, 'Vibeke Tandberg', *Le
Journal des Expositions*, No. 58, Paris,
1998
Jean-Max Colard, 'L'ame soeur', *Les
Inrockuptibles*, No. 167, Sept. 1998
Peter Herbstreuth, 'Vibeke Tandberg',
Kunst-Bulletin, April, Luzern, 1998
Mika Hannula, 'It's a Mystery to Me/
Someone Got Me Started', *Very*, No. 2,
New York, 1998

Arjen Mulder, 'De betovering van
Vibeke Tandberg', *Feit & Fictie* , No. 5,
Groningen, 2000
Midori Kimura, 'Vibeke Tandberg', *BT –
Bijutsu Techno*, No. 52, Tokyo, 2000
Lars Bang Larsen, 'Vibeke Tandberg',
Frieze, No. 50, London, 2000
Simon Morrissey, 'What's in a Lie?',
Contemporary Visual Arts, No. 22,
London, 1999
David Perreau, 'Remix, Images
Photographiques', *Zero Deux Magazine*,
No. 8, Paris, 1999

CHECKLIST OF WORKS

DAD #1-6 2000
c print, computer montages
series of 6 works, each 139 x 105 cm

Works courtesy the artist and Atle
Gerhardsen, Berlin

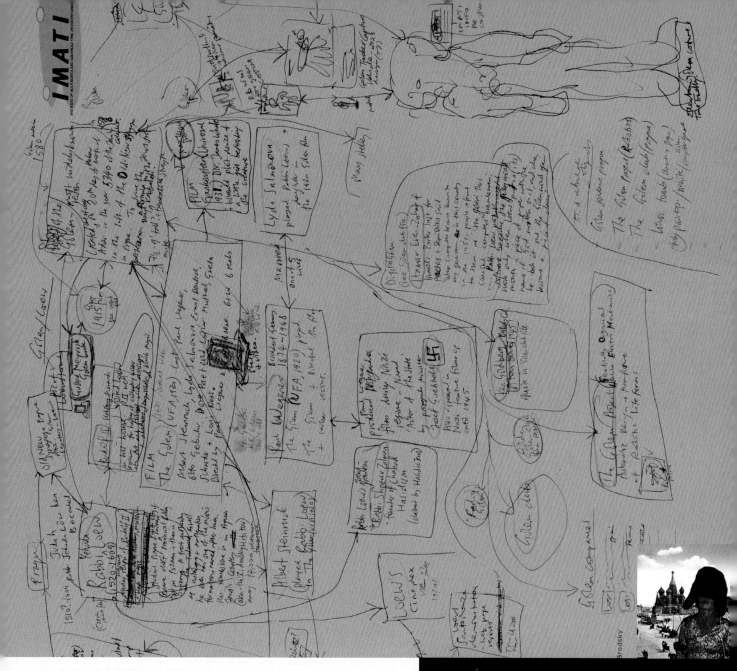

SUZANNE TREISTER

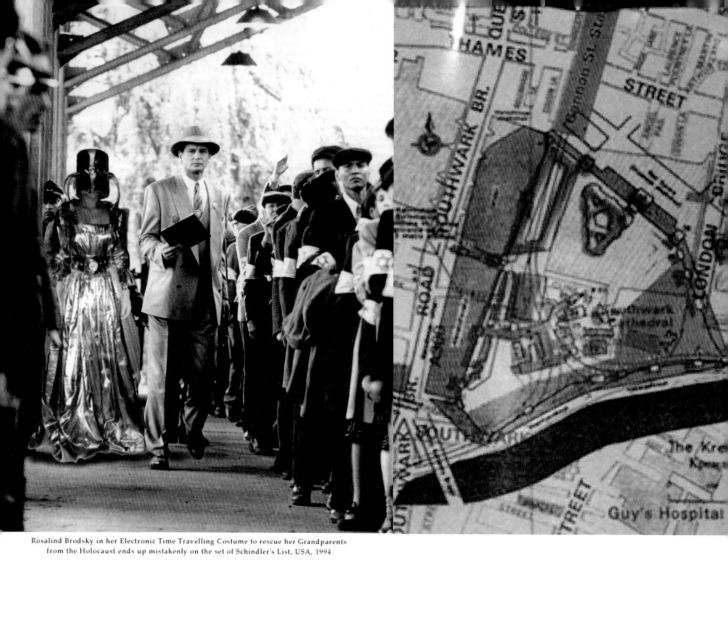

Rosalind Brodsky in her Electronic Time Travelling Costume to rescue her Grandparents from the Holocaust ends up mistakenly on the set of Schindler's List, USA, 1994

218

SUZANNE TREISTER

BIZARRE NEW WORLD

MAREK KOHN

Imagine *Dr Who* with roots in Mitteleuropa. On the one hand, the magnificent English tradition which delights in technology, but holds it together with elastic bands. On the other, a magnificent Jewish tradition of fascination with the psyche, which has led to the building of equally quixotic structures (both in literature and psychoanalysis) to make sense of it.

Welcome to the world of Rosalind Brodsky, orbiting eccentrically around our own. Brodsky began life as an alias for her creator, Suzanne Treister, and is now the star

of a book and CD-ROM publication, *No Other Symptoms: Time Travelling with Rosalind Brodsky.*

Loosely resembling an adventure game, the story is set in 2058, at an institute of esoteric advanced technology. The facility is crowded with paraphernalia through which visitors can explore Brodsky's life and adventures.

In a wardrobe hang several time-travelling costumes, lurex and wire affairs which the good Doctor's lovely assistants would have died for. Underneath them are attaché cases, packed with kit designed for various historical missions, such as the "case for embracing Judaism" – "basically a scaled up beard", according to Brodsky's accompanying notes.

In the bedroom a large *Introscan* TV

screen shows excerpts from Brodsky's career as a television cook, where she loftily disregards the laws of physics with a recipe for converting Black Forest gâteau into Polish pierogi dumplings.

Upon arrival at Brodsky's satellite spy probe (a simulated Christo wrapped Reichstag) visitors can use a painting program to create their own Brodsky-style artworks, electronically daubing items on to a variety of backgrounds: a Ukrainian shtetl, Lenin's bedroom, the United Nations, Mars... It transpires that Brodsky in her old age transformed much of her archival research into a painting game.

Foremost among the Brodsky icons is her range of feature vibrators. Some of these shining shafts are topped with famous heads, including Freud, Marx, Bowie, Emma

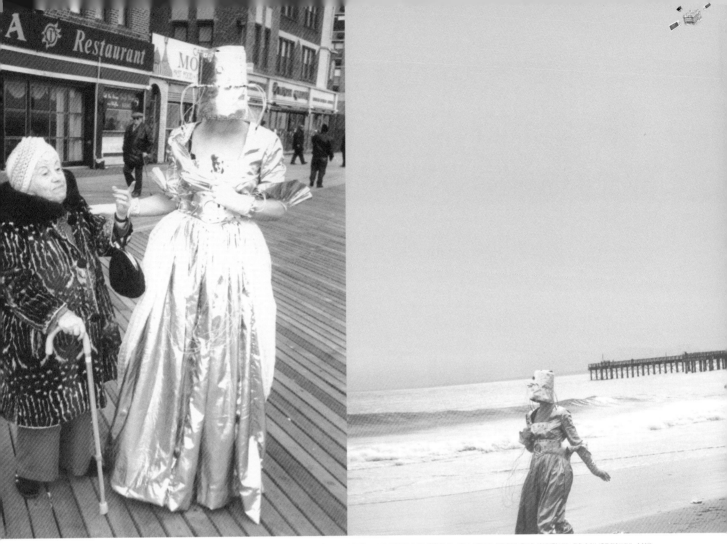

Peel and Warhol. Others celebrate great buildings, such as St Basil's onion-domed Cathedral, the Kremlin, and mad Ludwig II's Bavarian castle folly of Neuschwanstein, to which Brodsky moved in 2005.

The core of Brodsky's tales are the case histories recording her encounters with legends of psychoanalysis; Freud, Klein, Lacan and the errant Jung. They are interwoven with the three historical moments that preoccupy her: the Bolshevik revolution, London's Swinging Sixties, and the Holocaust. Some visitors will baulk at this. Why is the Holocaust juxtaposed with the *Avengers*, instead of being treated with Spielbergian monochrome seriousness? The answer is that this reflects the experience of an individual whose immediate family history was defined by the War –

Treister's grandparents perished in the Holocaust – but who grew up in the unprecedented comfort and security of the post-war boom. Our history is a muddle of the solemn and obscure traditions of our own families, and stuff we saw on TV.

I have the advantages here both of knowing the artist and having a similar heritage. But you don't have to be Jewish, or appreciate the symbolism of transforming a German dish into a Polish one, or have the kind of sensibility that is tickled by a song called 'Satellite of Lvov' – (a remake of Lou Reed's 'Satellite of Love', recorded by Brodsky's band in 2025).

Treister's work is an exuberant celebration of what the new media were supposed to be about. It is garage hypermedia, its shocking pink gothic letters jeering

at the commercial world of e-design whose ideal is to make everything look silver and seamless. You can see the wires, just like in *Doctor Who*, and that's how it's meant to be. Its heart is with homepage folk culture, which cares about individuals, not good taste or consumer profiles.

Rosalind Brodsky is a challenge to digital pretensions. Its acme is the scene entitled 'Ghosts of Maresfield Gardens'. Videoed in Freud's old study, in Hampstead, this cameo stars Treister's parents as the ghosts of Sigmund and Anna Freud, wearing sheets over their heads.

http://homepage.ntlworld.com/marek.kohn

Suzanne Treister

born London, 1958.

Lives and works in

Sydney, Australia

SELECTED SOLO EXHIBITIONS

2000 *Sightings/Archives from the Institute of Militronics and Advanced Time Interventionality*, Digimatter/ Grey Matter, Sydney; Greenaway Gallery, Adelaide, Australia

1999 *No Other Symptoms - Time Travelling with Rosalind Brodsky*, launch/ premiere: Freud Museum, London, UK; Artspace, Sydney, Australia
Odyssey (with Luke Roberts), Institute of Modern Art, Brisbane, Australia

1996/7 *Dying for your sins*, Australian Centre for Contemporary Art, Melbourne; Institute of Modern Art, Brisbane, Australia

1996 The Tannery - project space, London, UK

1995 *Software - Would you recognise a Virtual Paradise?*, Mizuma Gallery, Tokyo, Japan

1994 *Q.Would you recognise a Virtual Paradise?*, Contemporary Art Centre of South Australia; Australian Centre for Contemporary Art, Melbourne, Australia

1990 Ikon Gallery, Birmingham, UK: Arts Council of England touring exhibition: Spacex, Exeter; Oldham Art Gallery; The Minories, Colchester; Darlington Arts Centre; Nottingham Castle Art Gallery Kerlin Gallery, Dublin

1985-92 Edward Totah Gallery, London, UK, 4 solo exhibitions

SELECTED GROUP EXHIBITIONS

2001 *Model Citizen/No More Ice Cream, (An ICOLS project with Bronia Iwanczak)*, Artspace, Sydney, Australia

2000 *PUSAN International Contemporary Art Festival*, Metropolitan Museum of Art, South Korea
F I L E Festival internacional de linguagem eletrônica, Museum of Image and Sound São Paulo, Brazil.
World Wide Video Festival, Amsterdam, Netherlands.
Urban Futures 2000, Johannesburg University Art Gallery, South Africa

1999/01 *Contact Zones*, Johnson Museum of Art, Cornell University, USA, and touring; Centro de la Imagen, Mexico City, USA & Canada

1999 *WRO 99 - 7th International Media Art Biennale*, Wroclaw, Poland

1998 *ISEA 98*, The Tea Factory, Liverpool, UK
Pandaemonium Festival, Lux Centre/ Standpoint Gallery, London, UK

1996 *ICA/Toshiba Art and Innovation Commission exhibition*, ICA London, UK

SELECTED BIBLIOGRAPHY

David Barrett, 'On a Clear Day', *Frieze*, Issue 33, 1997
Robert Collins and James Josephs, 'Suzanne Treister', exhibition catalogue, Ikon Gallery/Edward Totah Gallery, UK, 1990
Michael Gibbs, 'Time Travel', *Art Monthly* UK, No. 235, April 2000, p 51
Higgins and Cohen, *New British Painting*, Phaidon, UK, 1988
Catherine Lumby, 'Suzanne Treister at post west, Adelaide', *Art + Text*, Sept. 1992
Jyanni Steffensen, 'Doing it digitally: Rosalind Brodsky and the art of the virtual female subject', *_Reload_Rethinking*

Women + Cyberculture, Mary Flanagan and Austin Booth (eds), Cambridge, Mass: MIT Press, 2001
Andrew Renton, 'Suzanne Treister at Edward Totah, London', *Flash Art*, May/June, 1992
Joni Taylor, 'Time travel is your only means of escape', *RealTime* 35, Sydney, Feb 2000
Suzanne Treister, *No Other Symptoms - Time Travelling with Rosalind Brodsky*, Black Dog Publishing Ltd, London, UK, Dec. 1999, CD ROM + book
Artist pages, *Arkzin*, No. 4 (100/101), Zagreb, Croatia, 12.'97/ 01.'98

CHECKLIST OF WORKS

Rosalind Brodsky (1970-2058) – Archival material on loan from the Institute of Militronics and Advanced Time Interventionality, London, England.

NO OTHER SYMPTOMS – TIME TRAVELLING WITH ROSALIND BRODSKY CD ROM

ROSALIND BRODSKY – SIGHTINGS:
A. Interviews with residents of the UK and Australia who have encountered Brodsky.
B. Paintings and drawings by children describing their encounters with Brodsky.
3 hour video/ mixed media on paper. various dimensions.

ROSALIND BRODSKY'S ELECTRONIC TIME TRAVELLING COSTUMES:
Rosalind Brodsky's Electronic Time Travelling Costume to visit the Russian Revolution
Rosalind Brodsky's Electronic Time Travelling Costume to rescue her Grandparents from the Holocaust.
Rosalind Brodsky's Electronic Time Travelling Costume to go to London and Paris in the 1960s.
various fabrics, electronic wiring and time travel components. Various (life-size) dimensions.

ROSALIND BRODSKY'S ELECTRONIC TIME TRAVELLING DEVICES (3 ATTACHÉ CASES):
Rosalind Brodsky's Case for Time Travelling in an Emergency
Rosalind Brodsky's Case for visiting her Father at the time of his Birth.
Rosalind Brodsky's Case for Embracing Judaism.
attaché cases, various fabrics, electronic wiring and time travel components. various (life-size) dimensions.

ROSALIND BRODSKY/I.M.A.T.I. TIME TRAVEL RESEARCH PROJECT #PRN1/27 – SUBJECT: Golem/Loews...
Wall display – wall texts, various objects, paper, plastics, photographic documentation and Brodsky's Electronic Time Travelling Golem Costume; fabric, electronic wiring and time travel components.

Institute of Militronics and Advanced Time Interventionality logo
Electronic wall transfer

Previous page photographs, courtesy Sardi Klein Archives, NY, USA.
All other works courtesy of the Institute of Militronics and Advanced Time Interventionality , London, England. (I.M.A.T.I. contact: suzyRB@va.com.au for further information)

MORE THAN A 100 YEARS AGO NIETZSCHE URGED US TO PLACE OURSELVES IN "LOVING
ABSORPTION IN THE EMPIRICAL DATA". WHAT AM I SUPPOSED TO DO NOW THAT EMPIRICAL
DATA IS MOSTLY SHINY OR IMPERVIOUS SYNTHETIC POLYMERS THAT DO NOT LEND THEM-
SELVES TO ABSORPTION? EVEN IF THEY DO, DO I WANT TO BE ABSORBED IN SUCH ALIEN
MATTER? THIS MAY SEEM A RHETORICAL QUESTION, HOWEVER SUCH REFLECTION PROVIDES AN OPPORTUNITY FOR
MY PRACTICE... A PRACTICE THAT TURNS OBSERVATION OF PHENOMENON – CURRENTLY PLASTIC (noun) phenomenon
— into a visuality. It is a visuality that is multifarious and plastic (adjective). Perhaps more than plastic, it is a plastic power
which allows me to see absorption when there is none, the familiar when it is utterly foreign, and to travel freely between
the metaphoric and the literal. SHIRLEY TSE 2002

SHIRLEY TSE

221

SHIRLEY TSE

RALPH RUGOFF

Shirley Tse cannily celebrates the phantas-magoric possibilities of polymers. The Hong Kong-born, Los Angeles-based artist trans-forms bubble wrap, Styrofoam, and poly-urethane into pullulating constructions whose sagging and dented surfaces alter-nately suggest organic growths and abject industrial architecture. And just as the com-mercially formulated plastics that Tse uses are typically associated with pack-aging and shipping, her sculpture likewise con-

jures a sense of work in transit, as if it were continually redefining its ultimate destina-tion or even figuring out whether its field of reference is two- or three-dimensional.

This last tendency is particularly evident in two series of large colour photographs, from 1998 and 1999, that depict Tse's vaguely geometric constructions in wilder-ness areas. Made from ingeniously mani-pulated inflated plastic bags and sutured solar blankets, Tse's objects initially seem as comically out of place as national-park tourists dressed in fluorescent sweats, but after a longer look, their awkward, rumpled shapes appear no less natural than the wind-

shaped rocks and desert surrounding them, their plastic hues no less appealing than the blue skies and red sandstone cliffs.

With a nod to Robert Smithson, Tse's work wryly sidesteps the dead-end logic that defines nature and culture as oppositional terms, instead embracing the complexity and hybrid morphology of our actual envi-ronment. Her *chef d'oeuvre* to date, *Poly-mathicsyrene* 1999-2000, develops this multiplicitous aesthetic to a brilliantly par-adoxical pitch. Wrapped around the gallery in continuous segments, 135 pale blue poly-styrene sheets bear elaborately hollowed-out forms that conjure everything from urban

POLYMATHICSTYRENE 1999-2000 INSTALLATION VIEW. POLYMATHICSTYRENE 35A, 35B, 35C 1999-2000 EXTRUDED POLYSTYRENE. FRONT PAGE IMAGE POLYMATHICSTYRENE 34 DETAIL 2000 EXTRUDED POLYSTYRENE.

topologies to geological formations, from computer circuitry to imprints left by unidentifiable consumer goods, from archaeological sites to futuristic structures. Viewers peer down on the work, which is installed as a waist-high shelf, as if surveying an aerial diagram of a relentlessly overcoded planet, a disorientating landscape where the natural and built environments, as well as the micro and macro, seamlessly meld.

Suggesting something dreamed up by an offspring of Louise Nevelson and Gilles Deleuze, *Polymathicstyrene* reveals Tse's conceptual agility as well as her formal inventiveness. The work neatly collapses all kinds of seemingly contradictory elements: Its precisely scooped out negative forms, carved with a router, fuse an aesthetic of the machined and the handmade, while its wrap-around sequences conjure a narrative that is both linear and circuitous. As we walk around the sculpture, examining and comparing the myriad of shapes that are the fruit of the artist's time-consuming labor, it becomes a meditation on the relation between memory and perception.

In other words, the sculpture's values are as plastic as that permanent yet permeable substance from which it is made. Like a faithful modernist, Tse consistently exploits her chosen art supply as the spring-board for her fluid investigations. Yet in manipulating a material to reveal its multiple 'truths', her work bypasses formalist credos and instead persuasively demonstrates art's status as an exhilaratingly heterogeneous endeavor where form, material, and reference collide.

Reprinted with kind permission of the author. First published in *Artforum*, Jan. 2001, p 122.

POLYMATHICSTYRENE 35A 1999-
2000 EXTRUDED POLYSTYRENE.

Shirley Tse born
Hong Kong, 1968.
Lives and works in
Los Angeles, U.S.A.

SELECTED SOLO EXHIBITIONS

2002 Murray Guy, New York, NY, USA
Capp Street Project at California College of Arts and
Crafts, Oakland, USA
2000 Murray Guy, New York, NY, USA
Plastic Works, Para/Site Art Space, Hong Kong
(catalogue)
Encapsulated, MacLennan Gallery, St. Louis, USA
University, St. Louis, USA
Shoshana Wayne Gallery, Santa Monica, USA

SELECTED GROUP EXHIBITIONS

2002 *Sprawl*, Cincinnati Contemporary Art Center,
Cincinnati, USA
Provisional Worlds, Art Gallery of Ontario, Toronto,
Canada
2001 *Tierra Incognita*, Nylon, London, UK
Hemorrhaging of States, TENT, Centrum Beeldende
Kunst, Rotterdam, Netherlands
01.01.01. Art in Technological Times, San Francisco
Museum of Modern Art, San Francisco, USA
2000 *Pleasure Treasure: Recent Acquisitions from the
Collections of Eileen and Peter Norton*, Luckman
Fine Arts Gallery, California State University, Los
Angeles, USA
Plastika, Govett-Brewster Art Gallery, New Plymouth,
New Zealand
all things everything true, CRG, New York, USA
1999 After the Gold Rush, Thread Waxing Space, New
York, USA
Stuff, TBA Exhibition Space, Chicago, USA

SELECTED BIBLIOGRAPHY

Jeanne Dunning, *Stuff*, exhibition
catalogue, TBA Exhibition Space,
Contemporary Arts Council, Chicago,
USA,1999, p 15
Draza Fratto O'Brien, 'The Flow of
Plastic', *Shirley Tse Sculpture and
Photography 1996-2000*, exhibition
catalogue, Para/Site Art Space, Hong
Kong, 2000
Adrienne Gagnon, ' Shirley Tse',
010101:Art in Technological Times,
exhibition catalogue, Theresa Herron,
'Shirley Tse: Creatrix of Plasticity',
newbeats.com, Dec.
Susan Kandel, 'Shirley Tse: Plastic Aphasia,
artext, no. 68, Feb. 2000, pp 44-45
Lisa Panzera, 'Shirley Tse at Murray
Guy', *Art in America*, Jan., Vol. 89, no.

1, 2001, p 119
Ralph Rugoff, 'Virtual Corridors of
Power: Ralph Rugoff approaches the
cutting edge of digital technology in a
timely exhibition at the San Francisco
Museum of Modern Art', *The Financial
Times*, Mar. 31, 2001
Ralph Rugoff, 'First Take', *Artforum*,
January, Vol. 39, No. 5, 2001, p 123
San Francisco Museum of Modern Art,
San Francisco, USA, 2001, pp 136-137
David Spalding, 'A conversation with
artists in '010101: Art in Technological
Times', *Artweek*, May, Vol. 32, issue 5,
2001, pp 13-14
Gregory Williams, 'Shirley Tse at Murray
Guy', *Frieze*, Jan., issue 56, 2001, pp
106-107

CHECKLIST OF WORKS

POLYMATHICSTYRENE 1999-2000
extruded polystyrene installation,
dimensions variable
courtesy the artist, Murray Guy Gallery,
New York and Shoshana Wayne Gallery,
Los Angeles

BIGFOOT in the eye of GUADALUPE
Image of Sasquatch reflected in eye of Relic

RETOUCHED AND ENLARGED IMAGE

In Mexico, the Spanish name for the Devil is the traditional term chango, or "monkey."

Yeti-like ape man

shallow cranium

small simian ears

wide and flat nose

large muzzle

Bigfoot-like simulacrum from central Oregon

image of the Beast

projecting brows

large humanlike eyes

spreading nostrils

full lips

Typical drawing from Bigfoot sighting

BIGFOOT IMAGE AS ACTUALLY SEEN IN EYE OF GUADALUPE

Bush Devil, Creek Devil

Mountain Devils said to live in a network of underground lava tubes called the "ape caves" at the foot of Mount St. Helens.

With the aid of a computer-enhanced imaging system, I looked into the eyes of the Guadalupe. In the pupil area I found a series of anthropoid apparitions I catalogued over 75 similar faces that looked like popular images of the Bigfoot or yeti.

ROGER PATTERSON PHOTO OF BIGFOOT

BIGFOOT REFLECTED IN EYE

Saint John Bosco (1815–1888) had visions of the Devil and demons appearing to him as "monkeylike beasts." The original name for Bigfoot was "mountain Devil." The Devil and the Beast are thrown alive into the lake of fire. Revelation 19:20

MONKEY FACE ROCK REDMOND, OREGON

ROE SKETCH OF SASQUATCH

Jeffrey Vallance

1998 LAS VEGAS

JEFFREY VALLANCE

225

A COLLECTION OF EDITED EXCERPTS FROM THE TEXTS *MY LIFE WITH DICK,* *SEARCHING FOR BIGFOOT IN THE EYE OF THE GUADALUPE* AND *DISNEY'S INFERNO: TO HELL AND BACK.* / *MY LIFE WITH DICK* — ON JULY 19, 1990, THE RICHARD NIXON LIBRARY AND BIRTHPLACE WAS DEDICATED IN YORBA LINDA. SHORTLY THEREAFTER, I MADE A PILGRIMAGE OUT TO THE LIBRARY, DEEP INTO THE BOWELS OF THE DANTE-ESQUE FACILITY. IN LATE NOVEMBER (1994), I TRAVELED TO MEXICO CITY JUST IN TIME TO ATTEND THE INAUGURATION OF EL PRESIDENTE ERNESTO ZEDILLO. THAT EVENING, AFTER THE INAUGURATION, I WAS MICROSCOPICALLY EXAMINING THE EYES OF THE VIRGIN OF GUADALUPE WHEN I FOUND A PRETERNATURAL APPARITION OF NIXON REFLECTED IN HER PUPIL. / *SEARCHING FOR BIGFOOT IN THE EYE OF THE GUADALUPE* — I made a pilgrimage to Mexico City – to the Basilica de Guadalupe, where the spontaneous image of the Blessed Virgin is preserved. I took a look into some pictures of the eyes of the Guadalupe, and was astonished at what I found: likenesses such as a shroudlike portrait of Christ, an image that looks like folk singer Bob Dylan (during his "Born Again" experience), cult leader Charles Manson, Mexican wrestler and activist Superbarrio, and a profile of President Abraham Lincoln. / *DISNEY'S INFERNO: TO HELL AND BACK* — Of the thousands of people from around the world who make sacred pilgrimages to the Happiest Place on Earth, few devote much thought to the mystery of *what exactly makes them so damn happy there.* Perhaps the answer can be revealed by delving into the dark side of Disneyland. The structure of Mr. Toad's Wild Ride, for example, correlates precisely with the "Inferno" section of Dante's epic poem *The Divine Comedy.* Both Dante's and Mr. Toad's voyages through the underworld correlate with trips through the digestive system. Texts reprinted with permission of the author, *Art issues, Press* and *LA Weekly.*

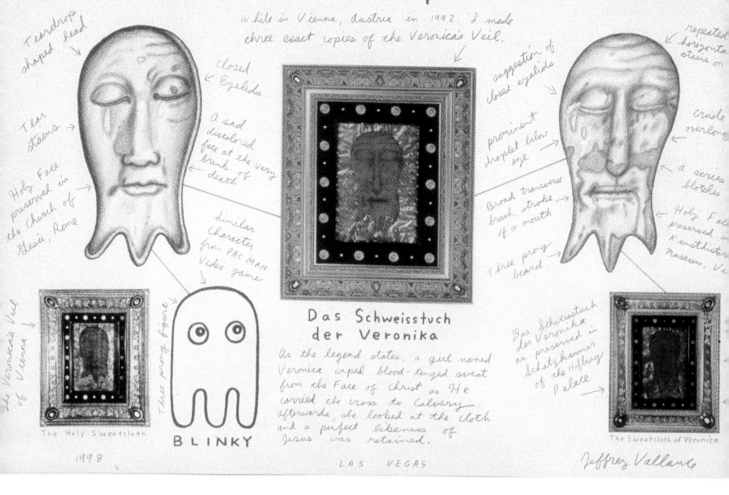

JEFFREY VALLANCE

RALPH RUGOFF

Throughout his richly varied career, Jeffrey Vallance has continued to examine the semiotic underpinnings of religion, folklore, and national identity. Deeply engaged with both the power and promiscuity of images, his art revels in contaminated categories and impure cultural artifacts. Aided by a deadpan sense of humor, his work also explores the ways in which our most legitimate symbols – and our symbols of legitimacy – are forged and reproduced with a claustrophobically self-referential logic.

In the early 1980s, Vallance developed an extended body of work dealing with Blinky the Friendly Hen, a frozen chicken that the artist transformed into a symbol of universal martyrdom. After adopting it as a pet, Vallance buried Blinky in a pet cemetery; ten years later, he disenterred its remains so they could be forensically examined in order to determine the cause of the bird's death. Besides documenting these events in a book and a video, Vallance created an extensive range of Blinky artifacts, including relics, shrouds, and icons executed in a mind-boggling array of media. The death of Blinky was not treated tragically by Vallance, but as an occasion for enacting a kind of ludicrous immortality achieved – in the modern fashion – through a wanton proliferation of images.

In constructing a Blinky iconography, Vallance drolly elevated a common object into a symbol of eternal life; elsewhere his work has looked at the transformation of the hallowed into the prosaic. Vallance, in fact, has returned to this theme repeatedly, often while examining the relationship between 'sacred' objects and 'profane' copies. In 1991, he produced a body of work based on the Shroud of Turn, the Veil of Veronica, and the Holy Lance (a spear said to have pierced the side of the crucified Christ). Vallance's duplicate versions of these relics invoke a historical project of multiplication: three 'original' Holy Lances, for instance, are ensconced in different museums in Europe, each accompanied by its own legitimating genealogy. (In the Middle Ages, the Church actually sanctioned such reproductions: by touching the copy to the original relic, it was officially transformed into a sacred object in its own right.)

In a related group of works, deranged clown faces and a profile of George Washington are presented as 'discovered' images hidden within the stains on the Shroud of Turin. Calling to mind the way researchers studying the Virgin of Guadalupe shroud have found countless pictures concealed in the Virgin's eye, these pieces suggest a relationship between interpretation, paranoia, and delirium. Like all of Vallance's counterfeit relics, they also insinuate that our relationship to representation – especially the museum's display of physical evidence – is essentially theological, based on faith, not rationality.

In both of these projects dealing with debased theological conceits, Vallance defined one of his key roles – that of cosmographer, exuberantly mapping that potentially infinite territory in which iconography and mass marketing meet. A similar approach is clearly evident in his ongoing project, *Jeffrey Vallance Presents the Nixon Museum* (1991 to the present). Neither a straightforward simulation nor a parody, Vallance's version of a presidential museum wryly mimics the indiscriminate logic of inclusion that distinguishes such places, where no item is too trivial to be displayed provided it can be linked, through biography

The CLOWNS of TURIN
found on the HOLY SHROUD

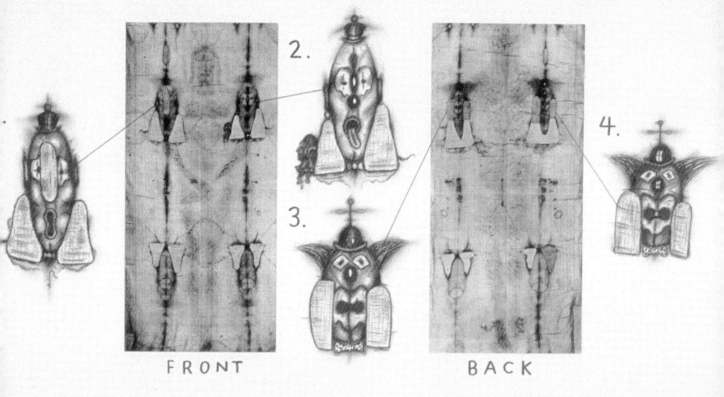

FRONT BACK

Four Clown Faces appear in Scorch Marks on the Shroud

1998 *LAS VEGAS* *Jeffrey Vallance*

or iconography, to the museum's all-consuming subject.

In Vallance's museum – as in the official Nixon Library – objects belonging to every conceivable category are stamped with Nixon's name and portrait, including watches, paperweights, ping pong paddles, matchbooks, shower heads, and even nail clippers. Many of these items are historical memorabilia from various political campaigns, but Vallance's collection features a number of items that the artist himself has either fabricated or altered. Yet despite its incorporation of fictive elements, Vallance's institution is arguably a more accurate repository of historical truths than its authorized counterpart because it features a truly uncensored collection of paraphenalia, including Nixon hash pipes and roach clips, as well as the cheeky campaign button, "They Can't Lick Our Dick".

Even with such material on display, Vallance's project mimics the format of the presidential shrine so astutely that when it debuted in 1991 at a Los Angeles art gallery, numerous visitors assumed it was a bonafide annex of the Nixon Library. It was an assumption that the artist slyly encouraged by displaying a selection of souvenirs

from the official museum's gift store, as well as by offering for sale his own comparable range of gift items.

Vallance, however, is ultimately less interested in creating a duplicitous simulation than in calling attention to the consequences of our culture's ceaseless circulation of images. Repeated until it loses all suggestion of rational meaning, the figure of Nixon appears not as an icon of authority in Vallance's project, but as an emblem of delirium. Indeed, in Vallance's museum the ex-President's identity seemingly loses any sense of being anchored to an actual historical referent. In this way, his project underscores how in our culture of marketing, even the most abject or absurd symbol can seemingly take on a life of its own, opening up a gulf between what semioticians used to call the 'signifier' and 'signified'.

From his earliest works, Vallance has used the museum as a model of cultural knowledge while drawing attention to its historical roots in the Medieval display of holy relics. In the process, his art pointedly insists that culture and worship may be inextricably linked, while the practices of the art world are never far removed from those of cults. Vallance is not a cynic, how-

ever. His work continually finds new ways of enlarging the museum's metaphorical borders, while expanding and reanimating our understanding of links between diverse cultural endeavors. Indeed, whether producing fake holy relics, charting contemporary conspiracy theories, or creating an alternative presidential museum, Vallance's art confronts us with social and aesthetic impurities that defy our inherited notions of order and logic.

In the end, his hybrid aesthetic counsels us against a metaphysics that pits the true against the false, the genuine against the counterfeit. It reminds us that, in a world of copies, the truth of pictures is deeply promiscuous. It may not matter, then, whether an exhibited object is actually an original or only a copy; what matters most is whether we have faith in it as a metaphor. With good-natured humor, Vallance's art thus proposes that we reserve our sense of wonder for the ability of symbols – which are never less than 'real' – to profoundly move us whenever we give them the benefit of our belief.

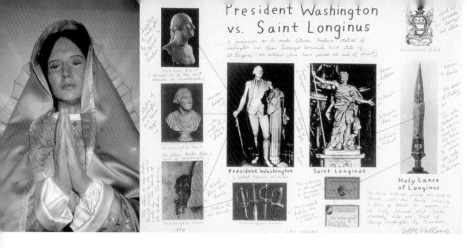

THE VIRGIN OF GUADALUPE 2000 MIXED MEDIA.
PRESIDENT WASHINGTON VS. SAINT LONGINUS
1998 PENCIL, PEN, COLLAGE ON PAPER. FRONT
PAGE IMAGE BIGFOOT IN THE EYE OF GUADALUPE/
IMAGE OF SASQUATCH REFLECTED IN EYE OF RELIC
1998 PENCIL, PEN, COLLAGE ON PAPER.

Jeffrey Vallance born Redondo Beach, California, USA, 1955. Lives and works in Umea, Sweden and Las Vegas, USA.

SELECTED SOLO EXHIBITIONS

2001 *The Virgin, The Poet and the President*, Lehmann Maupin Gallery, New York, USA
2000 *Anamolies*, Rosamund Felsen Gallery, Los Angeles, USA
1999 *Paranormal Diagrams: Heretical Theories*, Art Institute of Boston, USA
1998 *Paranormal Diagrams: Heretical Theories*, Lehmann Maupin Gallery, New York, USA
Jeffrey Vallance: A 25-year Survey, Galeria Praz-Delavallade, Paris, France
Jeffrey Vallance/ Drawings, Y1, Stockholm, Sweden
1995 *The World of Jeffrey Vallance*, Santa Monica Museum of Art, California, USA
1994 *The Nixon Museum*, Galeria Praz-Delavallade, Paris, France
1993 *Three is a Shroud*, Rosamund Felsen Gallery, Los Angeles, USA
Emi Fontana Gallery, Milan, Italy

SELECTED GROUP EXHIBITIONS

2001 *The Magic Hour*, Kunstlerhaus, Graz, Austria
2000 *inSITE 2000*, San Diego, California/Tijuana, Mexico
1999 *Midnight Walkers and City Sleepers*, W139, The Erotic Museum, Red Light District, Amsterdam, Netherlands
Heaven, Kunsthalle Dusseldorf, Germany; Tate Gallery, Liverpool, UK
1998 *Everybody Loves a Clown, Baby, Why Don't You?*, Guggenheim Gallery at Chapman University, Orange, California, USA
1997 Scene of the Crime, UCLA at the Armand Hammer Museum of Art, Los Angeles, California, USA
1996 *Popocultural*, South London Gallery, London, UK
1995 *Elvis + Marylin: 2 x Immortal*, The Institute of Contemporary Art, Boston, USA
1994 *Pro-Creation*, Kunsthalle Freiburg, Germany
1992 *Paul McCarthy, Lari Pittman, Jeffrey Vallance*, Studio Guenzani, Milan, Italy

SELECTED BIBLIOGRAPHY

Michael Duncan, 'Review', *Art in America*, May 1994, pp 126-127
Jan Estep, 'Three's a Shroud: Jeffrey Vallance, God and You', *New Art Examiner*, March 2000
Amy Gerstler, 'Review', *Artforum*, May 1993, p 110
David Humphrey, 'Jeffrey Vallance', *Art Issues*, No. 17, April 1991, p 29
David Pagel, 'Jeffrey Vallance', *Bomb*, Summer 1996, pp 38-42
Nancy Princenthal, 'Jeffrey Vallance at Lehmann Maupin', *Art in America*, February 1999, p 106
Ralph Rugoff, 'Jeffrey Vallance's Strip Shows', *Artforum*, May 1996, pp 43-47
Roberta Smith, 'Jeffrey Vallance: Paranormal Diagram, Heretical Theories', *The New York Times*, 16 Oct. 1998
Alisa Tager, 'Art on the Strip', *Art in America*, February 1997, pp 43-47
Edward Young, 'I Con Man', *Fortean Times*, 70, August 1993, pp 35-37

CHECKLIST OF WORKS

THE VIRGIN OF GUADALUPE 2000
mixed media, dimensions variable
DANTE 2000
mixed media, dimensions variable
RICHARD M. NIXON 2000
mixed media, dimensions variable
CLOWNS AND SHROUD THE FOUR CLOWNS OF TURIN 1998
mixed media on paper, 55.9 x 76.2 cm
IMAGE OF NIXON FOUND IN NATURE EX-PRESIDENT'S SIMULACRA SEEN IN PERENNIAL COMEBACK 1998
mixed media on paper, 55.9 x 76.2 cm
NIXON'S DOG CHECKERS EXHUMED POOCH TO BE REBURIED NEXT TO FORMER PRESIDENT 1998
mixed media on paper, 55.9 x 76.2 cm
DISNEY'S INFERNO: SKELETON FROM THE PIRATES OF THE CARIBBEAN 1998
marker on paper, 21.6 x 27.9 cm
DISNEY'S INFERNO: HAUNTED MANSION 1998
marker on paper, 27.9 x 21.6 cm
DISNEY'S INFERNO: MR. TOAD IN THE PORTAL OF HELL 1998
marker on paper, 27.9 x 21.6 cm
CLOWN OASIS AN EXHIBITION OF WORKS BY ARTISTS AND CLOWNS AT RON LEE'S WORLD OF CLOWNS LAS VEGAS, NEVADA 1998
mixed media on paper, 55.9 x 76.2 cm
SHROUD OF BLINKY CIRCULAR LOGIC 1998
mixed media on paper, 55.9 x 76.2 cm
RIGHT EYE OF THE GUADALUPE 1998
mixed media on paper, 55.9 x 76.2 cm
LEFT EYE OF THE GUADALUPE 1998
mixed media on paper, 55.9 x 76.2 cm
THE HOLY VEIL OF VERONICA THE CLOTH THAT WIPED THE FACE OF CHRIST 1998
mixed media on paper, 55.9 x 76.2 cm
THE HOLY LANCE OF LONGINUS A.K.A. DIE HEILIGE LANZE, THE SPEAR OF DESTINY, THE ROMPHEA, AND THE SPEAR OF SAINT MAURICE 1998
mixed media on paper, 55.9 x 76.2 cm
THE CLOWNS OF TURIN FOUND ON THE HOLY SHROUD (1) 1998
mixed media on paper, 55.9 x 76.2 cm
private collection, Dallas
PROPHETIC WOUND: THE STAIN OF WASHINGTON BLOOD STAIN ON THE SHROUD MADE BY THE HOLY LANCE 1998
mixed media on paper, 55.9 x 76.2 cm
private collection, New York
THE EYES OF THE GUADALUPE MANY IMAGES SEEN REFLECTED IN THE VIRGIN'S EYES 1998
mixed media on paper, 55.9 x 76.2 cm
private collection, New York
CATHOLIC LEAGUE'S 1998 REPORT ON ANTI-CATHOLICISM 1999
report cover, black & white laser copies, signed letters, envelope 73.7 x 101.6 cm
Works courtesy the artist and Lehmann Maupin Gallery, New York

THE SHROUD OF BLINKY 1978
blood on paper, plexiglass, 33.7 x 44.5 x 21 cm
collection: Barry Sloane, Los Angeles
DIE HEILIGE LANZE 1992
forged metal, brass, wire, leather, plexiglass and wood case, 2.5 x 50.8 x 8.3 cm; case 10.2 x 60 x 16.5 cm
collection: Barry Sloane, Los Angeles
LA MACCHIA DI WASHINGTON (THE STAIN OF WAHSINGTON) 1993
FIAT enamels, acrylic and gummalacca on board 55 x 40 cm
collection: Barry Sloane, Los Angeles
SCREAMING SINISTER CLOWN FROM THE SERIES THE CLOWNS OF TURIN (DETAILS OF THE HOLY SHROUD) 1992
acrylic on raw canvas, nails, 67 x 52.7 cm
CLOWN OF TURIN (OWL) FROM THE SERIES THE CLOWNS OF TURIN (DETAILS OF THE HOLY SHROUD) 1992
acrylic on raw canvas, nails, 67 x 52.7 cm
CLOWN WITH BEANIE FROM THE SERIES THE CLOWNS OF TURIN (DETAILS OF THE HOLY SHROUD) 1992
acrylic on raw canvas, nails, 67 x 52.7 cm
DETAIL OF THE HOLY SHROUD: GEORGE WASHINGTON STAIN FROM THE SERIES THE CLOWNS OF TURIN (DETAILS OF THE HOLY SHROUD) 1992
acrylic on raw canvas, nails, 67 x 52.7 cm
ELVIS SWEATCLOTHS I, II, III. 1993
sweat on satin, each 55.9 x 55.9 cm; overall dimensions variable
SINISTER CLOWN WITH LITTLE PRESIDENT WASHINGTON FROM THE SERIES THE CLOWNS OF TURIN (DETAILS OF THE HOLY SHROUD) 1992
acrylic on raw canvas, nails, 67 x 52.7 cm. unframed
collection: Larry Kauvar, San Francisco
TRAVELING NIXON MUSEUM (WITH SHROUD) 1991
wood case with found objects, chiffon scarf, 50.8 x 57.2 x 18.4 cm
collection: Eileen and Peter Norton, Santa Monica
NIXON IN CHAINS 1991-92
books, chains, padlock, wood bracket dimensions variable
TRICKY DICK. BY BRUCE BEASLEY, GIFT OF TOM PATCHETT N/D
polyester resin
THE CLOWNS OF TURIN
(Special Thanks to Victoria Reynolds & the Nevada Institute of Contemporary Art for help with the Clown banner) 1995-96
2-part acrylic on canvas banner, easel with glitter, latex balloons: banner 228.6 x 294.6 cm; painting on easel 90.8 x 71 cm; easel 179 x 83.8 x 83.8 cm
BLINKY, THE FRIENDLY HEN 1988
15 minute video-tape
BLINKY THE FRIENDLY HEN, 2ND EDITION N/D
book, 24 pp *Jeffrey Vallance*, Smart Art Press, Santa Monica
NIXON ARTIFICIAL FINGERNAIL 1995
fake fingernail and decal, 2.3 x 1.3 x 0.5 cm
Works courtesy the artist and Rosamund Felsen Gallery, Santa Monica

BLINKY'S VEIL - MANDYLION III 1989
monoprint on silk, pins, 44.5 x 40.6 cm
private collection
courtesy the artist. Praz/Delavallade, Paris and Rosamund Felsen Gallery, Santa Monica

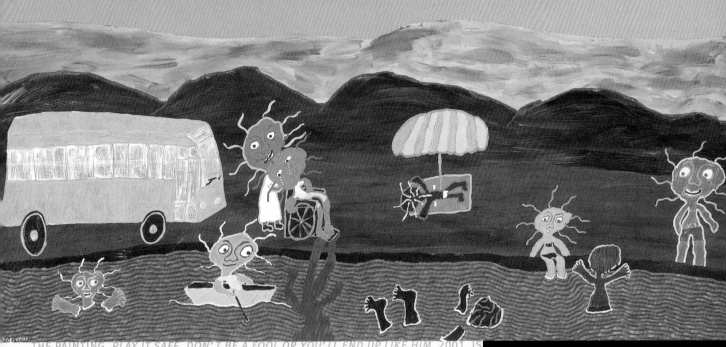

THE PAINTING, *PLAY IT SAFE, DON'T BE A FOOL OR YOU'LL END UP LIKE HIM* 2001, IS ABOUT A GUY WHO DIVED RIGHT IN TO THE RIVER WITH OUT LOOKING AND HE ENDED UP IN A WHEEL CHAIR. HE IS SITTING BACK WATCHING AND THINKING ABOUT HOW HIS LIFE COULD HAVE BEEN, FOR A MOMENT HE LOOKS INTO THE WATER AND SEES HIMSELF WALKING AGAIN – IT'S ABOUT SAFETY. LIKE IT SAID ON THE TV COMMERCIAL, BEFORE PEOPLE GO SWIMMING IN A STRANGE PLACE THEY SHOULD CHECK IT OUT. It won't cost you more than two or three minutes to see how deep it is and all that. Safety... if you don't follow the rules you end up in a wheel chair! HARRY J WEDGE 2002

HARRY WEDGE

H J Wedge's full-frontal political imagery portrays a satirical view of his reality. This is a reality that many Australians could not possibly have conceived of, or would want to. His story is similar to that of many Aboriginal people in Australia, of institutionalisation – a process and position which leaves many Aboriginal people like H J Wedge as the constructed 'other'. Victims of this process are left with feelings of disempowerment and low self-esteem[1]. Wedge's 'environmental reality' is Erambie Mission in Cowra (central NSW) where he was born and still resides. It is the creation of a chain of social and political events that centre around the continuing dysfunctional relationship between Indigenous and non-Indigenous Australians.

H J WEDGE

ABORIGINAL INSTITUTIONALISATION

JONATHAN JONES

For H J Wedge's community, the pattern of institutionalisation can be considered to have begun in 1890 with the establishment of Erambie Mission. Missions, as institutions, were contrived in the early 1800's to separate Aboriginal people from european society and created as autonomous communities on the outskirts of towns. Erambie was 'managed' in this way from 1924 until 1965 when it was given over to the Aboriginal community to operate. Yet today, the structure of segregation remains and like many mission communities the residents are still ostracised, leaving them without the opportunities enjoyed by mainstream society. Because of this marginalisation and isolation, complex, communal environments have emerged from, creating 'comfort zones' which have reinforced generational institutionalisation. Today mission life remains as negative, historical legacy tending towards dependency. Aboriginal people who reside on missions are, in fact, within a 'comfort zone' created from a white administration and now maintained by current politics and

social position. Much of the dialogue depicted in Wedge's current series *taken over the environment* derives from this post-colonial Aboriginal paradigm.

H J Wedge – like many other indigenous artists including the highly regarded Rover Thomas and Emily Kame Kngwarreye[2] – works within a strong narrative mode, bringing together histories of his community through documentation. One of the factors for the people of the eastern seaboard is that State and Federal Government institutionalisation, social invisibility and attempted assimilation have directly affected Aboriginal people since 1788. The violation of these people has been sustained the longest of any other Aboriginal group within Australia, resulting in the recontextualisation of 'traditional' life. H J Wedge is a product of this process, leaving him 'de-tribalised'. Like many of his contemporaries,[3] he has replaced 'traditional' heritage with 'post-colonial' legacy – thereby creating strong document-like narratives that portray the reality of this social history.

The artist's unique style of narrative painting operates as an art of seduction. Viewer's can be enchanted by his signature lyrical figures, but this is a false sense of security. This illusion provides an opportunity for powerful political statements. The series *taken over the environment* places the viewer within a chronological account of Australia's development, and reflects on the effects of continued Aboriginal institutionalisation.[4] H J Wedge has the ability to focus on a moment, to freeze time; this makes his work comprehensible. From photographic details he outlines the raw elements of the narrative, while his painting style leaves the construction of the story to the viewer's imagination. In the same way that an image from a newspaper is contextualised by the article, the artist's images are contextualised by his statements: his world view originates from life on the mission – it is a 'realist vision' immersed in the actual. As H J Wedge says: "this is my opinion – it's how I see it, lots of people will believe me and thou-

sands probably don't."[5]

Popular culture is another source of stimulus. This arrives in Erambie Mission via the television. Works like *play it safe, don't be a fool or you'll end up like him* are inspired by the media, another aspect that contributes to the accessibility of his work. Again, his figures directly engage the audience – their contorted faces illustrate the social effects of the artist's institutionalisation.

The marginalisation of Aboriginality within mainstream culture means that Aboriginal identity is based on representations that tend to control – and silence – Aboriginal people. What sets Wedge apart is his refusal to be silenced – his refusal to be positioned as 'other'. This act of counterpoint is in stark contrast to the 'collective amnesia' that characterises post colonial and contemporary Aboriginal history. H J Wedge's voice is not unlike that of African-American artist Jacob Lawrence,[6] who also created social and political narratives in order to document his situation. Like Lawrence, Wedge's narratives are grounded in his ability to tell stories. The retention of this cultural practice, and the development of critical investigation within a social and political framework that wasn't intended to be questioned, may prove to be a catalyst in breaking the cycle of systemic Aboriginal institutionalisation.

1. Brenda L Croft, *Wiradjuri Spirit Man*. H J Wedge. Craftsman House, Sydney, 1996
2. In 1990 Rover Thomas and Trevor Nickolls where the first Aboriginal artists to represent Australia at the Venice Biennale. Emily Kame Kngwarreye, Judy Watson and Yvonne Koolmatrie represented Australia in the 1997 Venice Biennale, curated by Brenda L Croft and Hetti Perkins.
3. Including Elaine Russell and Ian Abdulla.
4. Institutionalisation includes missions, judicial/ correctional facilities and educational system
5. H J Wedge interview, 1 March 2002.
6. Jacob Lawrence, American born 1917. African-American political artists grew up in Harlem in the 1930s.

THE SERIES TITLED *TAKEN OVER THE ENVIRONMENT* 2002, RELATE TO EACH OTHER AND RELATE TO THE STRUGGLE OF ABORIGINAL PEOPLE OVER THE YEARS. THE FIRST PAINTING SHOWS THE WHEN THE ENGLISH CAME OUT HERE IN 1788 AND HOW THEY TOOK OVER THE LAND AND PEOPLE WITH FANCY WEAPONS, LIKE CANNONS AND GUNS, WHILE THE NATIVES ONLY HAD SPEARS AND BOOMERANGS. It was an unfair fight... massacres and death. It was Aboriginal country and they took it unfairly. The second painting shows how they came back to the missions and Aboriginal homes, burning their houses down and killed the people, messing everything up. They couldn't leave it alone. The last painting in the series shows the future — how on the street it's happy, but the fight still goes on, things have changed but Koori still need their rights. Other people come here and get jobs, houses, and are set up by the government, while us Kooris are still getting the raw deal — and it's our country from the beginning. They get everything, while we get nothing. Things are changing for others but not for us, we are still being killed and we are still fighting for our land, rights and what we believe in.

Harry J Wedge born
Cowra, Australia, 1958.
Lives and works in
Cowra, Australia

SELECTED SOLO EXHIBITIONS

2001 *H J Wedge Recent Works*, Gallery Gabrielle Pizzi, Melbourne, Australia
Works on Paper H J Wedge, Boomalli Aboriginal Artists Co-operative Ltd., Sydney, Australia
1997 *H J Wedge Recent Works*, Gallery Gabrielle Pizzi, Melbourne, Australia
1994 *Brain Wash* Gallery Gabrielle Pizzi, Melbourne, Australia
1993 *Wiradjuri Spirit Man*, Boomalli Aboriginal Artists Co-operative Ltd., Sydney, Australia
1992 *Wiradjuri Spirit Man*, Tandanya National Aboriginal Cultural Centre, Adelaide, Australia
H J Wedge, Coo-ee Gallery, Sydney, Australia

SELECTED GROUP EXHIBITIONS

2000 *Bonheurs des Antipodes: Regards sur l'art Contemporain Australien*, Musée de Picardie à Amiens, Amiens, France
1999 *Beyond Myth and Reality*, Reaching the World Festival program, Olympic Games 2000, Australian Embassy, Paris, France
1998 *Close Quarters*, Monash University, Melbourne; Australian Centre for Contemporary Art, Melbourne
1995 *16 Songs: Issues of personal assessment and indigenous renewal*, The Saint Louis Art Museum. Saint Louis, USA
1994 *True Colours: Aboriginal and Torres Strait Islander Artists Raise the Flag*, Perth Institute of Contemporary Art, Perth; Australian Centre for Contemporary Art, Melbourne; Brisbane City Art Gallery, Brisbane; Performance Space, Sydney; Boomalli Artists' Co-operative, Sydney; Blue Coat Gallery, Liverpool; South London Gallery, London; City Gallery, Leicester, UK
Urban Focus: Aboriginal and Torres Strait Islander Art from the Urban Areas of Australia, National Gallery of Australia, Canberra, Australia
Power of the Land: Masterpieces of Aboriginal Art, National Gallery of Victoria, Melbourne, Australia
1993-4 *H.J. Wedge - The Artist's Studio*, Art Gallery of New South Wales, Sydney, Australia
1993 *Budapest Autumn Festival*, Vigado Gallery, Budapest, Hungary
Australian Perspecta 1993, Art Gallery of New South Wales, Sydney, Australia

SELECTED BIBLIOGRAPHY

Anthony Bond, *9th Biennale of Sydney: The Boundary Rider*, exhibition catalogue, Biennale of Sydney, Art Gallery of New South Wales Sydney, Australia, 1992
Eddie Chambers, *Black People and the British Flag*, INIVA (Institute of New International Visual Arts) exhibition catalogue, touring Britain, 1991
S Couderc, *Bonheurs des Antipodes: regards sur l'art Contemporain Australien*, exhibition catalogue, Musée de Picardie à Amien, Amien, 2000
Hannah Fink, The Oxford Companion to Aboriginal Art and Culture, Australian National University, Canberra 2000
Judith Ryan, *Power of the Land: Master-pieces of Aboriginal Art*, exhibition catalogue, National Gallery of Victoria, Melbourne, 1994
Margot Neale, *Yiribanna: An Introduction to the Aboriginal and Torres Strait Islander Collection*, exhibition catalogue, Art Gallery of New South Wales, Sydney, 1994
Hetti Perkins 'H J Wedge', *Australian Perspecta 1993*, exhibition catalogue, Art Gallery of New South Wales, Sydney, p 92
Hetti Perkins, 'Blak Artists, Cultural Activists', *Australian Perspecta*, Victoria Lynn (ed), exhibition catalogue, Art Gallery of New South Wales, Sydney, 1993
Gabrielle Pizzi, *Beyond Myth and Reality*, exhibition catalogue, Reaching the World Festival program, Olympic Games 2000, Australian Embassy, Paris, 1999
H J Wedge, *Wiradjuri Spirit Man*, Craftsman House, Sydney, 1996

CHECKLIST OF WORKS

TAKEN OVER THE ENVIRONMENT I 2002
acrylic on un-stretched canvas
184 x 76 cm

TAKEN OVER THE ENVIRONMENT II 2002
acrylic on un-stretched canvas
184 x 76 cm

TAKEN OVER THE ENVIRONMENT III 2002
acrylic on un-stretched canvas
184 x 76 cm

PLAY IT SAFE, DON'T BE A FOOL OR YOU'LL END UP LIKE HIM 2001
acrylic on un-stretched canvas
184 x 76 cm

Works courtesy the artist and Boomalli Aboriginal Artists Co-operative Ltd, Sydney

CANG XIN

THE SENSE OF INTERACTION BETWEEN HUMAN BEINGS AND MATERIAL OBJECTS IS ONE OF THE ESSENTIAL BASES OF ANCIENT CHINESE WISDOM. IN ANCIENT RELIGIOUS RITUALS, HUMAN EXISTENCE AND REPRODUCTION WERE BOTH ENDOWED WITH A SENSE OF MYSTERY AND WERE SEEN AS HAVING A VITAL RELATIONSHIP TO HEAVEN, EARTH AND ALL THE MYRIAD CREATURES THAT DWELT THEREIN. HUMANS COULD COMMUNE WITH ALL KINDS OF EXTERNAL THINGS. IT IS THE DEVELOPMENT OF THIS METHOD OF COMMUNICATION ON A SPIRITUAL LEVEL THAT FORMS THE FRAMEWORK FOR CONTEMPORARY MANKIND'S INTERACTION WITH THE ENTIRE EXTERNAL WORLD. The tongue has a very obvious functional nature, but aside from the main functions of speech, ingestion of food and distinguishing between flavours, it also possesses more sensual and intimate functions of touch and communication. These functions appear to be rather primitive, but they extend the possibilities of an alternative form of touch and communication between our bodies and the other objects that form part of our contemporary lives. This work has been ongoing since 1996, and when I first began it was only those objects used in everyday life that I chose to communicate with. But as time went on and I travelled to many locations around the world to continue this work, I chose objects that would symbolise the cultural edifices and historical monuments of that city or country. Only in this way can the significance of the tongue truly become apparent. Cang Xin talks about his work *Communication*.

CANG XIN

CONTACT: AN ART CONSTRUCT
THAT IS PHYSIOLOGICAL

ZHU QI

For Cang Xin, the sensitivity of the tongue is a kind of gift. This could have to do with his personal experience as a Manchu, exposed to shamanistic religious practice in China. Cang Xin began using his tongue to lick various objects as early as 1996. Since then, he has licked myriad objects, enough to comprise a virtual encyclopedia of objects existing in his world.

The objects he has licked include: books, cups, carved seals, exhibition catalogues, paper money, cameras, light bubs, bricks, shoes, even portraits of Sartre and Nietsche, not to mention the great wall, the forbidden

city and the ground in Oslo, Norway. In Oslo, he even did a performance in which he interacted on-site with a Norwegian woman by touching tongues with her. Cang Xin refers to these actions as 'contacts' or 'communications.'

In Cang Xin's works, the spiritual nature of 'spirit communication' in shaman culture becomes a kind of rationalised mysticism. Perhaps influenced by the concept of inter-activity in the electronic age, Cang Xin seeks to return to the orientalist concept of the 'spirit world' through his perform-ance art.

In traditional China or even the Far East, the so-called 'myriad objects' were vessels, which contained life. That is to say that a tree or a chair was a living object with a spirit. The same spirit may have been embod-ied by the vessel of a person or even a pig in a previous existence. Cang Xin explains

the revelation as it occurred to him as a child: He was at the market buying fish with his mother who is a devout Buddhist. Surrounded by the market, his mother re-lated to him the traditional practice of lowering a banner on a certain day of the year to release a myriad spirits from their vessels. Like a revelation of sorts, he came to the realisation that "I could be them (the fish) and they (the fish) could be me." From this point forward, he says that he has been intrigued by this concept.

In the nineteenth century as Western scientific notions were gradually introduced into China, the underlying notion that the object exists apart from the spirit began to occupy a central and guiding place in modern thinking in China. No doubt, art was similarly influenced by the scientific and pragmatic notions of industrial cul-ture. Thus, even in on-site performances

and happenings, the artist's thought process often emphasised concept over form. In such thinking, spirit association and emotional expression were often relegated to a position of secondary importance.

In his many performances involving "contact", Cang Xin endeavours, in a manner reminiscent of primitive religious practices, to achieve pious contact with the myriad objects around him. In doing so, he becomes a conduit for spiritual communion and through the experience of communicating with the spirits embodying various objects around him. He achieves a certain relativism as it might exist in the various types of objects and the various cultural systems with which he comes into contact. Cang Xin views his performances as both hypothetical and constructed.

In the Middle Ages, sacrificial priests or shamans were synonymous with scientists.

Only after the Enlightenment were the two gradually separated into two distinct roles, which eventually evolved into the two distinct systems, thought and spirituality. Thus developed the split between the mind and the heart common to modernism. In traditional China, the words *xinling* (the spirit of the heart) and *sixiang* (cognitive thought) were often combined in the word *xinsi* (thoughts of the heart). The heart and the mind were one and the same, inseparable. *Xinsi* was central to thought and writing of Confucianism.

Cang Xin views his 'contact' performances as ways to self-healing or salvation. This too is a driving concept in his art. He attempts a spiritual construction that is staged much like a shaman ritual, bringing together or blending, at a spiritual level, the roles of sacrificial priest and scientist. Thus, objects are no longer objectified, but

spiritualised. Spirituality is no longer 'pragmatised', but is embodied in the piety of emotional exchange.

In the many images of the artist coming into 'contact' with the myriad objects around him, perhaps because there are so many of them, the images gradually come to achieve an 'otherworldliness'. The images are not a simple accumulation of single 'communications'. Rather, these myriad 'com-munications' form a kind of organic entity that is growing, that is spreading and multiplying in a way that takes on a kind of intuitive spiritual magic that is very immediate. Cang Xin believes that the art concept should possess such a physiological force. The concept should not be simply a random happening, but an outgrowth of the self.

Translation by Robert Bernell

EXCHANGE SERIES 7 PARLIAMENT
HOUSE, LONDON, UK 2000/.
FRONT IMAGE; EXCHANGE SERIES 6
TEMPLE OF HEAVEN, BEIJING 2000/6.

Cang Xin born in
Suihua, Heilongjiang
Province, China,
1967. Lives and
works in Beijing.

SELECTED SOLO EXHIBITIONS

1997 *Program for the Patient: Auto-write*, solo exhibition
of performance art, east village studio,
Beijing,China
1994 *Virus Series – Trample the Face*, solo exhibition of
performance art, east village studio, Beijing, China
1993 *Virus Series- No.1*, solo exhibition of performance
art, east village studio, Beijing, China

SELECTED GROUP EXHIBITIONS

2001 *Dialogo- the other; Chinese Contemporary Art
Exhibition*, Chiesa Santa Teresa dei Maschi, Bari,
Italy; Young Museum, Mantova, Italy
Hot Pot, Chinese Contemporary Art, Kinesisk
Samtidskunst, Oslo, Norway
The 8th International Performance Art, Tokyo, Japan
Contemporary Chinese Photography, Galerie Loft,
Paris, France
2000 *Photographs of Four Artists*, Chinese Contemporary
Gallery, London, UK
Xieyang Island Performance Art Festival, Guangxi,
China
1999 *Out of Control,* Beijing Design Museum, Beijing,
China
Modern Photography of Four Artists, Q Gallery,
Tokyo, Japan
1998 *431 Video & Computer Art Exhibition*, Changchun,
China

SELECTED BIBLIOGRAPHY

Massimiliano Gioni, 'Trouble Paradise',
Flash Art, Summer, 2000, pp 65-66
Inghild Karlsen, 'Per Gunnar Tverbakk',
Hot Pot, exhibition catalogue, Kinesisk
Samtidskunst, Kunstnemes hus, Oslo,
Norway, 2001, pp 56-57
Meg Maggio, 'From action to image',
Art Asia Pacific, Issue 31, Sydney, 2001,
pp 80-81
Zhao Shulin, 'China 2001', Dialogo -
the other, exhibition catalogue, Chiesa
Santa Teresa dei Maschi Bari, Italy,
2001, pp 1-3
Richard Vine, 'After Exoticism', *Art in
America,* July 2001 pp 31-36, 39.

CHECKLIST OF WORKS

EXCHANGE SERIES 4 MING TOMBS,
BEIJING, CHINA, 2001/3
photograph 140 x 140 cm

EXCHANGE SERIES 4 DONGBIANMEN
WATCH TOWER, BEIJING, 2000/3
photograph 140 x 140 cm

EXCHANGE SERIES 4 BEIJING, GREAT
WALL, CHINA, 2000/3
photograph 140 x 140 cm

EXCHANGE SERIES 6 CONFUSCIAN
TEMPLE, BEIJING, 2001/6
photograph 140 x 140 cm

EXCHANGE SERIES 6 TEMPLE OF
HEAVEN, BEIJING, CHINA, 2001/6
photograph 140 x 140 cm

EXCHANGE SERIES 6 TEMPLE OF LAND,
BEIJING, CHINA, 2001/6
photograph 140 x 140 cm

EXCHANGE SERIES 5 SCULPTURE PARK,
OSLO, NORWAY, 2001/4
photograph 140 x 140 cm

EXCHANGE SERIES 7 PARLIAMENT
HOUSE, LONDON, UK, 2000/
photograph 140 x 100 cm

Works courtesy the artist and Chinese
Art, Beijing

bless all of the grandmothers in the future

MIWA YANAGI

237

Reality no longer has the time to take on the appearance of reality... it captures every dream even before it takes on the appearance of a dream.[1]

Yanagi Miwa's *My Grandmothers* 2000-2002, are projections of future realities that have not yet been realized. Each piece is a narrative shot from the end of one's life; the last scene from an autobiographic film. According to the artist, the grandmother, represented by stars on her website, is in fact an *omamori*, or talisman, that guides and protects us over time. Grandmothers are thus a projection of our future selves who we will use as our personal guardians throughout life.

Though we have the ability to choose and nurture our own children, the passage of time prohibits us from selecting our past generations. *My Grandmothers* allows us to visualize our own aged selves and imagine a maternal ancestor that we have never met, transgressing past and future. The artist breaks conventional notions of family and extends the role of the grandmother to our present selves. The project brings forth multiple visions of youths who attempt to confront their mortality. As a

MIWA YANAGI

MY GRANDMOTHERS 2000-2002

MIKA MONIQUE YOSHITAKE

result, the narratives range widely from the wild and adventurous to noble guardians of youth, and dejected souls of the post-apocalypse to withdrawn sleeping beauties. Although each piece exists as a 'virtual grandmother', the artist believes each woman will be realized in fifty years time.

The grandmothers are produced through an intensive process, much like that of film. Yanagi asks women (and men) between the ages of 17-30 to envision themselves fifty years from now and materializes their vision through photographic image and text. In the initial stages, she places a call for participants interested in her project on her website and conducts e-mail and in-person interviews. After selecting the participant, she decides on the physical appearance of the 'virtual grandmother' and the surrounding environment in which she will exist. The photographs are taken at various locations around the world and the participant uses her/his own body to portray her/his aged self. Yanagi ages the participant's facial and bodily features through the use of extensive makeup and computer processing. In the final stages,

she combines the photographs and reworks them on her computer with detailed precision. She then gives the grandmother a voice by composing a text based on the interviews.

Yanagi's approach, one that warrants a vast array of voices, signals the artist's deviation from her previous series which involved strict anonymity. Yanagi's critical interest in consumer culture since 1993 – particularly evident in her photographic installations of *Elevator Girls* – reflects the dichotomy of uniformity and fragmentation of women in the customer service world. Set within the spectacle of the department store, in wide-open architectural structures with sharp spatial recession, the dehumanized faces of the women are equally as deadpan as their uniforms. Behind this public self, the alienated self inhabits the same transitory structure of the elevator – hence reflecting a larger society of fragmentation and detachment. However, in *My Grandmothers*, instead of generating a lost sense of time and space through the spectacle of the shopping mall, the future informs the present by claiming the subject. Each portrait is a return to subjectivity, an opportunity to turn inward and examine the self via the future. The singular images subvert anonymity and replace stereotypes of women in the consumer world through the incorporation of individual narratives. Fear and alienation are inherent as the women approach death, but here, Yanagi accords agency to the hopes and dreams of the subjects verbally through the texts that accompany the photographs.

Living in a society in which more than one-sixth of the population has reached the age of sixty-five and couples are producing fewer children, Yanagi advocates productive roles and self-sufficiency for the elderly in Japanese society. She has noted that in most Japanese legends, the grandmother is symbolically regarded as a fool. Hence, one of the project's central aims is to imbue wisdom and extend the vitality of life. Two portraits in particular manifest a strong degree of independence. Both *Mika* and *Miwa* depict a woman who is surrounded by children in a panoramic outdoor landscape set in hyper perspective with vast horizon lines. Mika stands firmly in the center of a vast green sea looking up with a grin. Her stance and white *zenso*-like garb, informs us she is a guardian of her students who swim around as though in search of foreign species. They have survived isolation for quite some time not knowing if others exist around them. Amid the dark crags laid out across the horizon,

she states her wish, "That all the life forms that live on this island give birth to the next generation." Her words bespeak present-day Mika's desire and conviction for survival and doubly, Yanagi's wish for future grandmothers. The aim for independence is cultivated even further for Miwa, who gathers children around the globe and brings them along with her on her extensive travels. Hunched over and elegantly all in black, she looks back to check on the children who adoringly run along behind her.

Other images embrace strict solitude. Withdrawal is a form of free will for Ayumi whose narrative is derived from Kawabata Yasunari's novel, *House of Sleeping Beauties* (1961). Here, old men seek pleasure in a house full of drugged maidens who offer to sleep next to their sexually impotent customers. A man, not visible in the image, has just got up from Ayumi's bedside. Behind the closed sliding doors of the *tatami* mat room Ayumi's long grey hair falls gracefully from the red futon that enwraps her bare body. Too heavily drugged to respond, Ayumi's endless sleep makes the state between life and death ambiguous. Kawabata attributes sleep as the ideal form of withdrawal that offers satisfaction for both the giver and receiver. Here is an instance where pleasure no longer necessitates sexual potency, but rather, an inspiration to dream.

Conversely, a sense of sexual drive intoxicates Yuka, whose flaming red hair flies like a thunder bolt as she speeds across the Golden Gate Bridge in the sidecar of her young lover's Harley. She epitomizes wild freedom, showing off her gold front tooth that glistens in the sunlight. Relaxation bores her: after spending months inside the peaceful hub of hot springs, she soon escapes to the electrified sins of Vegas. As she cascades towards her next adventure, the spark of liberation – evident in her broad grin – is like the cigarette that burns between her fingers.

Each tale in *My Grandmothers* embodies implicitly the full experience of a youthful past by extending the role of the grandmother to the present self. Nurture, withdrawal, and adventure are just a few of Yanagi Miwa's themes on ageing. Transgressing time, these projections embody her response to an increasing ageing society through the dreams of today's youth anticipating what is to come.

1. Jean Baudrillard, *Simulations*, Semiotexte, New York, 1983, p 152.

SACHIKO

Even though I thought that I had become totally used to living alone by now,
yesterday, no matter how hard I tried, I just could not stand being in the house by myself.
It seemed as if the winter sunset had overtaken the entire world,
and was, little by little, scorching everything in its path.
I up and drove to the airport, and, not surprisingly, got on the first airplane I could find.
I was trying to escape from the sun, but now I was the one chasing it.

Among all the skies I've seen so far, this is the most extraordinarily divine.
At this very moment, this is probably the most beautiful brightness .
Although I used to hope of dying while gazing upon such a heavenly sky,
my bearing witness to this brilliance right now makes my prior wish nothing but a trivial dream.

As I was about to depart from the airport, I called my friend Kimiko and
told her that I was on my way...and my, was she surprised!
Since I chose this airplane at random, my trip has encountered quite a detour.
I wonder how many hours it will take to get to Iviza via Singapore?
Until I reach that far away island where Kimiko resides, I shall surrender myself to the light.

YUKA

I used to think that as I got on in years, it would be right nice to spend my remainin' days
relaxin' at some hot spring resort without a care in the world. Sure enough, as soon as I
turned seventy, I up and moved to Yufuin*, where I proceeded to spend several years in
exactly the kind of comfort that I was looking for. However, smack in the middle of that
daily routine of soakin' in all that beautiful scenery, I started to think that it might be nice to
leave that tiny world behind, and soon enough, I decided that I wanted to go somewhere far,
far away. And so, after collectin' my wits—and without so much as a word to my
relatives—I went and got on a plane bound for L.A. Lookin' back, I guess you could say
that I died there in Yufuin. As a result, well, I guess I came back here—back here to the
"here and now."

Anyway, right in the midst of all that darn' monotony of idlin' away the days all by my
lonesome there on that trip, I met my current boyfriend (a bit of a 'playboy; if you know
what I mean!), and before I knew it, I was whisked away on an unbelievable romance
replete with a cross country search for 'black gold.' And, as you can probably imagine,
although I've turned down his repeated offers of marriage, that little devil just won't give up!
As for the kids and grandkids back in Japan, well, I just don't see them anymore. I bet my
own grandchildren wouldn't even recognize me—or me, them, for that matter. But, not too
awful long ago, I told one of my grandkids over the phone that I've been zapped off into
some other universe—I guess they call it 'transmigration' in those know-it-all books—and
with that, she started to cry and told me that I've already kicked the bucket!

Oh, my tooth? Well, let me just say that it's a little 'reminder' of my big payoff in Vegas last
year! Anyhow, he's always makin' me laugh with his non-stop jokes. Accordin' to him, my
big ol' laugh--attacks bring about a good luck smile worthy of a goddess herself!

(*) Yufuin is a famous hot springs resort in Kyushu, the southern-most main island of Japan.
 It is known for its remarkably beautiful scenery situated around a natural basin.

Miwa Yanagi born Kobe City, Japan, 1967. Lives and works in Kyoto, Japan.

SELECTED SOLO EXHIBITIONS

2001 Gallery Kodama, Osaka, Japan
2000 Galerie Almine Rech, Paris, France
1999 Gallery Kodama, Osaka, Japan
1998 Art Space Niji, Kyoto, Japan
1997 *Criterium 31*, Contemporary Art Gallery, Art Tower Mito, Ibaraki, Japan
1994 *Looking for the next story*, Gallery Sowaka, Kyoto, Japan
1993 *The White Casket,* Art Space, Niji, Kyoto, Japan

SELECTED GROUP EXHIBITIONS

2001 *Biennale de Lyon*, Lyon, France
2000 *Japan medium light*, Montevideo, Amsterdam, Netherlands
Gendai: Between the Body and Space, Art Center, Warszawa, Poland
1999 *A sense of reality*, Utsunomiya Museum, Utsunomiya, Japan
Fancy Dance - Contemporary Japanese Art After 1990, Art Sonje Museum, Kyongju, Seoul, Korea
Looking For a Place, Site, Santa Fe Biennial, Santa Fe, USA
Signs of Life, Melbourne International Biennial, Melbourne, Australia
Visions of the Body, National Museum of Modern Art, Kyoto; Museum of Contemporary Art, Tokyo, Japan
1998 *Tastes and Pursuits: Japanese Art in the 1990s*, National Museum of Modern Art, New Delhi, India; Metropolitan Museum of Manila, The Philippines
Techno+Therapy, Osaka City Central Public Hall, Osaka, Japan
Art Now in Japan and Korea - Between the Unknown Straits, Meguro Museum of Art, Tokyo, Japan
Taipei Biennial' 98, Taipei Fine Arts Museum, Taipei, Taiwan
1997 *Cities on the Move*, Secession, Vienna, Austria; Capc Musée d'art contemporain de Bordeaux, France; PS 1, New York, USA; Louisiana Museum of Modern Art, Denmark; Hayward Gallery, London, UK; Museum of Modern Art, Helsinki, Finland
Lust und Leere - Japanische Photographie der gegenwart, Kunsthalle Wien, Austria and touring
1996 *Oh, My "Japanese Landscapes"?* Fukuoka Art Museum, Japan
Prospect '96, Schirn Kunsthalle Frankfurt, Frankturt am Main, Germany

SELECTED BIBLIOGRAPHY

Clayton Campbell, 'Ouverture: Miwa Yanagi', *Flash Art*, Jan-Feb. 1999, p 88
Juliana Engberg, 'Miwa Yanagi', *Signs of Life*, exhibition catalogue, Melbourne International Biennial, 1999, p 105
Simon Fitzgerald, Review of exhibitions, *Art in America*, March 1997
Noriko Fuku, *Women Photographers from Japan 1864 – 1997*, Visual Studies Workshop, Rochester, USA, 1998

Takayama Hiroshi, 'My Grandmothers', *Asahi Graph*, 15 Sept. 2000, p 88
Lie Mina, 'My Grandmothers', *Asahi Graph*, 15 Sept. 2000, p 101
Eriko Osaka, *Criterium 31*, exhibition catalogue, Art Tower Mito, 1997
Yozo Yamaguchi, *Oh, My "Japanese Landscapes"?* exhibition catalogue, Fukuoka Art Museum, Japan, 1996

CHECKLIST OF WORKS

from the series 'My Grandmothers' 2000-2001:

SACHIKO
c- print mounted on aluminium and covered with plexiglass, photo 86.7 x 120 cm; text 21.6 x 30 cm

YUKA
c- print mounted on aluminium and covered with plexiglass, photo 160 x 160 cm; text 40 x 40 cm

HIROKO
c- print mounted on aluminium and covered with plexiglass, photo 120 x 144 cm; text 30 x 36 cm

AYUMI
c- print mounted on aluminium and covered with plexiglass, photo 58.3 x 100 cm; text 14.5 x 25 cm

MIE
c- print mounted on aluminium and covered with plexiglass, photo 160 x 120 cm; text 40 x 30 cm

MINAMI
c- print mounted on aluminium and covered with plexiglass, photo 133 x 160 cm; text 33.2 x 40 cm

MIKA
c- print mounted on aluminium and covered with plexiglass, photo 150 x 180 cm; text 45 x 37.5 cm

ERIKO
c- print mounted on aluminium and covered with plexiglass, photo 120 x 180 cm; text 45 x 30 cm

Works courtesy the artist, Yoshiko Isshiki Office, Tokyo and Galerie Almine Rech, Paris

THE SPEAKERS FORUM IS A KEY ELEMENT OF AN EXTENSIVE RANGE
OF PUBLIC PROGRAMS ORGANISED BY THE BIENNALE OF SYDNEY.
THE 2002 SPEAKERS FORUM FEATURES CURATORS FROM AUSTRALIA
AND MANY PARTICIPATING COUNTRIES, AS WELL AS ACADEMICS AND
CULTURAL COMMENTATORS. ITS PURPOSE IS TO BROADEN THE AUDIENCE FOR CONTEMPORARY
ART AND PROVIDE AN OPEN FORUM FOR DISCUSSION AND CULTURAL EXCHANGE. WE ARE EXTREMELY
GRATEFUL TO OUR VENUE PARTNERS AND ESPECIALLY TO THE PARTICIPANTS FOR THEIR ENERGY
AND CONTRIBUTION TO THIS IMPORTANT SERIES OF PUBLIC TALKS.

SPEAKERS FORUM

241

ELEANOR ANTIN (USA)
The Last Night of Rasputin: a film with performance by Eleanor Antin

Acclaimed American performance artist, Antin reveals the extraordinary life of the unknown African-American dancer "Eleanor Antinova", prima ballerina of Diaghilev's *Ballet Russes*, and her historic encounter with Rasputin. The performance also includes a performance by one of Australia's esteemed art-world figures, Daniel Thomas, who will introduce Antin.
(Artist, New York)

ERIL BAILY (AUSTRALIA)
Non-electronic and Electronic Reality

In his paper *Speed and Information: Cyberspace Alarm!*, Paul Virilio claims that we live in stereo-reality: that is the simultaneous reality of the physical and the virtual; or Non-E (non-electronic) and E (electronic) Reality. This is a discussion of some of the differences between these two realities (as analysed by Virilio) and some of the observable and speculative consequences of these changes. For instance, in Non-E Reality human beings are orientated in physical space in which time is calibrated as function of distance. In E Reality, geophysical space 'disappears' and humans are orientated in 'instantaneous' time - a perpetual present or 'now'. In Non-E Reality, Identity is understood to be stable and enduring whereas in E Reality it becomes increasingly ambiguous and ephemeral.
(Lecturer, Theories of Art Practice, Associate Dean of Postgraduate Studies, Sydney College of the Arts, Sydney University)

SASKIA BOS (NETHERLANDS)
Audience participation and contemporary art

This is a discussion about which of the big international exhibitions succeed in the creation of new models for audience participation, whether it be mere entertainment or simple tourism. In this presentation Bos will also discuss the continuing influence of the Romantic Tradition where the viewer is invited into the work of art.
(Director, De Appel Foundation, Amsterdam)
This is Bos' first visit to Australia and her travel has been made possible by the support of the Australia Council and Department of Foreign Affairs and Trade.

ISABEL CARLOS (PORTUGAL)
Non-style and self-referentiality

More than a decade ago Frederic Jameson wrote, "if the experience and the ideology of the unique self, an experience and ideology which formed the stylistic practice of classical modernism, is over and done with, then it is no longer clear what the artists and writers of the present period are supposed to be doing. What is clear is merely that the older models – Picasso, Proust, T.S. Eliot – do not work any more (or are positively harmful), since nobody has that kind of unique private world and style to express any longer". With these words in mind and recent artistic practice in sight, Carlos, a freelance curator and critic, will analyse how artists have confronted this lack of "unique private world and style to express" and come to the conclusion that it is through a "non-style" and a focus in "self-referentiality".
(Freelance curator and art critic, Lisbon)

CAROLYN CHRISTOV BAKARGIEV (ITALY)
The New Millennium and Arte Povera

This is a discussion illuminating the interconnections of the formal and theoretical relationships that exist in the art works of Fontana, Fabro, Pistoletto, Merz and Kounellis and which have now influenced several generations of artists.
(Chief Curator, Castello di Rivoli, Turin)
Christov Bakargiev's visit to Australia for the Biennale of Sydney 2002 Public Programs is made possible by the support of the Italian Institute of Culture in Sydney.

JUSTIN CLEMENS (AUSTRALIA)
The Murderous Fantastic

People are obsessed with murderous fantasies. From the *Terminator* to the *Titanic*, there is hardly a Hollywood movie that does not explore a range of murderous fantasies. The same goes for other forms of media. Diverse commentators have pointed out that part of the horror of the September 11 terrorist attacks was in their *realisation* of such fantasy scripts in which intense pleasure is derived precisely from images of mass destruction. In his lecture, Clemens will explore some of the common psychological uses of murderous fantasy, drawing examples from popular culture and historical events. Are murderous fantasies not only ubiquitous and necessary – but desirable as well?
(Lecturer Narrative Formations in Australian Literature, Psychoanalysis and Literature, Deakin University, Melbourne)

EDWARD COLLESS (AUSTRALIA)
Search Engine

In our digital culture, distinctions between the real and the hallucinatory, or the actual and the virtual, or the factual and fantastic are as dubious and difficult as the attempt to distinguish between a so-called original and its copy. In this milieu, production and consumption are identical: the reality of "reality TV", for instance, is not represented on the screen but induced at the screen interface by the participatory decisions of its audience. In this culture, art is an anachronism. Indeed, the categories of art, design, cinema, architecture, music and so forth - their practice and their critique - disappear as they converge in global "technics", pragmatic modulations and fabrications of appropriated data.
(Head of Art History Studies, Victorian College of the Arts, University of Melbourne)

CATIIERINE CROWSTON (CANADA)
The Order of Alterity: Raising the Question of the Alternative in Canadian Curatorial Practice

In this presentation will raise questions about the notion of "the alternative" in Canadian contemporary curatorial practice. How do curators, working both within and without institutions, define alternative forms of curatorial practice. Alternate to what? In what ways? For what reasons?
(Director of Exhibitions and Programs/Senior Curator, Edmonton Art Gallery, Canada)

KATHRYN FINDLAY (SCOTLAND)
Architecture and the Future

This is an overview of Findlay's architectural projects that have challenged existing knowledge about technology, structure and materials. In each of her projects a technology is analyzed and used in a way, which is considered new knowledge to the architecture profession. For example, "The Truss Wall House" completed in 1993, was the development of a patented method of building compound curve reinforced concrete for the patent holding owner. Not only did this work find a new way of using the system spatially, it was also environmentally innovative. This is also a discussion of the important theme in her work 'Forming the Sustainable', a process of design and construction, which changes the way that technology and architectural design interface.
(Manager, Ushida+Findlay Ltd, London)
Kathryn Findlays' first visit to Australia has been made possible through the support of the Board of Architects of NSW.

BARBARA FISCHER (CANADA)
The Effects of Simultaneity

The topic that interests me is twofold: on the one hand, I am curious about the effects of simultaneity that are produced by electronic information dissemination, especially concerning exhibition practices and local audiences. The simultaneous eruption of connected ideas seems to call for greater networks of collaboration – though physical matter and geographic distance run up against this flow. Curatorial practice takes place in the space of that paradox. The second topic has to do with the changing landscape of "culture", the idea of the museum after cultural studies. Again the effects of simultaneity throw into relief old, new, and diversifying cultural topoi, from x-treme sport to fashion to club cultures. Is the museum/gallery just one of them, i.e. x-treme art? And/or can one make a case for the museum as an integral site for various topoi?
(Curator, Blackwood Gallery, University of Toronto Canada)

MARINA GRZINIC (SLOVENIA)
Visual Art Culture from Slovenia, Central Europe and the Balkans

Establishing a new style of visual "writing" was a result of the conscious visual reconfiguration of an "original" socialist alternative cultural structure. What resulted were innumerable "explosive" contrasts and a series of "technical imperfections" which attempted to comprehend the outer and inner, sexual and mental, order and disorder, conceptual and political, original and recycled space and time. There are two main strategies of visualization, which reflect both history and the body in connection with sexuality, and the social and historical corpus of different art practices.
Fiction reconstructed - Salon de Fleurus

In Grzinic's installation of the *Salon de Fleurus*, Picassos, Cézannes and Matisses are exhibited before us. But rather than being concerned with an individual item, the viewer is forced to become concerned here with the system, not in the sense of a specific reconstruction of space or an installation, but a reconstruction of a system of thinking – one that 80 or 90 years ago elaborated the institution of modern art as we know it today. Therefore, in the "New York" *Salon*, we can purchase not only paintings but also furniture and all the items in both rooms. Every painting sold is substituted with a copy of the same or with another from the same period. Thus the *Salon* regenerates and transforms itself continuously.
(Freelance media theorist, art critic and curator, Research Fellow, Slovenia Academy of Science and Art, Ljubljiana)

RAINER HAUBRICH (GERMANY)
Between Art and Urbanism – The Architecture of New Berlin

This is a discussion about the regeneration and renovation of Berlin in the late twentieth century. Now ten years into the re-development, what are the realities of the transitions from architectural cartoons to the actual manifestations of these grandiose plans?

(Editor and writer, *Art & Architecture*, Die Welt, Berlin)
Haubrich's visit to Australia has been made possible by the support of the Goethe Institut, Sydney

LOUISE KATZ (AUSTRALIA)
Retreat/Projection/Retreat

What is the appeal of sci fi/fantasy? Why the current resurgence of public interest in the genre? Katz will discuss this and the inspirations and processes of the writing of fantasy novels for both young adults and older readers. Her recent book, *The Other Face of Janus*, set both in 21st century Sydney and within Heironymous Bosch's *Garden of Earthly Delights*, is a story based in the myth of the double, which represents reality in its most perplexing aspect. Katz will also discuss her own background in the visual arts and how she was "overtaken" by writing.

(Writer, Aurealis Award Winner for Speculative Fiction 2001)

MARIA LIND (SWEDEN)
Exchange and transformation on contemporary art, corporate culture and resistance

In the midst of the so called new economy, it is relevant to look at the question of exchange and transformation in society in general, as well as in contemporary art, to ponder and question the creation and dissolution of values within various types of economies, of circulation of goods, ideas, information and feelings. In this sense exchange involves different forms of transformation and strategies of informalisation, as well as media jamming and import and export of labour. Exchange and transformation as notions, also imply an activity between the local context, and a wider, even global, context. Interests in the modus operandi of corporate culture and its globalization are an undercurrent to this, as is the relationship between the public and the corporate, between manufacturing and industrial production, mass production and the tailor-made. Lind questions how these issues are connected to the emergence of, and sometimes reactions against, network societies and to developments in the new knowledge-and service-based economy and its inter-organizational relationships on both micro and macro levels.

(Director, Kunstverein München, Munich)

VIRGINIA MADSEN (AUSTRALIA)
Sounds for the future beyond the screen and into the dark

An art of sound does not simply depend upon technology, but rather the complex and sensuous space of *duration* – a 'speed-space' which opens onto a more intensive listening. This presentation questions what might be the future place of an art of sound (and a listening tuned to it) within the all-encompassing rhetoric of 'media convergence', and a largely uncritical digital and multi-media environment. The high-speed image appears to dominate and organize the perceptual field, a field in which, furthermore, the screen continues to be the dominant and ever anchoring framework - an originary metaphor. This is a critique that focuses on the need to open up and/or create spaces for an 'intensive listening' amidst the prevailing *reduction of vision* which, Madsen argues, has become a characteristic of contemporary (western) cultures.

(Post Doctoral Research Fellow in Media & Communications, University of NSW)

JOHN MARSDEN (AUSTRALIA)
Fiction and Truth

This paper is an exploration of the bright and dark sides of the creative process. Fiction is a powerful vehicle for conveying truth and this paradox is at the centre of this presentation. What are some of the truths to be found in novels?

(Writer, latest novels *Winter*, *The Head Book*)

ANNE MARSH (AUSTRALIA)
A Fantastic Real: Contemporary Photography and Theoretical Ideas

This paper considers photography as a fantasy apparatus and the camera as a time machine. The works of Roland Barthes and Walter Benjamin will be used to explore the idea that photography is a kind of writing of desire. Examples from the Biennale of Sydney 2002 exhibition will be discussed in relation to these ideas and contemporary photo-practice.

(Head of Art History, Monash University, Melbourne)

ANNA MUNSTER (AUSTRALIA)
Very Big and Very Small: Digital Fantasia,

How does the contemporary passion of wonder function to invigorate and dupe us, facilitate our love of, and characterise our current attitudes towards the strange crossbred artifacts from the world of science and the world of art? Among the current metaphors used to describe the unfolding relations between art and science, the two ascriptions that are most frequently aired are those of collaboration and/or intersection. This has produced an over-lapping sphere of aesthetic and intellectual activity focussed upon new imaging technologies within the life sciences, scientific visualisation tools, and more recently the production of living matter as artwork through the application of biotechnology in art practice. Anna Munster, lecturer in digital media theory at the University of NSW, will examine the dimensions of this hybrid aesthetics, from its aspirations for miniaturized nanotechnological art to the grand expectations that new media art can develop ecologically to breed artificial life forms. This micro and macro inter-penetration of art and science is facilitated through the re-emergence of the affective impact of fantasy and wonder. Although the cross-fertilisation of art and science is often associated with the return of Renaissance culture, Munster suggests that wonder and technofantasia better resonate with the passions, aesthetics and sciences of Baroque visual culture.

(Lecturer in Digital Media Theory, College of Fine Arts, University of NSW)

JOHN PETER NILSSON (NORWAY)
Changing Realities

It is no longer obvious what is centre and what is periphery. Nordic contemporary art is rooted in a paradox: the region has become aware of its peripheral status while liberating itself from its Nordic heritage. It is possible to detect a new brand of tacit individualism. Modern social welfare policy has created a secure, democratic cultural climate. On the other hand, it has resulted in a desire to transgress accepted norms.

(Editor and contributor, *NU: The Nordic Art Review*, Stockholm)
Nilsson's visit to Australia for the Biennale of Sydney 2002 is made possible by the support of the Swedish Institute of Culture, Sweden.

CELESTE OLALQUIAGA (VENEZUELA /FRANCE)
Look But Don't Touch: The Role of Relics in an Era of Visual Excess

As we move into a culture marked by human displacement and invisibility, our relationship to the world is changing drastically, exacerbating our status of cultural beings to such a degree that all natural experience (bodies, death, nature itself) is relegated to a secondary place – the raw material of a manufactured being so sophisticated that it can (almost) forget its matrix along the way. This condition is not new: it is the consequence of a very long process of acculturation that started, for the West, with a shift from an experience of immediacy to one of increasing detachment and intellectualization of reality. This process can be followed, for example, in the medieval transformation of veneration from a ritual of direct physical contact (the kissing and caressing of relics), to a mediate interpretation of symbols (the ensuing iconographic representation). However seemingly remote, this change from tactility to vision is a fundamental aspect of modern culture, where first-degree experiences, such as touch, conform the tissue of what eventually is distinguished as tradition – a way of being heavily inscribed in space and fixed in time. The accelerated disintegration of this tissue in the last two centuries has provided modern culture with a dense, albeit fragmentary, background against which its own celerity and ubiquity stand in stark contrast. This paper traces the peculiar involution of the sense of touch in Western culture. Starting with a history of the use of relics, describing their eventual fall from grace, and focusing on the "aura" which provides dead objects with a certain transcendence, this is a proposal of reasons and ways in which natural remains have been fetishized through the ages - something that is particularly relevant now, when technology is rendering nature and the body into relics from a not-too-distant past.

(Writer and independent scholar, Paris)

MICHAEL J OSTWALD (AUSTRALIA)
Complex Symmetries: Future Architectures

With the rise in the sciences of complexity, and the associated development of fractal geometry, architecture has been forced to reassess its role in the modern world. This presentation outlines various approaches adopted by architects to reflect this changing worldview and describe several visions for the future of the Built Environment.

(Head, School of Architecture and Built Environment, University of Newcastle, NSW)

RALPH RUGOFF (USA)
Do Biennales Matter?

This paper will be a discussion about the inflationary growth of international biennales over the past decade, and how the status of even the most major events – like Documenta – has

been subsequently diminished by their increase. What are the common pitfalls of biennales as well as some of the ways these might be remedied?

(Writer, curator, cultural theorist, Director of CCAC Institute, San Fransisco, CA)

CAMILLE SCAYSBROOK (AUSTRALIA)

Massively Multiplayer Online Games: 'Who Am I and What World Is This?'

As technology approaches the point at which tens, even hundreds of thousands of people can assemble in a virtual space, represented by 'Avatars', or created visual personas, visual and artistic communication looms as the Internet's next frontier. This revolution has already begun in the form of the Massively Multiplayer Online Game (MMOG). This genre of computer game has mutated from two main traditions. Hypertext Fiction, in which readers may navigate their way through a non-linear narrative by making choices at crucial points in the text – anything from clicking on a character's name to find out more about them, to answering the question 'Does the heroine survive? Then there is the tradition of 'role-playing' games (of which 'Dungeons and Dragons' is the most famous) which can best be described as a more upwardly mobile form of Theatresports. In 1999, 'Everquest' was born, a Tolkienesque fantasy set in the world of Norrath, which today has a subscription base of over 400,000 players. This presentation will discuss several theories about online worlds, including a detailed study of 'Everquest' and the fact that all MMOGs to date, rely on the seemingly simple formula of *find treasure, get rich, kill anyone who gets in your way.*

(Writer, video game designer, art historian, New York/Sydney)

MARKETTA SEPPALA (FINLAND)

Barriers of the Arts

Focusing on Finnish art, this presentation drafts certain tendencies in the interaction of Finnish art(ists) with the rest of the world with the aim of identifying mechanisms by which art is defined, and locating "Finnishness" in the current situation. The post-national, multicultural postmodern world, in which there are no more clear value centers and where difference and pluralism are accepted, even waited for; cultural interaction is in a completely new phase. The nature of globality has changed, and the interaction between the global and the local is becoming very complex. Multiculturalism is a dominant topic of discourse at the moment, and its emphasis is on indignity and the inherent traits of a specific culture. But how can the preconditions for significant, characteristic art be maintained and strengthened in the post-national, postmodern world which, due to the ever more increasing spread of communications technology, is simultaneously shrinking and expanding, fragmenting and getting more uniform?

(Freelance curator, Director, FRAME Finnish Fund for Art Exchange)

DARREN TOFTS (AUSTRALIA)

The world will be Tl?n: Mapping the Fantastic on to the Virtual

This paper will revisit one of the key texts of the fantastic, Jorge Luis Borges' classic 1940 short fiction, "Tl?n, Uqbar, Orbis Tertius". Borges' short parable of an entirely simulated, fictitious world has become one of the key texts of postmodernism, a touchstone in our understanding of the blurry lines of demarcation between reality and its copies. But it also has much to teach us about our current preoccupation with the creation of virtual worlds in the digital age. This is a discussion of the capacity of the digital to create virtual worlds that, like the fabulatory world of Tl?n, are excessive and "too real". In our contemporary virtual culture, the troubling question at the heart of Borges' fiction is still as urgent— do we need reality any more?

(Senior Lecturer in Literature, Chair of Media & Communications, Swinburne University of Technology, Melbourne)

PER GUNNAR TVERBAKK (NORWAY)

Introversion to Dynamism

During the nineties, Nordic art underwent big changes that can be summarized as a movement from introversion to dynamism. A completely new art scene emerged and still it remains difficult and problematic to point to any clear trends that can frame and define contemporary art in the countries Iceland, Norway, Sweden, Finland and Denmark. While the Nordic region shares the characteristics of other so-called peripheral art scenes; a combination of an international style with local distinctive stamps, there are marked differences between the various national art scenes. This makes for an exciting pluralistic attitude and an often overly complex set of cultural situations.

(Freelance curator, writer, Oslo)

LINDA WALLACE (AUSTRALIA)

Architectural Media Space

Drawing on the exemplary writings of Vilem Flusser and his 'universe of technical images', this paper is a discussion of the concepts of 'architectural media space' as it relates to public space in real and virtual terms, architectural practice (particularly in relation to "transarchitecture", intellectual property issues and single screen, interactive video and internet work. The presentation also speculates on how notions of 'public space', as both a space for discourse and for the physical gathering of bodies exists, can be imagined or re-imagined to exist within the current media sphere within which we live.

(Artist, writer, freelance curator, Sydney)

MACKENZIE WARK (AUSTRALIA)

Virtualities

'Why is it that the axis of imagination has shifted from the relation between the real and the ideal, to the relation between the actual and the virtual?' Perhaps it is because the truly significant transformation that took place, gradually, over the course of the 20th century, was the becoming concrete of virtuality itself. When telesthesia, or perception at a distance, combined with the digital, a space and time was created, in actuality, in which the virtual found its circuits of possibility. Whereas an earlier tradition saw the ideal as a spiritual or celestial world apart, now the virtual seems as real as the actual, just a mouse click away from entering the world.

(Visiting Professor in Comparative Literature, State University of New York and Guest Scholar in American Studies, New York University)

MARGARET WERTHEIM (AUSTRALIA)

Lithium Legs and Apocalyptic Photons: The Fantastical World of James Carter,

What drives a man with no science training to think he can succeed where Einstein and Stephen Hawking have failed? For the past thirty years Jim Carter – gold miner, abalone diver, trailer park owner – has been developing his own alternative theory of physics. From the subatomic to the intergalactic, Carter has devised a complete theory of reality, presenting his ideas in lavishly illustrated, self-published books. Replete with ecstatic prose, and now elaborated in a series of computer animations, Carter has generated an entire phantasmagorical universe. With his "circlon" theory of nuclear structure, his refusal to believe in gravity, his Rube Goldberg-like smoke-ring machines, and his secret hand-chiseled caves he could not be further removed from the orthodox world of research science. Is this genius, heresy, or lunacy? And who of us are equipped to judge the difference? This is a discussion of the fantastical world of visionary "outsider physicist" Jim Carter. Here is a life in which science becomes not just a system for comprehending the world, but a kind of empirical poetics. Through this exploration of Carter's work there is a concurrent examination of the power of science to enchant our conceptual landscape.

(Writer and cultural commentator, *Pythagoras Trousers* and *The Pearly Gates of Cyber Space*, documentary maker)

ROGER WOOD (AUSTRALIA) AND RANDAL MARSH (AUSTRALIA)

This is a discussion about the contexts, processes and influences on contemporary architecture in Melbourne. Wood Marsh Architects want their work to be something between a *James Bond film and Tel Aviv*. An influence in their work is the art and architecture of the early 1970's. In collaboration since 1983, their firm, Wood Marsh Architects, is known not only for architecture but also for furniture, interior and urban design, sets and installations, visual art exhibitions and performance works. Their design for the soon to be opened Australian Centre for Contemporary Art has been described as *A work of art for art*. Wood and Marsh will talk about their inspirations, design principles and processes.

(Architects/designers, Melbourne)

The 13th Biennale of Sydney was made possible with the financial assistance of a number of public and private sector partners in Australia and abroad. We are grateful for the recognition and financial support of the many participating governments and cultural foundations who have assisted in bringing artists and works to Australia. We also thank our generous corporate partners and sponsors, in addition to those companies which helped with in-kind support. All are listed on the following pages with gratitude.

A special thank you is due to our Ambassadors and Benefactors whose patronage is greatly appreciated, particularly as these individuals frequently respond generously to the call of many organisations and worthy causes.

The Biennale of Sydney also wishes to thank the artists, collectors and galleries who have lent works to the exhibition and who have often provided invaluable assistance.

A great many people often working beyond the call of duty have contributed to the making of this exhibition. Among these are our gifted and resourceful staff whose skill, good humour, and optimism are an inspiration. It has been a privilege to work with them. Without their energy and expertise this exhibition could not have been realised.

We particularly value the cooperation and creative contribution of our venue partners and their professional staff with whom we have worked very closely. Their staff and infrastructure have been crucial to the presentation of the 13th Biennale of Sydney and we are indebted to them for their practical assistance. To the many volunteers and interns who have worked behind the scenes we extend a warm thank you, not only for their time and hard work, but also for their friendship.

Last but not least the Biennale Board under the enthusiastic and dedicated chairmanship of Luca Belgiorno-Nettis has been particularly positive and undeterred throughout our challenging fundraising campaign. To each of them a sincere thank you for recognising the exciting potential of Richard Grayson's concept for the exhibition, and for their vision and good advice.

PAULA LATOS-VALIER / GENERAL MANAGER

PRINCIPAL AND FOUNDING PARTNER

Transfield Pty Ltd

PRINCIPAL PARTNERS

Tempo Services Limited

Australia Council for the Arts
– Visual Arts & Craft Board
– Audience and Market Development Division

New South Wales Government
– Ministry for the Arts

City of Sydney

Art Gallery of New South Wales

Museum of Contemporary Art

13TH BIENNALE OF SYDNEY
PARTNERS + SPONSORS

Beyond Online Ltd

JCDecaux

ResMed Ltd

SBS Television

Singapore Airlines

Sydney Airport

245

AMBASSADORS

Franco Belgiorno-Nettis AC CBE
– Founding Governor

David Coe

Ari Droga

John Kaldor AM

Ann Lewis AM

John Schaeffer

Gene and Brian Sherman

BENEFACTORS

Geoff and Vicki Ainsworth

Anonymous

Terrey and Anne Arcus

Helen and David Baffsky

Franco and Amina Belgiorno-Nettis

Anita and Luca Belgiorno-Nettis

Andrew and Cathy Cameron

Ginny and Leslie Green

John Kaldor AM

Elizabeth and Colin Laverty

Ann Lewis AM

Amanda and Andrew Love

Mitchell and Robyn Martin-Weber

Sally and Reg Richardson

Penelope Seidler

Gene and Brian Sherman

Michael Whitworth and Dr Candice Bruce

THE EXHIBITION COULD NOT HAVE BEEN REALISED
WITHOUT THE ASSISTANCE OF

Artspace

City Exhibition Space

Object – Australian Centre
for Craft and Design

Customs House

Government House

Sydney Opera House Trust

Sydney Film Festival

Sydney Writers' Festival

New South Wales Government
Exhibitions Indemnification Scheme

Sydney Harbour Foreshore Authority

International Art Services

Royal Botanic Gardens, Sydney

ARTISTS NATIONAL RESIDENCY PROGRAM

NSW

Bundanon Trust

College of Fine Arts, University of NSW

Gunnery Studios, NSW Ministry for the Arts

Hill End Artists in Residence Program, Bathurst Regional
Art Gallery in association with Gavin Wilson and NSW
National Parks & Wildlife

Marrickville Council

Newcastle Region Art Gallery

The School of Fine Art Gallery, University of Newcastle

VICTORIA

RMIT Gallery

RMIT University

Schools of Fine Arts, Classical Studies and Archeology,
University of Melbourne

Victorian College of Art, University of Melbourne

WESTERN AUSTRALIA

Central TAFE Art Gallery, Perth

West Australian School of Visual Arts, Edith Cowan
University

QUEENSLAND

Architecture Department, University of Queensland

Gold Coast City Art Gallery

Institute of Modern Art, Brisbane

Mr & Mrs Corrigan

QLD Artworkers Alliance

Queensland College of Art, Griffith University

TASMANIA

Tasmanian School of Art, University of Tasmania

PARTNERS

Allco Finance Group Ltd

CSR Ltd

Macquarie Bank Foundation

Smorgon Reinforcing and Steel Products

Four Points by Sheraton Sydney

Thrifty Car Rental

Yarra Trams

Price Waterhouse Coopers

The Board of Architects of NSW

Marrickville City Council

The University of New South Wales,
College of Fine Arts

Asahi Breweries Ltd

The Myer Foundation

ASSOCIATES

ArtHouse Hotel

Hennessy Cognac

Taubmans

Transfield Services

DONORS

Westfield Holdings Ltd

ABN AMRO

ADI Ltd

Aristocrat Technologies
Australia Pty Ltd

Coates Hire

Gilbert + Tobin Lawyers

SAP Australia Pty Ltd

Jardine Lloyd Thompson

PARTICIPATING COUNTRIES

AUSTRALIA

BELGIUM

BRITAIN

CANADA

CHINA

FINLAND

FRANCE

GERMANY

HONG KONG

IRELAND

ITALY

JAPAN

KOREA

MEXICO

NETHERLANDS

NEW ZEALAND

NORWAY

POLAND

PORTUGAL

SLOVENIA

SWEDEN

USA

VIETNAM

2002 CULTURAL FUNDING

248

The Biennale of Sydney is pleased to acknowledge
the generous support of the following participating
governments and cultural organisations that have
assisted in the presentation of the exhibition.

AUSTRALIA
Australia Council for the Arts
– Visual Arts and Craft Board
– Audience and Market Development Division
New South Wales Government
– Ministry for the Arts
City of Sydney
Department of Foreign Affairs and Trade

BELGIUM
Commissariat Ministry of Flemish
Culture/Ministerie van de Vlaamse Gemeenschap
Commissariat général aux Relations internationales
de la Communauté Française de Belgique

BRITAIN
The British Council, London & Sydney

CANADA
Department of Foreign Affairs and International
Trade of Canada/ Ministère des Affaires étrangères
et du Commerce International du Canada
The Canada Council for the Arts/ Le Conseil des
Arts du Canada
Alberta Foundation for the Arts

CHINA
Australia-China Council, Canberra

FINLAND
FRAME, Finnish Fund for Art Exchange

FRANCE
Association Française d'Action Artistique,
Ambassade de France, Canberra
Alliance Française, Sydney

GERMANY
Auswärtiges Amt
Institut fur Auslandsbeziehungen
Goethe-Institut Inter Nationes Sydney

IRELAND
Department of Foreign Affairs, Cultural Relations
Committee

ITALY
Italian Institute of Culture, Sydney

JAPAN
Shiseido Co. Ltd, Corporate Culture Development
Department
Toshiba International Foundation
Japan Foundation, Sydney

NETHERLANDS
The Mondriaan Foundation
Consulate-General of the Netherlands, Sydney/
Consulaat-Generaal van het Koninkrijk der
Nederlanden

NEW ZEALAND
Creative New Zealand, Arts Council of New
Zealand Toi Aotearoa International

NORWAY
NOCA – Norwegian Contemporary Art

SLOVENIA
Ministry of Culture of the Republic of Slovenia

SWEDEN
Moderna Museet cooperates with Clear Channel
and Advokatfirman Vinge
Swedish Institute

USA
Official U.S. participation in the Biennale of
Sydney 2002 is made possible by generous
support from THE FUND FOR U.S. ARTISTS AT
INTERNATIONAL FESTIVALS AND EXHIBITIONS,
a public-private partnership of the National
Endowment for the Arts, the U.S. Department
of State, The Pew Charitable Trusts, and The
Rockefeller Foundation, and administered by
Arts International

Auswärtiges Amt

republika slovenija
ministrstvo za kulturo
www.gov.si/mk

creative nz

ARTS COUNCIL OF NEW ZEALAND *Toi Aotearoa*

GOETHE INSTITUT SYDNEY

The British Council

MODERNA MUSEET
MODERN MUSEUM
INTERNATIONAL PROGRAMME

ifa — Institut für Auslands-
beziehungen e. V.

FRAME
FINNISH FUND FOR ART EXCHANGE

THE CANADA COUNCIL | LE CONSEIL DES ARTS
FOR THE ARTS | DU CANADA
SINCE 1957 | DEPUIS 1957

Ministerie van de
Vlaamse Gemeenschap

iiC Istituto
Italiano
di Cultura
Sydney

Department of Foreign Affairs
and International Trade

国際交流基金
The Japan
Foundation

af
Alliance Française
A F A A
AMBASSADE DE FRANCE

Consulaat-Generaal van het
Koninkrijk der Nederlanden

SHISEIDO

TOSHIBA INTERNATIONAL FOUNDATION

Mondriaan Stichting
(Mondriaan Foundation)

Ministère
de la Communauté
française

AND SUPPORTING GALLERIES

Air de Paris, Paris
Alexander and Bonin, New York
Andrea Rosen Gallery, New York
Artangel, London
Atelier van Lieshout, Rotterdam
Atle Gerhardsen, Berlin
Barbara Flynn, Sydney, New York
Barbara Gladstone Gallery, New York
Barry Sloane, Los Angeles
Bellas Gallery, Brisbane
Blast Theory, London
Boomalli Aboriginal Artists Co-operative Ltd, Sydney
Carl Hammer Gallery, Chicago
Chartwell Collection, Auckland Art Gallery Toi o Tamaki
Chinese Art, Beijing
Cranford Collection, London
Crystal Eye Ltd, Helsinki
Darren Knight Gallery, Sydney
David Quadrini, Dallas
David Zwirner, New York
Dean Valentine & Amy Adelson, Los Angeles
Eileen and Peter Norton, Santa Monica
Electronic Arts Intermix, New York
Foksal Gallery Foundation, Warsaw
Fondation Cartier pour l'art contemporain, Paris
Fondazione Sandretto re Rebaudengo per l'Arte, Turin
Gagosian Gallery, London, New York
Galeria Filomena Soares, Lisbon
Galerie Almine Rech, Paris
Galerie EIGEN+ART, Berlin/Leipzig
Galerie Georges-Philippe & Nathalie Vallois, Paris
Galerie Nordenhake, Berlin
Gallery for Contemporary Art, Celje
Gallery Skuc, Ljubljana
Gary and Tracy Mezzatesta, Los Angeles
Gavin Brown's enterprise, New York

Gow Langsford Gallery, Auckland, Sydney
Greenaway Art Gallery, Adelaide
Hans-Joachin Sander, Darmstadt
in Situ, Paris
Irish Museum of Modern Art, Dublin
Jay Film and Video, Newcastle upon Tyne
Jay Jopling/White Cube, London
Kerlin Gallery, Dublin
Lehmann Maupin, New York
Lisson Gallery, London
Locus+, Newcastle upon Tyne
Marc Selwyn, Los Angeles
Mark Deweer, Otegem
Matt's Gallery, London
Maureen Paley Interim Art, London
Max Hetzler, Berlin
Metro Pictures, New York
Milestone Film & Video, New Jersey
Mizuma Art Gallery, Tokyo
Murray Guy Gallery, New York
Patrick Painter Inc., Santa Monica
Paul Lannoy, Belgium
Rachel and Jean-Pierre Lehmann, New York
Ronald Feldman Fine Arts, New York
Ronny Van de Velde, Antwerp
Rosamund Felsen Gallery, Santa Monica
Roslyn Oxley9 Gallery, Sydney
Shoshana Wayne Gallery, Los Angeles
Simone & Jacques Leiser, Belgium
The Approach, London
The Institute of Militronics and Advanced Time Interventionality , London
The Museum of Contemporary Art, Los Angeles
Tolarno Galleries, Melbourne
Toyota Municipal Museum of Art, Aichi, Japan at Superfactory, Hiroshima, Japan
Washington University, St. Louis
Yoshiko Isshiki Office, Tokyo
Yuill/Crowley, Sydney

The Biennale of Sydney also wishes to thank the artists who have lent works and the private collectors who do not wish to be named.

Special thanks are also due to the many artists' agents for their invaluable assistance.

13TH BIENNALE OF SYDNEY

BOARD AND STAFF

251

TRANSFIELD

A leading innovative Australian
company in the construction, development
and maintenance of infastructure

TeMPO

T

Australia's leading
multi-service organisation

Australia Council
for the Arts

The Biennale of Sydney is assisted by the
Australia Council, the Federal Government's
art funding and advisory body

The Biennale of Sydney is assisted
by the New South Wales Government
through the Ministry for the Arts

BEYOND ONLINE

JCDecaux

RESMED

SINGAPORE
AIRLINES

A STAR ALLIANCE MEMBER